Visualizing the Revolution

PICTURING HISTORY

Series Editors
Peter Burke, Sander L. Gilman, Ludmilla Jordanova,
†Roy Porter (1995–2002), †Bob Scribner (1995–8)

Visualizing the Revolution

Politics and the Pictorial Arts in Late Eighteenth-century France

Rolf Reichardt and Hubertus Kohle

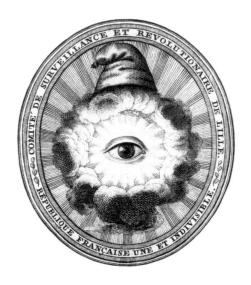

REAKTION BOOKS

Published by Reaktion Books Ltd
33 Great Sutton Street, London EC1V 0DX, UK

www.reaktionbooks.co.uk

First published 2008

English-language translation © Reaktion Books Ltd, 2008
Translated from the German by Corinne Attwood
Translations from the French by Felicity Baker

All artworks/photographs of artworks reproduced in this edition
are in the authors' collections.

Printed and bound in China

British Library Cataloguing in Publication Data
Reichardt, Rolf
 Visualizing the Revolution : politics and the pictorial arts in late
 eighteenth-century France. – (Picturing history)
 1. Art, French – 18th century 2. Art – Political aspects – France
 – History – 18th century 3. France – History – Revolution, 1789–1799
 – Art and the Revolution 4. France – Intellectual life – 18th century
 I. Title II. Kohle, Hubertus
 709.4'4'09033

ISBN-13: 978 1 86189 312 3

Contents

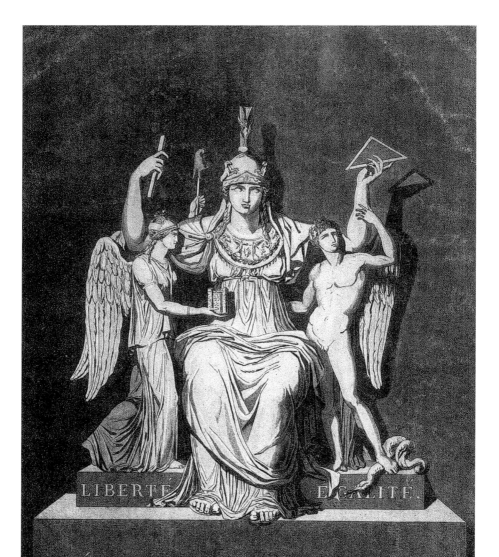

LIBERTÉ. EGALITÉ.

RÉPUBLIQUE FRANÇAISE

Projet de Groupe a executer au fond du Pantheon Français.

Introduction:
On the Threshold of a New Era for the Arts

So impressed was Goethe by a collection of French caricatures he saw in Frankfurt in 1797 that he began writing a treatise on the subject. The 'Olympian' of Weimar, a long-time connoisseur and collector of elaborate, classical-style French engravings (antique landscapes, *vedute*, *historie* and genre prints),[1] found himself both attracted and repelled by the distorting, even vulgar metaphors of some of the prints in circulation at the time of the Directoire, conflicting as they did with traditional ideals of beauty.[2] Although Goethe never completed his treatise, he did return to the theme in *Die guten Weiber* (1800), a novella in the form of a dialogue. In one episode featuring a debate on the subject of caricatures, even the opponent of these new-fangled cartoons grudgingly concedes their strong impact on her.[3]

Goethe's ambivalence would appear to be symptomatic of the prevailing crisis of aesthetics at a time when even an academy trained British artist like James Gillray was abandoning historical and genre painting in favour of caricatures of contemporary events, and German painters were developing pictorial satire into a more expressive form.[4] (It should be noted here that at that time, *caricature* denoted not only visual satire but any characteristic graphic portrayal.) There were no longer any definite criteria for what constituted a 'good' picture. Recent research in art history confirms that during the years 1760–1810 the arts underwent a seismic structural upheaval, with France being perhaps the foremost laboratory for this cultural experiment. Werner Busch has provided a particularly profound analysis of the stages of this process of transformation.[5]

As academic 'high art' was being subjected to increasingly stringent criticism, so classical theory was gradually losing its universal validity. Traditional iconography was being cut loose from its cultural moorings and the safe refuge of the 'Ancients' being abandoned, metaphysical values were in crisis, and the sacred was coming under attack from both sides by reality and authenticity. This secularization and contemporization had a dual effect on the pictorial arts.

First, the function of allegory was being diminished, and traditional iconography was being relativized. In order to ensure recognition for their work, artists customarily utilized the traditional iconography and classical symbolism of figures and forms when portraying particular themes. Now, however, they began taking liberties when utilizing ancient Christian models, giving rise to a conflict between old forms and new content, and at the same time the development of a new iconographic archive. Second, the classical hierarchy underwent an upheaval, so that the boundaries between historical, genre, landscape and portrait painting became blurred, giving rise, for example, to genre paintings with historical meaning. This was especially the case with caricatures, which were for the most part produced anonymously, a fact which, combined with their forceful realism, meant that they were ideally suited to the expression of contemporary experiences and, above all, the sense of rupture with the past.[6] This was also the case with the new type of 'popular picture', the history of which remains to be written.[7]

Werner Hofmann has characterized this process of transformation as a rejection of the classical rule of unity of place, time and treatment; in the transition to the Early Modern, the picture lost its traditional 'monofocus', becoming instead 'polyfocal', in Hofmann's vivid metaphorical neologism.[8] This new perspective, briefly outlined here, on the artistic revolution that occurred during the transition to a new era (1760–1810), sheds new light on what has long been the Cinderella of art history. The 1790s are still something of a blind spot in this new comprehensive examination, at least in the case of France, either in that the decade is ignored altogether, or because the focus is on prominent individual works of representational art in themselves, without taking into account their connection with a particular period of time. Whereas the French Revolution may not have been the primary artistic event of the late eighteenth century, the premise here is that it did function as an essential catalyst of the process of transformation outlined above. Artists became highly politicized, and conscious of contemporary events; innovative symbolism was introduced, leading to experimentation with provocatively expressive and emotional processes of representation, which was further developed, given form, and 'ennobled'.[9] It was hardly coincidental that Goethe's aesthetic crisis was triggered by socially critical prints emanating from revolutionary France.

It might appear at this point that despite the vast amount which has been written on the subject of the French Revolution, there remains a blind spot in the field of art history that has finally come under the microscope since the Bicentennial of 1989, primarily because research into the Revolution inaugurated a 'cultural turn' at that time.[10] But this is not in fact the case, at least not in the sense of the problem outlined above, as a brief overview of the relevant general publications will demonstrate.

In the field of academic history there is Michel Vovelle, former Chair of Revolutionary History at the Sorbonne, and the administrative director of the scientific Bicentennial.[11] Vovelle played a prominent role in the Jubilee thanks to his pictorial history of the Revolution, the most comprehensive work on the subject.[12] However, although his five volumes contain a wealth of iconographic material, the descriptions of historical events and the relevant pictures are not displayed together. In addition to this somewhat creative layout, many of the prints illustrated have been injudiciously cropped. Shorn of their original titles and subscriptions, their expressiveness is somewhat diminished. In this case too,[13] the images merely function as supplementary illustrations to the pre-prepared, self-contained historical text.

In contrast, Annie Jourdan's *Les Monuments de la Révolution, 1770–1804* ignores the iconographic testimonials of the Revolution and concentrates on the rich body of textual sources in which the elite group of artists and politicians outlined their original conceptions for the portrayal of revolutionary ideals in the form of monuments, sculptures and allegorical pictures.[14] She thereby neglects not only the authentic language of form and hence the emotionality of the artworks, but also the connection between high art and popular artistic productions, which was crucial at that time.[15]

Works of art history, on the other hand, focus on the pictures themselves, most notably a volume of essays by Philippe Bordes and Régis Michel,[16] which provide a supreme overview, from the central aspects of the revolutionary art of the Salons, the politicization of painting and sculpture, competitions and art theory, up to and including ceremonial architecture and the establishment of museums. However, it gives scant attention to the 'lower' arts and the interchange between the different levels of art. In contrast, the catalogues of the large general Jubilee exhibitions present a broader spectrum of artistic works,[17] although even the best of these do not offer a fully

comprehensive presentation. There are also a few monographs which deal with particular types of art from the time of the Revolution, not only painting[18] and sculpture,[19] gardens[20] and architecture,[21] but also prints[22] and medallions,[23] fashion[24] and faience.[25]

We are, therefore, dealing with an amorphous, hybrid, multifarious artistic production, as rich in material as it is diverse, hitherto only spasmodically examined by historians, and which, on the other hand, cannot easily be encompassed within the criteria of art history. This is especially true in the sphere of high art, as the artworks in question are 'virtual' works – because of the rapid pace of revolutionary events, few of the works planned and commenced even by painters, let alone architects and sculptors, were ever completed.

Perspectives

In view of the current situation with regard to material and research, *Visualizing the Revolution* makes a case for a new perspective, one more appropriate to its specific nature than previous books. In it we present a thorough examination of the thesis that, during the Revolution, the public role of pictorial art, its societal function and its emotional content were clarified; also the possibility of producing parodies and travesties of earlier works of art from the perspective of a political avant-garde. As such, it was more a case of intentional restructuring than of artistic innovation, which was initiated verbally rather than graphically. Napoleon harvested the fruits of this radical reappraisal of the function of pictorial art and the characteristic transmutation of 'verbal leadership' into new forms of visual art. With the establishment of the bourgeoisie, the process of the transformation of the arts in France reached its conclusion under his rule.[26] Although there is more agreement with regard to pictures than to other forms of revolutionary art, these will be our starting-point, since they generally had their own intrinsic meaning, which expressed more than the texts, and they constituted a quintessential medium of political culture and mass education.

First, our hypothesis is that this subject-matter presents an intersection and connection between historical and aesthetic approaches. Second, we have selected and arranged our primary materials in such a way as to facilitate examination. Pictorial art during the time of the Revolution was so thoroughly pervaded by politics that any presentation on the basis of individual genres cannot encompass the actual effective interconnections between them at that time. Visualizations of the *ancien régime* and the *nouveau régime*, the creation of new types

mounted National Guard, to the vigil around his sarcophagus on the ruins of the Bastille by 1,200 mourners, to the magnificent white horses taken from Marie-Antoinette's stables to pull the majestic hearse. Just as Louis XIV had marked the inauguration of his reign in 1660 with an extravagant procession into 'his good city of Paris',[6] so the leaders of the Revolution seized this opportunity to take possession of the capital symbolically – by retrieving the remains of the free spirit and 'prophet' of the Revolution,[7] which had been expelled from the official church in 1778 and buried in a provincial cemetery – and holding a state funeral to re-inter them.

In addition to its fundamental significance, this anti-absolutist ritual was also designed with a quite concrete political goal in mind, as evidenced by a satirical print that was widely disseminated in the late summer or autumn of 1791 (illus. 3).[8] Three weeks after the failed attempt at escape by Louis XVI, on 21 June, referred to by the inscription on the monument to the left as a 'Faux Pas', Fame is proclaiming in a somewhat lurid fashion the new apportioning of worldly renown in France: for Louis XVI there is only the off-key rear fanfare, with the inscription 'the day of 21 June', while Fame is shown playfully kicking the royal bust off its pedestal into the thistle patch beneath. In contrast, a mellifluous fanfare is proclaiming the

3 *Le Faux pas*, coloured etching, 17.3 x 22.5 cm, Paris, July 1791.

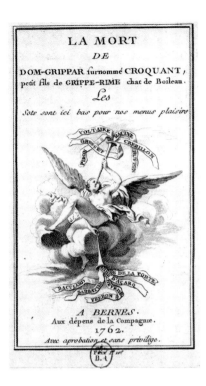

rule of law and the ascendant glory of Voltaire,[9] who is depicted with a halo of stars and surrounded by the attributes of the art of Poetry (Pegasus, lyre, manuscripts). His position on the pedestal of the 'immortal man' is emphasized by the scene in the background showing his admission into the Panthéon. The verses in the inscription furthermore underline that after the old age of the 'tyrannical idol', a new era is dawning for the *citoyen*: an era of liberty and recognition of his worth.[10] The anti-monarchism underlying the celebrations of 11 July, which is implicit in commemorative pictures of the event, is quite explicit in caricatures. The pictorial composition of this revolutionary communication may be entirely new, but not the 'double fanfare'. The anonymous artist has borrowed freely from the title vignette of an Enlightenment pamphlet from the literary underground, which had aimed this pictorial salvo at the struggle between the *philosophes* and *anti-philosophes* as early as 1762 (illus. 4). Representatives of the enemy camp are named on banners: among the 'outsiders' are Elie Fréron, editor of the conservative newspaper *Année littéraire*, and other opponents such as François de Baculard d'Arnaud and Antoine Sabatier de Castres, forming such a dense

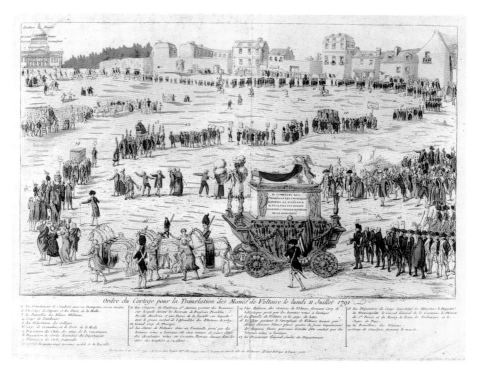

5 *The Order of the Cortege for the Transfer of Voltaire's Remains on Monday 11 July 1791*, coloured etching, 32.7 x 50.4 cm, Paris, Paul-André Basset, 1791.

mass that Fame is able to recline on them, while the fanfare on high proclaims the imminent victory of the *bons auteurs*, with Voltaire's triumph to the fore.

Although there are pictures of Voltaire's admission to the Panthéon in all manner of styles and levels of art, they all focus on the 'state', that is to say the official aspect of the festival procession. However, as all newspaper reports of the time testify,[11] there was also an unofficial element. As numerous revolutionary activists in the forefront of the festivities complained, in honouring Voltaire they were honouring an *aristocrate*, far removed from the ordinary people, while ignoring those members of the petty bourgeoisie of the Faubourg Saint-Antoine who had stormed the Bastille.[12] The National Assembly and the Council of Paris therefore approved a last-minute addition to the pageant, depicted in a popular print from the workshop of Paul-André Basset (illus. 5). This tinted etching likewise shows the ceremonial carriage (with the inclusion of an inscription[13]) in the foreground, also the costumed attendants (but without standards), and the deputies walking

behind the carriage, while further ahead to the front – by the first bend of the procession – are two divisions, one carrying an edition of the complete works of Voltaire, the other a copy of Voltaire's statue by Houdon. Although the leading division appears smaller due to the effect of perspective, the image and text are no less detailed. The mid-section of the procession is dominated by the emblematic stone of the Bastille, a prison in which Voltaire was twice incarcerated, as they are carrying a reliquary-like souvenir of its destruction. The group framed by four shields is made up of 'Les Citoyens du Faubourg St-Antoine portant des Bannières sur lesquels étoient les Portraits de Rousseau, Franklin, Desille, Mirabeau et une Pierre de la Bastille . . .' (legend, no. 11). A number of other recently deceased contemporaries are also being honoured under Voltaire's patronage – in accordance with proposals by members of the literary and political Enlightenment that *Grands hommes* should be distinguished not as individuals but as members of a group. The leading and largest division is made up of the widows of fallen Bastille stormers to the rear, the workers charged with demolition of the fortress to the fore, and, in the middle, one of the models of the Bastille (illus. 7), which a man called Palloy had modelled out of the rubble of the detested state prison, in order to send one to the administration of all the *départements*, along with other symbolic objects, *'ex votos* of liberty', there to be consecrated in festive ceremonies.[14] According to newspaper reports, this Pierre-François Palloy was the leader of the demolition crew, and he had provided the workers with every conceivable implement of torture from the cells of the Bastille to carry aloft in the procession:

Those trophies of liberty were followed by citizens who took part in the storming of the Bastille, and by their wives; among their number was an Amazon who had a share in their labours of war. On an unfurled standard an image of the Bastille could be seen; a representation in relief of that fortress followed after it, borne by the good citizens of the faubourgs whom the lampooners Gautier and Royau call the woollen caps: they are proud of their caps, as symbols of liberty.[15]

Although they had yet to be institutionalized as *bonnets de liberté*, the headgear of the *sans-culottes* already had an important role in establishing the socio-political identity of the revolutionary activists. Their choice of flag, with the picture of the Bastille, signalled their closeness to the people. This flag might well have been one of the flags sewn by female citizens for the National Guard, which were depicted and described in a coloured print by Vieilh de Varenne (illus. 6). Several of the divisions preceding this 'cortège de la Bastille' also emphasize the

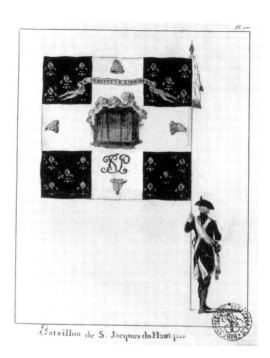

6 Raymond-Augustin Vieilh
de Varenne, *Battalion of St
Jacques du haut pas*, coloured
etching, 19.5 x 15 cm, Paris,
1790.

overwhelmingly popular character of the entire leading half of the procession, in particular the 'Forts de la Halle' and the deputations from the democratic new revolutionary clubs (*sociétés fraternelles*).

The revolutionary procession of 11 July 1791 was constituted from two cultural levels: on the one side was the plebeian half, represented by Palloy, a mason who rose to become a rich building contractor and who invested his fortune in the production of a popular symbol of the Bastille; on the other side there was the elite half represented by Cellerier and David, the latter the academically trained painter who, thanks to his exhibitions in the Salon of the Louvre and state commissions, enjoyed official recognition by the National Assembly. The pictorial art of the time reflects this dualism very clearly by presenting two entirely different views of one and the same media event: while Basset's 'naive' print emphasizes the militant plebeian revolutionary symbolism of the procession, without neglecting the 'official' aspect, the more artistic engraving by Berthault focuses on the 'Roman' side of the event, relegating everything else to the background in the form of a many-headed human mass. It was no coincidence that the former was produced not long after the event by a Paris printmaker who clearly saw how to profit from the new conjunction between democratic and valuable political prints,[16] while the latter,

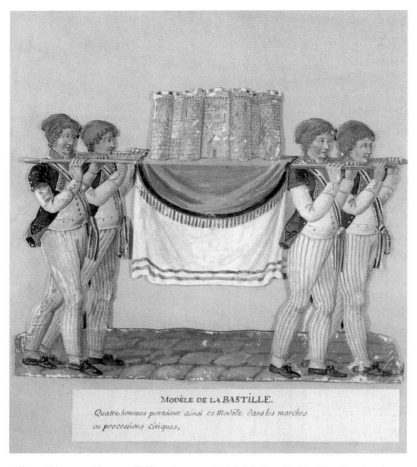

MODÈLE DE LA BASTILLE.

Quatre hommes portoient ainsi ce Modèle dans les marches ou processions civiques,

7 Pierre-Etienne and Jacques-Philippe Lesueur, *Model of the Bastille, Four Men Carrying the Model During Civil Processions*, gouache mounted on paper, 36 x 53.5 cm, *c.* 1791.

which did not appear until 1794, was produced from a costly copper engraving in folio format,[17] its symbolism and technique being derived from the valuable collectors' graphic art of the later *ancien régime*. The caricature *Le Faux pas* occupied a position midway between the two, managing to convey general political principles with both vivid drama and iconographic finesse, and, after 10 August 1792, publicizing the toppling in Paris of the equestrian statues of the king.

If the procession of 11 July was reminiscent of the Entrées of the *ancien régime*, it was intended as a counterpart to the splendours of the funeral ceremonies of the monarchy, albeit with quite a different goal from the dynastic burials of Saint-Denis. Whereas a coloured etching by François Lagrenée the younger portrays the arrival of the

20

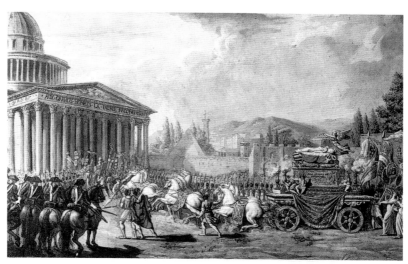

8 François Lagrenée the younger,
*The Transportaion of Voltaire's
Last Remains to the Panthéon*,
watercolour, 1791.

9 Pierre-Antoine de Machy, *The
Burial of Voltaire's Last Remains in
the Panthéon*, oil on paper, restored
on canvas, 53 × 38 cm, 1791.

procession at a temple-like columned façade (illus. 8), a painting by
Pierre-Antoine de Machy (illus. 9) depicts Voltaire, surrounded by
women wearing bonnets and hats, being laid to rest within a domed
church. A nearby bust is a reminder of Count Mirabeau, who had
been interred there only three months previously. Even though the
two views are quite different, they do both feature the same building:

the former Sainte-Geneviève church, which the National Assembly had re-dedicated on 4 April 1791 as the symbol of the glory of the nation: 'Aux Grands Hommes la Patrie reconnaissante' was apparently the inscription on the pedestal.[18] This highlights the architectonic dimension of the festivities and the symbolic history behind it: with Voltaire's admission to the Panthéon, the different art forms were unified collectively as 'revolutionary works of art'.

A temple to the glory of the nation

At the time of Voltaire's death the engraver Antoine Duplessis conceived of a remarkable *Templum Memoriae* (illus. 10). The Great Man of Ferney appears twice on the detailed print – on a pedestal-like mound in the centre, receiving a laurel-leaf crown from Apollo and Melpomene as author of the national epos *La Henriade*, and also in front of the steps of the temple in the form of a bust, which is being carried by Clio and a host of winged genies into the position of honour between the central columns, flanked by Sophocles and Racine to the right and Corneille and Euripides to the left. To the left of the picture, crowds of people have gathered to honour the famous philosopher, from Calas and Sirven, rehabilitated victims of miscarriages of justice, to the representatives of Prussia and Russia. Opposite them, Voltaire's opponents are being carried down to Hell, as described in the detailed legend. There is far more to the print, but suffice it to say that the central theme, for our purposes, is the establishment of a 'Temple de Mémoire' for Voltaire and other 'Great Men'.

Duplessis' *Templum Memoriae*, which was a visualization of essays of that time, contains a dual reference to the Panthéon. It bears a somewhat strange resemblance to the Sainte-Geneviève church by Jacques-German Soufflot, which was still under construction at the time, with its innovatory fusion of Greek Revival and Gothic elements of style and principles of construction. At the time when Duplessis was creating this picture, he would have been able to see the portico of the building, but not yet the dome, which was only completed in 1785–90 by Jean-Baptiste Rondelet. However, he would have had access to reproductions of Soufflot's plans (illus. 11).[19] Duplessis developed Soufflot's plans for the temple of glory a stage further, his design for the dome being unusual in incorporating a high drum to allow room for a series of commemorative sculptures.

As it happened, in early April 1791, when the National Assembly was preparing a worthy state funeral for their deceased speaker Mirabeau, Duplessis' vision was unexpectedly realized when they decided to adopt

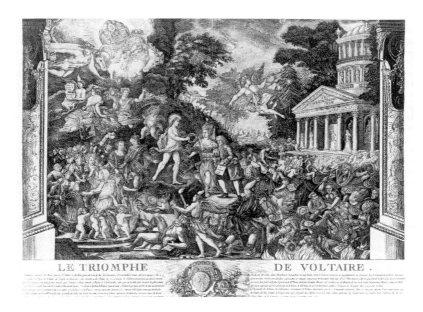

10 Antoine Duplessis, *The Triumph of Voltaire*, engraving and etching, 50.8 x 60.8 cm, 1791.

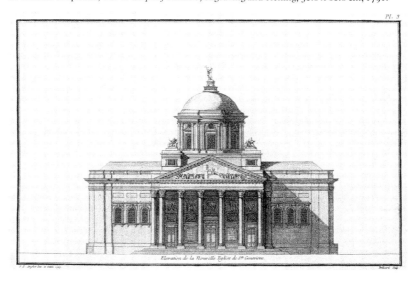

11 Jérôme-Charles Bellicard after Jacques-Germain Soufflot, *Elevation of the New Church of Sainte-Geneviève*, etching and engraving, 1757.

his design. There are at least three significant elements to this revolutionary turn of events that are worth examining.

First, the re-dedication of Sainte-Geneviève to convert it to the Panthéon signified the transfer of sacredness from a church to a new

state institution, and, most importantly, this was an act of secularization, which became ever more overt over time. Whereas Mirabeau's accession to the Panthéon on 4 April still took the form of a religious procession with accompanying Te Deum,[20] the plans for the festivities in Voltaire's case, three months later, avoided any appeal to the Christian or Catholic tradition.

Second, the change of function of Soufflot's famous masterwork was a reflection of anti-monarchist sentiments, for Sainte-Geneviève, which was dedicated to the patron saint of Paris, was also extremely closely connected with the royal palace. Louis XV had funded the church's construction as a votive offering in thanks for his cure from a serious illness, and on 6 September 1764 he had personally performed the ceremonial laying of the foundation stone. The ornamental decorations on the inner and outer walls consisted largely of medallions featuring Bourbon lilies as well as portraits of Louis XV and Louis XVI and their initials.[21] Indeed, for a time Soufflot intended that Sainte-Geneviève should contain a royal burial crypt, to be covered by a pyramid.[22] However, the Revolution's leaders distanced themselves most emphatically from this architectonic 'religion royale', allowing the removal of the wall decorations, those 'feudal emblems', in so far as they were ready, and by excluding the French kings from admission to the Panthéon.

Third, consistent with this political metamorphosis, the departmental Council and the National Assembly, not content with merely symbolic acts and alterations, commissioned the deputy Quatremère de Quincy to remodel the entire architecture of Sainte-Geneviève so that its change of function would be both highly visible and enduring.[23] Although Quatremère was in fact a sculptor, not an architect, by virtue of his publications on the art of construction and his friendship with David as well as other former colleagues of Soufflot, he was well-enough known and adequately qualified to develop a highly ambitious programme in a number of memoirs,[24] and to oversee its implementation until March 1794 on the largest construction site of revolutionary Paris. In agreement with the protagonists of the Revolution, he conceived of a whole series of 'minor' measures, which in themselves did not exactly impinge as such upon the substance of the finished building, yet which nevertheless fundamentally altered its character.[25]

Initially, Quatremère had the windows of the arms of the cross filled in, and the polished panes in the upper levels of the dome tower roughened, so that the interior would be illuminated only indirectly with 'sublime' light, like the cella of a Grecian temple. The idea was

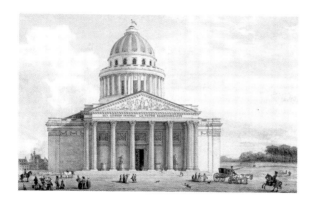

12 Jean-Baptiste Hilaire, *The French Panthéon*, pen and wash drawing with brown ink on paper, 36.9 x 39 cm, 1794/5.

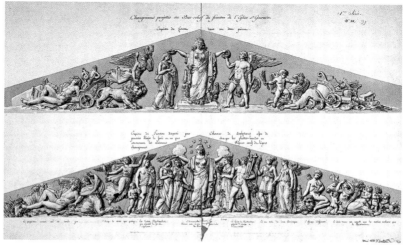

13 Louis-Pierre Baltard, *Changes Projected to the Bas-relief of the Pediment of the Church of Sainte-Geneviève*, pen and wash drawing with brown ink, May 1821 (under the relief by Moitte, under its planned Christian modification).

that this would facilitate both gatherings and contemplation, but also give greater prominence to the exterior colonnade of the portico. Soufflot's church of light,[26] which was designed to draw the gaze away from the walls, was transformed into a strictly profane building, designed to reflect seriousness (*sévérité du style*) and dignity (*gravité*) instead of light. A drawing by Jean-Baptiste Hilaire (illus.12) documents not only this new condition of the building, which was completed by the autumn of 1793, but also three other alterations to the façade. For the pediment of the portico, Soufflot had provided a half-relief with figures; to replace this, Quatremère commissioned the sculptor Jean-Guillaume Moitte, who played a large part in the new sculptural programme,[27] to create a revolutionary allegory of *La Patrie*

25

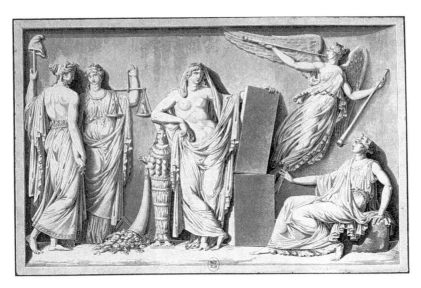

14 Guillaume Boichot (after Moitte?), *The Revelation of the Rights of Men and Citizens*, pen and wash drawing with brown ink, 19.3 × 28.5 cm, 1796.

(illus. 13) to accompany the portico's inscription. This was not to be decorative, but plainly sculpted. Although in high relief, the figures are arranged in horizontal rows, so that the viewer can 'read' them like linear pictorial writing, somewhat like Egyptian hieroglyphics. In the centre, next to the altar to the Nation and the Gallic rooster posing majestically on the steps of the throne, *La Patrie* confers two laurel-leaf crowns: on the left to Virtue, in the form of a modest, virtuous young girl, and on the right to a winged *Génie* holding a club like that of Hercules, who, self-confidently reaching out for the crown of glory, represents the 'Great Man'. This central scene is flanked on one side by a military chariot laden with emblems of virtue and *Liberté*, who is slashing at the dying *despotisme*, and on the other side by the juvenile *philosophie*, with the torch of Enlightenment, conquering monstrous folly and superstition. The illustrious symbolism of this strictly symmetrical relief is reminiscent of ancient Greek temples, not least the metopes of the Parthenon.[28]

For the outer walls of the portico, Soufflot provided low relief with scenes from the Old and New Testaments. Quatremère replaced these with allegories of the achievements of the Revolution by different sculptors, in celebration of patriotism, universal education, the law and the new judicature. The place of honour above the entrance portal was occupied by a fifth tablet inscribed with Human Rights by Guillaume Boichot (illus. 14). The composition emphasizes above all the origins of

the *Droits de l'homme* in the laws of nature, for *Nature*, leaning on the many-breasted Diana of Ephesus, occupies the centre of the scene and presents the viewer with the tablet of human rights placed on a kind of altar. She is attended by the sisterly figures of *Liberté* and *Egalité*, while *Fama* and *Francia* are commenting on the scene – the one triumphantly, the other in astonishment. The clothing and demeanour of the female figures in this scene are derived from Antique models.

As an addition to Soufflot's sculptural programme, Quatremère placed four statues between the columns of the portico, corresponding to the bas-reliefs. They portrayed a warrior dying in the arms of the *Patrie*, the weight of the law, and behind these, *Philosophie* instructing a youth, and *La Force* in the form of Hercules. This last sculpture, later replicated by Boichot, has survived in the form of a bronze model by the artist (illus. 15). It is reminiscent of the apotheosis of the classical form of Roman exemplars, but also hints at the absolutist allegory and panegyric of an engraving by Jean Valdor for the youthful Louis XIV that depicts him as a – likewise seated – Hercules (illus. 16). In 1793, when Boichot made his sculpture, Hercules no longer personified the power and might of the ruler, but the invincible power, violent when necessary, of the sovereign people, who had dethroned Louis XVI in August 1792.[29] Such was the symbolic power of this transference of allegorical meaning that Jacques-Louis David suggested to the National Convention on 17 November 1793 that a colossal statue of the Herculean French people

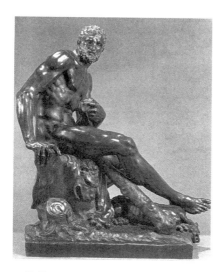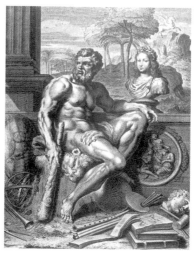

15 Guillaume Boichot, *The Power of the Emblem of Hercules*, bronze, h. 88.9 cm, *c.* 1795.

16 *The Gallic Hercules*, engraving, 42 × 35.4 cm, 1649. Dedicated to the young Louis XIV.

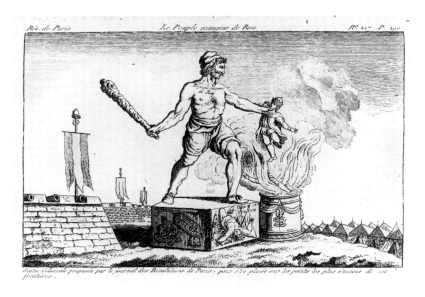

17 *The People Eats the King*, etching, 10 X 14.2 cm, 1793.

be erected on the border of the Republic.[30] Although the deputies
decided in favour, this was in fact never carried out; but it did appear
immediately afterwards in the form of an etching in the newspaper
Révolutions de Paris, which claimed credit for the idea (illus. 17). It
portrays the gigantic figure of a plebeian Hercules, wearing the cap of
liberty, standing on a mound rising above an encampment in front of
the defence walls of the Republic. The slogan on his naked breast
proclaims 'The king-devouring people', and so he is accordingly beat-
ing a midget king with his club and throwing him onto a sacrificial
altar, in the flames of which another figure is already burning. The
inscription on the pedestal of the monument, 'Mort aux Tyrans'
(death to tyrants), sounds a warning to all the princes of Europe.
Against this contemporary background it is quite clear that Boichot's
figure of Hercules, in spite of the nobility of its symbolism, had a
revolutionary significance for the Panthéon, in that it implicitly radi-
calized the hitherto somewhat elitist anti-royalism of 1791.

Sculptures played a prominent role in Quatremère's figurative
programme, for, in accordance with the prevailing belief in their
strong didactic effect, he regarded them as substitutes for the teach-
ing of Christian morality, as 'catéchisme figuré des devoirs de
l'homme en société'.[31] Patriotic statues were to adorn not only the
entrance to the Panthéon, but also the columns winding around the
tower, as in the aforementioned engraving by Duplessis. Also, the

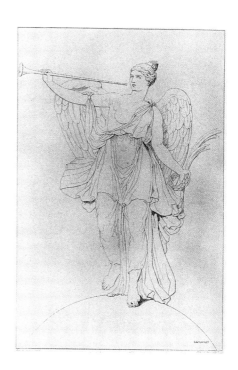

18 A. Tardieu and Normand the
Younger after Claude Dejoux,
The Glorious Goddess of the Panthéon,
etching, 43.8 x 27.5 cm, *c.* 1794.

dome was to be crowned not merely by the figure of *Ecclesia*, as envisaged by Soufflot, but by a colossal, thirty-foot high *Rénommée* in lead by Claude Dejoux. In a reproduction in an etching (illus. 18), she is depicted raising the fanfare to signify glory, holding palm branches and a laurel-leaf crown in her left hand, stepping lightly across the dome as on a globe, ever ready to honour yet another 'Great Man' in the name of the nation.[32] A plaster model of this *Rénommée* in all its glory was on display in the state foundry, the very same place where, in 1763, Edme Bouchardon's equestrian statue of Louis xv had been cast in bronze. In 1795, when the members of the Commission of the Jury des Arts were passing judgement on it, they were 'struck by the great impact and beautiful disposition of the sculpture, its boldness and extraordinary size making an imposing effect absolutely new to France and even to Europe'.[33]

The sculptural catechism was to continue on into the interior of the Panthéon, separated from the cult of the 'Great Men', whose mortal remains were to be accommodated in the crypt, which was in the form of a cross, and was originally intended as a place of honour for saints. On 13 December 1791 the sarcophagi of Mirabeau and Voltaire were laid to rest there. Above them, in the four arms of Soufflot's centralized construction, there were to be allegorical statues personifying the

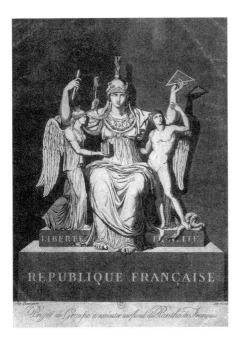

19 Antoine Quatremère de Quincy,
Project for the French Panthéon,
aquatint, 39.5 x 27 cm, 1794–5.

virtues of philosophy, the natural sciences, the arts, and patriotism:
'The moral and political virtues, the gifts of genius belonging to the
sciences which serve society, and to the arts which beautify it: that is
the natural distribution of the symbols which must bring life to our
four vaults.'[34] Pride of place in the choir, opposite the entrance portal,
was reserved by Quatremère for a work of his own: when the citizen
entered the Panthéon his first view would be of a monumental group
of figures representing the nation (illus. 19), dominated by Minerva on
an elevated throne, on whose head would be a helmet adorned by two
figures of Pegasus, like the statue of Athena in the Parthenon.[35] Her
arms are raised in a gesture simultaneously protecting and command-
ing two winged genies at her side; in her right hand she holds the Staff
of Liberty, pointing it at *Liberté,* who has a liberty cap and a miniature
model of the Bastille. In her left hand she holds the scales of justice,
assisted by *Egalité,* the Hydra of tyranny beneath his foot.

Finally, the immediate vicinity of the Panthéon was to be land-
scaped in accordance with the spirit of the Revolution – a grove of
patriotic virtues, with statues of Great Men and shaded pathways for
'promenades philosophiques', with tombstones and monuments in
the form of pyramids and obelisks, as in the picture by Lagrenée.

Thus arranged, the Panthéon was to function both as a venue for
festive state occasions and a congenial place for the edification of the

citizens, for the exchange of ideas, for reconciliation. As the radical revolutionary activist Jean-François Varlet aptly summed it up: 'A RESPECTABLE MONUMENT serving as a forum for the regenerate nation; a university of democratic morality; a school for emulation, supervision, instruction [. . .] – AN EDIFICE erected in honour of concord, peace, where citizens can come and put an end to all their hatreds; agree on their mutual wrongs, forgive one another, embrace, esteem one another [. . .]. – A CLUB for the sovereign people, where the assembled citizens can imagine that they see the shades of dear ones floating above their heads, gently murmuring, inviting them by their powers of persuasion to soften their passions and, if possible, to put human weaknesses behind them.'[36]

These utopian expectations were never realized. Little by little the Panthéon became not a place of refuge for the edification of the citizens and for national unity, but a bone of contention between political factions. Quatremère had prudently stuck to allegories for his sculptural embellishments so as to avoid any disputes with regard to personalities. However, when it came to the reception of the mortal remains of specific individuals in the temple of glory, there was constant public dispute as to who merited a place of honour and who did not; whether classical intellectuals such as Montaigne and Montesquieu, or revolutionary 'martyrs to Liberty' such as Antoine Désilles,[37] Louis Michel Lepeletier de Saint-Fargeau[38] and Joseph Châlier. Were army generals such as Lazare Carnot or republican child-heroes[39] like Joseph Bara and Agricol-Joseph Viala worthy? Furthermore, according to political vicissitudes, 'Great Men' were taken into the Panthéon and then later ejected. For example, Jean-Paul Marat was finally officially admitted on 21 September 1793, ousting Mirabeau, who had meanwhile been tarnished for receiving a salary from Louis XVI, but Marat too was later cast out following the Thermidor Reaction.

Programmatic conclusions and hypotheses

If the progression of ceremonial, artistic and architectural activities in connection with Voltaire's accession to the Panthéon was not typical in its particulars, but was – in our view – structurally typical of the culture of the Revolution, then a series of fundamental assertions and theses follow from the instances given above:

1. Just as Voltaire's 'Panthéonization' was a collective artistic production, so too all the arts during the Revolution were closely united with regard to function and effect. From patriotic 'memorials' and flags to

clothing, festival ornamentation, architecture and figurative representation, all the elements were interrelated and in mutual support. During the Revolution the different arts were connected and treated collectively in a richly symbolic fashion. For this reason, the most important aspect was not the aesthetic quality of the 'work of art'; the primary element was the official role and (immense) public effect of the multi-media interaction in the service of political actuality.

2. The character of revolutionary art was therefore essentially hybrid – and that is the case both with regard to pictorial tradition and cultural levels. For in one way it functioned as a great melting pot, of ancient and Christian, 'classical' and popular models, from which it formed a political symbolism which was as meaningful and universally comprehensible as possible. In the Panthéon and in the construction programme in general, traditional elements of Graeco-Roman temples were combined with the religiosity of the 'royaume très catholique' into a novel Cult of the Nation. Given the intensity of their efforts to transfer the religious and authoritative aura of the art of the *ancien régime*, in which they had been schooled, onto the *nouveau régime*, while at the same time distancing themselves from the former, to have recourse to ancient models was quite liberating for artists during the Revolution.

3. There was undoubtedly a mixing of stylistic and socio-cultural levels, whereby artistic works such as the antique-style catafalque for Voltaire, and plain productions such as Palloy's model of the Bastille, produced a combined effect. A very exacting artist like David dabbled in the lower levels of the caricature, while the unknown artist who produced the pictorial satire *Le faux pas* took pains to ensure that it reflected his humanistic education, for all its popular sensationalism. It was certainly the case that, as ever, certain categories of art retained specific affinities with particular levels of style and social 'target groups': whereas, for example, the architecture and sculptures of the Panthéon followed the tradition of 'high art', and, like the aforementioned engraving from the *Tableaux historiques de la Révolution française*, had to be aimed primarily at the cultural elite, there were numerous economically produced satirical leaflets, and the plebeian element in Voltaire's procession, which were more suited to the mentality of ordinary people. Furthermore, the Revolution narrowed the gap between elite art for the connoisseur and so-called popular art. Their juxtaposition in some spheres led to a commingling in the political and wider public spheres. Although there was a noticeable

inclination towards 'popular' levels of style, this was not only a conse-quence of the material dearth experienced by artists who, after the departure of their princely patrons and wealthy collectors, were forced to look for other sources of income, but also of the changing function of artists.

4. This points to the essentially didactic function of the revolutionary arts. In order to impress the new political-social principles on the minds of the general populace (barely half of whom were literate), thereby ensuring their support, the protagonists of the Revolution made fully conscious use of pictures. In the Jacobin Club in Paris on 27 November 1791, the journalist Joseph-Marie Lequinio explicitly expressed the Jacobins' intention of attacking the Catholic Church and absolutist propaganda with their own weapons: 'You know all the harm that fanaticism has done by spreading its images around the countryside. I propose that the Society undertake to persuade all the artists to work in the opposite direction, and to make analogous images for the Revolution.'[40]

Quatremère made the same concise assertion at the same time to the cultural politicians of the Revolution: 'Place the arts in the hands of the people and they will become an object of dread for tyrants.'[41] This systematic politicization and democratization constitute a clear choice in favour of pictures with a constantly reiterated basic motif to intensify their didactic effect on the masses, in preference to artistic uniqueness, perfection of form and depth.

5. The popularizing tendency of Revolutionary art in no way meant mindless simplicity and banality. It was far more the case that it not only inspired numerous nameless or little-known artists to produce a multiplicity of striking ideas for pictures, it also gave rise to numerous interconnections and relationships between motifs and different types of pictures, between different levels of style, genres, media and areas of practice. We have seen how the double fanfare in the 1791 caricature *Le faux pas* was adapted from the frontispiece of a pamphlet from 1762, and how Duplessis' *The Triumph of Voltaire* influenced both the architecture and intended purpose of the Panthéon, also how Boichot's *Hercules* was similarly influential on a panegyric engraving of 1649 as well as graphic revolutionary 'agit-prop' of 1793. These are just a few examples, but they are sympto-matic of the interconnectedness of revolutionary art, and of its influential and creative use of pictorial tradition.

6. It would therefore be a mistake to apply to the Revolution Cicero's dictum 'Inter arma enim silent Musae', as sometimes did happen.[42] However, it is true that the pictorial arts were in a somewhat parlous situation during the Revolution because they were for the most part produced in a context of being 'rooted in life', because of their connection with the political events of their day, and the concomitant heightened tension between ephemerality and permanence. They were functioning under a cloud of destruction, renewal and repeated destruction. Works attracted attention at the time, especially the sometimes extravagant ceremonial architecture, served the purpose of the day, and then were rapidly expunged. This was the fate of Voltaire's ceremonial carriage, which remained on display for a time beneath the portico of the Panthéon until it was disturbed during remodelling and then removed to an unknown location. Durable works of art, such as the sculptures in the entrance to the temple of glory, and the ubiquitous busts of Marat, all fell victim to the iconoclasm of the political backlash. Large projects intended to endure either did not get past the planning stage or remained half finished, having been overtaken by events. Even the coherent programme of remodelling a completed building such as the church of Sainte-Geneviève could not be completed; and those ornamental sculptures for the Panthéon that survived the Revolution, such as the high relief by Moitte on the entrance pediment, were removed and replaced by religious figures when the profaned sacred building was restored to its original function. Even important works of religious art were lost, and they can be only approximately reconstructed, above all with the help of the 'lower' forms of art, especially graphic art. These set the tone, not only because of the paucity of surviving works of art, but also because of their special closeness to everyday political activity during the Revolution. This realization need not be the cause of undue disappointment: it can be viewed as a spur to developing a social- and cultural-historical understanding of art history, and to take more seriously and look more closely at even the less sophisticated, at first glance even nondescript, artistic productions of the French Revolution.

In the following chapters, we attempt to prove these observations and hypotheses and, as far as possible, to consolidate them.

2 Contemporary Images of Revolutionary Change

Printmaking as the principal currency of artists

'It has been observed that in all revolutions, caricatures have been used to mobilize the people, and no one could deny that that procedure is as treacherous as its effects are swift and terrible.'[1] This was the opening salvo of a written diatribe commenced in February 1792 by Jacques-Marie Boyer-Brun,[2] a royalist publicist who had left the town council of Nîmes and moved to Paris. He dissected and vilified a series of revolutionary caricatures, but in the process provided a more insightful analysis of the role of these proliferating prints than did many supporters of the Revolution.[3] In fact, political printmaking in France had suddenly achieved such a degree of significance that for a decade it could be considered the 'principal currency' of artists.[4] Whereas the numerous projects for prestigious paintings, sculptures and buildings in the spirit of the Revolution were all too frequently overtaken by events and hence never completed (there are further examples in chapter Four), printed and duplicated images were far more suited to the political–social need for an 'art for its time', which could engage immediately and effectively with the accelerating speed of change of the present day.

Printmaking was pre-eminently suited to fulfil this requirement, primarily because little was required in the way of labour and materials, and prints could be produced quickly and economically – especially in the case of etchings. In contrast to copper engravings, which required months of skilled labour, an etching could be produced and ready for sale within a week or so. Unlike the prints of the mid-eighteenth century,[5] which were dominated by engravings, the pictorial publicity of the Revolution consisted primarily of etchings, which were printed on loose sheets of paper and then often coloured by hand. Their success was largely due to three features that were entirely novel with regard to their increased distinctiveness and dominance:

1. They were almost exclusively political publications. In place of the religious tracts, landscape and genre engravings, *vedutas* and portraits so beloved of the *ancien régime*,[6] there were caricatures and allegories, portrayals of people and events, all of which dealt with contemporary actualities. Their phenomenal output was connected with the press revolution of 1789,[7] with regard to their content as well as medium, as for the first time printed pictures became an established feature of newspapers – and this was the case not only with Louis-Marie Proudhomme's *Révolutions de Paris* and Camille Desmoulins' *Révolutions de France et de Brabant* on the radical revolutionary side of the political spectrum,[8] but also Jean-Gabriel Peltier's *Actes des Apôtres* and Gautier de Lyonnet's *Journal général de la cour et de la ville* on the opposing, conservative side.[9] Although the etchings were often distributed at a later stage than the text of these newspapers, they continued to appear fairly regularly for a number of years, and as a rule to illustrate a definite, precisely given place in the text. Along with the revolutionary press, pictorial publicity was both an indicator of and a factor in the formation of political opinion among the public at large, as Boyer-Brun confirmed: 'But it is to be noted that caricatures are the thermometer that shows the degree of intensity of public opinion; those capable of mastering its variations can also control public opinion.'[10]

2. Revolutionary prints were suited to a new kind of symbolism, one attuned to the people. In so far as there was in fact any oppositional pictorial political publicity under the *ancien régime*, it was almost entirely created using the same repertoire of Christian iconography and absolutist symbolism used by the Church and state themselves. For example, in 1762 a series of prints originating from sources close to the Jansenists and the Parlements

20 Nicolas Godonnesche, *Depraved Assertions Presented to the King*, etching, 22.8 × 14.7 cm, 1762.

turned the royalist tradition of coins featuring historical events against Louis XV and the Jesuits (illus. 20).[11] In contrast, as will be seen, revolutionary printmakers cultivated much more obvious, often lurid, methods of portrayal, with references to sights familiar to ordinary people. They took their motifs from daily life, from popular sayings, and popular pamphlets such as the *Cris de Paris*, sprinkling the captions with colloquial expressions. These notes were often not even printed, just casually jotted down. Boyer-Brun was quite clear about the point of this:

Caricatures have throughout the ages been one of the major means deployed to make the people understand things that would not have sufficiently struck them if they had merely been written. Before the people could read or write, caricatures even served to represent diverse objects which needed to be communicated, and so they were then what they still are today: spoken writing.[12]

The expression 'spoken text' (*écriture parlée*) was as novel as it was apposite. Boyer-Brun was adapting the medium and production of revolutionary prints to both the literate culture of educated people and the oral–visual culture of the barely literate lower classes, in a way that could be enjoyed by all. What these simple, even crude, images lost in terms of artistic finesse, they gained in their effectiveness on the public at large.

3. The pictorial publicity of the Revolution, apart from exceptions such as the aforementioned *Tableaux historiques* and the portraiture of François Bonneville,[13] were a new kind of mass medium for their time. In contrast to traditional copper engravings, their output was doubled to an average of 1,000 to 2,000 prints per plate. Furthermore, thanks to the increasingly common practice of reprinting and making multiple copies, the number of editions could easily be increased tenfold. At the same time, the cost of the average print was reduced from one or more *livres* to a few *sous*, so that it was well within the means of the less well-off. Sale by street vendors, which had hitherto been limited to popular broadsheets, became the most important outlet for printed matter during the Revolution. Furthermore, anyone could easily view these pictures for free, for whether they were dismissed as 'trash',[14] or welcomed as evidence of the new freedom of the press,[15] their ubiquity was undeniable. They were found not only under the arcades of the Palais-Royal, but on the Paris boulevards and on both sides of the Seine too. For instance, when the educational reformer and publisher Joachim Heinrich Campe visited Paris in July 1789 as a revolutionary tourist, he

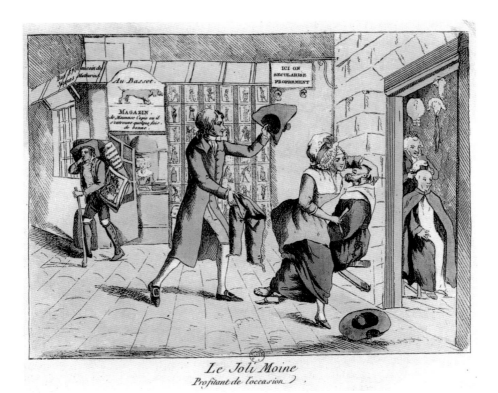

Le Joli Moine
Profitant de l'occasion ?

21 *The Handsome Monk Taking Advantage of the Situation*, coloured etching, 18.5 × 24.8 cm, 1762.

noted that on the Quai de Conti, all the large buildings, upriver as well as downriver, as far as the eye could see, were festooned with engravings, mostly concerned with the Revolution,[16] and especially large and magnificent medallions. During a visit to Paris somewhat later, in 1796, the canon of Hamburg, Friedrich Johann Lorenz Meyer, observed that the Quai de Voltaire resembled an exhibition of prints.[17]

Politicization, mass production and symbolic popularization – all of these caused as much of an upheaval in the printing trade as in book publishing.[18] Many traditional firms either could not or would not adapt themselves to the new conditions for success, and withdrew from business, like Pierre-François Basan,[19] or even went bankrupt. Whereas established engravers and publishers of valuable collectible graphics, such as Nicholas Ponce,[20] bemoaned the Revolution as a time of artistic decline, other hitherto minor producers of folkish prints, and even some woodcutters and etchers from the provinces, eagerly seized this new opportunity to expand their business. Among them was Paul-André Basset, whom we have already encountered at the accession of

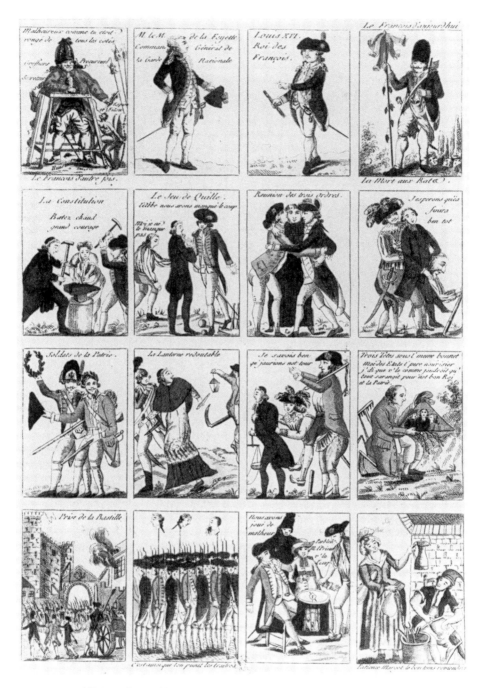

23 *Miniature Copies of Separate Caricatures Printed on One Sheet*, coloured etching,
33 X 21.9 cm, 1789.

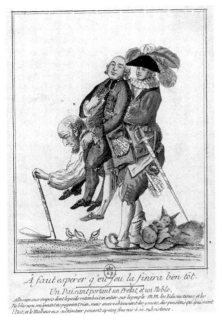

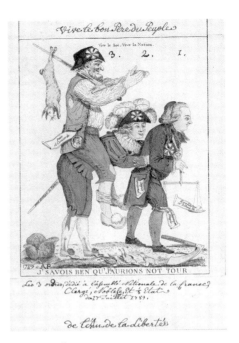

24 *Let's Hope This All Ends Soon*, coloured etching, 19.7 × 15.1 cm, 1789.

25 Johann Anton de Peters, *I Know All Too Well It Will Be Our Turn Soon*, coloured etching, 19.7 × 15.1 cm, 1789.

nouveau régime is declaring his support for 'paix et concorde', and has replaced the old inscription on his mattock, 'mouillé de larmes' (wet with tears), with the new motto 'infatigable'. However, he has downed tools so that 'rempli de courage' (filled with courage: as indicated by the stick carried on his shoulder), he can savour the shot hare, the pest of his fields. The nobleman, for his part, will only take up his sword, formerly red with blood, 'to protect the Nation', while the reformed abbot eschews the pensions and the luxuries of the prelates, now pays taxes, and is trying to balance the principle of 'Egalité et Liberté' with that of 'Bringing Relief to the People'. The portrayal of the people, in particular the peasants, as beasts of burden and riding animals for the upper Estates had a long icono-graphic tradition, of which the engraver was well aware;[35] however, its symbolic reversal was a significant revolutionary innovation. All in all, this graphic satire so successfully caught the mood of the moment and the expectations of the people that it was copied not only by the publisher Jean-Baptiste Letourmy in Orléans and circu-lated as a popular woodcut (illus. 26) in the provinces, there were also a number of versions with female figures substituted (illus. 27),[36]

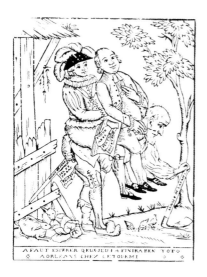

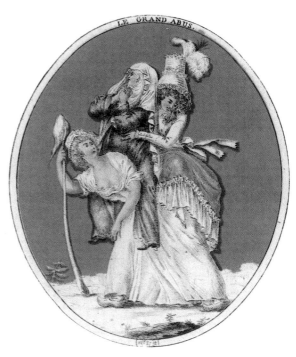

26 *Let's Hope This All Ends Soon*,
woodcut, 21.5 × 29 cm, Orléans,
Jean–Baptiste Letourmy, 1789.

27 Villeneuve, *Le grand Abus*,
unsigned aquatint on a red ground,
oval 10.5 × 8.5 cm, 1789.

which in their turn appeared in *toile de Jouy*, the popular calico prints by the manufacturer Oberkampf in Jouy-en-Josas (illus. 28). The peasant woman riding on a countess and a nun has exchanged her bonnet for a fashionable hat; she is swinging her spindle – the traditional emblem of female oppression – like a commandant's baton, and is breastfeeding her baby, as recommended by Jean-Jacques Rousseau.

This highly successful practice of representing the experience of revolutionary reversals of fortune by means of contrasting pairs of pictures was repeated not just in further allegories of the Estates,[37] for it was also applied to the personification of the French people. Two pairs of pictures in the miniature gallery (see illus. 23, scenes 1 and 4) contain back to front, but otherwise accurate, duplications of two anonymous coloured etchings,[38] from which Villeneuve produced, with a few minor changes, oval black-and-white aquatint prints with a red background – his hallmark (illus. 29, 30). Even without the accompanying caption ('You unhappy wretch, they gnawed away at you from every side'), the humiliation and suffering of the French people under the *ancien régime* are quite evident. It implies that the French were formerly like an abandoned giant baby shut up in a

45

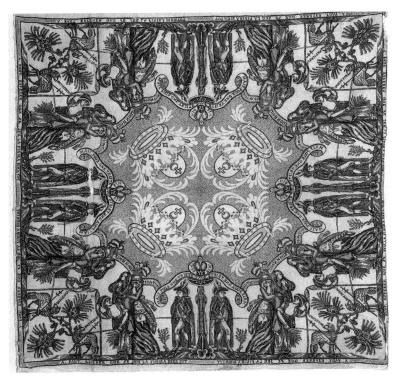

28 *We're Heading For A Sad End; Let's Hope This All Ends Soon*, handkerchief (violet, red and blue figures printed on brown cotton), 70 x 71.3 cm, 1789.

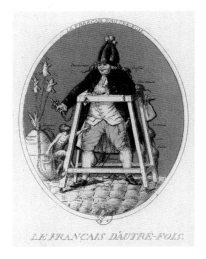
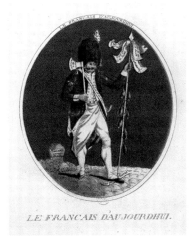

29 Villeneuve, *The Frenchman of Another Time*, aquatint on a red ground, oval, 10.3 x 8.4 cm, 1789.

30 Villeneuve, *The Frenchman of Today*, aquatint on a red ground, oval, 10.4 x 8.5 cm, 1789.

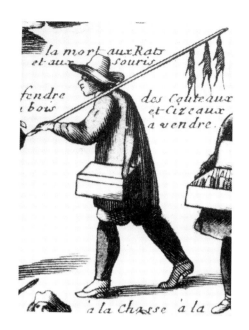

31 Jacques Chiquet, *The Crisis of Paris*, coloured etching (detail), *c.* 1740.

playpen, being pacified with childish toys such as rattles and wind-wheels. Unable to use the sword at his side, he is powerless in the face of harassment by the 'Ancienne Police', in the form of an ape, and the even worse exploitation by the judicial and tax authorities. His tormentors have taken the form of loathsome rats, gnawing at him from all sides; they bear the names 'Prosecutor, Clerk, Secretary, Assistant Tax Collectors, Lawyers and Bailiffs'. However, thanks to the Revolution, the opposite picture suggests, the Frenchman has freed himself from the old oppression, and has changed into a National Guardsman. Self-assured, he is trampling the old 'Despotisme' into the dust, and affirming the new political principles with the mottoes on the sash across his chest and on his hatchet: 'The Nation the Law and the King'; 'Live free or die'. The French citizen also appears as a rat-catcher, who has tied his vanquished tormentors onto his pike, thereby revealing himself to be a politicized successor to the well-known figure of the town crier, as portrayed in popular prints (illus. 31). The writing on the scrolls on his pike,[39] the hallmark of the rebellious *citoyen*, refers to a series of actual events and achievements that the artist attributes to this self-liberation of the French people: the revoking of privileges on the night of 4 July, the decree nationalizing the property of the Church on 2 November 1789, the Festival of Federation on 14 July 1790, and the revelation of the royalist oath of allegiance sworn by the *chevaliers du poignard* on 28

47

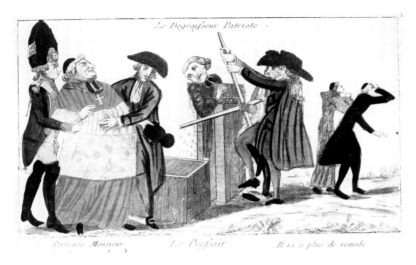

Le Dégraisseur Patriote

Présente Monsieur *Le Pressoir* *Il n'i a plus de remède*

32 *The Patriot Skimming the Fat*, coloured etching, 13.7 × 22.9 cm, 1789–90.

February 1791. As a sign that the axe in the grenadier's fist is no mere empty attribute, a few decapitated heads in the background are a reminder of the spontanous lynch–mob justice of the revolutionary crowd in July 1789; the lamp–post behind the heads, the symbol of the people's justice, is an eloquent warning: 'Puisse t–ils servir d'Exemple' (Let these be an example).

An even more effective way for printmakers to represent the contemporary experience of the dawning of a new and better age was to portray the contrast between the *ancien régime* and the *nouveau régime* in one and the same picture. Although this could be conveyed merely by opposing the midget–like oppressed man of former times to the gigantic National Guard of the present,[40] or the overfed priest of yesteryear on one side and the lean abbot of today on the other,[41] it was far more effective to integrate the presentation of before–and–after into one symbolic treatment, illustrating how and by what means the metamorphosis had been accomplished. This was the aim of one coloured etching by an anonymous artist that came onto the market on the occasion of the nationalization of the property of the Church in February 1790 (illus. 32), and which evidently enjoyed great popularity.[42] On the left is a corpulent priest, personifying the former privileges of the clergy, who is being led towards a 'patriotic fat reduction machine'. His attendants, a National Guard and a deputy of the Third Estate, are laying their hands on his body as if estimating the anticipated yield; and as he is obviously waiting for his treatment impatiently, like a patient, they are pacifying him with the words

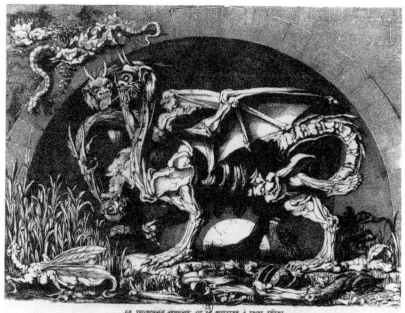

37 Jean-Louis Desprez, *Chimera*, etching, 32.4 x 38.2 cm, between 1777 and 1784.

divided into exploiters and exploited, which prefigured the actual social development of France, was given its most concise symbolic expression in an anonymous print that appeared around spring 1790 (illus. 36). Half dragon with wings and tail, half carnivorous wild cat, a three-headed man-eating monster with bloody fangs is tearing into the remaining flesh on the decapitated body in its belly. As their head-gear reveals, and the caption explains, the clergy, the nobility and the judiciary of the *aristocratie* have united against the people in the form of this beast, with the moral support of the regular clergy:

A three-headed monster signifying the three Estates of the Aristocracy is in the act of devouring the remains of the corpse of the people whom it has merci-lessly gulped down into its carnivorous entrails. It is preceded by Fanaticism which has Dragon's tails and is clothed in a Monastic Robe; astride its back rides Hypocrisy, squeezing a snake which is secreting its Aristocratic Poison.

This cannibalistic monster was not in fact an invention of the Revo-lution, but was adapted from a copper engraving that had appeared twenty years earlier. This ingenious early Romantic creation by a

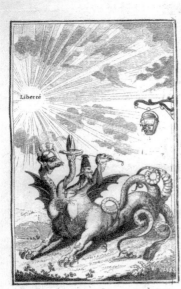

ÉTRENNES
A LA VÉRITÉ
OU
ALMANACH
DES
ARISTOCRATES.

CE QUE C'EST QUE L'ARISTOCRATIE.

L'ARISTOCRATIE est un monstre qui
n'est ni mâle ni femelle, mais qui réunit
les deux sexes ; il a les griffes d'une har-
pie, la langue d'une sangsue, l'ame d'un
procureur, le cœur d'un financier, les
pieds d'un bouc, la voracité d'un vau-
tour, la cruauté d'un tigre, l'orgueil
d'un lion, la lasciveté d'un moine et la
stupidité d'un district ; on l'a vu pendant
plus d'un siecle s'abreuver du sang des
hommes, engloutir les moissons et les
espérances du laboureur, dévorer le
peuple et causer en France les plus grands
ravages. Ce n'est qu'avec de grandes for-
ces et beaucoup de courage que des Chas-
seurs Citoyens sont parvenus à l'épouvan-
ter et lui faire prendre la fuite ; il se retira
d'abord à Spa ; à travers les bois et les
A 2

Les Fripons craignent les reverberes

38 *Rogues Fear Street-lamps*, etching, 14 x 9.5 cm, 1789. Frontispiece from *Etrennes à la vérité, ou Almanach des Aristocrates* (Paris, 1789).

youthful winner of the Prix de Rome, Jean–Louis Desprez,[48] in 1771, was intended to arouse a sense of horror (illus. 37). By 1790, stripped of its architectonic and natural framing, the image had evolved into an extremely expressive political–social diatribe. As the legend accompanying the fifth version of Deprez's engraving provided a concrete explanation,[49] the addition of just a few class signifiers was sufficient to adapt the model for revolutionary purposes. The unnamed copier of 1790 proved himself to be an expert at creatively combining pictorial propaganda and skilful artistry.

More common than this extraordinary portrayal of the *aristocratie* were graphic satires depicting them as the Hydra, or many-headed dragon. In order to be immediately meaningful and generally comprehensible, they had to be neither crude nor naïve, as can be seen from the frontispiece of a revolutionary almanac that appeared in autumn 1789 (illus. 38). The monster's heads represent the upper Estates, not only the high nobility and the prelates, but also a judge wielding a quill pen, and a member of the landed gentry with a dagger between his teeth. The accompanying description of the *aristocratie* characterizes the two noblemen as haughty and cruel, the clergyman as lecherous and lascivious, and the administration represented by the

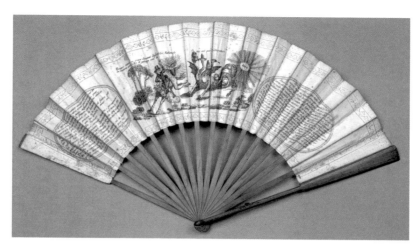

39 Etching for an ornamented fan, 1789.

judge as heartless and stupid. Acting in unison, according to both image and text, these 'gluttonous vultures' have devoured the French people and gorged themselves on their blood:

The aristocracy is a monster, neither male nor female, but of both sexes together; it has the claws of a harpy, the tongue of a leech, the soul of a prosecutor, the heart of a financier, the feet of a billygoat, the voracity of a vulture, the cruelty of a tiger, the pride of a lion, the lasciviousness of a monk and the stupidity of a provincial judge; it has been seen for over a century slaking its thirst with the blood of men, wolfing the labourer's harvests and hopes, devouring the people and causing in France the greatest devastation.

This definition, which also reads like a description of the aforementioned print from 1790, contains several highly suggestive allusions, not only by selecting words alluding to the grievances of the fiscal revolts under the *ancien régime* and the *cahiers de doléances* from spring 1789: the phrase 'les griffes d'une harpie' is a sideswipe at Marie-Antoinette, who was vilified as a rapacious 'harpie' in pamphlets as early as 1784, following the 'affair of the diamond necklace', and then again during the Revolution.[50] The imminent demise of the beast, which is anxiously eyeing the lantern lit by the sun of freedom, and the words inscribed on it, is quite evident. The lamp-post symbolizes the summary justice of the revolutionary lynch mob – an iconographic meaning that had its origin in the hanging of Privy Councillor Joseph-François Foulon on 22 July 1789, and was strengthened by Camille Desmoulins' *Discours de la lanterne*.[51]

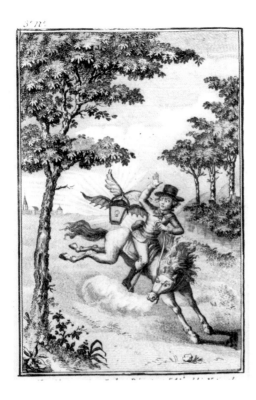

40 *Mounier Disguised as a Jockey Deserting the National Assembly*, etching, 16 x 9.5 cm, 1789.

The accompanying text describes the 'citizen huntsman' chasing the fleeing beast and finally bringing him down.

The finely drawn dragon of the *aristocratie* in the almanac was so impressive that it was used together with the accompanying description to decorate the fans of patriotic women (illus. 39), often combined with an illustration from Desmoulins' newspaper *Révolutions de France et de Brabant* (illus. 40). The caption of the illustration has become the heading of a reversed copy, while the unframed text on the left-hand side explains that the rider of the bucking horse represents Jean-Joseph Mounier, who left the National Assembly in 1789 in protest at the October sessions. The inclusion of a winged lantern as an essential element of the collage was no mere chance: shining more brightly than in the original, it is pursuing the defecting traitor of the people and at the same time threatening the aristocratic monster.

The people versus the aristocratic dragon was a more common image than the lantern in revolutionary pictorial publications, when it was a case of inciting or celebrating the redressing of actual or alleged grievances against the *ancien régime*. The people were also depicted as a plebeian Hercules and a secularized Archangel Michael. The

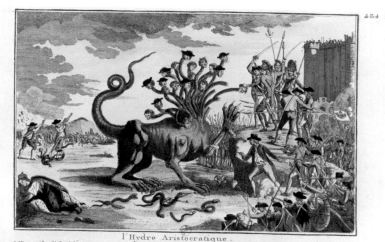

l'Hydre Aristocratique.

41 *The Aristocratic Hydra*, coloured etching, 17.5 × 26.7 cm, 1789.

storming of the Bastille by the rebellious *petite bourgeoisie* of the Faubourg Saint-Antoine in particular was portrayed in a whole series of allegorical pamphlets as the victory of the patriots over the many headed *Aristocratic Hydra* (illus. 41). The fearsome monster gave a visible form to the fear that was spreading on 14 July – that the troops surrounding Paris were hatching an 'aristocratic plot', and that aristocrats supposedly hiding in the Bastille were going to break forth, torching the capital and slaughtering the population.[52] Against this background of *La Grande Peur*, and the horrific stories associated with the state prison, the accompanying legend of this picture, in the form of a mythical saga, is comprehensible:

This male and female Monster's only human feature is its heads; it is by nature ferocious, barbaric, bloodthirsty; it feeds only on blood, tears and the food of the unfortunate; it seeks to invade on all sides, to satisfy its ambition and insatiable greed; it thinks everything that has breath must be subjected to it and live for it alone; desolation, famine and death come ever in its wake. Being hunted out of the different empires it passed through one after the other, it had long since taken refuge in France, where it caused the greatest harm; there, its heads multiplied to the point that it could no longer stay in hiding. It was observed on 12 July 1789 at 4 o'clock in the evening, on the road from Versailles to Paris. Suddenly an energy takes hold of every

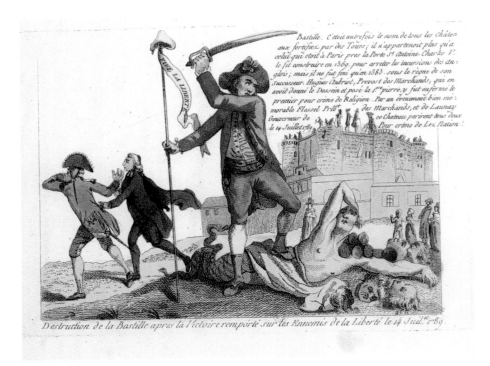

42 *Destruction of the Bastille after the Victory won from the Enemies of Liberty on 14 July 1789*, coloured etching, 17 x 26.7 cm, 1789.

person's mind, the bells ring everywhere, the cry for liberty revives the patriotism in every heart; everywhere, people take up arms, and on 14 July they attack the Bastille, the horrible lair where the monster sacrificed his victims; in four hours that fortress was taken by storm; the monster who had taken refuge therein is assailed on every side; every man hastens to cut off its heads, and several of them fall under the avenging sword of liberty. But that Monster, that new Proteus, escapes from the sight of its brave enemies, it flees in diverse guises to foreign lands, dragging despair and shame along with it. Delivered from such a fearsome scourge, France, until that moment brought to its knees and plunged in grief, begins to show a new countenance; its inhabitants, ruled from then on by wise laws, a citizen King and patriotic Ministers, will live happily.

Other versions of this print modify the saga of a political big-game hunt somewhat, likewise the title of the allegory,[53] but all portray the patriots' victorious fight against the dragon representing the vanquished state prison. There are also condensed versions of the same symbolic treatment,[54] as in the 'sequel' to the famous etching *Réveil du Tiers état*: after the Third Estate has thrown off its shackles, it is shown on the opposite page, having grown into an enormous

A perusal of the pictorial satires of the new epoch ushered in by the Revolution reveals two facts: graphic artists had been proclaiming the dawning of a new age of democratic rule since 1789–90, before the National Convention officially introduced the revolutionary calendar in autumn 1793,[61] and before François Queverdo created his decorative plaque of the republican calendar in 1793–4.[62] They were generally in agreement with the press, which dated the 'Age of Freedom' from the storming of the Bastille, and asserted that the beginning of the year should be moved to 14 July.[63] Furthermore, revolutionary graphic art developed an expressive and radical new symbolism that not only presented arguments but often instigated action too, by depicting 'the people' as autonomous, sovereign agents, and as militant activists. They politicized traditional modes of pictorial expression and turned them into highly effective symbolic instruments with great appeal as well as underlying depth of meaning – whether depicting the people allegorically as rat-catcher or dragon slayer, operating the wine press or wielding the threshing flail.

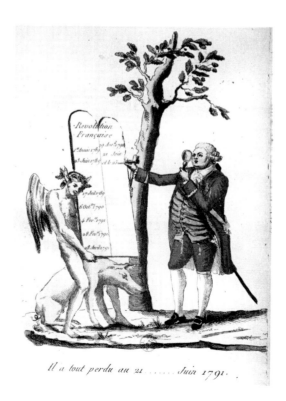

47 *He Lost it all on 21 . . . June 1791*, coloured etching, 20.8 × 13.1 cm, 1791.

Il a tout perdu au 21 Juin 1791.

Revolutionary graphics constituted an art for their time par excellence; they not only visualized the experience of epochal caesura, they also reflected the vicissitudes of public opinion, as well as exerting a decisive influence on them. The best examples of the latter are to be found in pictorial altercations on the subject of the monarchy, for no other revolutionary theme gave rise to such a profusion of pictorial publications over such a lengthy period of time as that of Louis XVI and the monarchy. Without going over the same portrayals repeatedly,[64] the following outline will concentrate on a few examples, especially those which exemplify the art of the transference of motif and the inversion as well as alternation between revolutionary and royalist prints.

An anonymous leaflet from the summer of 1791 can serve as the starting-point (illus. 47). Louis is shown receiving a plaque inscribed with revolutionary events from a genie with satyr ears riding on a hog (the latest attribute of the 'king'). The print dates from 1789, Year I of liberty, from 4 February 1790 to 21 June 1791. Despite his usual lack of prescience, Louis is writing on it the date of his eventual overthrow. Making allowances for a few oversights due to haste on the part of the writer,[65] it is clear that the entries on the plaque relate to key events of the Revolution with which the king was intimately involved, media treatments of which were instrumental in the formation of his public image. At this point it is worth charting his changing image chronologically over the course of such events.

At the outset, imaginative monuments of the sovereign represented him as the revitalizer of France. When the Estates-General assembled in May 1789 and declared themselves to be the National Assembly, the court painter Nicolas-André Monsiau and the Florentine engraver Vincenzo Vangelisti celebrated the monarch as the 'Père de la Patrie' and the 'Roi d'un Peuple Libre' (illus. 48), and were given the honour of presenting this print to him in person.[66] Louis is seen posing in his royal robes on a pedestal with an appropriate inscription, set amidst classical architecture. He is no longer wearing the ancestral crown, but is acquiescing to the fact that Minerva, on his right, is instead weighing a 'couronne civique', a citizen's crown, in the scales of justice. Like the rainbow over Louis' head, the allegorical figures in the foreground are proclaiming the advent of beneficent rule, under which feudalism is to be abolished. Religion and Tolerance are being reconciled by Truth, and Fanaticism is stabbing itself to death; the crowned Francia is receiving the 'doléances du Peuple', and in the background the proponents of *Liberté* are presenting burnt

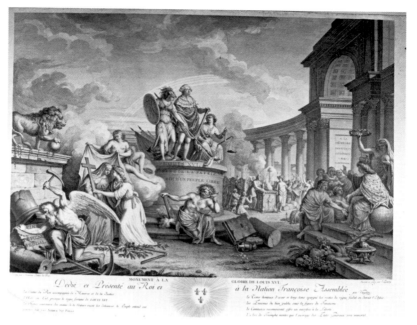

48 Vincenzo Vangelisti after Nicolas-André Monsiau, *Monument to the Glory of Louis XVI*, etching and engraving, 38.5 x 54 cm, 1789.

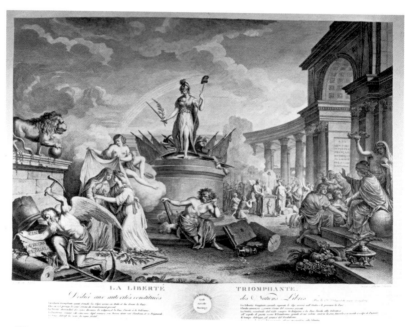

49 Vincenzo Vangelisti after Nicolas-André Monsiau, *The Triumph of Liberty*, etching and engraving, 49 x 60 cm, 1789.

offerings. As if the Estates-General and the King had arranged this in concert, the triumphal arch bears the inscription: 'A la Mémoire des États-Généraux de MDCCLXXXIX'.

Only a few weeks after publication, however, the premature glorification in this print was overtaken by events, when on 17 June the National Assembly declared itself to be the new sovereign. Three days later it opposed the royal command calling for the dissolution of Parlement, for which it received the backing of the Paris Revolution on 14 July. Vangelisti had meanwhile passed away, and his widow reworked the copper plate on his behalf, to bring it in line with subsequent developments (illus. 49). The figure of *Liberty* has been substituted for that of Louis.[67] Equipped with the helmet of Minerva and holding a dagger to use against her opponents and a palm branch for her supporters, she has no need of either the accompanying figures or the pedestal inscription of the original version. The artist, who signed herself 'Citoyenne Delagardette',[68] also minimized all other signs of royalty. She disguised the Bourbon lilies by altering the burst of rays to resemble Hercules' 'Arcole'. She also erased the fleurs-de-lis from Francia's mantle, providing her with a Phrygian cap and showing her receiving 'les remerciments des Peuples Libres'. The bilingual legend, reflecting the publisher's location in both Paris and Milan, also confirms that the meaning of the image has been deliberately changed to make it revolutionary. The allegory of Religion has forfeited her cross and is being exhorted to be tolerant, whilst Science and the Arts are both participating in the burnt sacrificial offering in the background. The inscription on the triumphal arch reinforces this radicalization by ascribing recent achievements to the rebellious people themselves rather than to any organization acting on their behalf: 'A la Mémoire du Peuple Français qui conquit sa liberté le 14 Juillet MDCCLXXXIX'. In other words, using their own weapons to attack academically educated producers of panegyrics to rulers.

Although initially there was no parallel symbolic displacment of the king in popular revolutionary graphic art, even in this sphere a certain distancing from the *père de la patrie* was evident by summer 1789, as can be seen in an allegory by the aforementioned Johann Anton de Peters (illus. 50). In response to an earlier picture dating from 1783,[69] Peters' coloured etching envisages a monument to 'Louis XVI, Restaurateur de la Liberté Francaise' in the Place de la Bastille. The two illustrated leaflets on the ground and the inscription on the side of the pedestal explain why Louis merited this place of honour: he had sanctioned the storming of the Bastille (right leaflet) during a visit to Paris two days later (left leaflet: ' Arrivée du Roi le 17 Juillet'), and publicly

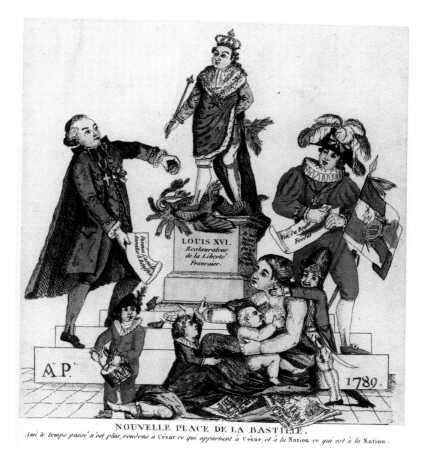

NOUVELLE PLACE DE LA BASTILLE.

Ami le temps passé n'est plus, rendons à César ce qui appartient à César, et à la Nation ce qui est à la Nation.

50 Johann Anton de Peters, *The New Place of the Bastille*, coloured etching, 21.4 x 16.6 cm, 1789.

proclaimed 'I wish to be as one with my people'. Now, however, he is no longer playing any active role, and in spite – or perhaps because – of his royal robes, he appears to be more like a marionette puppet, remaining motionless in his place and presiding over the disputing Estates. While the nobility and clergy are standing very close to the steps of the monument, not prepared to relinquish their ancient privileges without a fight, the Third Estate, in the form of a maternal 'Nation', is turning to face the new generation of free and stalwart citizens. It is no coincidence that a number of revolutionary prints can be seen protruding from the skirts of this allegory of the Nation.

After the king was forced by the *dames de la Halle* to leave his residence in Versailles and move to Paris, he continued to present himself to artists in a favourable light for a time. On 19 October 1789, for

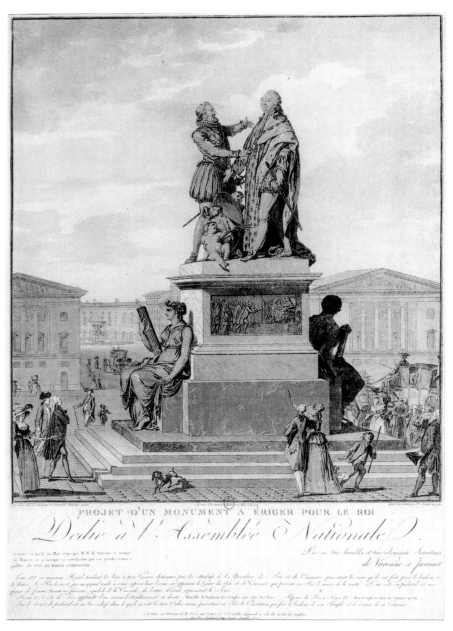

51 Jean-François Janinet after Charles Santoire Varenne, *Project for a Monument to be Erected for the King and dedicated to the National Assembly*, coloured aquatint, 43 × 37 cm, 1790.

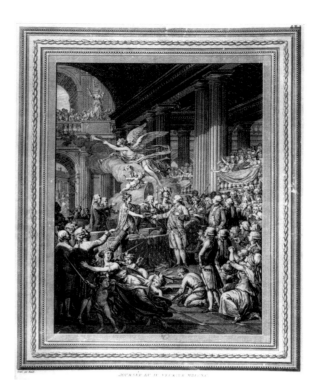

52 François-Anne David, *The Day of IV February* MDCCXC, etching and engraving, 37.4 × 19.3 cm.

instance, he showed himself to be quite affable when strolling along the Champs-Elysées.[70] On 4 February 1790, when the king attended the National Assembly, he praised the Declaration of the Rights of Man and promised to respect the Constitution then in preparation, an event that was celebrated ten days later with a Te Deum and portrayed in extremely varied ways, according to the artistic proclivities and political predilections of different artists. Although formally trained engravers still used the iconography of rulership, they no longer praised Louis XVI alone, but acting in conjunction with 'partners', in some cases highlighting his remarkable passivity, as already depicted by Johann Anton de Peters (see illus. 31), by contrasting it with the activity of the idealized *bon roi* Henri IV. The latter might be placed off to one side, as in another commemorative print by Jean-François Janinet (illus. 51).[71] Alternatively, the king might be shown as *primus inter pares* in the company of the National Assembly, as by the engraver François-Anne David (illus. 52). Louis is shown onstage, in the manner of someone at a confessional, holding his hat under his arm. To the jubilation of the spectators, the king is receiving the plain citizen's crown from Francia, who is wearing the crown and royal

Le roi expliquant à son fils les droits de l'homme.

Ô Père des Bourbons, soulage donc mes peines.
Dois je passer mes jours à me forger des chaînes

53 *The King Explains the Rights of Man to his Son*, etching, 11 x 17 cm.

54 *O Father of the Bourbons, Relieve my Sorrow*, etching, 1790. Frontispiece of the pamphlet
Louis XIV à Saint-Cloud au chevet de Louis XVI, 1790.

mantle instead of him. The beggars in the foreground are raising their arms to her rather than to Louis. Because the king has now become a contractual partner of the people, Tyranny in the left foreground is turning to flee.

In contrast, populist art eschewed any such elevated allegory in this instance, merely depicting the citizen king Louis, a cockade in his hat, instructing the dauphin in human rights (illus. 53). This scene, somewhat resembling a woodcut, is taking the king at his word, for on 4 February he had declared to the deputies:

I shall therefore defend, I shall maintain constitutional liberty, whose principles are consecrated by the general wish, in agreement with mine. I shall do more, and together with the Queen, who shares all my sentiments, I shall prepare the mind and the heart of my son, from an early age, for the new order which circumstances have brought into being.[72]

In addition to these portrayals, which despite completely different levels of style were both visualizations of the reconciliation between the Revolution and the monarchy, there appeared in spring and

summer 1790 a series of illustrated pamphlets called *Entretiens des Bourbons*, which marked the entrance of a third political stance, an arch-royalist opposition, into this pictorial debate. Using the device of a fictitious debate with Louis' deceased ancestors (*dialogues des morts*), it was highly critical of the king's acquiescence, warned him against ratifying the Constitution, and advised him to put down the Revolution with force as a matter of urgency, as in the ninth *Entretien* with the Sun King.[73] The frontispiece of this anonymous leaflet (illus. 54) shows Louis XVI, stripped of the insignia of a ruler (his crown and mantle), as an amateur smith in a blacksmith's workshop, forging chains for himself. He is appealing for help from Louis XIV, who is floating on a cloud, a halo around his head, and enjoining subterfuge: 'attendez la seconde Législature'. This counter-revolutionary textual and pictorial propaganda was circulated with the assistance of middlemen such as the book dealer Michel Webert.[74] However, a National Guardsman denounced the ninth *Entretien* to the police. The Palais-Royal was then raided several times, and thirty-six copies were confiscated from the book dealer Beuvris on 14 August.[75]

As Louis XVI delayed ratification of important decrees of the National Assembly in the following months, despite his vow quoted above, so the tenor of pictorial publications altered accordingly. At first he was ridiculed for his gourmandizing, as in two large-format

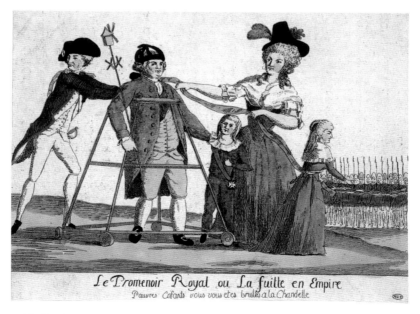

55 *The Royal Promenade, or the Flight to the Empire*, coloured etching, 14.1 × 20.1 cm, 1791.

HET GELDERSCHE ZWYN.

W aerom of toch een Jood geen Zwijnenvleersch wil eeten? ——
Zou 't zijn, om dat voorhoen een booze en helfche Geest,
Die een' ellendeling hadt, jaeren lang beneeren,
Wierdt uitgedreeven in 't Geflacht van 't morfig Beest? ——
Misfchien. —— Maar is die Geest in ieder Zwijn gedreeven? ——
Neen! —— Wat men daar van zeg, voor mij, 'k geloof het niet;
Hij voer flechts in een foort, waar van 'er weinig leeven,
Daar Hij 'er een van is, dien gij hier flobb'ren ziet.
Die foort treet met de fnuit fchier alles in ondermijnen :
Zij fchept, vertrapt, vergruist, bepist, waer ze evergaat.
'k Stel vast, de Duivel voer flechts in die foort van Zwijnen. ——
't Zij met die ftraffe, of mild met Spoeling overlaed,
Vergeefsch is 't, nimmer is van 't Onder iets te hoopen :
Men koopt het jong, wanneer 'er niets aan is te zien,
Doch wen 't zyn' aart ontdekt, dan wil men 't graag Verkoopen,
Maer kan 't 'er oud en boos; wie zal 'er geld voor biên?
Geen menfch. —— Wie koopt een Zwijn, waer voor de Bort moet vliên? —
Die het den Bort met zulk een zeezend Varken loopen.

56 *Het Geldersche Zwyn*, coloured
etching, 14.5 × 18.4 cm, Dutch, 1787.

caricatures in the English style, which appeared in February 1791.[76] Then the suspicion arose that he was planning to flee France, so the National Guard prevented him from leaving to spend Easter at Saint Cloud on 18 April.[77] Jean-Paul Marat's newspaper *Ami du Peuple* kept fanning the flames of this suspicion, which was finally confirmed on 21 June, when the fugitives were apprehended in Varennes and brought back to Paris as prisoners.[78] After this Louis was deluged by a veritable flood of biting satire. These popular prints were usually cursorily coloured and rushed out onto the market anonymously. Some of them portrayed the attempted escape as a childish act on the part of a weakling dominated by his wife. He was variously depicted dressed as a blind monk,[79] undertaking his 'tour de France' as a cobbler's assistant,[80] riding his consort on a latter-day 'flight out of Egypt',[81] or being led along by her on a wooden stag with wheels to cries of '*Hé Hu! Da da!*'.[82] He was also portrayed in an archaic type of French walking-frame (illus. 55) with a child's cap instead of a crown on his head, holding a toy windmill on a stick instead of a sceptre, being dragged towards the German border by Marie-Antoinette while being held fast by a National Guardsman. In numerous other satires – presumably inspired by a caricature by Dutch patriots against William V of Orange (illus. 56) – Louis has been turned into a

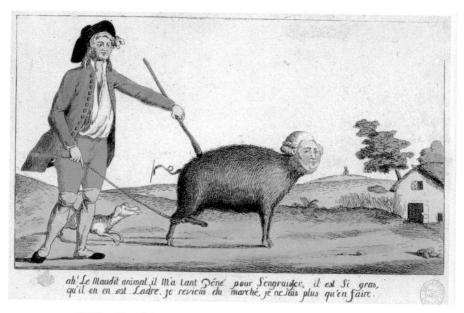

ah! Le Maudit animal il M'a tant Géné pour S'engraiser, il est Si gras,
qu'il en en est Ladre, je reviens du marché, je ne Sais plus qu'en faire.

57 *Ah! That Blasted Animal*, coloured etching, 13.9 X 22.7 cm, 1791.

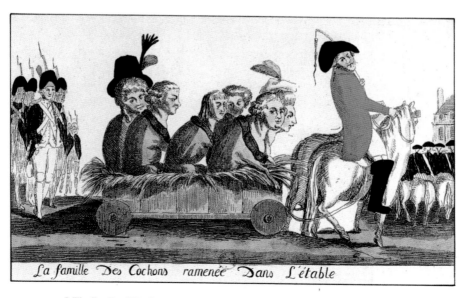

La famille Des Cochons ramenée Dans L'étable

58 *The Family of Pigs Returns to the Cowshed*, coloured etching, 12.3 X 21.2 cm, 1791.

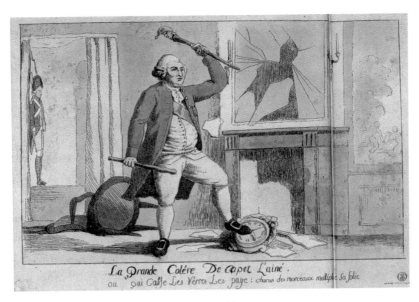

La Grande Colère De Capet L'ainé.
ou qui Casse Les Verres Les paye : chacun des morceaux multiplie sa folie

59 *The Great Temper of Capet the Elder*, coloured etching, 14.1 x 22.1 cm, 1791.

pig,[83] as a vivid pictorial reproach for his parasitism and deceitfulness. Jacques Bonhomme, the personification of the French peasant, is seen leading the unsold 'swine king' from the market back to his stall (illus. 57), at a loss as to what to do with this animal he has gone to the trouble of fattening up.[84] This theme gave rise to a plethora of variations: Louis in the form of a pig, barely recognizable to his ancestor Henri IV, attempting to drown his shame in a vat;[85] Louis sitting at table on a chair decorated with lilies, gorging himself on cakes,[86] Louis and his entire 'family' being driven back from Varennes to Paris in a manure cart (illus. 58). The royalist Boyer–Brun took particular umbrage at this last satire:

How perfidiously the agitators duped the French, when the royal family left for Montmédy! there was no limit to the kind of insult to which they subjected the family; [...] disgusting caricatures flooded Paris and the banks of the Seine [...]. The family of swine brought back to the shed: that was the execrable cartoon that the troublemakers disseminated in greater quantities than any other throughout that deplorable time.[87]

Furthermore, following the royal family's enforced return to Paris, the rumour was spreading that Louis, virtually a prisoner in the Louvre,[88] was losing his mind. On 29 June, Gorsas' *Courrier*, Gaintrai's *Journal de la Révolution* and Bonneville's *La Bouche de fer* all carried the following news item:

The rumour had spread before nine o'clock, and had been confirmed before noon, that Louis XVI had gone into a sort of delirium, and that he was smashing his mirrors, breaking up his furniture, etc. [...] It took the whole day to clarify the fact. At the news, it had been said quite amusingly that he would be made king of Charenton (the lunatic asylum).[89]

After this rumour was reported in the press, conspicious 'proof' followed hot on its tail in the form of a coloured etching (illus. 59) showing Citizen Capet wielding a stick and a fool's sceptre, smashing the mirrors in the Louvre and throwing a chair and a clock around, while a National Guardsman in the background looks on. His 'madness' is clearly not the outburst of a political hothead, as in the case of the plebeian ringleader *Père Duchesne*, but a sign of mental confusion. *Qui casse les verres les paye, chacun des morceaux multiplie sa folie*, as the caption puts it ominously. Although this scene was pure invention, it certainly resonated with the public – to the great annoyance of the conservative newspaper *L'Ami du Roi*:

On display on every street, and above all in that den of sedition called the Palais Royal, are multiple copies of engravings most villainously prejudicial to the royal majesty. It is impossible to turn one's gaze away from them without shuddering in horror [...] There are public rumours being spread with inconceivable speed. The newspapers of the revolution disseminate them, and soon France is totally steeped in falsehoods which outdo even the prints and the songs. The insults to the King have gone so far as to claim he has

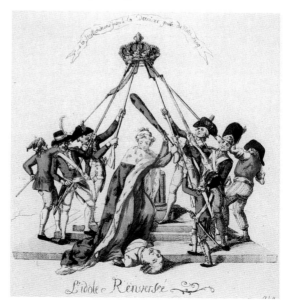

60 *The Toppled Idol*, aquatint, 39 x 33 cm, 1791.

75

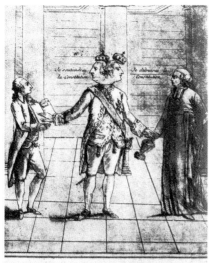

61 *King Janus or The Man with Two Faces*,
coloured aquatint, 15.6 × 13.6 cm, 1792.

latterly sunk into a bout of madness. They were making out he had shattered his mirrors, broken his furniture, and they were imputing to him all the wild extravagance that can be supposed to go with the starkest insanity [...].[90]

Be that as it may, the consequence of all of this graphic exposure was inescapable: Louis XVI, who had revealed himself in his true colours by his attempted flight,[91] was now being subjected to a barrage of pictorial character assassination, and could not remain king for much longer. The Jacobins of Strasbourg prepared a symbolic funeral service for him on 30 September,[92] complete with a commemorative headstone inscribed with 'Louis le faux', organized by the populist leaders Père Duchesne and Jean Bart.[93] Not only was he ejected from the circle of 'Great Men', as we saw in connection with Voltaire's accession to the Panthéon, even his bust was knocked off its pedestal by Francia herself, who then struck it with a cudgel (illus. 60). The anonymous artist was making a dual point: the Herculean Francia, dressed in the royal mantle and tricolor, is shown as the embodiment of the revolutionary people's will, while the crown, as the emblem of the monarchy, is being held aloft by soldiers and *sans-culottes* militiamen.[94] A perceptive contemporary, Boyer-Brun, who had commissioned the engraving, recognized all too clearly its prophetic warning:

The perfidious aim of this caricature is perceptible at first glance; it sought to persuade the people that they could bear the crown without the king, that the

beneficent Louis XVI was a useless idol who had to be *overthrown, trodden underfoot*, and that they could imitate the people of France [depicted in the cartoon] who were smashing that idol with a club. Was this not to say to the people: *Assassinate the king* [...]? [95]

So effective was anti-monarchist pictorial propaganda after Varennes that even by signing the Constitution on 14 September 1791, Louis could restore his prestige only fleetingly. David's print of February 1790 (see illus. 52) was reprinted, and a series of similarly representative graphics appeared, commemorating Louis' constitutional oath as Francia or the Nation respectively accepting the citizen king's oath of duty.[96] However, popular prints responded by showing Louis sitting in a cage and only signing the Constitution under duress,[97] or even playing a treacherous double game (illus. 61), on the one hand publicly praising the Constitution, whilst in reality striving for its destruction, and giving his veto on behalf of the priest who is refusing the oath.

The rising groundswell of disparagement of the king became apparent in 1792, when revolutionary clubs throughout the land began bombarding the National Assembly with anti-royalist diatribes. At the same time political satires against Louis XVI were proliferating in the public sphere. 'Never', reported one informant, 'had anyone seen caricatures attacking the king and the royal family so widely distributed as in the fortnight preceding the shameful day of 20 June 1792. [. . .] One year previously, certain of these caricatures had been displayed at the printsellers' shops in all the streets and all the river banks of the capital.'[98] The aforementioned revolutionary *journée* charted the progression of an ever more fundamental and aggressive pictorial polemic directed against Louis XVI. Since the king was obstinately refusing to sign decrees issued by the National Assembly against priests who refused to take the oath, and calling for the nationalization of the property of emigrants, on 20 June the royal apartments were surrounded by armed divisions that forced him to place the Phrygian cap on

62 *The New Pact between Louis XVI and the People on 20 June, 4th Year of Liberty*, coloured aquatint, 15.6 x 13.6 cm, 1792.

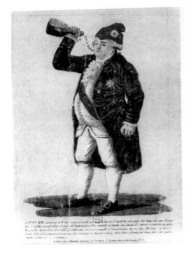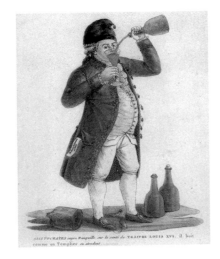

63 Villeneuve, *Louis XVI Puts On The Red Hat . . .*, coloured aquatint, 22.6 x 14.5 cm, 1792.

64 Villeneuve, *Aristocrats Do Not Worry About the Health of the Traitor Louis XVI . . .*, aquatint, 20.8 x 17.2 cm, 1792.

his head and drink a toast 'to the Nation', although they were unable to compel him to retract his veto. Whereas the tabloid press reported the event as a confrontation between the king and the sans–culottes,[99] more symbolic graphics focused on Louis himself, for instance a copy of the picture of the monarch's assumption of rule from an engraving of 1775 by Joseph Boze with the addition of a red cap with the national cockade,[100] or a full-length portait of a portly Louis, with the same cap, raising a bottle of wine in a toast to the nation (illus. 62). Although the anonymous artist might well have intended this gesture on the part of Louis to signify a new contract between the king and the people, it was turned into the opposite by Villeneuve, whom Louis earlier that year had ironically mocked as 'Saint Veto Martir, patron des emigrans et des refractaires'.[101] Villeneuve produced a mirror image of the picture (illus. 63) with a new caption:

Louis XVI had donned the red cap of liberty, he had cried Long live the nation! He had drunk the health of the Sans–Culottes. [...] Eh bien! The selfsame Louis XVI waited courageously until his fellow citizens had gone back home to wage a covert war against them and to exact his revenge.

In order to emphasise the incompatibility of the king and the Jacobin cap, Louis has been given the Order of St Louis on his chest. Even this did not suffice: when the royal family fled the Tuileries and took refuge in the Convention, from where they were finally interned in

78

the Temple,[102] Villeneuve intensified his adaptation and clarified the political goal of the monarch, who had been deposed for the time being (illus. 64). The line of writing in the first adaptation has been changed into wine being poured, three more wine bottles have been added on the floor for good measure, one of them now empty and broken. Secret papers can be seen protruding from Louis' walking costume ('Treachery exposed and punished, List of Proscriptions').[103] The red Jacobin cap has been changed into the green cap of a bankrupt, with the caption 'Il fait Banqueroute à tous les partis'. The derisive caption beneath the drawing, a pun on Louis' new prison and the name of the old order of knights, is eloquently silent on the fate of the drunken 'Templar'. In any case, the ever more open publication of old and new 'swine caricatures' and other cruel political satires on the *Ménagerie royale* in the temple was not propitious,[104] as one observer commented on 30 August 1792:

The arcades of the Palais Royal and those of the Assemblée Nationale are papered with caricatures representing the depraved ways of Louis the Traitor. He is drawn as a crowned swine, or else shown emerging from one of the château's sewers with his family [...].[105]

After 10 August and the toppling of monuments to the king in Paris, calumnies of 'Louis le Traître' were featuring in revolutionary prints before his trial in the Convention had even commenced. Here again Villeneuve played a leading role. His finely worked aquatint showing a bust of the king on a lantern (illus. 65) signified not simply the looming self-righteous people's justice, it also contained an extensive message that is gradually revealed in the accompanying text. This detailed legend draws a parallel between the storming of the Tuileries and St Bartholomew's Night, laying the entire blame for the sacrifice of 10 August on Louis – the new Charles IX.[106]

10 August 1792 was an even more dreadful day than 24 August 1572, and Louis XVI a very different monster from Charles IX. At least Charles, on the balcony of the Louvre with an arquebus in his hand, sniped at the Protestants and thus laid himself open to reprisals; but Louis XVI gives his Swiss Guards a drink in the morning, distributes money to them, reviews them, and then, after giving both to them and to his *chevaliers du poignard* the order to courageously assassinate the people through his palace casements, he goes off, as cowardly as he is perfidious, to hide in the bosom of the Legislative Body, and entreats asylum of the representatives of that same nation whose murder he has just ordered. That infamous crime was hitherto unknown in history.

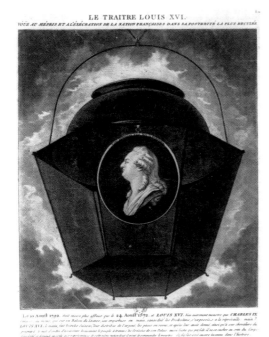

LE TRAITRE LOUIS XVI.
VOUÉ AU MÉPRIS ET À L'EXÉCRATION DE LA NATION FRANÇAISE DANS SA POSTÉRITÉ LA PLUS RECULÉE

65 Villeneuve, *The Traitor Louis XVI Dedicated to the Scorn and Loathing of the French Nation . . .*, aquatint, 22.7 X 17.2 cm, 1792.

The inscription on the portrait in the medallion completes the reference to the sixteenth century. The unusual expression 'This suspension is well worth deposition' alludes to a somewhat colloquial utterance by Henri IV ('Paris vaut bien une messe'), and implies a comparison with a sombre 'historical' chain of events: just as the Bourbons had won the French crown as a result of Henri's victory in the Wars of Religion, so they had lost it again following a new St Bartholomew's Night of the Patriots.[107] In addition, the word 'suspension' in the medallion's caption is a double entendre: the word means 'suspended' as well as 'hanged', so the medal is suggesting that Louis' fate is hanging by the same thread as the lantern, and that this fate is death.

As the trial of the king progressed, Villeneuve's allegories became ever more concise and cutting, increasingly incorporating religious elements to reinforce the impression that a higher power was at work in determining Louis' fate. At the turn of 1792–3, Villeneuve depicted a hand breaking through a wall (illus. 66) to transfer the warning to Belshazzar recounted in the Book of Daniel (V, verses 26–28) to 'Louis Capet': 'God hath numbered thy reign and finished it; thou art weighed in the balance, and art found wanting'. Furthermore,

66 Villeneuve, *Traitor Louis XVI Read Your Sentence . . .*, etching and aquatint, 20.3 × 17 cm, 1793.

although the muscular arm is therefore implicitly divine, it is allowing itself to be used as an instrument of the people. However, in the end Louis was put to death not by his peasants like Belshazzar, but by the guillotine, as attested by the miniature beneath the arm: 'It awaits the Guilty' is the caption on the guillotine. As proof of his guilt, the legend quotes extensively from a Jacobin pamphlet by one Durocher:

BULLETIN
DES AMIS DE LA VÉRITÉ,
PUBLIÉ PAR LES DIRECTEURS
DE L'IMPRIMERIE DU CERCLE SOCIAL.

Prix de l'abonnement, 18 livres, franc de port pour 3 mois,
72 livres pour l'année.

A PARIS,

Chez les Directeurs de l'imprimerie du Cercle Social, rue du Théâtre-François n° 4.

67 *Bulletin of the Friends of Truth . . .*, etching, 42 x 53 cm, Paris, Imprimerie du Cercle Social, 1793.

A hundred times guilty and a hundred times pardoned, Louis the Last has too fully experienced the people's benevolence and generosity not to do himself this much justice: that he must have exhausted all the feelings of human kindness that only a remnant of piety could have maintained for him over the past four years. No doubt his conscience is his cruellest torturer; and why is it not possible to leave him to that inner torment, infinitely worse than death? But the most sacred law, the salvation of twenty-four million men, requires that he be judged; and the glory of France, depending on the judgement of the present generation and of future generations, demands that he be punished. [...] In the present state of France and the dangerous unrest in Europe, how can one consider this monster otherwise than as a rallying point for counter-revolutionaries, and as the core of counter-revolution? That being the case, does sane policy allow a pardon in his favour that, sooner or later, would become the cause of the overturning of the republic?[108]

Villeneuve's motif made such a strong impression that it was used for an eye-catching poster advertising the Cercle Social (illus. 67). Numerous copies and replicas were also made of Villeneuve's aquatint of the beheading of Louis (illus. 68). With this, the revolutionary 'aesthetics of immediacy, even of terror',[109] congruent with the procedure of the guillotine, reached its acme. The threatening arm of the previous image reveals itself in this one not only as the

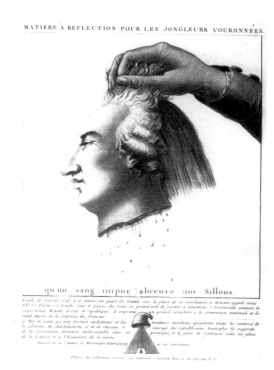

MATIERE A REFLECTION POUR LES JONGLEURS COURONNÉES.

qu'un sang impur abreuve nos sillons.

68 Villeneuve, *Something To Reflect Upon for the Crowned Jugglers*, etching and aquatint, 16 x 14.1 cm, 1793.

avenging arm of the executioner, holding the decapitated head aloft for all the spectators of the public execution to see,[110] it is also reminiscent of the arm of Perseus, who turned Polydectes into stone by holding up to him the decapitated head of the Medusa. The blood dripping from Louis' neck heightens the impression of an 'instant snapshot', while at the same time presenting an opportunity, with the assistance of a verse from the Marseillaise, to refute the popular belief in the illustrious blood of the 'miracle-worker kings', which was evident on the occasion of Louis' execution.[111] Although this picture required no further comment, Villeneuve, an avid reader of radical revolutionary newspapers and pamphlets, added at the bottom of the page a corroborating text which he had just come across, to make the connection with the symbolic portent of revolutionary justice. It is the slightly altered opening passage of a seminal article by Robeswpierre, who had been particularly consistent in calling for the death sentence to be handed down to Louis in the Convention, against the wishes of those who wanted to hold a referendum:

On Monday 21 January 1793 at 10 o'clock in the morning, in the Place de la Révolution, hitherto named Place Louis XV, the tyrant fell beneath the blade

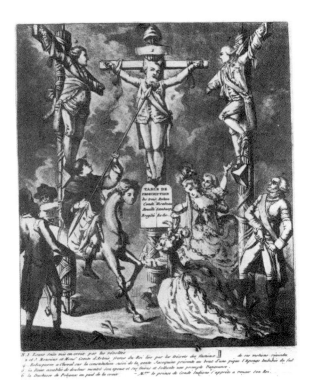

69 Michel Wébert, *The New Calvary*, aquatint, 20.3 X 14.7 cm, 1793.

of the Laws. This great act of justice caused consternation among the Aristocracy, annihilated the superstitious cult of Royalty and created the republic. It confers greatness on the National Convention and renders it worthy of the trust of the French.

Villeneuve omits a few of Robespierre's rhetorical sentences and then continues the quotation:

in vain did a bold faction and some insidious orators exhaust all the resources of calumny, charlatanism and chicanery; the courage of the republicans triumphed: the majority of the Convention stood steadfast in its principles, and the genius of intrigue yielded to the genius of Liberty and the Ascendancy of virtue.[112]

Whereas such terse pictorial satires and vilifications of the king dominated revolutionary publication for a time, there was opposition to them in the royalist underground, although by means of a quite different, more wordy, symbolism. This was also the case with caricature-like replicas, such as the *New Calvary* (illus. 69), possibly inspired by Boyer-Brun, which was published in the Palais-Royal at the turn of 1792–3 by Wébert. Like Villeneuve, he made use of

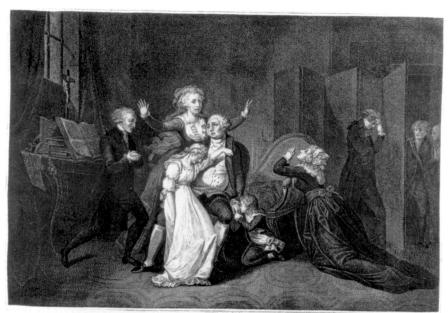

70 Carlo Lasino after Charles Benazech, *The Last Meeting of Louis XVI with his Family the Day Before his Execution*, aquatint and etching, 34.8 x 46.2 cm, Paris, Darbi, 1793.

biblical inversion, although with the opposite intention. The perpendicular post of the cross on which Louis is being crucified (also those of his relatives the Comte d'Artois and Prince de Condé, who had been condemned *in absentia*) is made up of a bundle of fasces, the emblem of republican unity, wrapped around with tricolor bands and topped with a Jacobin cap. The tablet affixed to the cross is inscribed, not with the revolutionary Rights of Man, but a terrorist notification ('table des proscription') with the names of persecuted royalists. Robespierre, riding on the mare of his 'constitution', is administering to the crucified king not vinegar but the 'slobber' (*fiel*) of the revolutionaries. So offensive did the latter find this drawing that they sentenced Wébert to death on 20 May 1794.

From that time on, royalist printmakers refrained from producing such dramatic and hence risky polemics against the *régicides*. During Louis' trial they tended to favour genre-like scenes of the Father of the Nation drawing up his will in the temple and personally instructing the dauphin.[113] After 21 January 1793, pictorial prints critical of the Revolution seldom portrayed Louis' execution itself, and never his bleeding head in 'close up', but opted instead for the

events leading up to it, for instance Louis, next to his confessor, revealing his human greatness with what are presumably his last words to his people.[114] This would be echoed in a nineteenth-century privatized, historical art genre, in tune with the conservative situation, with a penchant for such moving, internalized scenes from the Revolution.

A painting by Charles Benazech corresponded most closely to the royalist view of the king. Instead of depicting the humiliating decapitation of the monarch, it shows Louis on the eve of his execution, based on the eye-witness report by his confessor Edgeworth de Firmont,[115] taking leave of his family.[116] Benazech's picture achieved wider circulation than any other revolutionary print. There were sixty French reproduction engravings and more than seventy reprinted variations, among them an etching published in Paris by the Italian Carlo Lasino (illus. 70) as well as a quantity of further copies throughout Europe.[117] Louis is seen as a dignified *pater familias*, aware of the gravity of his situation yet keeping his composure. He is gazing thoughtfully at his daughter, who is huddling up to him in tender sadness, whilst the Dauphin is clutching his knees in childish despair. As in pictures of the Crucifixion, on both sides of the 'suffering man' there are mourning figures, praying on bended knees: Louis' sister Mme Elisabeth and his confessor Edgeworth de Firmont; their intercession, signified by the cross and an open Bible, lend an intimate air to this portrayal of intimate feelings of religious fervour and solemnity. However, the scene is dominated by Marie-Antoinette's pathetic gesture, intended primarily for public effect: she appears not only to be overcome by fear and grief, but is also theatrically drawing attention to the fact that something remarkable is happening. In the background is an embodiment of reflection – one of Louis' valets, Jean-Baptist Cléry, is clutching his head as if to impress upon the viewer that he is quite overcome with emotion, grief and contemplation. Like Daniel Chodowiecki in Berlin, whose engraving *Les Adieux de Calas à sa famille* was supposed to have provided the model,[118] Benazech combined on the one hand the pictorial model of the mourning of Christ with this exaggerated depiction of a sentimental family drama; on the other hand, however, he attempted to give the scene the aura of a contemporary historical picture by drawing on the fount of classical pathos formulas.

Benazech's portrayal reveals itself to be typical of expressive, primarily traditional symbolic visualizations of the royalist situation, which increasingly distanced themselves from the novel drama and succinct density of revolutionary graphics. This was the tenor of a series of historical prints commemorating events in the life of Louis

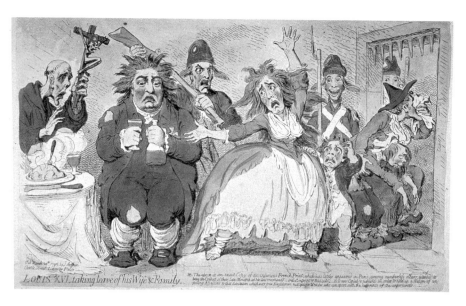

71 James Gillray, *Louis XVI Taking Leave of his Wife and Family*, coloured etching, 24.8 x 37.8 cm, 20 March 1793.

XVI, which the engraver Jean-Baptiste Vérité, inspired by the example of Bouillon and Benazech among others, had published by Colnaghi in London from November 1794;[119] also the anonymous *Apothéose de Louis XVI*, in which the martyred king, whole again, rises up from his place of execution into heaven in a gloriole of light.[120]

One did not need to be a revolutionary to find such pathetic religious symbolism artistically antiquated, as evidenced by a hand-coloured etching by no less than James Gillray. When Gillray came across Benazech's painting, which was exhibited in a number of English towns,[121] he responded immediately with a crude parody (illus. 71), which was published by James Aitken of Castle Street, London, on 20 March 1793. It merits mention here because Gillray was an academy trained artist who had deliberately chosen to switch from historical painting to political caricature, and so was particularly competent to discuss Benazech's style. In the legend accompanying his portrayal, Gillray ironically laid a false trail, to avoid being accused of anti-royalism:

The above is an exact copy of an infamous French Print, which has lately appeared in Paris, among numberless others, intended to bring the Conduct of their late Monarch in his last moments into Contempt & Ridicule; it is now copied & publish'd, in order to hold up a Nation of unfeeling Assassins

to that detestation which every true Englishman must feel for Wretches who can sport with the suffering of the unfortunate.

Benazech's image, which Gillray is alluding to here,[122] is of course anything but 'ridiculing' or 'murderous' of the king. In one sense, though, Gillray had made an 'exact copy' of it, in that he cited the themes of Benazech's pathetic historical picture point by point in order systematically to parody all of the elements. On the right, he has replaced the profoundly emotional, reflecting figure by that of Mme Elisabeth, holding her hand over her face and nose in despair. On the left, the praying confessor Edgeworth has been changed into a fanatical monk, clutching a crucifix with a 'Jacobin Kasper' in place of a body, and a roast chicken instead of an open Bible on the altar table – a play on Louis' last supper in the Temple. On the right side, the king's weeping children have degenerated into anxious, vomiting ragamuffins. The stricken witnesses behind the screen have been turned into guards, grinning intimidatingly and also maniacally. Above all, the royal couple in the centre of the picture have lost all dignity. Marie-Antoinette's expansive gesture of pathos is contradicted by her spread-out fingers and wildly dishevelled hair, like that of a Fury, her crude facial expression, and her stockings, which have fallen around her ankles. Louis himself, the almost holy martyr in the original picture, is turning his gaze inward away from the cross, and has become a pitiful wretch. The wine glass and the bottle in his hands together seem to form an hourglass, the sands of which are running out, like the stream of urine between his legs, caused by his fear. Benazech's traditional historical picture has been turned into a general satire of its time; the political and artistic as well as conservative symbolism of the royalists could hardly be more cruelly taken *ad absurdum*.

French revolutionary printmakers, for their part, did not develop quite such a refined art criticism, but responded to the pathetic pictures of events such as Benazech's with political allegories. Once more, Villeneuve was in the forefront. In 1793 he produced an aquatint in which the demise of Louis XVI is seen as the beginning of a series of progressive historical events spreading out from France (illus. 72).[123] Even more expressively than Benazech, Villeneuve too imputes an otherworldly power to the scene in his picture, not however that of the Christian God, but Chronos, the god of time. Chronos is shown inside a brightly lit circle of the crowned heads of Europe, or to be more precise, their busts, which are arranged like monuments, with candles on their heads representing their political

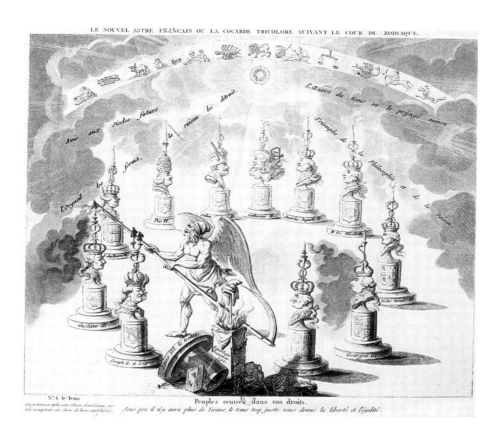

72 Villeneuve, *The New French Star, or the Tricolore Cockade at the Heart of the Zodiac*, aquatint and etching, 24.9 × 30.3 cm, 1793.

life. Wearing a Phrygian cap and holding in his hand a scythe that he is using as a candle extinguisher, he has just begun to extinguish the light of life of the rulers. His intention is explicitly stated in the legend 'At last may I destroy this cohort of ambitious men, these vile usurpers of the rights of their fellow men'. In fact he has already knocked the head of Louis XVI – along with its crown and coat of arms of lilies – to the floor. The inscription on the pedestal comments derisively on this toppling of a monument: 'Louis XVI the Traitor and the Last'. An altar to the Nation, with an eternal flame and a liberty cap, has taken the place of the toppled bust, and the pedestal proclaims the watchword of the new era: 'Égalité - République Française 1792'. There is also an actual historical background to those next in line to be extinguished by Chronos. Just as the imperial brothers Joseph II and his successor Leopold II died after abortive attempts at reform in 1790 and 1792, the king of Sweden, whom Chronos has

just reached, was shot on 29 March 1792 by aristocratic conspirators before he could carry out his planned crusade against the French Revolution. The circle of those about to be extinguished progresses from Pope Pius VI, to the Czarina Catherine II, George III of Great Britain and Charles IV of Spain, giving the picture a self-evidently anti-royalist future perspective. The caption too proclaims: 'Peoples, take back your rights. Soon there will be no more tyrants, the all too just hour has struck and gives you liberty and equality.' There is an added dimension to the image in the form of a heavenly 'time horizon' arching over the earthly symbolism of Chronos, dominated by 'THE NEW FRENCH STAR' in the form of the national cockade. It is no coincidence that this constellation lies exactly in the zenith, above the decapitated head of Louis XVI. It is beaming a warning to those despotic rulers who have not already heeded it: 'Pride shaped them, reason destroys them', and a ray of hope to the people: 'Triumph of Philosophy and Reason'. So in fact this toppling of kings is not the work of Chronos but the New Age of the French Revolution, symbolized by the national cockade. To emphasize the impression of the inexorability and natural inevitability of the revolutionary change, the artist has combined the power of the rays of the cockade, whether enlightening or annihilating, with two further motifs of political iconography: the signs of the zodiac, to indicate that the Revolution is in harmony with nature, as well as the wheel of fortune, which Chronos is turning as he moves around the circle. Working in concert and moving round in the same direction, both motifs circumscribe the experience of revolutionary autodynamics – since this circular arrangement precludes ongoing experience of an open future.

In many respects, revolutionary graphic art was an art for its time par excellence: it gave meaningful expression to the prevailing caesura by means of contrasting pairs of images, thereby bringing the former age of the *ancien régime* into sharper relief, if not also somewhat contrived. No other pictorial art has been quite as successful as revolutionary graphic art in consistently following such a convoluted theme as the twists of fate of the monarchy over a number of years, depicting actual events as they occurred, and engaging in a controversial debate on the subject, thereby revealing the essential character of the progress of the Revolution to be one of accelerated time.

All in all, David's high-toned, monumental historical picture, with its contemporary theme, in which heroic individuals are portrayed performing historic acts with universal significance, was in stark contrast to the *fait divers* of the engraving. In the surviving fragment of the unfinished work as well as in the preliminary sketches, they are depicted naked, in the manner of Raphael, Michelangelo or Poussin. David thereby imbued the transformation of the oppressed into citizens of the state, which was being played out in contemporary events, with timeless significance, which had hitherto been accorded only to events in ancient history. Many of David's enthusiastic contemporaries did in fact conceive of the Revolution as a return to the age of antiquity, which Johann Joachim Winckelmann only a few decades earlier had eulogized as a golden age of artistic flowering and political freedom, lost forever.[10] A certain Chery claimed to recognize Cato in the people taking the oath of readiness to die for the nation; and even the bareness of the room, which was appropriate in view of its original function, was equated with the earnestness and austerity of the early Roman Republic:[11] 'the Freedom we have won is going to bring the happy days of Greece and Rome back into our midst.'[12] Researchers have viewed this tendency to 'classicize' the picture as signifying an important shifting of emphasis between the *ancien régime* and the Revolution. In former times, artists were fond of drawing on antique themes to allude to the present metaphorically, and this was to some extent also true of revolutionary art, which still clung to antique themes; see, for example, Louis Gauffier's *Générosité des dames romaines*, which alludes to the part played by the wives of the artists at Versailles on 23 September 1789. However, in the case of David's drawing it appears to be the other way round: here, antiquity has been usurped by the contemporary scene.[13]

In an essay by Wolfgang Kemp (an instructive example of the usefulness of visual reception theory) it is pointed out that the lines of perspective in David's preliminary sketch meet between Bailly's eyes as he swears the oath. In an earlier draught (not illustrated here), in contrast, the lines converge on his hands.[14] Taken together with the strictly frontal viewpoint of the whole composition, great emphasis is placed on Bailly's location in the picture, intensifying his appeal to the viewer. Bailly is in the line of vision of the viewer of the picture, not of the people participating in the event. Critics at the time pointed out that as Bailly is standing with his back to the people he is supposed to be addressing in the picture, logically he has no function in it.[15]

Who, then, is the intended viewer? He is none other than the deputy of the revolutionary parliament. David's projected ten-metres-broad

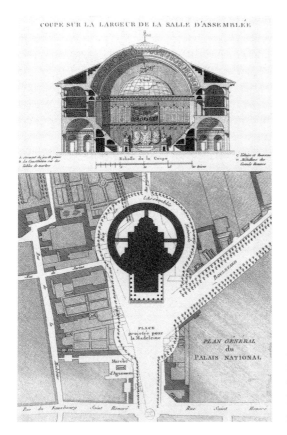

COUPE SUR LA LARGEUR DE LA SALLE D'ASSEMBLÉE

PLAN GÉNÉRAL
du
PALAIS NATIONAL

78 Jacques-Guillaume Legrand and Jacques Molinos, *General Plan of the Palais National*, engraved by Poulleau, 27.2 × 42.5 cm, Paris, Ponce, 1792–3.

painting was intended to be hung facing the deputies, on the wall of their new building, which had been designed by Legrand and Molinos (illus. 78). The semicircular hall of the planned building would have been mirrored by the more or less semicircular composition of David's painting, which is supposed to have been the main reason for this arrangement of the revolutionaries in the picture.[16] The two were to culminate in a full circle, a natural symbol of completion, unity and equality. Just as Bailly's central position would have drawn the gaze of the viewer of the painting, the minds of the parliamentary deputies would have been focused for all time on their duty to the oath taken in the Versailles' tennis court in 1789. The deputies would have been at one with the origin of the Revolution and its eternal goals. It is hard to imagine any picture having a stronger appeal to its intended audience than that of the intended *Tennis Court Oath*.

There is a darker side to the picture, in its resemblance to Jeremy Bentham's design for a prison, which Michel Foucault has cited as

79 Jeremy Bentham, *The Penitentiary Panopticon or Inspection House*, drawing by W. Revely after J. Bentham, pencil, pen and watercolour, 1787.

proof of the controlling nature of the modern state (illus. 79). It is not too difficult to discern parallels between the design of the prison, with its rows of cells arranged in a semicircle, and the arrangement of the parliamentary deputies; and between the guard in the centre of the semicircle of cells, with his unobstructed view into the window of each, and the central figure of Bailly.[17] Of course, there is a crucial difference in that unlike Bailly in David's picture, the prison guard is not in view. This lends itself to an important interpretation, though: the revolutionaries started out with a policy of 'radical transparency', that is, a desire to distance themselves from the arcane politics of the *ancien régime*; as the Revolution progressed, the duty to strive to fulfil this political goal developed into a 'compulsory–voluntary' one. It is interesting to speculate further whether there might not even be an underlying connection between this sort of arrangement and a totalitarian tendency. The writings of Rousseau, which were profoundly influential on the Revolution, prefigured this tendency, which was realized in the years 1793–4.[18] The all-seeing eye, usually placed within a pyramid, which was originally a symbol of the almighty power of God, became in the figure of Bailly an instrument for impressing the oath upon the parliamentary actors. During the Terror it was the predominant emblem of the Jacobin Club and its

80 *Surveillance and Revolutionary Committee of Lille*, etching, Lille 1793–4.

'Comitées de surveillance' (illus. 80), and thence the agent of the enforced *unité révolutionnaire*, which was only decisively weakened at the time of the Thermidor Reaction.

David's picture achieved renown through much smaller reproductions – for example, an engraving by the son of François-Louis Couché, from which 3,000 sheets were printed. There is no doubt that had the original picture been exhibited as planned, it would have made a magnificent and also rather overwhelming impression. However, the planned installation never took place, for two reasons. Legrand's and Molinos' design for the parliament building was based on a remodelling of the church of the Madeleine, construction of which had only just begun. Their plan would have lent an appropriate atmosphere to the 'Worship of the Law', but it was never carried out. Instead, the Tuileries theatre was adapted for use as the parliament, but there was no room inside for David's painting. Secondly, the theme of the picture soon became outdated, even politically suspect, as has already been mentioned. Many of the people portrayed in it had been thrown out of the revolutionary movement by then, and were *personae non gratae*, or had even been guillotined during the Terror – including Bailly himself, the central figure of the picture. As the Mayor of Paris, he was one of the most influential people in the early days of the Revolution. As a supporter of the monarchy, however, he was eventually sidelined. His fatal error in the eyes of the later republicans was his involvement in the so-called 'massacre du

Champ de Mars' on 17 July 1791, during which he gave the order to fire on demonstrators from the revolutionary clubs, who were demanding the deposition of the king. Not long after this event, Bailly left the parliament. Two years later, at the height of the Terror, his past caught up with him, and he was executed as a monarchist on 12 November 1793.

Architecture for the representatives of the nation

There were a number of reasons for the parliamentarians' choice of the Tuileries theatre. For one thing, it was far less expensive to remodel an already existing building. This was an important consideration as the Revolution progressed, for the army was draining vast amounts of money to maintain defences against attacks launched by the forces of the coalition. There was also a symbolic reason for the choice of the Tuileries, as they would be sitting in the same place as the now vanquished monarchy. Third, the choice of a theatre is significant in itself. The relatively recent phenomenon of parliamentary democracy in continental Europe had always displayed a certain theatricality in its iconography, and this was certainly the case with the revolutionary French parliament, not only in view of the fact that sittings took place on a stage, but also by virtue of the consciously cultivated art of rhetoric.[19]

The function of the building was quite novel, and unknown under traditional monarchy: the Parlement of the *ancien régime* in France had a jurisdictional function, and it did not represent the people in any genuine sense.[20] The seating arrangement in their courthouses, with the judge facing the entire courtroom, was ill-suited to a general assembly.[21] As an early constitutional monarchy Britain was an exception with its parliament; however, the type of building developed there was not emulated on the Continent, or later in the United States. Under the British constitutional monarchy, then as now, Members of Parliament sat facing each other, grouped according to political party, government and opposition, with the Speaker's pulpit in the middle.[22] The principle of polarity in forming public opinion, which was expressed in the building itself, and which developed into the opposition between Whigs and Tories in Britain from the seventeenth century, was far less pronounced in Continental democracies, where an alternative concept started to emerge in France with the French Revolution. Similarly, having abolished the Estates and corporations of the *ancien régime*, the revolutionaries rejected any parties as 'factions', and the group in power claimed to represent the

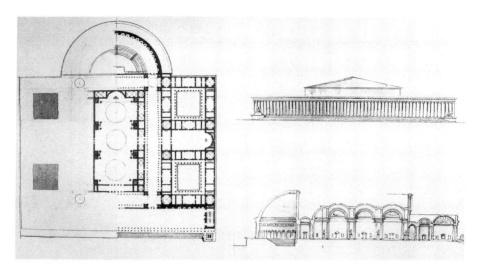

81 Alexandre Maximilien Le Loup, Plan for a building for the Estates-General, ground-plan, elevation and cross-section, 1789.

entire people, the Nation itself.[23] In all parliamentary disputes, there was a prevailing belief in the 'unité' of the 'volonté génerale', and this found expression in the enclosed form of the building itself. The most enclosed form is the circle, and this shape dominated the early designs for the parliament building. This was less so in the case of the design entered by Alexandre Maximilien Le Loup (illus. 81) in the competition launched in the winter of 1789 by the Academy of Architecture for a building to accommodate the Estates-General.[24] His design featured three adjacent rectangular chambers, each with a central dome, of course not yet for the delegates of the entire nation, but of the Estates at that time. Following the example of the Roman god-emperor, the king would naturally take his place in the apse, ceremonially the most prominent position.[25] That is also where he sat in the Salle des Menus Plaisirs in the Palace of Versailles, which was adapted to accommodate the Estates-General. This Salle was a lengthy rectangular room in which the King sat at one end, with the Three Estates arranged around the other three sides, with no attempt at even a symbolic expression of unity.[26] Unity was, however, given some symbolical expression by means of the later elliptical arrangement of the rows of seats, after the room had been remodelled once again, and this came to be regarded as the ideal arrangement for parliamentary seating.

A notable example of the fully fledged revolutionary idea was Etienne-Louis Boullée's design for a National Assembly (illus. 82),

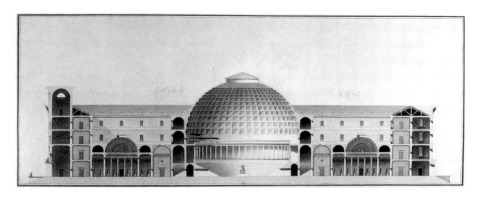

82 Etienne-Louis Boullée, *Plan for the Building of the National Assembly*, cross-section, ink wash and watercolour, 54 × 138 cm, 1791–2.

completed in 1791–2, but never built,[27] featuring a circular assembly room, placed in the symbolically significant centre of an enormous square layout. Just as in a theatre, there were sloping rows of seats descending to a central stage. Above the upper rows of seats there was a colonnade, evidently inspired by classical theatre design, such as the Ledoux theatre in Besançon. 'All the points of its surface [i.e., the dome] are equidistant from the centre', as Boullée noted in his architectural treatise, prepared at the height of the Revolution.[28] With a little imagination this concept could be transposed to a circular form of construction and taken as the symbolic expression of an enlightened form of government based on the principle of equality rather than hierarchy.

The external walls of Boullée's building were adorned with passages from the Constitution. Abstract figures representing the French *départements* rose up from a double stylobate. At the top was a relief composed of figures representing revolutionary festivals, with an allegory of Liberty crowning the roof. This richly symbolic scenery was in keeping with the significance of the construction. The profusion of textual passages on the walls is typical of revolutionary art, and testifies to a desire for a type of expression that the pictorial language of the time alone could not adequately fulfil.

There was a series of designs of this type, all based on a circular parliamentary chamber with only minor modifications. In order to emphasize the significance of the venue, Louis Combes designed a dome decorated with an astrological constellation, supposedly the one which would have been visible on the night of 14 July 1789, the beginning of the Revolution. This would surely have made as strong an impression on the deputies as David's picture would have done, albeit somewhat less oppressively.

83 Domenico Pelegrini, *Louis XVI at the Bar of the National Convention, 26 December 1792*, engraving, 39.5 x 48 cm, London, Colnaghi, 15 September 1796.

The circular form, which since the Renaissance had been considered the ideal form of natural completion, was not entirely practical, in view of the fact that the speaker would always have an entire row of deputies to his rear or at his sides. This had already been remedied in parliamentary practice, in the Manège of the Tuileries, the only suitable venue which could be found in Paris after the enforced 'homecoming' of the king in October 1789. The Speaker's tribune was placed in the middle of one of the long sides of the room, with the deputies seated in front of it in straight rows (illus. 83). A semicircular arrangement would have been even more suitable, allowing for the optimum distance between the speaker and the auditorium. Pierre Rousseau therefore designed a semicircular assembly hall, and located it, in a symbolically effective gesture, opposite the royal palace (illus. 84). He thereby gave visible form to the early revolutionary conception of a legislative assembly on the one hand, and an executive monarchy on the other, focusing the structure largely on the king.[29] It was no longer necessary for Legrand and Molinos to give any consideration to the proximity of the National Assembly to Louis XVI, as their design was produced at a time (1792) when the monarchy had already been

be saved and adapted for reuse in another context. However, this gave rise to a dilemma that was the subject of heated debate at the time, and for which a variety of solutions was put forward. Must the symbols of oppression be destroyed in order to end the oppression itself, or at least to serve as visible reminders of its termination; or could this devil be driven out by means of re-contextualizing instead? Could the slaves be semantically redefined, by a kind of sleight of hand, such as was quite common during the Revolution, letting them stand – as did actually happen – as allegories of 'abuses', of 'prejudice', of 'feudal power' and of 'arbitrary power', which would quite rightly be subjected to oppression? Did all works of art have inherent artistic value, so that even these works were worth retaining, even though they represented execrable subject-matter, produced under duress? Many attempts were made to resolve this aporia by means of historicization – an important reason for the establishment of museums, which received considerable support during the Revolution.[38] The royalist Abbé Maury, who emigrated in 1791, expressed the view that the statue of Louis XIV in the Place des Victoires should be understood as a document, which could be used to 'show posterity the kind of flattery once addressed to kings'.[39] Maury's argument could be used by those who, in contrast, were not taking a purely tactical line in dealing with this situation. So the meaning of a work of art could thereby be changed from a magical one to a rational–pedagogical one, just as the constituent elements of a historical development could justify even the worst subject-matter of a work of art. Many artists argued the case – more consistently than David – from the perspective of aesthetics. As the sculptor Caffieri put it:

Although it is only proposed to remove the four figures adorning the base of the statue of Louis le Grand in the Place des Victoires, that does nonetheless destroy the monument, since the figures are so symmetrical, and so related to one another and to the principal figure, that they cannot be separated or replaced without committing an aberration.[40]

Nevertheless, the ensuing fate of the monument was decided by the ever more radical course of the Revolution, in the light of which reflections such as those of the Abbé Maury and the artist Caffieri were viewed as somewhat academic and elitist. On 14 August 1792 the Assemblée Nationale decided that

in every part of the empire, in the churches, in the national buildings, even in those that were assigned as residences of the king, every object cast in bronze shall be removed, melted down and transformed into cannon.[41]

Louis le Grand renversé pour faire place à la Colonne de la Liberté et de l'Égalité

87 *Place des Victoires*, coloured etching, 14.2 x 22.5 cm, 1792.

Earlier than this, in the middle of June 1792, in fact before the storming of the Tuileries, which was the beginning of the end for the monarchy, the city council had ordered that even the statue of the king himself should be taken down and the bronze utilized for practical purposes, demonstrating that, in the eyes of the revolutionaries, a royal bronze was the most hateful of all.

The destruction of the signs of despotism was to be followed by new democratic statues representing revolutionary values. Therefore, immediately after the storming of the Tuileries, the same city council resolved to erect an obelisk on the Place des Victoires, with the Declaration of the Rights of Man carved on it as well as the names of the troop leaders who had heroically sacrificed themselves in the name of liberty on 10 August.[42] There is a print (illus. 87) commemorating this obelisk rising like a phoenix from the rubble of the absolutist equestrian statue and heralding the New Age. The meaning of the event is made quite apparent by the coat of arms in the foreground with the Bourbon lilies, signifying the end of the monarchy. It is also a celebration of military victory, as the name of the square itself indicates. During the time of the Directoire and under Napoleon, with the increasingly militaristic iconography of the latter days of the Revolution, it was thought that the Place des Victoires would be an appropriately effective location for statues of famous generals such as Desaix and Kléber. In certain ways this square demonstrates that the

revolutionary breach with the past was in fact not so radical that no discernible lines of continuity remained, the multifarious ideological reorientations notwithstanding.

The series of construction projects around the Place de la Bastille was rather more complicated, yet its very complexity is highly illustrative of the convoluted history of the Revolution. Only after the fortress had been swept away was it laid out as a real urban square, although even to this day still not entirely successfully. Even before the Revolution it had been part of a wide-ranging programme of 'embellisement', during which the last two pre-revolutionary Bourbon kings had attempted at least to ameliorate the worst of the sanitation problems endured by a city with a medieval infrastructure.[43] Such projects increased greatly in number after the destruction of the Bastille, a deeply symbolic structure which called for an appropriately symbolic replacement.[44] As part of the construction project for a National Assembly, Combes located his design on this site, in order to be able to replace the 'dreadful haunt of despotism' and the symbol of absolute repression of freedom with a symbol of liberty (illus. 88).[45] The designs by François-Antoine Davy de Chavigné (illus. 89) and Etienne-Louis-Denis Cathala featured lofty Roman columns as central monuments in place of the feudal prison, in both cases crowned by a statue of the king. The monarch was no longer to be revered as an absolutist prince and almighty ruler, but as the guardian of liberty and revolutionary fellow traveller. Although this was a wish rather than a reality, it was a wish that characterized the pro-royalist early days of the Revolution.[46] Other artists designed a 'Place royale nationale de la liberté' (a national royal square of liberty), giving expression to the utopian ideal of a constitutional

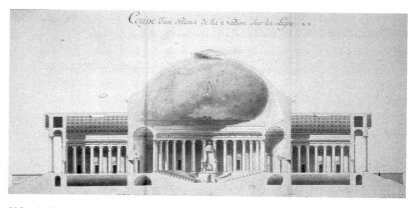

88 Louis Combes, *Section of the Palais de la Nation*, ink wash and watercolour, 63 x 123 cm, 1789.

89 Gustave Taraval after Davy de Chavigné, *The Column of Liberty*, etching and engraving, 37.2 x 56.5 cm, Paris, 1790.

monarchy capable of reconciling revolutionary achievements with the royalist past.[47]

The actual course of city reconstruction projects naturally turned out to be rather more modest. After the destruction of the mighty fortification in 1792, the foundation stone of a Column of Liberty, designed by Pierre-François Palloy, was laid in the presence of the King and representatives of the National Assembly as part of the Festival of Federation. The event was publicized by Palloy in commemorative prints and medallions. A Fountain of Regeneration was afterwards erected on the site (illus. 90), only to be demolished in 1802. This symbol of resurrection, with a suggestion of a sacred dimension, was widespread during the self-referencing Revolution. A celebration was held on 10 August 1793, when Convention, federation and election officials gathered there to drink the water spurting from the breasts of the fountain as a sign of their rebirth. The effect of this act extended far beyond the actual event, being depicted in engravings, popular prints and medallions all over France. David's *Tennis Court Oath* also represented a kind of resurrection, alluding to Christian images of the Apocalypse.[48] At the same time the area surrounding the former Bastille was renamed Place de la Liberté. Jean-Baptiste-Philibert Moitte proposed erecting a triumphal arch in

Fontaine de la Régéneration elevée sur les Ruine de la Bastille.

90 *The Fountain of Regeneration Rising from the Ruins of the Bastille*, woodcut, 11 × 8.4 cm, 1793.

the Concours de l'an Deux, supported by elephants and topped by a statue of Hercules, personifying the might of the people (illus. 91). When Napoleon later retained nothing from this design but the elephant, which was placed in the square together with a fountain,[49] while his Arc de Triomphe was situated at the opposite end of the city at the Place de l'Etoile, he appeared to be deliberately confusing revolutionary iconography. The element of strength was still there, but removed from any association with the people, which was characteristic of the *sans-culotte* Revolution of 1793, but not of the Empire, a point to which we will return later.

A notable example of the rise and fall of revolutionary fervour during the years 1789 to 1795 is provided by the Place Louis XV, which was later renamed Place de la Révolution, and finally, to give expression to the wish for unity after the Terror, Place de la Concorde. Because of its extensive area it was used for large gatherings and festivities, and,

91 Jean–Baptiste–Philibert Moitte, *Project for an Arc de Triomphe*, engraving, 1789.

most notably, for the execution of Louis XVI. The equestrian statue of
Louis XV by Edme Bouchardon was replaced in 1792 by a seated statue
of Liberty by Lemot (illus. 92). In 1796, after repeal of the Constitu-
tion of 1793, which was deemed to be too radical, the Directoire
wanted to erect a purely architectonic monument in its place.[50] In 1800,
under Napoleon, there was a gigantic column, covered in military
insignia and topped with a statue of the Republic, placing *La gloire de la
nation française* centre stage (illus. 93).[51] However, this figure of the
Republic would have been so far above the observer that it would have
been experienced only as a principle, not as a material reality. This
attempt at the neutralization of symbols was characteristic of the early
days under Napoleon, before the strategy of neutralization was
replaced by one of elimination during the age of the Empire.

These architectonic and symbolic fluctuations were not only occur-
ing in Paris. The provinces also merit some consideration, if there is
any truth to the assertion that revolutionary (art) history research has
finally begun to look beyond Paris. Almost everywhere in France,
public squares named for the king were being renamed Liberté. In
Lyon in 1792, the Place Royale was robbed of the royal equestrian
statue that made sense of the name. This had been erected in the
1680s, in conjunction with the great Paris public squares project, and
in its iconography represented a microcosm of the absolutist world
order.[52] Here too, as in the Paris Place des Victoires, the tension
between art and politics became quite evident at the time of the

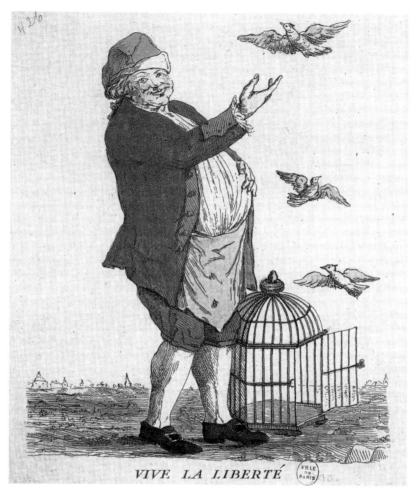

VIVE LA LIBERTÉ

95 *Long Live Liberty*, coloured etching, 17.7 x 13.7 cm, 1789.

example, a popular woodcut from Orléans depicts the lovely Liberty with a club borrowed from Hercules, trampling the Hydra of despotism (illus. 96). This Hydra is in fact none other than the politically secularized snake of original sin, which in medieval and early modern iconography was regularly destroyed by Mary and her holy companions. During the time of the Jacobin Terror, the appeal to liberty was usually reinforced by the famous military watchword 'vivre libre ou mourir' (live free or die), which although previously known was less widespread.[61] The motto was the subject of a larger picture by Jean Baptiste Regnault, *Liberty or Death* (illus. 97), a work that had the misfortune to be painted during the Terror but was only displayed at

119

96 After Jean-Guillaume Moitte and Jean-François Janinet, *Liberty*, coloured wood engraving, 33 x 44 cm, 1794.

the Salon in 1795, when it was harshly criticized. A genius of the French people is shown surrounded by allegories of Liberty and Death. Like Hercules at a crossroads, he has to choose between the two. If he does not choose death, liberty is his only option, and vice versa. The pose of the figure seems to suggest the outcome, as his right hand, pointing towards Liberty, is raised significantly higher than the left, as is seen in the Christian pictorial tradition of the Last Judgment and the division of souls into the Saved and the Damned.

In a widely discussed essay on *Hercules and the Radical Image in the French Revolution*, Lynn Hunt considers the increasingly apparent radicalization of the Revolution from the beginning of the Republic in a theoretical representational context,[62] with particular reference to the fact that the personification of Liberty during the Terror tended to be replaced by the figure of Hercules in many contexts. As a successor to the figure of the king, Liberty was the polar opposite, being female, and wearing the liberty cap in place of the royal crown. Nevertheless, there was the advantage of a number of visible overlaps with tradition. Hercules represented a return to the male gender, and emphasized might, which seemed necessary in view of the prevailing apprehension that there were enemies both within and without. As a figurative representation, Hercules typified the increasingly aggressive Revolution, and is also a significant indicator of the dynamics of

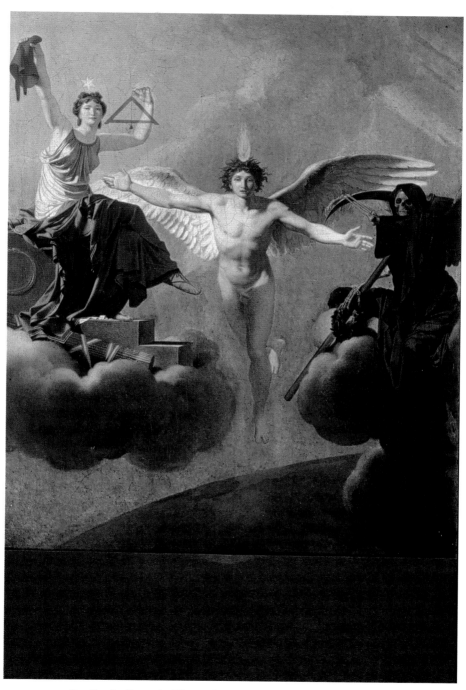

97 Jean Baptiste Regnault, *Liberty or Death*, oil on canvas, 60 x 49.3 cm, 1794.

the rising and falling curve of revolutionary tension from 1792 to 1796, as he disappeared from revolutionary iconography for a time after Thermidor.

Secularization, as observable in the print on Freedom from Orléans, stamped the symbolism of the Revolution to a great extent. It points on the one hand to the defeat of Christianity – which was on the agenda at the turn of the years 1793–4, with de-Christianization and the cult of the Supreme Being, but which had been widespread even before that time. In the process, the charisma of Christianity was transferred to the imagery and value system of the Revolution. Three caps on a faïence plate represented a holy trinity of liberty beneath the rising sun of a new era, and were at the same time a reference to the Three Estates (illus. 98). By means of such transference of meaning, many artworks were saved, albeit somewhat altered, when they might otherwise have been destroyed. There are numerous instances of statues of the Virgin Mary that were provided with phrygian caps and thereby transformed into allegories of liberty. Something of this sort occurred with the Virgin of the Assumption in the cathedral of Le Puy, which was provided with a liberty cap and also transferred from the choir of the church to a newly erected triumphal arch in the centre.[63] *Girls Praying in Front of a Statue of Liberty*, which in its altered version (illus. 99) certainly did not originate before the founding of the republic, is another typical example, and as viewers we feel immediately that something strange has happened to the picture. Actually, we know that the original of 1788 depicts a number of young women, who, in keeping with the aristocratic, bucolic spirit of the

98 *Hats of Liberty*, decorated plate, diameter 22.5 cm, Nevers, *c.* 1790.

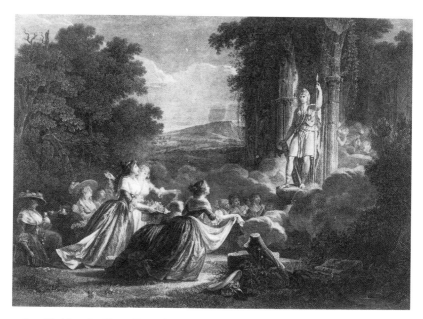

99 Jean Mathieu after Pierre-Francois Delauney, *Pilgrimage of Marriageable Girls to St Nicholas*, etching, 43 x 68 cm, 1790.

pre-revolutionary time, are approaching a statue of St Nicholas in the alcove of a ruined Gothic church, praying and presenting offerings of flowers. The title, *Pilgrimage of Marriageable Girls to St Nicholas*, reveals their objective: the women are praying for a propitious marriage and motherhood, as also indicated by the little angels and cupids within. However, in the altered version the figure is no longer St Nicholas, but a personification of Liberty in full regalia, dressed in an antique toga, with a liberty cap on his head, a lictors' bundle in one hand and a spear in the other. This transformation is also an interesting example of a displacement in this context: the ruined church, which in the original scene is a romantic aspect of a scene of gallantry, here represents the end of the Christian era, and its replacement by the age of liberty and reason.[64]

The second political concept of egalitarianism, which was the central issue in the disputes in the General Assembly of 1788 over appropriate representation of the citizens, played a less prominent but nevertheless central role. This may be connected with the fact that the bourgeois-liberal Enlightenment conception of equality was quite different from that of the radical *sans-culottes*. Therefore, representations of equality were usually limited to equality between the Estates. *Egalité* was rarely enforced as radically as in a print entitled

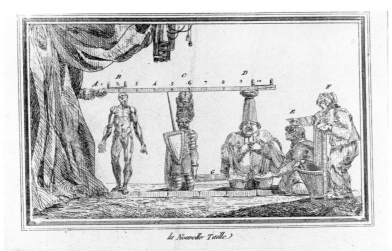

la Nouvelle Taille

A. Monsieur Necker derrière le rideau tient un Niveau sous lequel il fait passer les trois ordres, B. le Tier étas representé par un Ecorché à la hauteur du quel ce Ministre force la Noblesse C et le Clergé D. à se ranger malgré le chagrin que leurs cause cette nouvelle imposition E.F. sont des membres du peuple dont l'un armé d'une scie G. coupe l'excédant, et l'autre en attend joyeusement le produit :

100 *The New Height*, etching, 14.6 × 19 cm, 1789.

The New Height (illus. 100). Beneath the balancing scales, the *tiers état*, represented by an ecorché, can stretch himself to his full height, whereas the knight and the priest have to kneel down and have their legs sawn off by one *sans-culotte*, while the other is collecting these trophies of societal surgery in a basket. Along with an example referred to earlier (see illus. 75), a very popular motif should be mentioned here (illus. 101),[65] in which representatives of the three Estates are united in the symbol of the triangle of equality beneath *one* cap of freedom.[66] Also, in a simple woodcut from Orléans, the new harmony between the Estates is expressed by showing their representatives playing music together, with the citizen apparently taking the lead (illus. 102).

Finally, it is interesting to note the subtle differences between the representatives of the Third Estate and those of the other two. These must be attributable to the scepticism on the part of the revolutionaries as to whether the longed-for unification of the Estates would ever in fact be realized. This scepticism was all too justified in view of the attempted flight of the royal family in June 1791, the self-exile of the nobility soon afterwards, and the emphatic resistance of a large section of the Church. In a 1791 print by Crépy, in which the balance is bearing down on the three representatives at the same level, the citizen is set somewhat apart. He is furnished with the attributes of a

Trois Têtes sous l'même bonnet.

101 *Three Heads with the Same Bonnet*, coloured etching, 22 x 27 cm, Paris, 1790.

102 *Good, We're in Agreement*, woodcut, Orléans, Jean–Baptiste Letourmy, 1789.

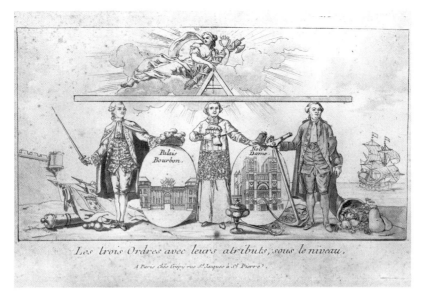

Les trois Ordres avec leurs atributs, sous le niveau.

A Paris chés Crépy rue St. Jacques à St. Pierre.

103 *The Three Estates with their Attributes*, etching with brown ink wash, 16.5 x 25 cm, Paris, Crépy, 1789.

ship and a horn of plenty, as evidence of his wealth-creating business acumen. The difference between him and the representatives of the other two Estates lies in the fact that their attributes – the nobleman's palace and the cleric's cathedral – are pictures within the larger picture (illus. 103). Another print of the night of sacrifice of 4 August 1789 depicts the representatives of all three Estates carrying the insignia of the monarchy (illus. 104). However, whereas the *tiers état* is holding it up with both hands, the nobleman and the cleric are each supporting it with one hand only, and are holding out their other hands to each other behind his back in mutual agreement regarding feudal rights;[67] so mistrust was lurking behind the desire for equality of the Estates. This confirms one theory of the history of mentalities, that the attitude of the early phase of the Revolution was character-ized by both gnawing anxiety and boundless optimism.[68]

In the radical phase of the Revolution, during which parliament was acting under great pressure from the grassroots, the concept of equality was the central political ideal.[69] One example of an artistic expression of this is the Concours de l'an Deux, which was intended as a contribution to the Republic's self-presentation. Many artists took part, most of whom were suffering hardship because of the loss of commissions as a result of the upheavals of the Revolution. A large number of entries for this competition consisted of architectonic

REUNION DES TROIS ORDRES *dessin*
en supportant tous également chacun a moms de peine

104 *Reunion of the Three Estates on 4 August 1789, Equally Carrying their Troubles*, etching with wash, 23.3 × 20 cm, 1789.

projects, including a design for a *Temple de l'Egalité*. The winners of the first prize were Jean-Nicholas-Louis Durand and Jean-Thomas Thibault, who subscribed to a common practice of *architecture parlante* in that their design for a temple succeeded in making architectonic structures 'speak', in the truest sense of the word (illus. 105). The supporting columns have been made into a kind of Hermes column, each portraying one of the Virtues: a building dedicated to Equality, supported by Virtues. There are few structures in which Robespierre's Virtuous Republic is more strikingly visualized, all the more so since the row of classical columns is quite plain, with none of the usual adornments, which were regarded as decadent. The exactly equal height of the columns also could be understood as having an allegorical significance: at the beginning of 1794 the Jacobin Antoine-Louis Albitte, Convention Commissar (*représentant en mission*) for the *département* of Ain, proposed shortening church towers so that they would not rise above the standard, egalitarian height of apartment buildings, to which the Carmagnole choristers made the playful rejoinder: 'Giants must be shortened / and the small made taller, / all the same height, / that is true happiness.'[70] The interior of Durand's and Thibault's temple was to be furnished with a series of frescoes depicting the history of the Revolution since 1789, beneath a modern glass ceiling.

The visionary architect Jean-Jacques Lequeu made use of another element of so-called revolutionary architecture. His idiosyncratic hybrid style, a mixture of Gothic, Baroque and classical elements, was

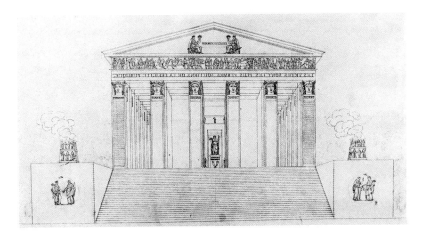

105 J.-N.-L. Durand and J.-T. Thibault, *Prize-winning Sketch for a Temple of Equality*, ink on paper, 1793–4.

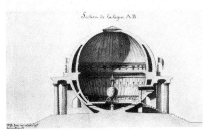

106 Jean-Jacques Lequeu, *Sketch for a Temple of Equality*, pen and wash, 1793–4.

a foretaste of historicist design in practice. In accordance with the cosmic rhetoric of Boullée, he placed a personification of Equality upon a globe supported by two set-squares, within a spherical-elliptical interior (illus. 106). For the exterior he selected Greek Doric columns (no bases or plinths), which were associated with virtuosity and were supposedly more natural. These had been popular elements of Neoclassical architecture since the mid-eighteenth-century rediscovery in southern Italy of the ancient Greek temples at Paestum. In addition, Lequeu's invention of a new order of columns was characteristic of the revolutionary mania for novelty (but also of its doubtfulness). The upper halves of the column shafts were formed of enchained busts of aristocrats. Lequeu's design shared the same fate

as the ideas of Durand and Thibault: the uprising of 9 Thermidor, in Year II, put a stop to almost all projects whose aesthetic and notably political radicalness was now outdated. This was in accordance with the dissolution of the Committee of Public Safety, which had been awarding contracts for the *Concours*. This committee, which had been appointed by parliament and provided with a very large budget, ruled with the constant threat of the Terror, as a consequence of which in the eyes of the henceforth moderate citizens it was primarily responsible for the violent excesses of the Revolution.

Whereas liberty and equality were often portrayed together, especially in the emblems of revolutionary clubs, on letterheads, etc., *Fraternité*, the third member of the trio, was seldom in evidence.[71] The first Festival of Federation was suffused with this most heartfelt of all the revolutionary virtues, as the concept of the general brotherhood of man had not yet been tarnished by the treachery of the monarchy and the clergy. A commemorative medallion was struck in connection with this festival, showing two hands entwined together, holding the *pique* with the liberty cap. It also featured in *Fraternity*, portrayed by means of universally comprehensible symbolism, apparently inspired by Christianity, derived from the protective cloak of the Virgin (illus. 107). The female personification holds two hearts fused into one in her left hand. Beneath her cloak, two children embrace, while trampling the snake of *Invidia* underfoot. It will be recalled that *fraternité* was also very much in evidence in David's *Tennis Court Oath*, especially in the foreground, with the embracing clergymen.

107 Louis Darcis after Louis-Simon Boizot, *Fraternity*, coloured etching for the lids of boxes or tins, diameter 8 cm, Paris, Depeuille, 1794.

108 *Liberty of the Colonized*, coloured etching for the lids of boxes or tins, diameter 7.5 cm, *c.* 1791.

Depictions of fraternity were most commonly utilized in connection with the subject of slavery. Under the rubric of the Rights of Man, all human beings have equal rights and are well disposed towards one another, regardless of their race or the colour of their skin. This is quite movingly expressed in an anonymous etching, *Liberty of the Colonized*, of *c.* 1791 (illus. 108). It depicts a National Guard putting his arm around a somewhat hesitant African in a red skirt. A beautiful young woman on the right is handing another African the uniform of the National Guard, thereby admitting him to the ranks of citizens of the state, to which the inhabitants of the colonies were also to belong in the future. The whole scene is framed by the French flag, which stands for the Nation, which alone made the *droits de l'homme* a reality.

clearly demonstrate the difficulties experienced by these zealous revolutionaries when their radical democratic ideals faltered in confrontation with the difficulties of production in a complex society.

Even though the Academy was soon reinstated, as part of the 'National Institute responsible for recording discoveries, for perfecting the sciences and the arts', it was crucially weakened, in that it lost its supremacy over the Salon. This was at the start of the Directoire, a time when many radical democratic ideals were dashed on the rocks of the harsh realities of a citizens' republic. The original idea was that the Salon would from now on function as the locus of public opinion with regard to the arts, acting independently of any corporate ties and thereby as part of the modern democratically constituted society. The fact that even in the nineteenth century the Salon was still not open to all, for quite practical reasons, but that admission was decided by a jury, and that members of the Academy also participated in this decision-making process, is another story. In a further development that only occurred almost three-quarters of a century later, the position of the institution would be weakened still further when it lost its preeminence in the training of artists under the auspices of the Ecole des Beaux-Arts.[10] All in all, the Academy proved itself to be too steeped in the traditions of antiquated artistic practices to be able to contribute productively to the economic and industrial needs of the modern state, in short, incapable of carrying out the duties required of it in the present, since the advent of the Revolution.[11] How these were imposed on the Salons after 1789 will be analysed briefly below.

The salon and state patronage of the arts during the Revolution – artistic freedom versus revolutionary engagement

In contrast to prints, which were sometimes reproduced in their thousands, paintings, being unique productions, were usually beyond the financial means of ordinary citizens, and consequently far less influential. However, they could be effective by other means. David's paintings of martyrs, which were prominently displayed in the National Assembly, probably affected the law-making deputies in quite different ways from prints, but they undoubtedly helped to focus their minds on the common cause. The place where so-called high art had its widest reception was the Salon of the Louvre, which was held every other year (later, for a time, annually) in the royal palace, and which was highly regarded and widely discussed at all levels of society, primarily due to the large and growing number of art critics who wrote for the newspapers. Most of the other exhibition

venues had been supplanted by the official Salon during the latter days of the *ancien régime* and this had established a situation whereby an artist had to be presented there if he wanted to become well known. Before the Revolution, in order to be presented in the Salon, he had to be a member of the Academy, which had been founded by the absolute monarchy in the mid-seventeenth century.[12] As already mentioned, during the Revolution, the Academy was first weakened and then later closed down, since it was regarded, with some justification, as an undemocratic arm of the government. Afterwards, entry to the Salon was open to all, which was reflected in the fact that works were no longer ranked in the catalogue according to a hierarchy of artists. It also led, unsurprisingly, to a more than fourfold increase in the number of exhibiting artists from 1789 to 1793.[13] The resulting problems also multiplied, especially in the nineteenth century, but they began appearing in the 1790s. In particular, whereas the directors of the Academy had always maintained very high standards, albeit narrowly defined, the quality of many of the works exhibited now left a great deal to be desired, the exhibitors' high opinion of their own artistic talent notwithstanding. Consequently, after the Salon of 1798, a jury was established to maintain artistic standards and to limit the number of works exhibited.

For the purposes of this book, however, and the examination of decisive questions in the history of societies and mentalities, the initial free-for-all access to the Salon was far from being a shortcoming. On the contrary, the removal of the Academy's filter facilitates a more direct access to the emotional state of an entire professional body, as expressed in its works of art.

A review of the subject-matter of the paintings, prints and sculptures exhibited in the revolutionary Salons is initially disappointing, after what has been learned of David's 'discovery' of contemporary history and its sublime artistic expression. Although the proportion of works that reflected contemporary events gradually increased over the years, it remained relatively low, seldom rising above five per cent. At the same time it is true that during the revolutionary decades, the themes of classical history painting, in the broadest sense, were in decline.[14] Traditional themes predominated, and although religious scenes were not so much in evidence as previously, they certainly did not disappear. In addition, there were sentimental scenes of family life and romance, portraits, Italianate landscapes, architectural *vedutas*, etc. Even a *Drunken Woman Being Brought Home from an Orgy* was on offer in the Salon of 1793, with the name of the artist prudently omitted[15] – but perhaps with the aim of discrediting the degenerate

aristocracy by implication. The fact that genre painters found themselves in a difficult situation and were even despised in the 'Société populaire et républicaine des Arts' was in marked contrast to actual production.[16] Therefore it is worthwhile looking at it more closely for significant works. Many of the works exhibited have long been lost, or are no longer identifiable, so for the present the annotated entries in the Salon catalogues will have to suffice.

The Salon from which the fewest traces remain in this regard is the one of 1789, which opened on 25 August, the 'jour de la Saint-Louis', only a few weeks after the most decisive events of the Revolution. This is therefore hardly surprising, since oil paintings take a long time to complete. Nevertheless, a few artists did turn their attention to the event that was considered by contemporaries to be the central one – the storming of the Bastille, and the protagonists. As in many of the following Salons, prominent among them was the former Bastille prisoner Jean-Henri Masers de Latude (illus. 109). Special homage was paid to him in the text accompanying a portrait of him by Vestier.[17] Latude had been thrown into prison by Louis xv's mistress, Mme de Pompadour, but with good reason. Acting out of greed and ambition, he had secretly sent a phial of poison to her, followed by a letter warning her about the poison. He was caught and imprisoned again in 1784 after having escaped down a rope. During the Revolution he took every opportunity to cast himself as a tormented victim of despotism.[18] There was also a sketch by Durameau in the Salon of 1789, commemorating the convening of the Estates-General, clearly intended as a preparatory sketch for a large picture in the Salon d'Hercule of the royal palace at Versailles. In addition, there was a series of prints featuring contemporary scenes.[19]

The Salon of 1791 took place under radically changed conditions. It had been removed from the eminence of the Academy and put in the hands of the political leadership of the *département* of Paris, as part of the general process of disestablishment during the Revolution. Since it was only a few months after the king's unsuccessful attempt at escape to Varennes, instead of opening on a day with symbolic associations with the king, the Salon opened two weeks later than usual, on 8 September.[20] As well as the design for *The Tennis Court Oath*, a number of other pre-revolutionary pictures were re-exhibited, among them David's *Oath of the Horatii* and his *Brutus*.[21] In the light of recent events they could have a decisive political effect, and given the general lack of exhibits with contemporary patriotic appeal, they would achieve this in the guise of ancient history. The Horatii, whose unconditional allegiance to the fatherland was so

109 Antoine Vestier, *Jean-Henri Masers, Chevalier de Latude*, oil on canvas, 129 x 97 cm, Salon of 1789, no. 111.

extreme that one of them killed their own sister for her vacillation, could be seen as embodiments of the revolutionaries.

For the rest, there were portraits of famous contemporaries, either those who had actually played a decisive role in the preparation and execution of the Revolution, or those who were credited as such – Voltaire and Rousseau, Mirabeau, Lafayette, Lameth, and also – somewhat surprisingly in this early phase – Robespierre.[22] In addition, there were allegories of the victorious Revolution, and *Liberty*

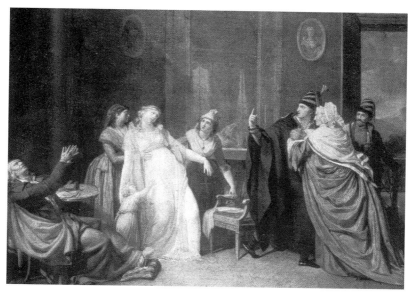

110 Jean-Baptiste Mallet, *The Departure of a Volunteer*, oil on canvas, 71.5 x 59 cm, Salon of 1793.

Restored to the Monastic Orders, a picture by the Walloon painter Léonard Defrance, which was probably identical to another from 1782, *Dissolution of the Monasteries in Belgium.* Although this was an expression of the artist's reaction to the reforms by Joseph II, it could easily be recycled for use in the revolutionary context.[23]

Following the abolition of the monarchy and also the Academy, that 'dernier refuge de toutes les aristocraties',[24] artists exhibiting in the Salon of 1793 were primarily concerned with the war with hostile European powers, which was far safer than dealing with the extremely volatile domestic political situation. As usual, many of them harked back to antique themes, especially duty to the nation, even to the extent of sacrificing one's own life. Some artists did deal explicitly with scenes from the present, not cloaking the appeal of the nation in antique garb, but portraying contemporary scenes – the actual programmatic application of revolutionary culture in the present. Especially popular were scenes of leave-taking, depicting the conflict of interest between patriotism and the family, which was ultimately decided in favour of the Republic. The aesthetic quality of the *Departure of a Volunteer* by Jean-Baptiste Mallet[25] is in inverse proportion to its high moral tone (illus. 110). A young man is about to leave home to follow his colleagues, who are calling him to arms, provoking melodramatic reactions on the part of his family. An old

woman is holding up a small child to him – his mother-in-law with his offspring, which, the picture suggests, he is about to abandon, while his wife, facing him, is fainting at the prospect. On the left is his father-in-law, who, like the theme itself, clearly has his origins in the bourgeois morality set-pieces by Jean Baptiste Greuze, especially the famous *La malédiction paternelle*. However, these pictures differ in one important respect. In Greuze's picture, the young man appears to be going off to join the soldiers in the spirit of adventure, so the paternal anger is justified. In Mallet's picture, however, the protagonist is pointing upwards, indicating not the judgement of the Christian God but of the nation. The entreaties of his family are in vain against this higher principle. The 'levée en masse', whereby the former mercenary system was replaced by a people's army, which for a long time was superior to anything the conservative forces could come up with to oppose it, was given its spiritual legitimation by such pictures.

The message of this picture is reinforced elsewhere, as is clear fom the entries in the catalogue, which were always very detailed where personal revolutionary engagement could be demonstrated. 'The Father arms his son for the defence of the Homeland, of Liberty and Equality. This Picture represents the family of the Artist.'[26] Whereas Mallet's future soldier was alone and in opposition to his family, here the whole family is acting in unison. The determination to defend nation, liberty and equality is spelled out in the catalogue, whereas it had to be figured out by the viewer in the preceding painting. Nicolas Le-jeunes, a member of the Berlin Academy who had worked in Italy for a long time, used his own family as the model for his picture, to emphasize his identification with the goals of the Revolution.

Antoinette Desfonts, with *The Death of Beaurepaire*, was one of the few to portray an actual battle with a genuine hero, one who had defended the fortress of Verdun against the Prussian enemy by all possible means, being finally brought down by a shot to his head.[27] This became a political issue because one deputy of the National Assembly declared Beaurepaire's death to be suicide, whilst at the same time the suspicion arose that he had actually been shot by one of his fellow soldiers in the castle so that they could finally surrender.[28] Antoine Chaudet also appears to have paid homage to this *Devouement à la patrie* with a work of this title in the Salon of 1793,[29] which was to have hung in the Panthéon. A few years later Chaudet became one of the most significant sculptural apologists for Napoleon Bonaparte.

The remainder of the works recalled the great events of the Revolution. Charles Thévenin painted the fall of the Bastille.[30] P. Berthaud

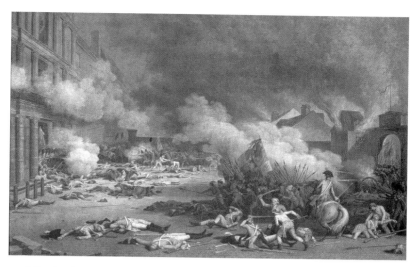

111 P. Berthaud (probably Jacques Bertaux), *A Tableau Representing the Day of 10 August 1792*, oil on canvas, 124 X 192 cm, Salon of 1793, no. 125.

showed a large picture of the storming of the Tuileries on 10 August 1792 (illus. 111), which was not very highly regarded by one critic, largely because of justified doubts as to the artist's patriotism.[31] The assault by the *sans-culottes* on the bastion of absolutism, which was being defended by Swiss guards, displayed a certain lack of heroism. In the right foreground, one of the guards is being shot; however, his assailant does not engage the sympathy of the viewer. The critic reproached the 'maladresse' of the portrayal, as it failed to glorify the assailant. Something similar was at fault with the aforementioned picture by Thévenin. Only when it was exhibited again in 1795 – or perhaps another version of it, but this is difficult to ascertain today – did it receive critical approval, and for obvious reasons: whereas 1793 was an inauspicious time to portray the brute force of the people, by 1795 it was acceptable to do so, after the shift of the republic from radicalism to bourgeois *juste milieu*. One medallion, which was distributed to all *départements* and sections of the city, got round the general difficulty of portraying violence in a positive light by means of an allegory. It depicted a personification of liberty trampling on an attribute of the monarchy.[32] In the *Siege of the Tuileries by the Brave Sans-culottes* by Antoinette Desfonts, the problem was solved by opting for the middle ground between the actual portrayal of events and allegory.[33] A personification of Liberty represents the people in battle, in a similar fashion to the famous *Scène de barricade* painted decades later by Eugène Delacroix. In the case of 'realistic'

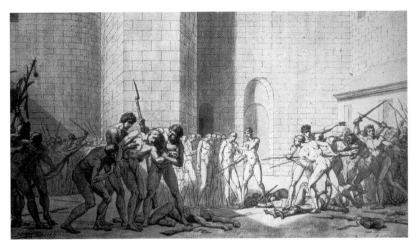

112 François-André Vincent, *The Storming of the Bastille*, pen-and-ink drawing with brown ink wash, 33 X 55 cm, 1789.

representations, which did not make use of allegories, it was always safer to eschew scenes of violence in favour of humanitarian acts. For example, the *Storming of the Bastille* by François-André Vincent (illus. 112) foregrounds the liberation of the prisoners instead of the events preceding it. Hubert Robert, in the first year of the Revolution, downplayed the scenic element to give maximum effect to the mighty architecture of the Bastille (illus. 113), and adequate emphasis to the myth of the Bastille as instrument of the oppressive *ancien régime*. The people portrayed are minute in contrast to the building, which was in reality not especially impressive, thereby making it appear all the more imposing to the viewer.

The nightmare of the recently overcome Terror was the theme, both implicit and explicit, of the Salon of 1795. Ansiau painted a *Détenu* [Prisoner] *Garnerey a Retour d'un détenu dans sa famille,* and Leroy presented two clearly very moving scenes: one of them was *Deux jeunes filles apportant la liberté a leur père détenu en prison; l'une d'elles est évanouie entre ses bras*, the other was a portrait sketch of Roucher, which was drawn, as the commentary in the leaflet explained, shortly before Roucher was taken away to be executed. André Chénier, the subject of a portrait by Suvée (illus. 114), suffered the same grim fate, although there was no indication of this fact either iconographically in the picture itself or by any other means of expression.[34] Another artist, Beauvallet, who exhibited four anti-terrorist allegories in the Salon of 1795, did not omit to mention that he himself had been in prison when he painted these pictures.[35]

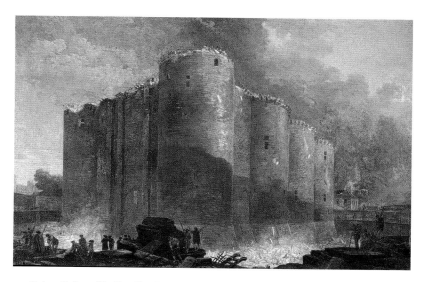

113 Hubert Robert, *The Bastille*, oil on canvas, 77 x 114 cm, Salon of 1789, no. 36.

114 Joseph-Benoît Suvée, *André Chénier*, oil on canvas, Salon of 1795, no. 460.

In other works, especially sculptures, the allegory of liberty was transformed in so far as it was more frequently seen liberating the people from the 'monster' of the Jacobin Terror, which in this case simply took the place of royalist despotism. Even an apparently innocuous picture such as Drolling's *A Young Woman at a Window Granting Liberty to a Bird, and With Her a Little Boy Watching the*

Prisoner's Departure could be interpreted by the alert viewer as being associated with events in the recent past.[36]

In the Salon of 1796 – and even the one of 1798 – scenes of the past were again in evidence, an indication of the traumatic effect of the Terror. An artist called Ferry addressed its melodramatic aspect directly with his *Affreuse nouvelle*. According to the commentary, 'This is the instant when a wife, surrounded by her family, learns from a letter of the cruel death of her husband, victim of a revolutionary judgement in Nantes'.[37] The revolutionary *noyades*, drownings in the Loire, inflicted on unwilling or often even critical contemporaries by the Jacobin regime's police, were among the most appalling memories of a population grown weary of the Revolution. The Terrorist regime was regarded as being entirely to blame for the promotion of these oppressors of the people. A picture of the parliamentary president Boissy d'Anglais featured his heroic resistance to these bloodthirsty hordes, which was described in detail in the accompanying commentary.[38]

The rest of the exhibits dealt with more or less private situations during the Revolution. *Representative of the People, Surrounded by his Family, Scattering Flowers on the Tomb of his First Wife,* by Hilaire Ledru, was presumably supposed to legitimize a professional class that had largely fallen into disrepute. *Trait historique de la guerre de Vendée,* by Louis-Marie Sicard, depicts the persecution of a republican soldier in the Vendée, and a young woman risking her life in an attempt to hide him from his persecutors.[39]

On balance, artworks with contemporary historical themes made a poor showing, especially in view of the fact that, in total, between 300 and 900 works were exhibited in the Salons during the 1790s.[40] The organizers were well aware of this situation, and so in 1796 they felt obliged to include this dramatic appeal by the Minister of the Interior in the foreword to the official guide:

Liberty invites you to record her triumphs. Transmit to posterity those actions which must bring honour to your country. What French artist does not feel the need to celebrate the grandeur and the energy deployed by the nation, the power with which it controlled the events, and created its own great outcomes? The subjects you derive from the history of ancient peoples have been proliferating around you. Have pride, display a national character; depict our heroism, and may the generations coming after you not reproach you for not seeming to be French in the most remarkable period of our history.[41]

However, even such urgent appeals were to little avail, nor were thinly veiled threats such as this one by Pierre Chaussard: 'Artists,

reflect on this. Make sure that the republican future does not hold you to account for the use to which you have put your talents.'[42] There were two main reasons for this reticence. First, in view of the rapidity of change, it was difficult to find subjects that would not quickly become either irrelevant or even politically dangerous – David's unfinished *Tennis Court Oath* being a prime example. The second reason was perhaps even more decisive, and has to do with a fundamental decision with regard to political art, which was outlined in the foreword to the *Description des ouvrages de peinture, sculpture, architecture et gravure exposés au Salon du Louvre* for the Salon of 1793: 'Artists do not fear the charge of unconcern about the interests of their Homeland; they are intrinsically free; independence is inherent in Genius'.[43] Even though the author emphasized the political engagement of artists, in reality, freed from their dependence on absolutist, aristocratic and clerical connections, artists were not only able, but also compelled to redouble their efforts to produce works for the anonymous market, and there was clearly more demand for apolitical themes in lower genres than for political treatments of patriotic themes taken from the present. There was an inherent paradox in the revolutionary context: even the radical Jacobins were for the most part adherents of the bourgeois principle of the free market, so their interest in artistic propaganda for the revolutionizing of society was in conflict with their economic credo. This was a contradiction that could be reconciled only by redoubling their efforts to transform the consciousness of the people, which would then result in a radical change in their taste in art. They did attempt to bring this about, but they were unsuccessful. They could not succeed because this form of consciousness training was increasingly seen as totalitarian, and therefore incompatible with the ideal of liberty.

Revolutionary art competitions – an alternative?

The freedom and transparency of the reformed Salons were intended as a counterpart to the cliques and sinecures associated with the royalist Academy. This was also the case with a second branch of revolutionary art politics, namely the great competitions, on which the government pinned its hopes of achieving what it could not with the Salons, where it had only limited influence with regard to the ranking of artists. Here at last the government could set the themes, in an open procedure, in which entrants would present themselves to a public that ideally would focus on the quality of the entries and not

the names of the artists. The most important competition was the *Concours de l'an deux*, individual results of which have been referred to earlier.

After the government had severed artists' ties with their traditional patrons, the subsidies that were introduced in place of them were independent of their chosen subject-matter when the artworks were presented in the Salon. Therefore the government could only exert its influence in this regard *post-festum*, in other words, when it came to the awarding of prizes for the best exhibits there. This was to be changed, however, with the introduction of the Concours de l'an Deux, of which there was one for each genre. Artists were enjoined to dedicate their efforts to the 'époques les plus glorieuses de la Révolution française', and this they mostly did in the form of allegories. They were enticed by lucrative prizes, and also, for the overall winners, the prospect of being commissioned to execute their proposed design as a 'monument national', while the other artists would be commissioned to paint a subject of their own choosing.[44] Even in the case of the latter, the majority of the prize-winning artists chose subjects taken from antiquity for their paintings, or entirely avoided historical themes.

This was the case with Jacques Sablet, who presented *Maréchal-ferrant de la Vendée* to the *Concours*. He received second prize, and J. L. Copia later made an engraving from it (illus. 115). However, the picture which Sablets subsequently painted under commission from the state could not have been more non-revolutionary or apolitical: *Peasant Women of Frascati in a Landscape* or *Girls Playing Jacks*, an innocuous genre painting that was ideally suited to his own talents as well as the market, as evidenced by the great demand for his pictures. At the end of the century there was a market preference for artistic portrayals of romantic reminiscences and dreamy dalliances rather than paragons of virtue. Nevertheless, the paragon of virtue came into his own in the engraving by Copia, which soon became famous. The historic episode portrayed was described in the subscription:

This brave man, having heard that the Chouans had attacked the patriots very close to his Commune, left his forge and walked to meet them with no other weapon than his hammer, felled a large number of them and returned after the victory loaded with the spoils of several of the brigands.[45]

In his left hand the protagonist holds the weapons he has seized from the Chouans, and in his right hand the hammer he uses for his work as a smith, and with which he has clearly hunted down the traitors of the Revolution, and meted out their just deserts. The blood on the

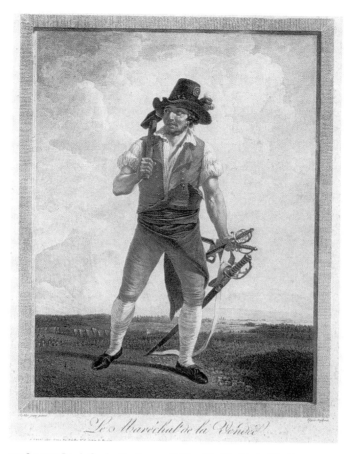

115 Jacques-Louis Copia after Jacques Sablet, *The Maréchal of Vendée*, coloured etching and aquatint, 38.6 x 27.5 cm, 1794.

hammer, which has been referred to elsewhere, is not shown in the engraving by Copia, though.

A few more of the designs submitted were fully in the spirit of the radical Revolution, and were awarded prizes in the Concours de l'an Deux. François Gérard took advantage of this opportunity to cast off his image as an apolitical, even anti–revolutionary artist,[46] and submitted his famous sketch for *The Tenth of August 1792* (illus. 116). Gérard, who was a student and close collaborator of David, came closest to equalling the work of his teacher with this drawing of the sublimation of the present in the achievements of the Revolution, in which parliament is portrayed as the nexus of the people's Revolution. The people are beseeching Robespierre, to clamorous applause from the gallery, to abolish the monarchy. 'Plus de roi' reads the sign

147

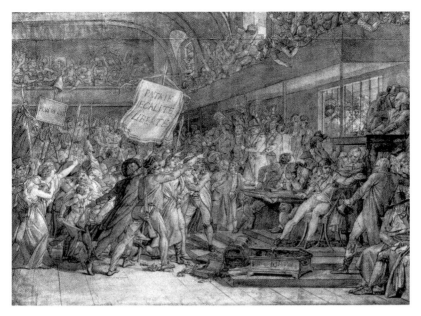

116 Francois Gérard, *The Tenth of August, 1792*, sketch, brown wash with white highlights, 66.8 x 91.7 cm, 1794.

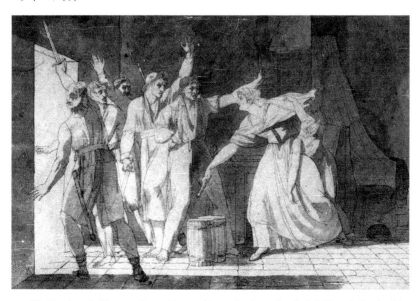

117 *The Heroism of a Woman, who would sooner blow up her house than let it fall into the hands of the enemy: the so-called Heroine of Saint-Milhier*, pen-and-ink drawing with wash, 30.5 x 44 cm, 1794.

on a pike topped with a liberty cap. The crowd turns in fury to the royal family, which has fearfully retreated into the pulpit of the parliamentary scribe. It appears that only the dignified and steadfast Robespierre, who is cast as the guardian of the virtuous Republic, can withstand the might of the people.[47] The first prize for this dynamic drawing earned Gérard 10,000 *livres* and a commission to complete a large-scale version of the work, which he commenced in 1796. The fact that he stopped working on it in 1798 might well have had as much to do with the non-payment of the prize money as the cooling of his revolutionary ardour.

Gérard had to share the prize with François Vincent, who entered a now lost sketch of the *Heroine of Saint-Milhier*: 'A young woman surrounded by her children was calmly seated on a powder keg; she held two pistols in her hands, willing to blow up her house and her whole family sooner than fall into the brigands' power. Her courage and that male bearing impressed them, and her manner forced their respect.'[48] The characterization of the woman's courage as 'manly' could be evidence of the gender differentiation of the time. Even a woman had to repudiate herself completely as a private person in this very popular story, which was based on an actual event in 1792. The sketch by an anonymous rival of Vincent altered some of the features of Léonard Bourdon's *Recueil des actions héroïques et civiques des républicains français* (illus. 117). Instead of sitting on the barrel, the woman is standing and aiming a pistol at it. The men's gestures of defence are not entirely convincing. The resolve and dignity of the woman, however, who is not to be deflected from her heroic act by the desperate entreaties of her daughter, are quite evident, and place the *Heroine of Saint-Milhier* in the ranks of revolutionary heroes. These revolutionary heroes, the new people of the revolutionary age, are the focus of the next chapter.

5 From Aristocrat to New Man

We will very soon be new people.

Everything is going to change: mores, opinions, laws, customs, usages, administration. Very soon we will be new men.[1]

The French Revolution was set on nothing less than the re-creation of human beings. In this it was essentially the forerunner for all subsequent European revolutions, up to and including the October Revolution, which were also determined to refashion their citizens, transform all existing social relations and transfer religious faith to a utopian model state. These efforts were intensified during the half decade from 1789 to 1794, but in the end the desire for a new beginning was thwarted because the revolutionaries had underestimated the immutability of social relations – and also of human nature.

Louis-Léopold Boilly's *Flag-bearer at the Festival of the Liberation of the Savoyens* depicts the very embodiment of this 'New Man' (illus. 118). This painting, which dates from the end of 1792 or the following year, is in the Musée Carnavalet in Paris, now one of the most important collections of art of the French Revolution.[2] Although the picture is quite small (33 x 22 cm), its effect is monumental. A man who takes up almost the entire height of the picture is holding up a flag, casually leaning it to the side. In the background is a hilly landscape, with some rather schematic tents.

The writing on the flag is clearly legible: 'LIBERTÉ OU LA MO[RT]', the Jacobin revolutionary watchword, which we have already come across several times. It could serve as the watchword for this scene, for the man is the singer Simon Chenard, who sang the Marseillaise at the festival to commemorate the recent liberation (or conquest) of the Savoyards by the revolutionary army. The self-confidently warlike rhetoric of this most popular revolutionary anthem has been transferred onto the figure of the singer.[3] He is painted from below, so that the viewer has to look up at him. His visionary gaze into the distance is almost reminiscent of Napoleon's imperious expression, the whole effect being heightened by the pipe hanging casually from his mouth. The imposing demeanour of the absolute ruler appears to have been transferred to the proletariat. Chenard is depicted wearing long trousers – i.e., as a *sans-culotte* – and with the revolutionary *carmagnole*,

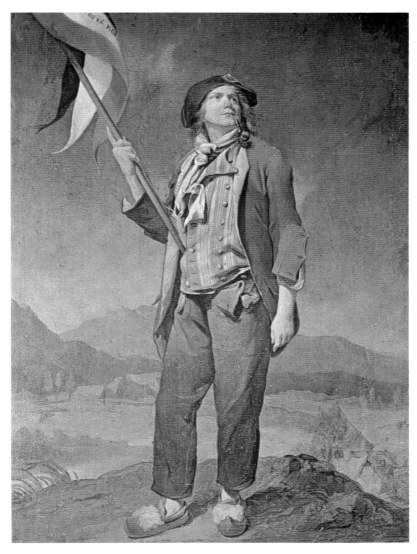

118 Louis-Léopold Boilly, *The Flag-bearer at the Festival of the Liberation of the Savoyens*, oil on canvas, 33.5 × 22.5 cm, *c.* 1792–3.

so his clothing is a hybrid of the garb of the worker and the soldier, not forgetting the obligatory cockade pinned to his hat.

Chenard's rather modest outfit is in inverse proportion to his significance in the picture, which is congruent with the anti-aristo-cratic revolutionary principle of elevating being over appearance, and advocating authenticity as a natural virtue, in opposition to the falsity of the class-ridden past. In a remarkable mixing of categories typical

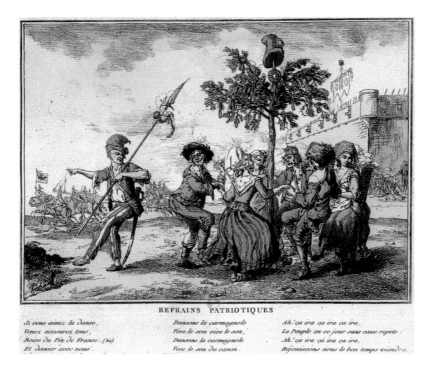

REFRAINS PATRIOTIQUES

Si vous aimez la danse,	*Dansons la carmagnole*	*Ah! ça ira ça ira ça ira,*
Venez accourez tous,	*Vive le son vive le son,*	*Le Peuple en ce jour sans cesse repete :*
Boire du Vin de France. (bis)	*Dansons la carmagnole*	*Ah! ça ira ça ira ça ira,*
Et danser avec nous.	*Vive le son du canon.*	*Rejouissons nous le bon temps viendra.*

119 *Patriotic Refrains*, coloured etching, 20.8 x 27.5 cm, 1792–3.

of revolutionary art, Boilly's small picture unites portrait, genre and history painting, with the aim of eliminating social categories – the aristocrat of history paintings and grand portraits, the *bourgeois* of the genre – to give artistic expression to the break with the hierarchical social order of the Estates.

Although the *sans-culotte* does not usually appear quite so monumental in visual evocations, nevertheless he is celebrated as the New Man for the New Age. He has been transformed from a beast of burden in servitude to the aristocracy to a bold victor, as in the pair of caricatures already seen (illus. 24, 25). He has the willing support of progressive members of the upper Estates, and so appears to be not so much an oppressor as a comrade – even when riding on the back of a nobleman. The *sans-culottes* dancing the revolutionary 'Carmagnole' in the *Patriotic Refrains* (illus. 119) are somewhat shabby in appearance, but this is without any satirical connotations. The proud demeanour of Boilly's standard-bearer, and of the peasants in the caricature, has here become folksy jollity. Their dance around the Liberty tree, which is as unassumingly depicted as the male and female dancers, is in celebration of the retreat of the Austrian

Hussars. The verses accompanying the image mention that the people are inebriated, which in counter-revolutionary caricatures was always a sign of the revolutionaries' bestial brutality. However, it has put this high-spirited company in the mood for singing the optimistic *Ça ira*, undoubtedly the most popular of all revolutionary songs, in which the realm of liberty triumphs over darkness.

In revolutionary portraiture as well there is a tendency towards simplification and avoidance of rhetoric in order to distinguish the new, authentic and natural people from the highly stylized self-promotor of the aristocratic age. In his portrait of Mme de Sorcy-Thélusson, which he painted in 1790, David broke with the form of Baroque tradition while adhering to a tradition of classicism that was already present before the Revolution (illus. 120). From her demeanour, the attention of this woman – the daughter of a wealthy family of bankers, married into an equally wealthy aristocratic clan – appears to be turned inwards. There is something awkward about the way her hands rest in her lap, as if she does not know quite what to do with them. Whereas the significant positioning of hands had traditionally provided artists with a golden opportunity for rhetorical expression, there is no sign of this at all here. Also, her gaze out of the picture onto the viewer appears rather uncertain, with no trace of haughtiness. Furthermore, the background is quite featureless. The wall behind her is completely bare, merely bathed in subtly mottled light. Nothing is visible apart from the back and arms of the red-upholstered armchair; the whole emphasis is on the virtuoso treatment of just a few colour tones. 'Man in society is entirely in his mask. [. . .] What he is, is nothing; what he seems to be is everything to him.'[4] This was Rousseau's description in 1762 of the effect of the traditional aristocratic portrait. In David's portrait of Mme de Sorcy-Thélusson, she has been turned into the very antithesis of it.

Furthermore, the sitter's impression of insecurity is not primarily due to gender roles, in that women were confined to the non-public sphere of the family. Female revolutionaries had equality with men with regard to the activities open to them, even though their innate ability to provide offspring for the revolutionaries is frequently brought to the forefront in portrayals (illus. 121).[5] After the market women of Paris had forced the cowardly king to return 'home' from Versailles, women were for a time the instigators of revolutionary activity, and were commemorated as such in many prints. The 'free-born citizen', in an anonymous print from the radical phase of the Revolution (illus. 120), is emerging confidently from beneath the skirts of a burly female worker, whose appearance of suffering seems

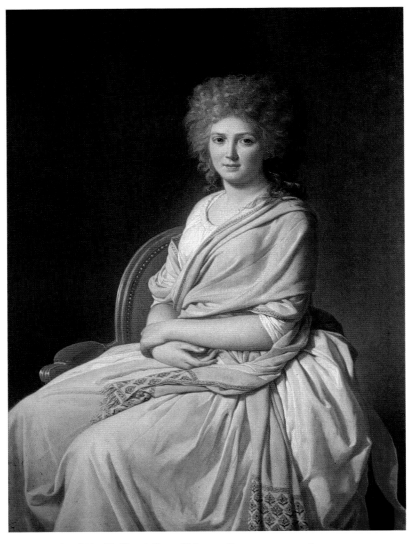

120 Jacques-Louis David, *Mme de Sorcy-Thélusson*, oil on canvas, 131 x 98 cm, 1790.

to be a mark of virtue, distinguishing her from the parasitical society women of the *ancien régime*.

It is true that women were often stereotyped, as still today, as being primarily emotional, which could sometimes conflict with the exigencies of the revolutionary common good.[6] However, they were certainly not confined to this role. The liberated French woman (illus. 122) has cast off her chains as confidantly as her male colleagues; on her lance is the motto 'LIBERTÉ OU LA MORT', and she is wearing a

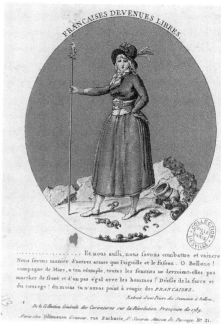

121 *Citizens Born Free*, etching with wash, 15.5 x 11 cm, 1792–3.

122 Villeneuve, *Liberated French Women*, coloured aquatint, 1789.

wide belt commemorating 14 July.[7] The Club Patriotique des Femmes (illus. 123) held readings from the press, political discussions and collections for the nation, just as in the Jacobin clubs, membership of which was exclusively male.[8] The generous donation of personal jewellery was also the central theme of another episode with antique precedents.[9] This was commemorated in an anonymous print in which the church poor-box has been converted into a patriotic collection box (see illus. 181). Women were first portrayed in weaker roles during the time of the Directoire, which can be considered as recompense for their active participation in the Revolution during the years 1793–4. Women had largely retreated from the political sphere by then; the privatization expressed here is a historical dimension of the post-revolutionary phase of *embourgeoisement*, but which was certainly not confined to the female sphere.[10]

Social engagement could go even further, however. *Pourquoi pleurez-vous?* was the title of a speech made by Joseph Chalier to those loyal to him, shortly before his execution (illus. 124), to which he had been sentenced by a Jacobin court in Lyon in 1793:

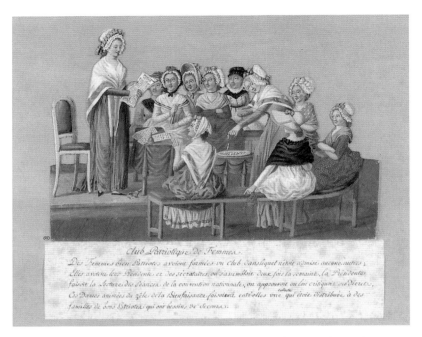

123 Jean–Baptiste Lesueur, *Patriotic Women's Club*, cut-out gouache mounted on card, 35.7 x 53.5 cm, *c.* 1791.

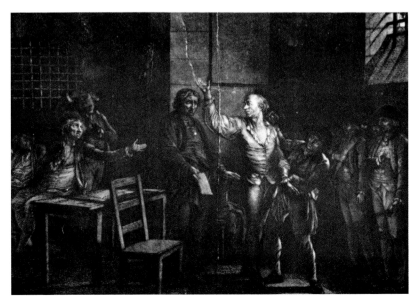

124 Jean Tassaert after Jacques Philippe Caresme, *The Last Words of Joseph Chalier in the Prison of Lyon . . .*, aquatint and etching, 31.9 x 25.3 cm, Paris, Tassaert, 1794.

Death is nothing for him whose intentions are upright and whose conscience was always pure. When I shall be no more, my soul will vanish in the Eternal, and in the immensity round about us. Chalier will know how to die in a manner worthy of the cause he has upheld.[11]

The New Man of the Revolution was one who subordinated his own private concerns to the public good, even if this meant laying down his own life or that of his loved ones. In fact, the death of a revolutionary could be the making of him, at least for the purposes of propaganda. 'The glory that we deserve will be ours only after our death', Saint-Just insisted.[12] Only in death could a revolutionary fulfil his mission, only then did he prove that he had taken to heart the uncompromising motto 'La liberté ou la mort'. For the New Man was prepared to sacrifice himself for the commonweal; indeed it was precisely in his renunciation of self-interest that he distinguished himself from aristocratic villains. The fact that Chalier won a lasting place in the annals of revolutionary pictorial history is certainly due to his steadfast conviction, as expressed in the passage above.

The artistic fate of a role model in antiquity can help to provide an explanation for what could otherwise seem quite inhumane today, a case in point being Brutus, in ancient Rome the first consul of the republic he helped to found with the expulsion of the last king. When his sons were caught in the act of conspiring to restore the monarchy, Brutus found himself in the situation under consideration here – if he wanted to remain true to the spirit of the republican state, he would have to sacrifice his sons – and that is exactly what he did, if the legend is to be believed. This story must have made an even more powerful impression on the revolutionaries of Robespierre's virtuous republic than on the audiences of Voltaire's play about Brutus.[13] The proliferation of busts, pictures and prints of Brutus during the republican phase of the Revolution speaks volumes.[14]

Hardly exciting artistically, and yet (perhaps consequently) all the more unmistakable in the propaganda of its subject-matter, is the work by an anonymous artist, produced in 1793–4 on commission from the mayor of Saverne, where it is still to this day (illus. 125). It is interesting to note that the artist painted his picture of Brutus on an old canvas, on which a picture of the *Virgin and Child* had previously been painted. The Christian past has been covered over and at the same time extinguished – doubtless an occurrence with great symbolic meaning.[15] In contrast to David's famous *Brutus Receiving the Bodies of his Sons from the Lictors* (illus. 126), which was painted not long before the Revolution, the moral message of the portrayal of Brutus by the

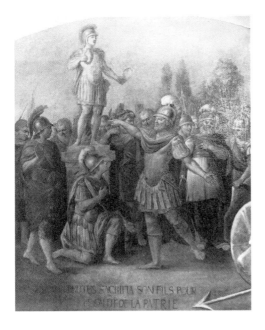

125 *Brutus Sacrifices his Sons to Salute his Fatherland*, anonymous, oil on canvas, 150 x 200 cm, 1793–4.

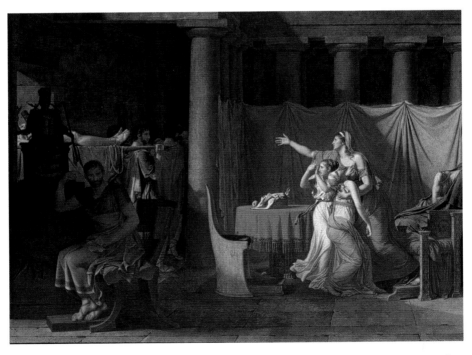

126 Jacques-Louis David, *The Victors Bring to Brutus the Bodies of his Sons*, oil on canvas, 323 x 422 cm, 1789.

anonymous artist is quite unambiguous. The choice of actual scene to be portrayed is significant, for here it is not the moment after the execution that is shown, but sentence being passed. Whereas David has placed Brutus to one side, slumped over, deep in thought, so that it is a picture of reflection rather than action,[16] the artist from Saverne has portrayed him as a radiant hero, who appears never to have known a moment of doubt. Quite unmoved, he sends his sons off to the scaffold, while they implore him to relent – in some respects the composition is like an exact copy of Le Brun's famous *The Family of Darius before Alexander* – without a ghost of a chance of succeeding. Brutus' lasting fame is also assured. The Roman warrior, elevated in the picture, composes himself before decorating Brutus with the wreaths of victory which were reserved for meritorious citizens of ancient Rome. For anyone still in doubt, the painter supplied an inscription (inscriptions were, of course, often added to revolutionary prints to augment and clarify the meaning, but they were the exception rather than the rule in the case of large oil paintings): *Brutus Sacrificing his Sons for the Salvation of his Country.* Sacrifice and salvation are shown in a clear causal relation; the certain salvation represented by the devotional image of Mary and Child beneath this painting has been transferred to the worldly eschatology of the libertarian state.

Martyrs of the Revolution

Since the time of *The Tennis Court Oath*, David's loyalties had been towards the Jacobins and the radical Revolution, although as late as 1792 he was planning a painting expressing loyalty to the king, with the theme of Louis presenting his son with the Constitution, or an allegory of the French people presenting the king with a crown and sceptre. However, he was increasingly more inclined to portray the secular martyrs who since the beginning of the Enlightenment had been ousting the traditional Christian martyrs.[17]

The arts then ought to contribute powerfully to public instruction. [They] are the imitation of nature in its most beautiful and its most perfect aspects; [. . .] It is not only by charming the eyes that the monuments of art have fulfilled this end; it is by penetrating the soul, it is by making on the mind a profound impression, similar to reality. It is thus that the traits of heroism, of civic virtues offered to the regard of the people will electrify its soul, and will cause to germinate in it, all the passions of glory, of devotion to the welfare of the fatherland.[18]

This was the radicalization of a programme that before the Revolution had been fostered by the Enlightenment and especially the Comte d'Angiviller, who with his 'grands hommes' had commissioned some of the leading French sculptors to create a series of works showing exemplary Frenchmen who were also dedicated to the commonweal.[19] In a case where revolutionary engagement was least likely to be expected, David took up his brush as his contribution to this project – and now, with the radicalization of the Revolution, he did not wield it in the rather reflective manner of his *Brutus*, particularly when commemorating someone who had come over from the opposing side, or someone whose achievement was especially remarkable on account of his youth.

An example of the latter was the aforementioned Joseph Bara. The picture that David dedicated to him (illus. 127) is the last of a series of three portrayals of martyrs, and also the most unusual. It commemorates a youth of just thirteen, who had declared himself to be on the republican side in the civil war of the Vendée towards the end of 1793,[20] for which he had been killed by the royalist Chouans. It will be recalled that David had proposed that Bara be admitted to the Panthéon, but the Thermidor reaction prevented this. 'The French alone have thirteen-year-old heroes; such great moral character is a product of liberty.'[21] The picture is unusual in that David used the hero's youth to create an entirely unrealistic historical portrait. However, it should be noted that the work was never completed, and parts of it have only been sketched out. The youth is depicted naked, and even though it is clear from *The Tennis Court Oath* that David followed the Academy's practice of painting figures first naked, then clothing them afterwards, there are a number of indications that this was not going to happen in the case of Bara's picture. Furthermore, it is evident only from the title that the subject is a youth, since the figure is rather girlish and androgynous, even to the extent that the legs are pressed so closely together that there is barely a hint of male genitalia. The figure therefore appears to be less a fallen ephebe than a lovely, even angelic creature, whose tender facial features express not so much suffering as desire, to lay down his life at this moment for the nation.

The New Man in this picture is in fact the natural one, and in Rousseau's view, which was extremely influential, especially in the radical phase of the Revolution, the re-creation of the human being meant in fact a return to his origins, to his purely natural roots. Bara's androgyny seems to signify a primeval state, a return to the time before the division into genders, the first division of the unity, which ultimately led to the slippery slope to civilization.[22] The child,

127 Jacques-Louis David, *The Death of the Young Bara*, oil on canvas, 119 x 156 cm, 1794.

with his undefined sexual attributes, is therefore held up as the incarnation of revolutionary ideals, and deified nature finds its strongest expression through him. This was the essence of revolutionary pedagogics: an emphasis on natural education, cultivating the inherent goodness and harmony of mankind.[23] The intention was to oppose both the traditional foundation of the *ancien régime* and the competitiveness of bourgeois society. Incidentally, this also hints at the fact that it is somewhat dubious to attempt to portray the Revolution as the culmination of a process of *embourgeoisement* initiated in the eighteenth century.

This brings us back to an assertion already made in connection with the revolutionary conception of the representation of the people: in contrast to England, political disputes were not seen as resulting in the reconciliation of competing interests, but rather in the emergence of the one truth, founded in the natural order. The fact that after 1793 the Terror sent thousands of people to the guillotine in order to establish universal harmony finally cost it its own head. In the Manichaean logic of the radicals, this pointed to only the necessity of eliminating everything that hindered the return to nature, because it was ostensibly so denatured.

Michel Lepeletier de Saint-Fargeau was the scion of an old French noble family, but during the Revolution he became a radical Montagnard and regicide. On 20 January 1793, just one day after Louis XVI

128 Anatole Devosge after Jacques-Louis David, *The Epeletier de Saint-Fargeau on his Deathbed*, pencil sketch, 38 x 33 cm, 1793.

had been condemned to die on the scaffold, the former aristocrat fell victim to a revenge stabbing by a royalist, whose intended victim was in fact the so-called Philippe Egalité, the former Duc d'Orléans, who ranked far higher in the echelons of the nobility, and who had spoken out in favour of the death sentence for the king. The work David painted to commemorate the hero of liberty no longer exists, as it was later purchased for an astronomically high sum by the anti–revolutionary daughter of the murdered man during the Restoration. It was first covered with defamatory comments then subsequently apparently destroyed, as was the later engraving based on the painting, of which only the engraver's damaged 'trial' proof of the print remains. Therefore the appearance of the painting is known only from this print, and from a sketch that was made of the painting (illus. 128).[24] Louis-Sébastien Mercier noted the patriotic effect of this picture:

What republican's patriotism is not replenished with new strength and courage, on seeing and lamenting these sad victims of the blind vengefulness of the powers who have formed a coalition against a generous people?[25]

David portrayed the dead man as a warrior of antiquity, possessed of classical beauty and athletic nobility. In the sense of the passage quoted above by David on the rôle of art, nature is seen in this picture in her most beautiful aspect, as only this can guarantee her edifying effect for

the nation; in other words, this aesthetic appeal lends a sensual dimension to the 'exemplar', which it would otherwise lack. A sword with a royalist emblem is hanging above Lepeletier; but, a sheet of paper is also attached to it, with the message 'I support the death sentence for the King'. David copied the position of the figure from the public remembrance ceremonials, which he organized as Master of Ceremonies.[26] Lepeletier's corpse was laid to rest in one of the royal squares, later known as the Place Vendôme (illus. 129). A huge crowd of people came to pay their respects and take their leave of him on exactly the same spot where the equestrian statue of Louis XIV had formerly stood. In fact, Lepeletier's body was placed on the vacant plinth,[27] as yet another example of the direct substitution of a new hero for an old one, a symbol for the transition from Aristocrat to New Man; moreover, in this case the aristocrat had declared himself to be a revolutionary.

One remarkable aspect of the drawing is the sword hanging above the body by a thread:

Do you see that sword suspended above his head, hanging by a single hair? [...] it signifies the courage it took Michel Le Peletier, as well as his generous colleagues, to send to execution the infamous tyrant who so long oppressed us – since at the slightest movement, at the breaking of that hair, they would all have been inhumanly immolated.[28]

Anyone with a classical education, and that included David himself, would understand the allusion immediately, and identify the

129 *Paying Tribute to the Memory of the Epeletier de Saint-Fargeau*, etching, 10.6 x 16.6 cm, 1793.

sword as that of Damocles, who was once a guest at a feast given by his ruler, and, as in David's picture, was seated beneath a suspended sword, to make him aware that the fate of the mighty was just as precarious as his own at that moment. The sword is not hanging threateningly over Lepeletier, though; his own blood is dripping onto him from it, as if it had only just been withdrawn from the fatal wound. This is made plausible by the message on the paper impaled by the sword, which applies to the dead Lepeletier himself. The paper is supposed to have been impaled on the sword in the act of murder. The transference of the import of the episode from antiquity onto the revolutionary incident is not an entirely smooth one, for David surely did not intend to include Lepeletier among the mighty. The implication is rather that in historically tempestuous times, anyone who fights on the progressive side is constantly in mortal danger.

Jean-Paul Marat was both the archetype and most forceful personification of the *homme nouveau*: people's advocate, idol of the masses and formidable agitator for radicalization of the Revolution in the struggle against its enemies, both real and imagined. He was not idolized only after his dramatic murder by Charlotte Corday;[29] he had already achieved nationwide fame since 1789 as an effective spokesman for the common man through the medium of his newspaper *Ami du peuple*, also as a self-styled watchdog, ever alert to the threat of plots instigated by the new 'aristocracy'. At one stage, as an opponent of the bourgeois-inclined Girondins, he was arrested on a charge of alleged indictment to 'Terror'. After the summer of 1792 Marat was emerging as an ever more prominent representative of the Montagnards, and was acting as a mediator between the Convention and the grassroots, which were organized in the revolutionary clubs and Section assemblies. His hatred for the aristocracy, as representatives of the old system, to which he gave vent in his *Ami du peuple*, was the theme of a famous print that shows him climbing out of a cellar (illus. 130).[30] Marat is being assisted by Diogenes, who is holding the lantern with which he had once searched high and low for an honest person in Corfu, subsequently retreating into his barrel after the search ended in disappointment. It appears that he has at last struck lucky, after more than two millennia of decadence and exploitation: 'Comrade Sans-Culotte, I have long searched for you', he greets the people's friend – another example of the self-styled millenarian nature of the Revolution. Diogenes is wearing a Phrygian cap, and his happiness is evident from his expression. He is taking the hand of his new friend, who is stepping on a snake (the aristocracy) as he climbs out. According to the caption, Marat withdrew into the cellar because

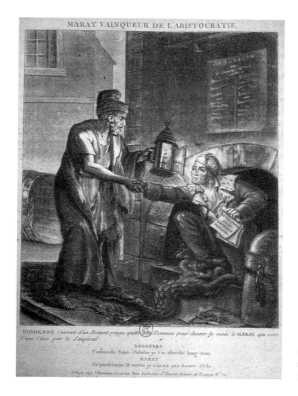

MARAT VAINQUEUR DE L'ARISTOCRATIE.

DIOGENES *Convert d'un Bonnet rouge quitte sa Lanterne pour donner sa main à* MARAT *qui sort d'une Cave par le Soupirail*.

DIOGENES
Camarade Sans-Culotte je t'ai cherché long-tems
MARAT
On persécutait la verité je n'osais pas d'entre d'Aele.
A Paris chez Villeneuve Graveur Rue Zacharie St Severin Maison de l'ancien N°. 7

130 Villeneuve, *Marat, Conquerer of the Aristocracy,* aquatint and etching, 20.7 × 17.3 cm, 1793.

he was persecuted for publishing the truth in his newspaper, and he had to go underground in order to defend it. Now that he has been rehabilitated after standing trial,[31] this is no longer necessary. Now even Marat can come out into the open in this new world and proclaim the truth.

Public exposure of this sort was not without risks, none the less, in view of the many enemies of the Revolution, about whom Marat was constantly sounding a warning. He was not entirely safe even in his own home, a fact that cost him his life. Marat's murder at the hands of Charlotte Corday has been portrayed in numerous artworks well into modern times. Another of David's pictures of martyrdom, *The Death of Marat* (illus. 131), has been regarded as one of the seminal works of modern art since Baudelaire's celebratory article of 1846.[32] 'Sa mort fut encore plus utile que sa vie.'[33] This observation by Georges Danton was not purely malicious, since Marat had been regarded by many Jacobins as a threat; but they were also well aware that the cult of Marat presented them with new opportunities for politicizing and influencing the revolutionary masses, which they were desperately in need of during the tense aftermath of the death of the king.

165

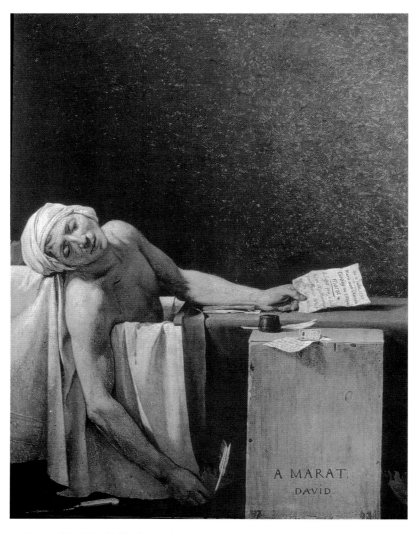

131 Jacques-Louis David, *The Death of Marat*, oil on canvas, 165 x 128.3 cm, 1793.

It is immediately apparent that, as with *The Flag-bearer* by Boilly, this painting occupies an intermediate position somewhere along the line distinguishing history painting, portraiture and reportage.[34] It also has some similarities with the portrait of Mme de Sorcy-Thélusson, for instance the bare room. The lower half of the picture is filled by the dead man, whom the artist has portrayed sitting upright in a bathtub covered by a cloth. In the bottom left-hand corner, a large patch is visible against the white sheet. The upper half of this picture is also quite bare, in this case featuring only the painting technique

known as 'stippling', which is lighter on the right side. In front of the bathtub is a plain wooden chest, with an inkwell, a quill pen, some money, and a letter on top. The chest bears a sombre inscription: 'À MARAT. DAVID.', giving itself the air of an epitaph. The head of the deceased Marat lolls to the right, and the right arm dangles from the bathtub, holding another quill pen in its fingers. There is a knife on the floor, obviously the weapon used by Corday to stab the people's tribune, the stab wound clearly visible beneath the collar-bone. The viewer has the sensation of having entered the scene immediately after the dramatic climax, the still upright pen in the dead man's hand in particular indicating that he has at that very moment passed from life into death.

The description of the picture sounds like a report of the scene of a crime. This reportage character, with its precise evocation of the objects found on the spot and their position, was intended by the artist, although he has changed and even falsified a great deal in order to achieve an 'effet de réel' (Roland Barthes), rather than reflecting reality itself. One noticeable aspect, which is certainly an explanatory factor, is the fact that contemporary descriptions of the victims of the counter-Revolution were usually similarly detailed, to a sometimes quite nauseating degree, in order to move the readers and prompt their identification with the victim.[35]

In contrast to the extreme precision with which even the smallest details have been recorded, the composition of the picture as a whole is very stylized and unrealistic, with everything subordinated to the dictates of aesthetics. This was what Baudelaire had in mind when, in his appraisal, he observed that, 'cruel, like nature, that picture has the very aura of the ideal'.[36] The perspective is entirely frontal. The only two large realistic objects in the picture – the bathtub and the wooden chest – are both exactly parallel to the surface of the picture, counter-acting any impression of realism.

This combination of extreme idealism and extreme realism is the hallmark of the picture's achievement from the point of view of art history, locating it on the borderline between traditional idealized history pictures and the realistic history pictures of the future, in the nineteenth century. Finally, there are the legible items: Corday's letter of request, which enabled her to gain access to her victim, and the letter on top of the chest, which identifies the dead man as a benefactor who had recently remitted money to a widow with a large number of children.

David was quite calculating in the characterization of his friend. Marat is portrayed as a poor, hardworking man (witness the patch on the bedsheet), the very antithesis of the epicurean aristocrat with his

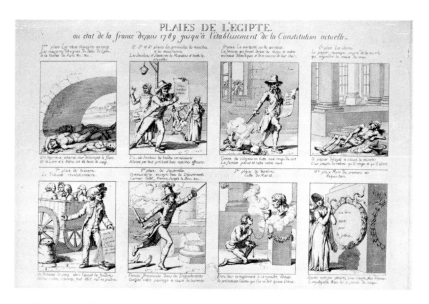

132 *The Plagues of Egypt*, engraving and etching, 24.6 × 29.4 cm, 1794–5.

luxurious lifestyle. It is furthermore the one that in its disposition shows a specific multivalence rooted in art-historical tradition that has been the topic of many discussions. It has long been noted that the dead body, with the arm hanging down, is reminiscent of the traditional Christian *Pietà*. Other, antique, models have been mooted, such as the figure of the deceased carved on classical Meleager sarcophagi, dedicated to the story of the famous Greek hunter. One suggested interpretation of this multivalence attempts to locate the picture firmly in its historic context, opting for both of the traditionally ascribed meanings, but describing them as intended for two different audiences.[37] This needs explanation.

The oft-noted transference of sanctity from Christian icons to the New Age of the universalistic state model is entirely applicable in the case of David's Marat. We know that Marat – along with other 'martyrs de la liberté', such as Lepeletier, Bara, Viala and Chalier – was elevated to cult-like status by the *sans-culottes* in Paris and indeed the whole of France, and that he was honoured like a saint with public holidays and commemorative festivals, political prayers, songs and plaster busts. It has been established that there are more than one hundred different engravings alone of the 'ami du peuple'.[38] The 'Nine Plagues of Egypt', in a later anti-Jacobin etching, *The Plagues of Egypt* (illus. 132), is an ironic reminder of this. A youth can be seen kneeling and lighting incense in front of a bust of Marat, evidently

experiencing no difficulty in substituting this new deity for his Christian God. However, quite apart from this biting satire, we know that throughout France statues of saints were replaced by statues of Marat, and that his picture was paraded through the streets of Paris before being presented in the courtyard of the Louvre, and that it was effectively proclaimed that Christ and Marat were of equal standing ('Oh cœur de Jésus, oh cœur de Marat'), acknowledging that Marat was the modern counterpart of the son of God, the original Christian ideal of the poor preacher and defender of the rights of the oppressed. Furthermore, we know that although the mass of ordinary supporters of the Revolution were in favour of the process of de-Christianization that had been underway since the middle of 1793, they had merely replaced the old symbols with new ones – apparently they were still performing the traditional ceremonies, but with new ritual objects. The cultured middle and upper classes, in contrast, had since the Enlightenment received an increasingly secular education, which tended to disparage the Christian tradition, and fostered a classically oriented outlook instead of a religious one.

David, according to this thesis, could satisfy both groups with his picture, and the coupling of realism and idealism can be understood in this context as well. There were plenty of reasons for it, too, as even the radical Montagnards in the Convention were far from being unanimously anti-bourgeois and anti-elitist, and many were sceptical about Marat because he was also soliciting the support of the people. The *sans-culottes*' demands for price controls, especially in times of famine during the latter years of the Revolution, were always rejected by the Montagnards since they were a threat to the interests of the producers. David's picture could be viewed as an appeal to the *unité révolutionnaire*, as a plea for a unification of revolutionary forces, especially in the face of external enemies. Recalling the portrayal of Voltaire's funerary procession of 1791 (illus. 5), discussed in chapter One, it could be said that that print, which was produced in the workshop of Paul-André Basset, had in its way already achieved what David set out to accomplish with Marat, whereas the engraving that Berthault produced from Prieur's picture was a one-sided expression of the bourgeois point of view, referring to antiquity (illus. 1).

It will be recalled that both of David's pictures, of Lepeletier and of Marat, hung for a long time in the Convention, where they functioned as *exempla virtutis*. They remained there until not long after Thermidor, when they were removed, ending up back in David's studio. In the looming bourgeois republic of the Directoire, there

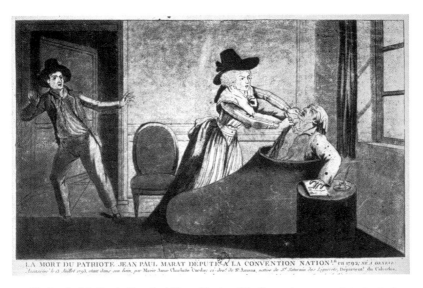

LA MORT DU PATRIOTE JEAN PAUL MARAT DÉPUTÉ A LA CONVENTION NATION.^{LE} en 1792; NÉ A GRANIT.

133 *The Death of the Patriot Jean Paul Marat Member of the Convention...*, aquatint, 16.9 x 26.9 cm, Paris, Basset, 1793.

could no longer be any consensus with regard to David, and only the 'Left', still sporadically rebellious, would continue to refer to him. Marat was also ejected from the Panthéon, for his radical egalitarian views were no longer in step with this new phase.

In contrast to David's painting of Marat, many popular prints that came onto the market following the assassination also included the murderess (illus. 133).[39] The public's enthusiasm for *fait divers*, the need to emphasize reportage, might lie behind this. Such prints have nothing of the sacred element that characterized David's picture, being merely intended to satisfy the public's appetite for sensationalism and information. There were even some portrayals that were critical of Marat, although these were usually private productions. The most impressive of these was a watercolour by Hubert Robert (illus. 134), which plays subtly with the material from David's picture.[40] Marat is seen lying in bed in a disorderly room that includes wine bottles standing prominently on the table, and he appears to be asleep. However, the quill pen still in his hand is a clear reference to David's motif, also the spear on the wall pointing to a bust of Lepeletier, like the Damocles theme in David's lost or destroyed work, although this might also be a reference to the danger facing Marat. The writing on the sheet of paper on the table – 'dénonciat[ion] de Robert par Baudoin' – makes it clear that Robert was familiar with David's picture when he made this water-colour, since this denunciation, which led to Robert's arrest, occurred

in October 1793, by which time David's *Death of Marat* was well known. Most decisive in Robert's work is the fact that the sense of the picture has been turned into the complete opposite – from the sublime to the ridiculous. For Robert, the 'New Man' had completely lost his lustre; he had fallen from his pedestal into mundane reality, bringing the entire conception of revolutionary art into question.

The transfer of the revolutionary ideal of virtue onto the military after Thermidor has frequently been noted in this book, and is also apparent in the promotion of the New Man. It seems to have been legitimated by the perception that after the onset of the war of 1792, there were enemies no longer just in France, but more especially abroad. Napoleon was then seen as the personification of this New Man, naturally enough. He had been a member of the Montagnards since 1793, and had successfully fought against the enemies both within – the royalists – and without, in particular the British and the Austrians. In 1801 the Italian Giovanni Battista Cornolli created a gigantic, four-metre-high statue of Napoleon as a peacemaker, of which there is a smaller copy in existence today (illus. 135).[41] The diminutive Corsican has been transformed into a splendid figure of a soldier from antiquity. He has just sheathed his sword, but nothing will prevent him from drawing it again, should need arise.

In the revolutionaries' utopia, such statues of great men would ideally have been placed within enormous museums, some of them in

134 Hubert Robert, *Marat in his Bed*, watercolour, 23 × 34 cm, 1793.

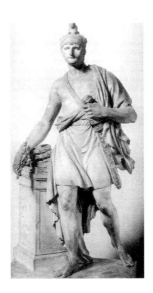

135 Giovanni Battista Cornolli, *Consul Bonaparte as Peacemaker*, plaster, 82 cm, a smaller copy of the statue exhibited in Paris in 1801.

the open air. The later emphasis on museums as venues for the edification of the populace was prefigured and decidedly politicized at this time. The mind and spirit of the observer were to be refined by strolling past these different heroes, and in the process of internalizing these different impressions he would be transformed into the New Man.[42] In the light of this an interesting proposal was put forward by Bernardin de Saint-Pierre, who in his writings, following on from Rousseau, contrasted the purity of the natural condition of humanity with the depravity of civilization. He suggested converting the Paris custom-houses, designed by Ledoux and partly destroyed by the people in July 1789 during an uprising, transforming these symbols of despotism into monuments to the heroes of the nation.[43] Walking around the city would thereby become a morally elevating experience, the expression of the transition from oppression to democracy.

Since the Revolution, heroic status was no longer connected to birth and class; anyone could attain it by accomplishing the goals of the Revolution, regardless of his social origins. This democratization of the concept of the hero also meant that entire groups could now be regarded as heroes, not just individuals.[44] This was the case with the 863 'Vainqueurs de la Bastille', who were officially recognized by the National Assembly on 19 June 1790, and distinguished with honours;[45] likewise the forty soldiers of the Châteauvieux regiment, who had been accused of mutiny and condemned to be galley slaves, but whose sentence was later repealed, and who were honoured as national heroes

on 15 April 1792 at a proletarian festival of liberty.[46] Léonard Bourdon, a member of the Comité d'Instruction Publique of the National Convention, even founded a sort of journal in which all heroic deeds on the part of patriotic soldiers and citizens were recorded and publicized nationwide.[47] Unfortunately these distinctions, and the privileges that often accompanied them, were sometimes the subject of acrimonious public disputes because of an irresolvable paradox: how could an egalitarian society create heroes, when, as we have already heard, this was a society whose favourite song was about the pleasure to be derived from cutting the great down to size and enlarging the little man, so that all were the same size?

The new man and the apotheosis of the people

The real hero of the New Age was not an individual then, or a group of individuals, despite all hitherto appearances to the contrary. It was now far more the people as a collective in whose name martyrs fought, and who were honoured, not only by David. David himself, the undisputed colossus of the revolutionary art world, who had also become one of the most powerful politicians of France in the Convention, devoted his efforts to the glorification of the people, for example with the still extant design for the stage curtains for the play *La Réunion du Dix Août, ou l'inauguration de la République française* (illus. 136), which was performed from April 1794 in the Paris Opéra.[48] It should be noted at this point that in the late eighteenth century the French theatre was not an exclusive venue for the

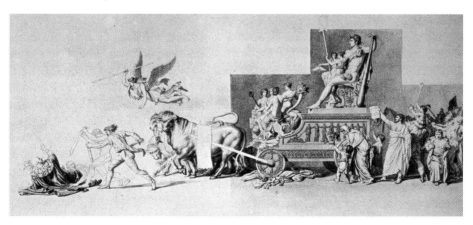

136 Jacques-Louis David, *The Triumph of the French People over the Monarchy*, pencil with highlights, 32.6 x 71 cm, 1794.

cultured elite, and that it was also frequently the arena for heated political debates. The design on the curtains seems to feature a festival procession, a frequent revolutionary event. Complete with a triumphal carriage, it is in the tradition of the pantheonization of Voltaire, as described in chapter One, which David was also co-responsible for designing. The triumphal carriage is adorned with an antique frieze of bands of palm leaves. Sitting atop it is the large-scale central figure of the drawing, a seated, mighty personification of the French people in the now familiar form of Hercules. It is accompanied by female personifications of Liberty and Equality, Science, the Arts, Trade and Affluence. The carriage is being pulled by bulls. Bailiffs in the lead are beating the king and other representatives of the aristocracy to the ground, while the carriage is rolling over their insignia. Following up the rear are representatives of the great and the good, some of whom are recognizable as historical figures. Cornelia, the mother of Gracchus, who is bowing down to her children, is an example of maternal love and fidelity to the nation. Brutus, who in David's pre-revolutionary oil painting was portrayed as a man of reflection rather than action, is seen here inciting revolutionary action. Lepeletier is pathetically clutching his side, where he was struck by the assassin's knife, to show that he is still prepared to struggle for the cause. Finally, there is Marat (among many others) who is demonstratively pointing to the wound as an eloquent testimony to the similarity with Christianity iconography.

This remarkable over-abundance of coded images is typical of revolutionary art – as if doubling and even trebling of symbolism could increase the impact of portrayals. Another possible reason for this might be found in the length of the composition, in which there is an implicit time frame, which in turn points to the eschatological future horizon of revolutionary thought. Guided by the abstract principles of Liberty and Equality, the people are travelling on the carriage of history into a future that, after the destruction of the old powers, is portrayed as an age of abundance. It is supported by the heroes of the past, who have pointed them in the right direction, sometimes by the sacrifice of their own lives. These heroes originate from just two epochs, the ancient Roman Republic and the present; the age in between was seen as a Dark Age dominated by the great powers, which are now falling beneath the front wheels. So even this work – like so many others – is to be understood indirectly in terms of (pre- and post-) revolutionary history.

David also made a major contribution to another project that was conceived as a monument to the French people. Once again Hercules,

who in absolutist iconography usually represented the ruler, was invoked to personify the people. This project is an important example of the problems encountered by the fine arts during the Revolution, and therefore merits close attention.[49] It formed part of the extensive *Concours de l'an deux*, whose significance for the history of art at the height of the Revolution we have already referred to on a number of occasions.

Following the now familiar pattern, on 17 Brumaire, Year II (7 November 1793), David suggested to the Convention that a monumental revolutionary statue be erected in the square on the west bank of the Ile de la Cité, on exactly the same spot where an equestrian statue of the 'bon roi Henri', Henri IV, had once stood.[50] This was furthermore one of the most frequented areas of the city, and connected with both halves of the city, north and south of the Seine, by the Pont Neuf. David's idea was that it should be an allegory of the people, once again personified by Hercules; that it should be fifteen metres high, and that the power it embodied should be visible, even tangible. The artist was also considering constructing the plinth for this statue out of the ruins of the old royal monument. The statues on the west front of the Gothic cathedral of Notre-Dame had also been knocked down and destroyed, like so many other works of art, in the erroneous belief that they too were portrayals of medieval French kings. David's plan was that they would likewise eventually form part of the plinth on which the allegory of the people would rise up in victory. Although we do not have any drawings by David himself of this project, the artist of the newspaper *Révolutions de Paris* was inspired by his speech to the Convention (see illus. 17).

These precise stipulations for the competition encountered opposition from the artists themselves, who perceived in them a threat to their artistic freedom. The situation is significant because of this opposition: freed by the Revolution from the constraints imposed on them by commissions from the Church and the aristocracy, artists were now facing new forms of dependency. As the artistic and political nexus for the government, David had to ensure that the designs reflected the conception of the revolutionary republic, a conflict that still bedevils artists in modern society in differing ways. One stipulation in particular is significant, and it highlights a problem we encountered in connection with the destruction of the statue of Louis XIV in the Place des Victoires: namely, the fact that David ordered that if old artworks reflected 'false consciousness', they should be thrown onto the scrapheap and used for the construction of the plinth for the statue of Hercules as the people. In this case, too, David's artist

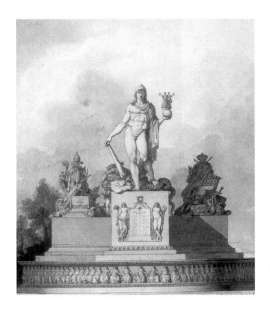

137 Jean-Guillaume Moitte, *Project for a Monument in Honour of the French People for the Pont-Neuf*, ink drawing, 56.5 x 48.8 cm, 1794.

colleagues for the most part preferred to preserve these artworks, even if they portrayed the wrong people.

This was to some extent the case with Jean-Guillaume Moitte (illus. 137), who followed David's main specifications quite closely, but balked at the 'scrap art plinth'.[51] Since his people's statue would be standing on a plinth almost exactly as high as itself, the monument would be approximately thirty metres high. Its enormity can only really be appreciated thanks to the tiny figure of an observer added to the bottom right-hand corner.

Moitte's design exactly typifies one dimension of revolutionary art that resulted from its high-minded claim to be the teacher of the people. For there was another aspect of David's specifications that artists, including Moitte, resisted complying with. In order that there should be no misunderstanding whatsoever regarding its message, David planned to augment his Hercules with a number of inscriptions: 'light' was written on its brow, 'nature' and 'truth' on its breast; 'strength' on the arms, and 'work' on the hands. Although the ascription of meaning might appear at first glance to be arbitrary, this was far from the case. The head (with its brain) was associated with enlightenment, and the arm stood for strength, as is apparent from the function of the various body parts; but David's colleagues wanted nothing to do with this; nevertheless they – and especially Moitte himself – had to ensure that their allegories were absolutely unequivocal, as is obvious from a close inspection of Moitte's design. The

individual elements are quite clearly assembled, inviting the meandering eye to read them; and any emotional effect is quite outweighed by their discursive aspect. The lower, round plinth is adorned with 83 statues of seated women, holding hands in an unvarying gesture. They symbolize the newly established *départements*, which are here joined together in an allegory of unity. They are also exposing, by their total uniformity (unintentional?), the schematic administrative reclassification that originated in the mechanistic philosophy of the Enlightenment and which set itself above the processes of history.

Above the circular plinth are two further angular levels, topped by the prominent one with the statue of Hercules, who is treading on the counter-revolutionary Hydra and holding a sphere in his hand, with personifications of Liberty and Equality balanced upon it. The sphere illustrates the fact that Hercules is not only literally on the spot on which the former king once stood (in that he replaced Henri IV), but also symbolically, as the symbolic globe was once among the possessions of the crown in the age of the old European monarchies. The plinth beneath Hercules is also occupied by personifications of both Abundance and Truth standing on either side of the tablet inscribed with human rights, which complement the demands of the Old Testament tablet of laws. Along the base of the broad rear plinth are the accoutrements of the vanquished monarchy and aristocracy, arranged in a line like a string of pearls. This in particular is an example of the didactic nature of the total arrangement, which is constructed rather like a pictorial puzzle that must be deciphered, without actually affecting the observer emotionally. Moitte's monument succeeded in evading David's narrow strictures, while at the same time serving the purposes of propaganda in every single detail.

The design submitted by Augustin Dupré to the competition of Year II for the reconstruction of the western tip of the Ile de la Cité constituted an interesting variation (illus. 138). The combination of a decidedly academically inspired Hercules with an Egyptian Isis statue gives prominence to the motif of nature, as represented by the Egyptian deity, who is squeezing milk from her breast. This allusion to the childhood of humanity – a parallel to David's Bara, and also the staged resurrection at the Place de la Liberté on the site of the destroyed Bastille – evokes a primeval state, for which humanity was yearning after centuries of depravity. The nakedness of the allegorical figure is supposed to evoke this natural state. The New Adam from *Regenerated Man* by Jacques-Louis Perée self-confidently turns to the sky, where his Christian forebears once invoked the help of their God (illus. 139). This self-confidence is a result of the human rights he is

138 Augustin Dupré, *The Sovereign People*, pencil drawing for a colossal statue on the western point of the Ile de la Cité, 45.5 x 35.6 cm, 1793–4.

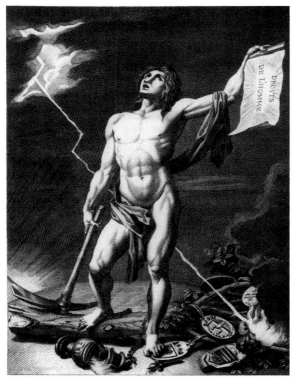

139 Jacques-Louis Perée, *Regenerated Man*, etching, 37 x 26 cm, 1794.

defending and for which he is fighting. The pickaxe identifies him as both a hard-working *sans-culotte* and as the destroyer of the symbols of despotism arranged on the ground, aided by heavenly intervention in the form of a bolt of lightning. Prints, often being aimed at a less sophisticated public, achieved their effect without so much allegorical overloading.[52]

The new man revealed

The aggressive rhetoric of radical revolutionary propaganda aimed at propagating the New Man came in for intense criticism during attempts to find a way out of a situation increasingly dominated by the ever more active guillotine. *Comment sortir de la terreur* was the title of an important publication on the latter phase of the Revolution.[53] Despite the wide variety of historical phenomena that occurred during the time after Thermidor, it could be claimed that in this phase the modern republic was constituted, tailored to the citizen, but also that the utopian dream of the formation of a harmonious society was replaced by the concept of a bourgeois subject, for whom the satisfaction of his own needs was paramount.

Is it not time to stop this revolutionary chariot which has been trundling on the horizon of France for the past five years, marking its path by fire, devastation, the destruction of trade, civil war, assassination and famine?[54]

The contrast between pre- and post-Thermidor is typified and idealized in a pair of paintings by Jacques Réattu, one of which dates from early summer 1794, the other from around 1795.[55] In the spirit of David's triumphal people's procession, the personification of liberty in Réattu's *Triumph of Liberty* (illus. 140) is storming ahead, behind genies of destruction who are rushing to crush the spirit of despotism once again. The strong movement from right to left, an aesthetic equivalent of the aggressive spirit of the Terror, has its correspondence in the later *Triumph of Civilisation* (illus. 141), a concentrically accentuated composition, more dignified in its effect, which contrasts the political value of liberty to that of civilization, which tends to be apolitical. It gives expression to the mentality of ordinary people, who long for peace and inwardness, and reject the enforced radical politicization of the individual that characterized the Revolution at its height.[56]

Similar sentiments accompanied the development of the iconography of Hercules. In Carlo Luca Pozzi's design for a monument to stand where the king was executed at the end of the garden of the Tuileries,

140 Jacques Réattu, *The Triumph of Liberty*, oil on canvas, 34.5 × 47 cm, 1794/95.

141 Jacques Réattu, *The Triumph of Civilization*, oil on canvas, 98 × 130 cm, 1795.

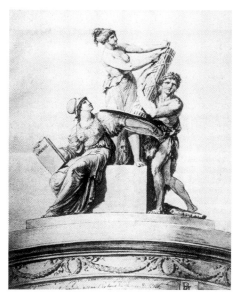

Président d'un Comité Révolutionnaire, après la levée d'un Scelé?.

142 Carlo Luca Pozzi, *Design for a Monument in the Place de la Concorde,* pencil drawing with wash, 24.7 × 19.9 cm, *c.* 1796.

143 *Chairman of a Revolutionary Committee after the Removal of the Seal,* coloured etching, 19.1 × 16 cm, 1795.

which after the fall of Robespierre was significantly renamed 'Place de la Concorde', it is clear that harmonious values are holding sway over combative ones (illus. 142). Pozzi's Hercules has put down his club by his feet, and appears to be more of a beautiful Ephebe than a cudgel-wielding maniac, as he still appeared in David's stand at the Festival of Unity in 1793, let alone a plebeian *sans-culotte* thug (*Le Peuple mangeur des rois*[57]) striking the figure of a struggling king.[58]

The New Man is seen in the same light, and a not altogether flat-tering one. The *Chairman of a Revolutionary Committee* (illus. 143) is shown clutching household cutlery and a bowl. The commentary states that he has just broken a seal. Clearly this chairman has just condemned someone to the guillotine, and then made off with his goods and chattels. As well as the Marat worshipper, the afore-mentioned print *The Plagues of Egypt* depicts a series of murderous revolutionary heroes, which the accompanying text compares to the ancient Egyptian plagues that Jehovah visited on the earth as a punishment. One print, which depicts *Revolutionary Tyranny Being Smashed by the Friends of the Constitution of Year III* (illus. 144), seems to be an inversion of revolutionary pictorial propanda. Instead of despotism and federalism, which during the period 1793–4 often fell

144 Massol after François-
Marie-Isidore Queverdo,
Revolutionary Tyranny,
etching and point pass,
27 X 19.5 cm, 1795.

beneath the wheels of the new powers, this print depicts a murderous
looking *sans-culotte* who has been bested by the Thermidorian. The
sans-culotte has dropped his pistol, and can no longer raise the dagger
in his other hand, although his proclivity to violence is still evident. A
variety of papers is scattered around him, including warrants for
arrest, the text of false charges and the Constitution of 1793, which is
branded as anarchic. He is being dominated by the well-dressed citi-
zen, who is pointing to the alternative to this constitution: the Consti-
tution of 1795, which is far more moderate than its predecessor. The
disputes concerning the violent aspects of the Revolution are the
subject of the following chapter.

Journée du 21 Janvier 1793
la mort de Louis Capet sur la Place de la Révolution
Présentée à la Convention Nationale
le 30 Germinal par Helman

146 Isidore-Stanislas Helman after Charles Monnet, *21 January 1793, The Death of Louis Capet at the Place de la Revolution, Presented to the National Convention of the 30th Germinal*, engraving and etching, 26.4 × 43 cm, 1793.

enthusiasm, but as quite varied. On the left, some people are waving their hats enthusiastically, while others on the right appear rather shocked. The dominant feature of the portrayal, however, and in fact the primary reason for the wide angle, is the opposition of the guillotine on the left and the empty plinth on the right. Until 1792 the latter was occupied by the aforementioned famous equestrian statue of Louis XV by Bouchardon. Its absence from the picture has a logical parallel in the killing of Louis XVI opposite it; in other words, the execution that had taken place scarcely a year before in effigy had now been followed by the execution in person.

The rather implicit presentation of the meaning of the print by Helman and Monnet could be due to the fairly realistic portrayal. Abundant and more explicitly positive connotations were found in pictures such as the drawing by P.-E. Lesueur (illus. 147) that was exhibited at the *Concours de l'an deux*. Once again, the artist was emulating antique models.[12] The diagonal viewpoint of the last print has been replaced by a hieratic frontal viewpoint in this one, producing a more obviously meaningful effect. Here too the guillotine and the base of the statue form a polarity. The crucial moment is likewise the head of the king being held aloft, which seems to confirm the

187

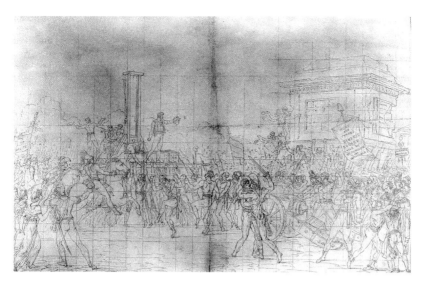

147 Pierre-Etienne Lesueur, *Execution of Louis XVI*, squared-up drawing, 26 x 38.5 cm, 1793.

thesis of one historian of the guillotine, that this depiction was proof of anti-royalist sentiments, whereas supporters of the king tended to portray the victim beneath the mechanism before the execution, in a position designed to elicit sympathy.

The participants in this festive-looking event are heroic in appearance, with close-fitting clothing, which almost gives an impression of nakedness in some cases. They are embracing one another, some even dancing, in jubilation at this event of global significance. The observer has an unobstructed view of the guillotine, for the foreground has been left clear to allow for this. The propaganda content of the picture is supplied by various slogans – 'LIBERTÉ ET EGALITÉ' on the flag on the left, 'DEATH TO THE TYRANTS . . . LONG LIVE THE ONE INDIVISIBLE REPUBLIC' on the flag on the right, and 'LIBERTÉ' on the cannon to the left of it in the foreground. This is reinforced especially by three men who are laying their hands on the banner and swearing an oath to liberty and their willingness to fight. In this context, there can be no misunderstanding the otherwise quite ambiguous scene over to the right, where two youths are wailing and imploring an old man for help at the sight of this appalling event. The old man, with an earnest countenance, appears to be explaining the necessity for the execution, without actually agreeing with the charges.

As already indicated, portrayals of the event by pro-royalists made their case in quite a different way, and they also tended to be produced

abroad, for with the prevailing mood of suspicion during the Terror, any departure from republican zeal could well be denounced as a betrayal of the nation, punishable by death. Pictures by Charles Benazech, an Englishman of French extraction, were especially influential, and engravings made of his pictures were widespread. They portrayed Louis in different situations before his execution, for instance taking his leave of his family (see illus. 70), a heart-rending scene that could hardly fail to move the viewer. *Louis xvi on the Scaffold* (illus. 148) also differs from most of the prints so far considered in its technical artistry. This large-scale print has the rich tonal qualities and classically stylized figures usually associated with paintings.[13] Johann Gerhard Huck, a painter and engraver from Mainz, dedicated the picture to Catherine II, presenting it to her as a memento of one of the scions of the great European royal family. In contrast to the overall panoramic portrayal, the focus is on the protagonists, primarily the monarch himself, who is bowed, Christ-like, in the rough grip of the executioner, focusing his dolorous gaze out of the image onto the viewer. The figure of the king is radiant against a sea of darkness. Rising above his head, symbolizing the protection of God, is the dome and cupola of the church of the Invalides, the sky around it clear, whereas everything else is obscured by dark clouds. Whereas

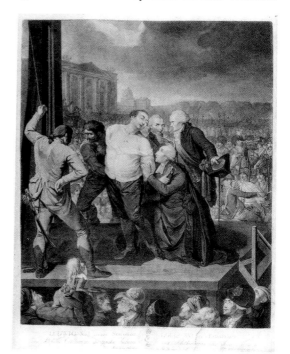

148 Johann Gerhard Huck,
Louis XVI on the Scaffold,
mezzotint, 65.5 X 51.7 cm,
1793.

189

the mood of Lesueur's drawing was festive and cheerful, here it is eerie. Even the official attendants behind the priest seem uncertain. The meaning of this picture, tinged as it is with Christianity, is reinforced by the row of figures in the foreground. Inspired by Renaissance and later depictions by German and Dutch artists in particular of the *Flagellation* and *Crucifixion*, here is a row of scurrilous-looking, deformed physiognomies, in marked contrast to the nobility of the suffering Louis. The satirical motivation is unmistakable.

'*A family of sansculottes refreshing, after the fatigues of the day*'

Anti-revolutionary propaganda was especially intense in Britain, where the political developments in France were followed closely. The engraving by Huck, in contrast, only appeared two years after the event in question, and its superlative pictorial language made no claim to reportage. The chief exponents of anti-revolutionary, and later anti-Napoleonic, satires and caricatures were James Gillray, Isaac Cruikshank and the latter's even more famous son George. Since English caricatures achieved widespread publicity throughout France during the Revolution, where they exerted their influence not only artistically but also on society,[14] they can be considered to contribute to the pictorial history of the Revolution and can be taken into account here. In any case, the cartoons that were commissioned by the Committee of Public Safety from autumn 1793 to autumn 1794 have to be considered as a response to British anti-revolutionary propaganda, and were directed in large measure at the political situation in the British Isles.[15] Although the burlesque style of parody of the French cartoons was influenced by the English exemplars, the former certainly did not attain the brilliance or iconoclastic power of the English prints.

Isaac Cruikshank's *The Martyrdom of Louis XVI, King of France* (illus. 149) is a satirical lamentation that appeals to the viewer's sympathies.[16] It is easy to see the reason why the artist gained such success with a simple print like this. Like the German Huck, his primary concept is the reversal of the usual composition in republican graphics, but he accomplishes this more decisively. Whereas there is usually a crowd scene, against which the figure of the king sometimes stands out with some difficulty, here there is no crowd behind the king, or at least one that is only represented metonymically – and therefore depersonalized – as a collection of bayonet points in the background and two raised trumpets. The trumpets serve as a reminder of the loud intervention of the soldiers just before the

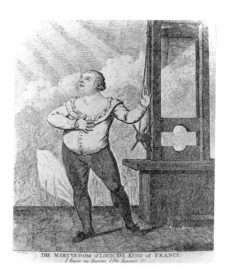

149 Isaac Cruikshank, *The Martyrdom of Louis XVI, King of France*, coloured etching, 32 x 19 cm, 1793.

THE MARTYRDOM of LOUIS XVI. KING of FRANCE.
I forgive my Enemies, I Die Innocent !!!

execution, when they tried to prevent the king proclaiming his innocence to his people. One is put in mind of Goya's artistic beacon *The Third of May* (illus. 150), which was likewise aimed at the French conqueror. This painting depicts a firing squad from beside and behind, and therefore likewise dehumanized, executing the Spanish insurgents who had risen against the Napoleonic occupation. The comparison is telling, in that both the Spanish insurgents and the

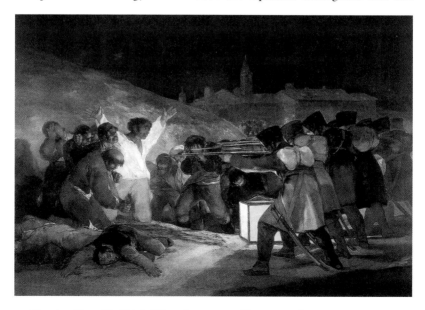

150 Francisco Goya, *The Third of May*, oil on canvas, 266 x 345 cm, 1814.

French monarch are depicted as martyrs. In Goya's painting, the hands of the outstretched arms of the portrayed victim are perforated, and therefore reminiscent of the Crucifixion; Cruikshank portrays his Louis as a quasi-redeemer, turned to face God and, like Christ on the cross communicating with his heavenly father, forgiving the perpetrators. The explanatory caption beneath the title of the print is 'I Forgive my Enemies! I Die Innocent!'

The execution of the members of the king's family, especially his wife Marie-Antoinette, were portrayed in Britain in similar fashion. The extremely high aesthetic standard of this caricatural production can be traced back to developments in public reasoning with regard to prints in Britain from the early eighteenth century. The speed with which the guillotine plummeted down onto the necks of its victims at ever decreasing intervals during the Terror presented an ideal scenario for critics to denounce the inhumanity of the Revolution. In France, this occurred especially after Thermidor, with the downfall of Robespierre, the leading figure of the Terror regime. Before this, such criticism was mostly expressed abroad, and especially in Britain, where Edmund Burke's conservative *Reflections on the Revolution in France* (1790) had formulated the most searing indictment of the principles of the French Revolution. Apart from Cruikshank, England produced one other ingenious pictorial propagandist, James Gillray. It should be added, though, that Gillray, like many other artists, was initially quite positive about the Revolution, and only turned against it in the face of its increasing brutalization.[17]

'Sing me the song of death' could be the title of a famous print by Gillray, although he himself preferred to give it the ironic title *The Zenith of French Glory – The Pinnacle of Liberty* (illus. 151).[18] This work, a response to the death of the king, was made soon after the event, and was distributed in France in February 1793. The event is universalized and the scene portrayed is an allegory of generalized destructiveness, surely intensified by France's recent declaration of war on Britain. With a little imagination one can make out the king's head beneath the guillotine; but in this case his execution is only one episode among many. Prominent in the foreground is a splendid example of a scruffy *sans-culotte*, fiddling an accompaniment to the death of the king, whom he is turned to face, leering. '*Sans-culotte*' is taken quite literally here, for there is hardly any remnant of his trousers, and he is sitting with a naked behind on top of a lantern, which he is misusing as a chamberpot. The cry 'A la lanterne' was always uttered when someone was to be put to death, since a lamp-post could be turned into a gallows in an instant. In Gillray's coloured

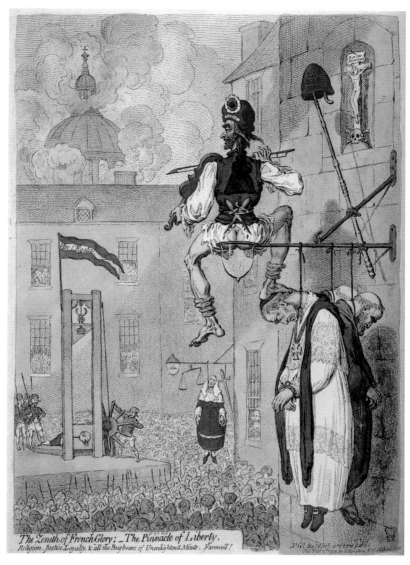

151 James Gillray, *The Zenith of French Glory – The Pinnacle of Liberty*, coloured etching, 34.4 ×
23.3 cm, 1793.

etching, this has just happened to three prelates, and the vile revolu-
tionary has his foot resting on the head of one of them. Between the
prelates and the guillotine a judge is hanging in full regalia. To the
right of the *sans-cullotte* is a blasphemous portrayal of the Crucifix-
ion; beyond the square the dome of a combusting church is visible,
another symbol of revolutionary anarchy. Gillray also utilized the

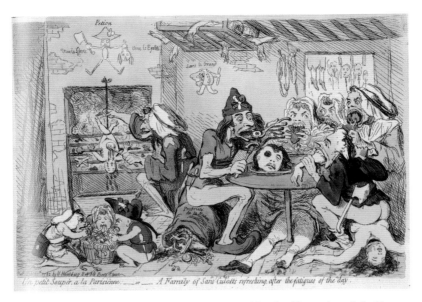

152 James Gillray, *Un petit Souper, à la Parisienne; - or – A Family of Sans-culottes Refreshing, After the Fatigues of the Day*, coloured etching, 1792.

technique of reducing a crowd to an indeterminate anonymous mass, in this case portraying it as a collection of liberty caps, scarcely individualized at any point.

Gillray's talent was for obscene exaggeration, a superabundance of narrative, and juicy brutality. The blood of the Revolution exudes from his prints as the appalled viewer takes in the details of the satirical portrayals. In this respect, *Un petit Souper, à la Parisienne* (illus. 152) is especially impressive: a renewed diatribe against the mob in the street, whose influence on parliament was held to be responsible for the slide of the Revolution into the Terror.[19] The innocuous title stands in ironic contrast to the content of the gruesome print. Exactly what efforts the family has undertaken during the day is signified to the left, where outside the room, leaning against the wall, are a pitchfork, a lance and even a rifle, with which, it is suggested, the family members have been on a murderous rampage. The trophies of this hunt take up most of the picture. Here too the term '*sans-culotte*' is taken quite literally, and the two male diners at table are both shown naked from the waist down. Armed with a bloodstained cleaver and knives, these modern cannibals are dismembering their victims. The one on the left is spooning into his mouth an eyeball, which he has removed from the head in front of him. The body this head belongs to is lying under the table, recognizable by the *culotte* that identifies him

194

as an aristocrat, or at least as a member of the upper class. Just as the character on the left is seated on a sack of royal jewellery, which is designated as 'Propriété de la Nation', but in fact has simply been stolen, the man on the right is sitting on the chest of another victim, this time female, and is devouring a human arm. The visual field continues in this vein: three women are gorging themselves on the organs of one of the victims, and the same thing is happening on the floor to the left, where even the small children are seen tucking into the chitterlings. The old woman behind them next to the fire is visibly pleased at the array of delicacies; she is basting a dead baby, which is being roasted to perfection.

As if the message of the print were not already abundantly clear, Gillray has also covered the walls and even the ceiling with telling details. There is an overhead rack filled with severed human limbs. Slogans of freedom and equality appear to be mocking a stickman named Petion, the 'inflexible' mayor of Paris during the Terror. Just as prescient is the scrawl on the wall, which reads 'Louis le Grand', above a figure who is missing his head, although at the time of this print – it is dated 20 September 1792 – there was as yet no question of guillotining the king. This makes it quite evident that this work of Gillray's was a quite specific and also extremely prompt response to the September massacre, when the Paris mob massacred well over one thousand political prisoners – mostly priests – while Pétion made no attempt to intervene.

Gillray's antipathy to the *sans-culottes* was in accord with the sentiments of the intended clientele of his Revolution prints.[20] These prints were costly to produce and so relatively expensive, and aimed at the wealthier members of society, whose desire to set themselves apart from the 'plebs' set their tone. The wealth of allusion of these prints was also appropriate; art-historical allusion was standard practice with British art of the eighteenth century, and also noticeable in the case of Gillray. His *Un petit Souper, à la Parisienne* had its pictorial antecedents: it bore the stamp of a work from two centuries before – *Magere Küche*, by Pieter Bruegel, who was as gifted as Gillray in the creation of grotesque types.[21]

Politicians were very well aware of the propaganda effect of art such as that of Cruikshank and Gillray. One episode from later on in Gillray's career is especially telling, particularly with regard to the validity of always assuming the political content of caricatures and satires to be just an expression of personal views. The British royal family, who were all too well aware of the effect on the public of Gillray's vivid cartoons, and were certainly frequently angered by his biting satires on

George III himself and his family, offered Gillray an annual pension of £200.[22] Gillray apparently accepted without hesitation, and made the necessary adjustments. He produced no more caricatures of the monarchy, but focused all the more on the Whigs, who were themselves critical of the monarchy, and who were henceforth portrayed as friends of the Revolution, almost as bloodthirsty as the *sans-culottes*. Furthermore, his caricatures of *Little Boney*, Napoleon Bonaparte, were so incisive that the French emperor later once said that they had caused him more harm than the entire British army.

One cannot overstate the significance of this barrage for domestic politics; it primarily served to limit liberal demands for the republicanization of the state, which were also being expressed in Britain at that time, and to oppose publicly Jacobin clubs, such as the London Corresponding Society.[23]

'Every thing seems out of nature in this strange chaos of levity and ferocity, and of all sorts of crimes jumbled together with all sorts of follies.'[24] Burke, who expressed this view in the bible of conservatism, the *Reflections on the Revolution in France*, provided with his apocalyptic observation a counterpart to the prints described above made by the English caricaturists. He insisted that Church and state should never be separated, as a guarantee that such madness would never ensue.[25]

As already said, French artists everywhere started emulating English caricatures, especially in connection with the aforementioned initiatives of the Committe of Public Safety, which were once again directed at David in particular, but at other artists too. The fact that a high-minded historical painter such as David had turned his hand to this 'scatological' genre caused a great deal of surprise later on; however, he surely did it in order to tackle his opponents on their own ground, and also because he knew he could reach a partly different audience with caricatures.[26] His prints especially, and sometimes also his paintings, were produced to some extent in response to Gillray, whose artistry he appears to have admired as much as Gillray in turn admired his.[27] David first turned his attention to Gillray's earlier prints, which were aimed at his own king. It has been demonstrated that the forms of the figures in David's *English Government* (illus. 154) are clearly derived from Gillray's *Lieutenant-Goverenant Gall-Stone, Inspired by Alecto* (illus. 153), and that the basic composition of David's *Sabine Women* (illus. 155), which he began in 1794 but only completed in 1799, would have been inconceivable without Gillray's *Sin, Death and the Devil* (illus. 156). Especially significant in this connection are the works that were inspired by anti-revolutionary compositions by the Englishman which were then turned around by the Frenchman. This

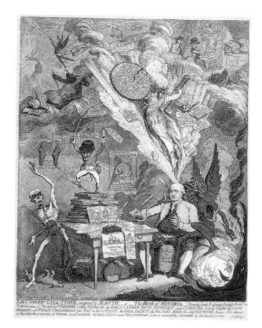

153 James Gillray, *Lieutenant Goverenant Gall-Stone, Inspired by Alecto; – or – The Birth of Minerva,* etching, 19.5 x 15.2 cm, 1794.

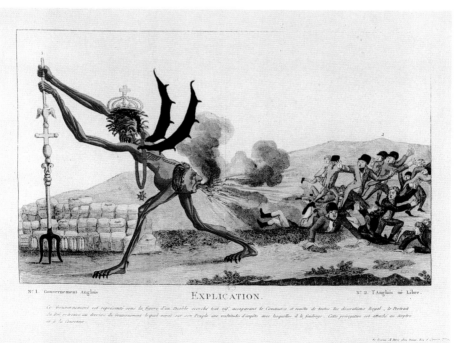

154 Dominique-Vivant Denon after Jacques-Louis David, *English Government*, coloured etching, 24.2 x 39 cm, 1794.

155 Jacques-Louis David, *The Intervention of the Sabine Women*, oil on canvas, 385 x 522 cm, 1794.

156 James Gillray, *Sin, Death and the Devil*, coloured etching, 31.9 X 39.9 cm, London, Boydell, 1792.

157 James Gillray, *The French Invasion; - or – John Bull Bombarding the Bum-Boats*, coloured etching, 35 x 25 cm, London, Humphrey, 1793.

is possibly the case with Gillray's *The French Invasion*, from 1793 (illus. 157), an imaginatively abstruse print that could well have provided the inspiration for David's *English Government* (see illus. 154). The outline of the map of England and Wales has been anthropomorphosized into George III, and that of France's northern coast into the profile of a *sans-culotte*. George is farting into the face of the Frenchman, out of whose mouth is spewing the boats with which the

French intend to invade Britain. In the print *English Government*, David transformed the backside of the devilish British monarchy into the face of George III spewing up his guts at his own subjects, throwing them into turmoil, an idea that must certainly have been derived from Gillray's conception, and then turned against its inventor.[28]

Retour à l'ordre

It goes without saying that French associations with the memory of the guillotine after Thermidor were decidedly less burlesque than those of the British, especially as expressed in caricatures. Far stronger elements of accusation and grief were brought to bear on the trauma that had befallen large sections of the population during the months of Terror in the years 1793–4. A typical example is the *Caustic Figures*, a coloured etching produced in autumn 1794 by Norman and Lafitte (illus. 158), which was commissioned and outlined by the lawyer Louis-Eugène Poirier, a victim of the Terror in the *département* of Pas-de-Calais. The title of the print, of which there are many versions, refers bitterly to a speech at the Convention of 9 July 1794, in which Bertrand Barère had glossed over an unusually high number of arrests and guillotinings.[29] Like other works from the Revolution, Louvion's engraving makes use of a pictorial structure familiar from Christian art, which has been semantically reversed.[30] Positioned between two pedestals supporting guillotines is the villainous figure of a blood-drinker, whom the legend introduces as Joseph Le Bon, the leader of a particularly vicious regiment in the northern French towns of Arras and Cambrai during the Terror. The composition is such that the viewer has no difficulty in assessing the force and speed of the machinery of death. Le Bon is filling one bowl with the blood flowing from the decapitated neck of an executed man, having already conveyed the other bowl full of steaming blood to his lips; it is obviously the blood of the other victim, who has already bled dry. It is clear from the mound of corpses on which Le Bon is standing that this alternating mechanism works all too well, and were it not for the scene in the upper half of the print, one would have to assume that it would continue to do so. Floating on high is a typical allegory of the Revolution. The figure of Truth is standing naked by Justice and in view of the National Assembly. In her hand she holds a sheaf of accusations relating to the infamies perpetrated by the Jacobins after Thermidor,[31] culminating in the horrific final events. A number of released prisoners are hailing the cloud-supported vision, in yet another instance of a secularized religious scene: to the right of Le

158 Jean J. B. Louvion after Louis-Eugène Poirier, *Caustic Figures*, coloured etching, 27.6 x 35.9 cm, 1795.

Bon are those who have been saved, hence the good, while the wicked ones are to his left. The right side as the good side, the left as the bad, this is the usual arrangement in scenes of the Crucifixion and other Christian themes. Here it is also a reflection of the fact that many familiar scenes and also firm beliefs had survived the de-Christianization phase of the Revolution.

The enormous number of executions, for obvious reasons, feature prominently in a series of bitter denunciations of the Terror. The *Robespierre Government* foregrounds several piles of decapitated heads (illus. 159). One is labelled 'Clergé', another 'Parlement', but the highest heap – especially galling for those who believed in Robespierre's vision of Terror and Virtue – is that of executed citizens, the 'Peuple'. The second point of this print can be seen in the upper half, where an astonished personification of Liberty (in fact the statue of *Liberty* on the plinth of the royal monument in the Place de la Révolution) is observing

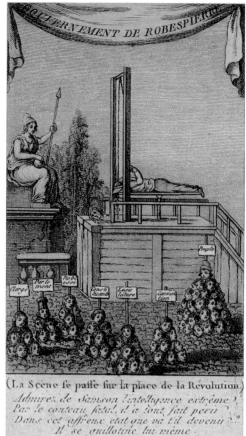

(La Scène se passe sur la place de la Révolution.)
Admirez de Sanson l'intelligence extrême?
Par le couteau fatal, il a tout fait périr?
Dans cet affreux état que va t'il devenu??
Il se guillotine lui même.

159 *The Robespierre Government*,
coloured etching, 9 X 5.6 cm,
1795.

the executioner Sanson in the act of guillotining himself – whether from
bad conscience or because he has run out of fodder, for his voracious
apparatus is left open. This idea is made even more pointedly in a print
that shows Robespierre executing his own executioner (illus. 160),
because, as the legend explains, all political groups have been eliminated.
A pyramid is rising out of the forest of guillotines, with the quite
unequivocal inscription 'CY GYT TOUTE LA FRANCE'.

Art of the second half of the 1790s was characterized by reflection,
mourning and melancholy, sentiments that were a direct consequence
of the unimaginable horror of the Terror. In 1799 Pierre-Narcisse
Guérin portrayed the (legendary) story of the Roman Marcus Sextus,
who on his return from guiltless exile, found his wife dead, and so was
plunged into dark despair (illus. 161). It was easy for contemporaries
to see this picture, which was lauded by conservatives, as an allegory

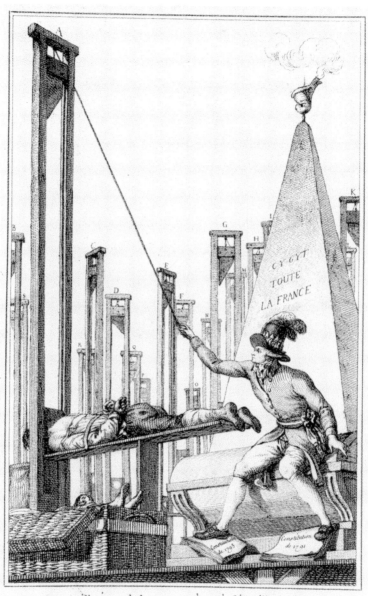

ROBESPIERRE, guillotinant le bourreau après avoir fait guillot.ᵗ tous les Français

A *le Bourreau*, B *le comité de Salut Public*, C *le comité de Sureté générale*, D *le Tribunal Révolution.ᵗ* F. *les Jacobins*, F *les Cordeliers*, G *les Brissotins*, H *Girondins*, I *Philipotins*, K *Chabotins*, L *Hebertistes*, M *les Nobles et les Prêtres*, N *les Gens à talens*, O *les Vieillards*, *Femmes et Enfants*, P *les Soldats et les généraux*, Q *les Autorités Constitués*, R *la Convention Nationale*, S *les Sociétés Populaires*.

160 *Robespierre Guillotining the Executioner After Guillotining All The French*, engraving, 13.9 x 8.3 cm, 1794–5.

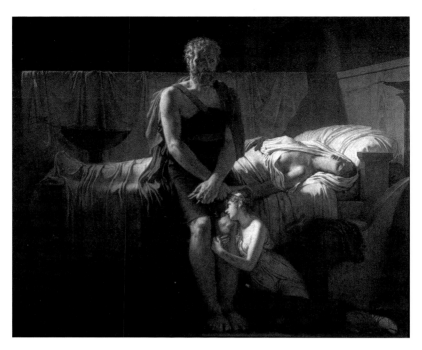

161 Pierre-Narcisse Guérin, *The Return of Marcus Sextus*, oil on canvas, 217 × 243 cm, 1799.

of the fate of all those who had emigrated from France during the Terror. A medallion minted one year after Robespierre's fall to commemorate the glorious days of the storming of the Bastille depicted a personification of France in mourning next to an obelisk immortalizing the victims of anarchy (illus. 162). The medallion also indicates the only escape from past degradation and present demoralization. Behind the mourning figure, the parliament, now cleansed of 'terrorists', represents the bastion of hope for the future, and an isolated small block of masonry proclaiming 'Loi et Justice' states its principles. Furthermore, the Convention building in the background should favour representative democracy over mob rule, and the 'law' should uphold the citizens' republic and its needs, and safeguard inequalities (especially with regard to property) against the radical *sans-culottes*' promulgation of equality. Louis-Marie Prudhomme, the former publisher of the newspaper *Révolutions de Paris*, illustrated his essays opposing the Terror[32] with a highly sentimental print in 1797 (illus. 163) depicting two mourners at the foot of a personification of liberty in the former Place de la Révolution, now Place de la Concorde. On the left is a dog, howling in loud lament at the execution of his master; on the right is a girl mourning her dead mother;

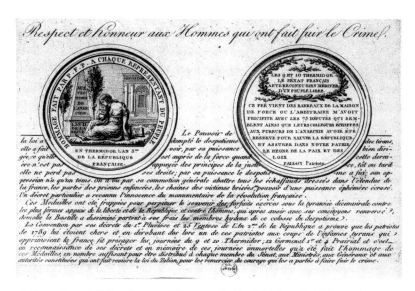

162 Pierre–François Palloy, *Respect and Honour to the Men Who Have Fled Crime*, etching, 11.5 X 17 cm, 1795.

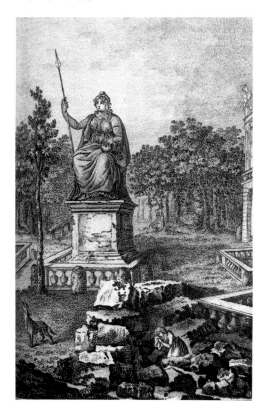

163 *The Faithful Dog in Front of the Liberty Statue in the Place de la Revolution*, etching, 17.6 X 10.7 cm, 1797. Published in Louis-Marie Prudhomme, *Histoire generale et impartiale des erreurs, des fautes et des crimes commis pendant la revolution française*, Paris, 1797.

and the legend informs us that the girl in turn died, only a month later, of a broken heart.[33]

It is not always easy to distinguish between opponents of the Terror and opponents of the Revolution in general. Anger and mourning over the bloodlust of the radicals could easily turn into condemnation of everything that had happened since 1789, for even the early years of the Revolution were not free of violence. *The Plagues of Egypt*, which we have already encountered during the examination of the cult of Marat (see illus. 132), is a particularly forceful example of this tendency. As well as the sarcastic portrayal of a *sans-culotte* burning incense, this caricature features seven more scenes, which derive their secular power from being presented as the return of biblical pestilences. It shows victims of drowning at Nantes on the Loire; starvation due to the Assignats; the condemned being led to the scaffold; the brutal commissar of the people, and so on. These were all episodes from the Terror, but the caption places responsibility for them on the Revolution as a whole: *état de la France depuis 1789 jusqu'à l'établissement de la Constitution actuelle.*

Boyer announces that the patient although suffering people consider that it would have been much better if all the legislators who have appeared since 1789 had reformed the abuses of the old laws, rather than making new laws.[34]

This observation from a Parisian police report characterizes the prevailing *état mental* as being tired of the Revolution and in favour of no more than reform, and blaming the great Revolution for all of the country's sufferings. However, even the decidedly anti-Terror *Plagues of Egypt* is not unequivocally anti-Revolution, as can be seen in the caption, which suggests that with the new constitution – the one from Year III, which resolutely suppressed the mob elements of the first republican constitution – the spectre would be exorcized.

Opponents of the great Revolution themselves certainly did not renounce violence. Historical evidence for this is provided by the reactionary *Terreur blanche*, which was every bit as violent, and visual testimony by republican counter-propaganda. The print *The Friend of Justice and Humanity* (illus. 164), with its ironic subtitle *Peuple Français, Peuple de Frères!*, portrays a representative of reactionary counter-terrorism. This activist, reactionary member of the *jeunesse dorée*,[35] with an aggressive facial expression, is wielding a dagger as he stomps ahead rather stiffly, trampling on the republican laws on the way. He is the epitome of the thugs in the background, dressed in the style of the *incroyables*, who are shown in the act of murdering their

164 *The Friend of Justice and Human-*
ity, etching, 20.8 x 16.7 cm, 1796–7.

L'ami de la justice et de L'humanité
Peuple Français. Peuple de Freres!

fellow citizens. The concepts of 'justice' and 'humanity' have been
chosen advisedly, since it was precisely these concepts with which the
conservatives distanced themselves from revolutionary radicalization.

The patriotic calculator and the beneficent lantern

Judging by the preponderance of representation of bestial violence
during the French Revolution, it would appear that the tendency was
towards a critical perspective on the Revolution. On the whole, the
visual propaganda of the Terror tended to be externally oriented, as
in portrayals of war, and usually favoured allegorical depictions.[36] If
the scope of our scrutiny is extended to include works of art in which
the focus is not on the execution of the king, this conclusion is not
substantially altered; but further interesting aspects of the theme are
revealed. This also provides an opportunity to examine scenes of
violence relating to the early Revolution, especially in connection
with the storming of the Bastille, as well as allegorical scenes in which
the tables are turned and the once dispossessed turn on their former
exploiters.

 One rather tragi-comic print, of which there are a number of
versions, appears to feature a secularized Last Judgment, but with
pagan archaic symbolism (illus. 165). A line of decapitated men, hold-
ing their own heads aloft on long pikes, is requesting admission to the
Elysian Fields – the classical equivalent of Christian Paradise. The

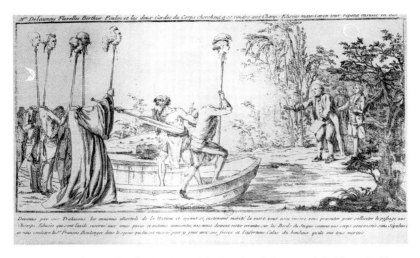

165 *Messieurs Delaunay Flesselles, Berthier and the Two Guards Try to reach the Elysian Fields: But Death Answers Below,* coloured etching, 17.6 × 33.4 cm, 1789.

elderly Charon, who is acting as the ferryman, as in the Greek mythological conception of the hereafter, is refusing to take them, with the exception of one man stepping into the rowing boat. He is being welcomed with open arms by some denizens of the Elysian Fields. Among the happy residents is Jean Calas, the Huguenot victim of an infamous miscarriage of justice under the *ancien régime* – the Toulouse parlement had Calas executed because he had apparently murdered his son to prevent him converting to Catholicism. Charon's speech in the legend gives a simple political reason for his decision.

The people being excluded are de Launay, the governor of the Bastille, the institution which was synonymous with the despotism of the *ancien régime*; Jacques de Flesselles, provost of the Paris merchants, who had supported de Launay on 14 July; Louis Berthier, intendant of the city of Paris, also head of surveillance for the monarchy; and Joseph-François Foulon, military intendant and former Minister of Finance, a fervent anti-revolutionary, who was supposed to have once said: 'Well then! If the rabble have no bread, they will eat hay', for which he was detested. He was generally regarded as an official of the monarchy, and during the storming of the Bastille he revealed himself to be an enemy of the people, for which he was subsequently lynched. The master-baker Denis François, seen here wearing a liberty cap, was hanged by an angry mob in October 1789 in the Place de Grève in Paris, then afterwards decapitated, for allegedly hoarding bread. The fact that Charon is allowing him aboard signifies an appeal for a limit to the violence; for immediately after this

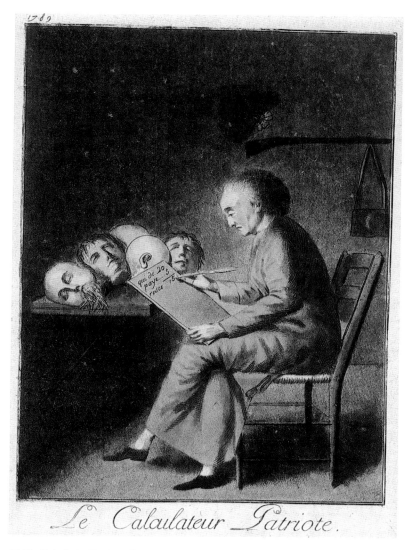

Le Calculateur Patriote.

166 *The Calculating Patriot*, coloured aquatint, 24.2 × 17.2 cm, 1789.

incident the National Assembly imposed martial law, while the court of Châtelet sentenced the ringleaders of the lynch mob first to the pillory, and then to prison.[37]

The Calculating Patriot (illus. 166) is another example of an extremely popular print from the early days of the Revolution, which appeared in dozens of variations and combinations with other motifs. Although the narrative content is quite open, so that it could lend itself to either revolutionary or anti-revolutionary propaganda,[38] in

209

most cases such prints were intended to be pro-revolutionary, which was, unusually, confirmed in a contemporary written report in the case of this print. In the memoirs of the Marquis de Ferrières there is a report on a speech by Clermont-Tonnerre in the National Assembly on 31 July 1789, in which he complained 'd'une estampe que l'on vendait à toutes les portes du Palais-Royal', which would incite the people. De Ferrières' description is unmistakable – it concerns this print, even referring to it by name as *Calculateur national*, and the date of the speech also provides a terminus ante quem. The print portrays a seated man, who is performing simple arithmetic: 'qui de 20 / paye 5 / reste 15'. The numbers vary in the different versions, and in many of them a print of the Bastille can be seen on the floor. All versions depict a row of decapitated heads, corresponding in number to the second figure in the calculation. They are the same individuals who in the last print were apparently requesting admission to the Elysian Fields, who are therefore identifiable as victims of early revolutionary uprisings, before during, and shortly after the storming of the Bastille, with which the *terminus post quem* is therefore given. Foulon is particularly easy to identify by the wad of grass in his mouth, a token of his infamous retort. Now the outraged critic Clermont-Tonnerre's outburst in the National Assembly is comprehensible; the calculation has clearly not yet been balanced – there are five decapitated heads on the table, so fifteen more are needed to make up the twenty, therefore this must be understood as a demand to deliver fifteen more – in other words, this is an incitement to murder, or was often so called in connection with Marat. However, the figure portrayed cannot have been intended to represent Marat, whose incitements in the *Ami du peuple* appeared later than this print.

Victims of acts of revenge during the time of the storming of the Bastille featured time and again in revolutionary graphics. *My Arse! — They'll Never Get over it Now!* (illus. 167), for example, is a satire from 1790, which is almost as burlesque as the anti-revolutionary graphics of the English caricaturists. The colloquial tone of the title corresponds to the vulgarity of the symbolism, aimed at people with little or no familiarity with high art. The perspective is somewhat out of kilter, which only adds to the overall tenor of the picture. The old man applauding on the right side of the picture is familiar from an earlier popular etching (see illus. 25), in which he was seen riding on the back of an aristocrat, symbolizing the new age, and likewise applauding, although with his arms in a different position. The hare speared by a knife, which he was carrying on his back in the earlier portrayal, is lying on the floor next to the knife in this print. In both cases the peasant is from the *tiers*

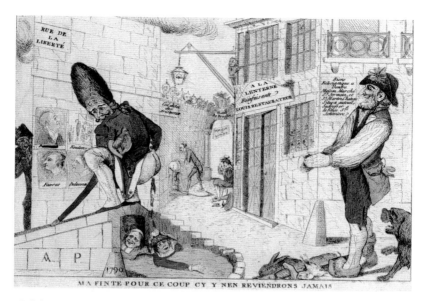

167 Johann Anton de Peters, *My Arse! They'll Never Get Over it Now!*, 17.5 × 24.6 cm, 1790.

état, which was now claiming for itself the former rights of the nobility. The only element that the new satire has not adopted is the shield with the slogan 'Paix et Concorde', as it would not be appropriate in view of what the old man is applauding – in front of him a National Guard is defecating with relish into an open sewer, through which a nobleman and a clergyman are being flushed, observing with horror the fate that awaits them. Behind the old man, the former inn 'A LA LENTERNE *Bienfaisante*' of 'Louis Restaurateur' is now up for sale following the nationalization of the property of the Church in December 1789; second, on the wall of the 'Cul-de-Sac des Aristocrates' (a play on words alluding to the aristocratic rectum) in the background, there is a row of heads on spikes (among them once again the 'hayman' Foulon), clearly there thanks to the prior use of the beneficent lamp-post as a gallows. In the left foreground in front of the National Guardsman are a number of 'Wanted' posters, in the tribunal style of revolutionary pictorial publicity. Among them is the likeness of the royalist conspirator the Marquis de Favras, who was executed in February 1790. There is much more that could be elaborated on from the highly allusive details, but suffice it to say that popular prints such as this would have initiated much general discussion, and may well have helped to spread anxieties about the future.

7 Visualizing the Revolution

Having concentrated up to now on the concrete forms and functions of the arts in revolutionary France, we now wish to conclude with some visual material of a higher level of abstraction, specifically philosophical pictures, which encompass and explicate the Revolution as a whole. The fact that it is consistently prints, not least of all popular prints, which lend themselves to these interpretations is yet another testimony to the leading role of prints in revolutionary art.

Revolution – a new political–historical concept

In the years 1794–7, Chateaubriand – then in exile in England writing his *Essai sur les Révolutions* – attempted to place the French Revolution in a comparative history of revolutions since antiquity. He failed, as he was later to acknowledge, because the cascading events of his time could not be encompassed within the confines of any traditional scale of assessment.

Often it was necessary during the night to delete the picture I had sketched during the day: the events raced ahead of my pen; a revolution was taking place which put all my comparisons on the wrong track: I was writing in a ship in a storm.[1]

Chateaubriand's failure is symptomatic for the general experience of his time of a complete break with the past, which was expressed in a new concept of 'revolution'. Whereas under the *ancien régime* the word *révolutions* was for the most part used in the plural as a derogative term for conspiracies, civil wars, changes of constitution and other political upheavals, in the later stages of the Enlightenment, and especially after 1789, it acquired a much more comprehensive and positive meaning. *Révolution* in the singular signified the triumphant struggle of a people for liberty, the accelerated structural change not only of the state and the economy but also of society and culture; *révolution* was a self-perpetuating, inexorable and irreversible process,

which continually generates revolutionary impulses anew, could not be terminated, and which led on to an open future.[2]

It was in this context that Marat, for example, expressed his views at the beginning of 1793. In an article in his newspaper on the continuation of the Revolution, he praised the unique ability of the French Revolution, with the support of the 'peuple', to overcome all obstacles in its path for four years: 'je regarde la révolution française comme un miracle continue'.[3] The implicit thesis, that the process of the Revolution in its entirety stemmed from an interconnected chain of revolutionary components, which was propelled particularly by the *journées révolutionnaires*, was an expression of an altogether new consciousness. Just two items of proof from the many available are sufficient to confirm this. In Year II of the republic, a breviary aimed at the *sans-culottes* posed the following question: 'Which are the most glorious moments of our revolution?', which it followed with a lapidary response: '14 July and 10 August 1792, 31 May and 1 June 1793.'[4] The unspoken message in this didactic dialogue was more implicitly stated in a dictionary of 1795, taking into account the drama and the cultural aspects of the process as well, and paraphrasing its power metaphorically. The article, titled 'Révolution Française', contained the following definition, among others:

It is primarily characterized by the fact that in France, in the space of four years, there were two principal revolutions and several additional ones [. . .] by dramatic scenes so violent that they transmitted their shock waves to almost the entirety of the peoples of Europe. – [. . .] The first Revolution of 1789, of which the last King himself was the prime mover, changed Royalty into a constitutional Monarchy. It was viewed by the French People as the work of the Centuries, of Reason and energy. [. . .] – In the second revolution, which changed the constitutional Monarchy into a Republic, the last King, Louis XVI, became a victim. [. . .] This last revolution was like a Volcano exploding. [. . .] – After all the violent, bloody shocks of two great revolutions interspersed with mass insurrections [. . .] France declared herself regenerated from her total physical and moral corruption, and restored, from a denatured state, to Nature.[5]

If we consider at this point the contribution of the arts to giving tangible form to this new consciousness of revolutionary acceleration of contemporary history, with its accompanying spate of arrests and trials, the aforementioned pairs of pictures (illus. 24, 25 and 29, 30) depicting the change from the *ancien régime* to the new France springs to mind. These pictures were restricted, for the most part, to the contrast between past and the present, without portraying the process of transformation from the old state to the new. The dynamics of the

Revolution were more on display in pictorial depictions of the disputes concerning the monarchy, particularly in Villeneuve's print *The New French Star* (see illus. 72). They were even more clearly expressed in a series of allegorical funerary processions and popular board games, which will now be considered.

The revolution on the march

On 16 May 1789 Charles Poitevin de Maissemy, Directeur général de la Librairie (director of publishing), wrote the following to the Lieutenant général de Police, Louis Thiroux de Crosne:

I have the honour, Sir, to warn you that a sort of copy of the engraving entitled *Convoi des Abus* [funeral procession of the abuses of power] etc. has been displayed and sold publicly for several days in Paris, on the boulevards [and] on the banks of the Seine, in the Tuileries and in the passages where there are print sellers. You remember that you denounced the original of that engraving to the Garde des Sceaux [Minister of Justice] who, in accordance with the orders of the King, strongly recommended to me that I should prevent its sale. Consequently I summoned here Mr Sergent, the engraver, who is its author and who stopped the sale of the engraving instantly, even though he had received the Censor's approval. Today this man complains in strong terms of the injustice done to him by forbidding the distribution of his work while permitting the distribution of copies or imitations that have been made of it. [. . .] Furthermore, the fact which he asserts is true, I have verified it myself; the forgery of Mr Sergent's *Convoi des Abus* is being sold publicly everywhere; this print certainly warrants suppression and is even more reprehensible than the original, although it is less well executed. Nothing is more likely to enflame people's minds than these kinds of engravings, and their authors deserve on all sorts of grounds to be punished. — What I see as vexing in all this is that your police inspectors are misleading you [. . .]. For certainly, if they spoke to you initially of Mr Sergent's engraving, they told you nothiing of that of Mr Macler, which has been on public sale for the past six days [...].[6]

This letter is highly instructive in many respects. Yet again it testifies to the omnipresence of revolutionary prints in the public sphere right from the beginning of the Revolution, and the inability of the old monarchy and its uncoordinated authorities effectively to control or stem this rising tide of prints, which they feared because of their powerful effect on the emotions of the masses. However, it also reveals the fierce competition between the printmakers, as well as their common practice of printing 'pirate' copies[7] of the most successful prints produced by their colleagues and putting them on the market within a week. In fact, at least six different versions and pirated copies of prints illicitly reproduced by the engraver Antoine-

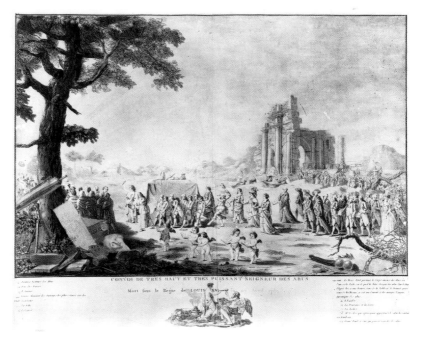

168 Antoine-Louis-François Sergent-Marceau, *Convoi de tres haut et tres puissant seigneur des Abus mort sous le regne de Louis XVI le 27 Avril 1789*, aquatint, 39.2 x 57.5 cm, 1789.

Louis-François Sergent-Marceau were in circulation in 1789. Their original author must have had a hand in this business on the quiet, as he himself released more reproductions of his prohibited print for sale, with the addition of a poem,[8] which was later taken over by the plagiarizer Macler.

Why did an aquatint by Sergent-Marceau (illus. 168) arouse so much interest in the public and the authorities that Boyer-Brun[9] had an engraving made from it in 1792, and commented on it in great detail? Because the image portrayed, in an obvious and meaningful way, the general expectations and political aspirations of a broad spectrum of society, furthermore only a few days before the general assembly of the Estates-General, which had originally been arranged for May Day but was postponed by four days. The title is an allusion to traditional representative staging of aristocratic obsequies. The artist imagined the imminent opening procession of the Estates-General as a funeral procession under the *ancien régime*, personified by the 'très haut et très puissant Seigneur des Abus'. There are a number of scenes in the picture that illustrate the socio–economic and political-legal deficiencies of the old France: in the background to the

right is the ruin of a palace, from which the privileged beneficiaries of the old system – the nobles and prelates – are fleeing in their carriages, in great distress;[10] in the right foreground are implements of torture such as balls and chains; to the left under the tree are the shadows of the 'Pauvres Victimes des Abus',[11] that is, deceased victims of miscarriages of justice, such as Jean Calas and the surviving Bastille prisoner Masers de Latude; finally, in the centre, surrounded by mourners, is the coffin containing the body of the deceased, with the insignia of his legal as well as noble and religious authority.

The Third Estate bearing the immense body of the Abuses, covered by a rich Pall on which the Mitre designates the Abuses of the Clergy; the Sword tied to a Purse, the Abuses of the Nobility; the square cap, those of Chicanery; next to the cap, an Iron Crown marks the tyrannical Empire of the abuses.

The female mourners accompanying the catafalque – with an allegory of Avarice and a Fury with an unsheathed dagger to the forefront, and immediately behind them the figure of Arrogance (*Orgueil*), all dressed up to the nines, and a prancing 'Folie' dressed like a lunatic – lend a carnivalesque atmosphere to the central scene. A more sombre group is at the rear, treading on the virtues Egalité, Prudence and Justice, as well as the principal royal minister Jacques Necker,[12] who was very popular at that time. He is walking at the head of delegates from the Church and the nobility, who will only permit deputies from the Third Estate to carry the coffin. The genies in the foreground are singing and prophesying that the Third Estate will increase in significance; this was the central thesis of the most successful treatises calling for reform of the Estates-General, passages from which they are 'singing aloud'.[13]

Sergent-Marceau's allegorical funeral points to two possible future outcomes. In general, as he suggests in the left foreground, the hoped for new alliance between the king and France (as in the delicate outline sketch on the white tablet) will lead to a flowering of the sciences and the arts; more specifically, the date of death is chalked above the gun cartridge. Clio and Chronos are enacting the inscription – they have just turned over a new leaf in the book of history, giving it the title 'Fastes du roy citoyen'. The date 'le 27 Avril 1789' probably refers to the completion of the print itself, not the revolt of the workers in the Faubourg Saint-Antoine against the owner of the paper-mill, Jean-Baptiste Réveillon, which erupted then, and is considered to be a forerunner of the 'journées révolutionnaires'.

Copies of this print produced soon afterwards do not add anything essential to it, but there are three significant aspects to the copies.

First, in the case of the incriminating 'pirated' reproduction by the otherwise unknown engraver Macler (a reversed copy, which the quoted Poitevin de Maisemy, a connoisseur, described as artistically unskilled), the date in the inscription is specifically given as '4 May 1789', the date of the opening procession of the Estates-General. The censor viewed this print as 'plus répréhensible que l'original', primarily because of the addition of a verse that strengthened the appeal to the king for reform:

Des antiques abus le souverain empire
A la voix de Louis tremble, chancelle, expire;
Victimes des Abus sechez enfin vos pleurs;
Et toi Divinité de la reconnaissance
Pépare ton encens et grave dans nos coeurs
Le nom du Prince, par qui renait la France.[14]

The sovereign empire of age-old Abuses / Trembles, falters and expires at Louis's voice; / Dry your tears, you victims of the Abuses; / And you, Goddess of Gratitude / Prepare your incense and engrave in our hearts / That Ruler's name through whose grace France is born anew.

There is a somewhat freer adaptation by Jean–Marie Mixelle (illus. 169), an artist of whose work nothing else remains. Mixelle emphasized the impression that the procession was a major event, by

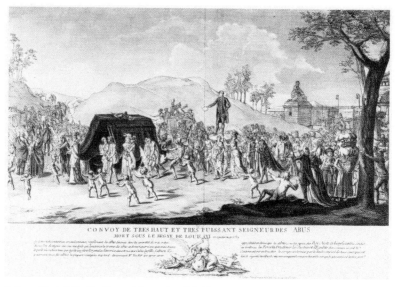

169 Jean-Marie Mixelle, *Funeral Procession of the Very Powerful Lord of Abuses, Expired in the Reign of Louis XVI on this 4 May 1789*, aquatint, 24.1 x 40.8 cm, 1789.

170 *Procession of Abuses*, anonymous etching, diameter 5.6 cm, 1789. The medal was probably used to decorate buttons and boxes.

depicting the catafalque of the 'Seigneur des Abus' being carried by women, and in the foreground, beneath the tree, replacing the attributes of the arts with a group of spectators, among them an ordinary woman with her pannier. In addition, he clearly indicated the starting-point of the procession as Versailles, the venue for the assembly of the Estates-General, and specifically the courtyard of the royal palace, which is surrounded by railings, and being guarded by a seated allegory of Peace by Jean-Baptiste Tuby.[15] Necker, who is elevated above the procession here too, is the most prominent figure. The Virtues are holding him aloft on a shield, so demonstratively and triumphantly, that this print could be included in the programme of 'public works' that the minister had carried out. Finally, Mixelle confirmed the 'date of death' as 4 May 1789, and in the legend he included the individual explanations from the original, almost verbatim.

It was this creative copy that served as the model for a medallion (illus. 170), as can be seen from the carriage behind the coffin and the railings of Versailles with the seated figure. Intensifying the symbolism, the miniature concentrates on what were considered at the time to be the central elements of the picture: the coffin with the satirically depicted patriots surrounding it, the victims of the *ancien régime* and genies of reform.

Taken all together, these variations testify to the public success of

Sergent-Marceau's original print. Whether these were used as patriotic decorations for buttons and tobacco tins, as in the last example, or whether they were put to further use as propaganda, as in Mixelle's case, or whether they were simply copied with little alteration for profit – all in all they amounted to a general pictorial prophecy: that the imminent Estates-General would remedy the prevailing dire state of affairs, and a hopeful future would emerge. These allegorical pictures thereby anticipated an uprising that would in the future be designated *révolution*. When, for example, Foreign Secretary Montmorin sent a circular to the foreign diplomats in Paris in April 1791 to reassure them about the French Revolution, he described – to Marat's great satisfaction – exactly the change that the *Convoi des Abus* had evoked pictorially two years earlier:

What people call revolution *is but the annihilation of a mass of abuses accumulated over centuries, through the people's liability to error or the power of ministers*, which was never the power of kings. Those abuses were no less disastrous to the nation than to the monarch [. . .]. They no longer exist; *the sovereign nation* now only has citizens who have equal rights, no despot other than the law, no one to speak for it except its public officials, *and the king is the first of its officials*: such is the French Revolution.[16]

Meanwhile, the course of the Revolution itself had overtaken these observations by Montmorin, which in the spring of 1789 would have seemed extremely prescient. Not only did the minister attempt to misappropriate the *journées révolutionnaires* and the role of the rising masses, he attempted to create the impression that the Revolution was already over. However, quite the opposite was in fact the case, and in spring 1791 there was mounting evidence for the imminent radicalization of the Revolution. The nationalization of the property of the Church, and the new constitution, which was still in the process of being formulated, could just as easily have led to the revolutionary movement coming into conflict with Louis XVI and conservative forces in the clergy and the nobility, as to the development of an anti-royalist pictorial polemic in the press and mounting republicanism in the grassroots clubs. It was this revolutionary development, which was suppressed by Montmorin, that led to a creative adaptation and reworking of the *Convoi des Abus*. The resulting large-format mezzotint, which was unusually carefully worked, has samples of the handwriting of the engraver A. Duplessis, the author of the aforementioned *Triumph of Voltaire* of 1778. Duplessis produced at least two etchings from his new print, both for artistic[17] and political reasons. Initially, probably in the early summer of 1792, he gave the

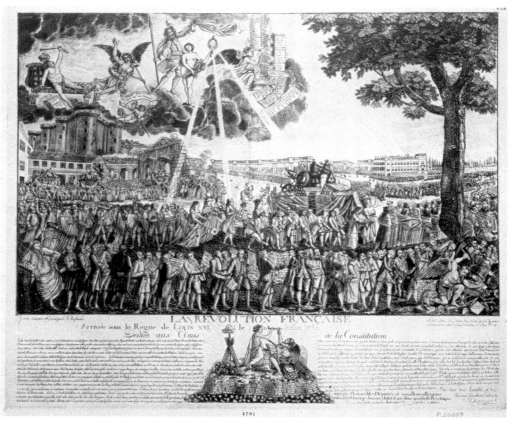

171 A. Duplessis, *The French Revolution Arrives in the Reign of Louis xvi, 14 July 1789*, aquatint, 38.8 x 59.6 cm, 1792.

date of the French Revolution in the caption beneath as '14 July 1789', dedicated the work to the 'Amis de la Constitution' and signed himself as 'très humble et très dévoué serviteur Patriote'. Not long afterwards, the advent of the so-called Second Revolution prompted him to add to the first date 'et le 10 Août 1792', to rededicate the print to the 'Amis de la Liberté', the old constitution having been superseded, and also to sign it self-confidently as 'serviteur Patriote libre'. The artist's intention of making his portrayal of the radicalization of the Revolution as up to the minute as possible is clear from the entire print, especially the second version of it (illus. 171), which merits closer inspection.

In claiming that the inspiration for this picture was his alone, Duplessis was putting experts to the test; for the appeal of his print is precisely the sense of *déjà vu*, in that it is clearly adapted from the

Convoi des Abus of 1789, albeit significantly altered.[18] There is the same motif of the satirical funeral procession, the same catafalque surrounded by the same figures, the same procession of the victims of miscarriages of justice, and in the legend are some of the same explanations, word for word, as in the original.[19] However, in the new version the crowd has vastly increased in size and in interest so that it almost seems too large for the confines of the frame. A comparison between the original and the adaptation reveals just how powerful was the progression of the Revolution, and also justifies the title, which this old-new portrayal so appositely brings to life: *la révolution française*. This print is therefore both a visualization of the revolutionary process, and a product of it, with the different elements of the picture contributing to the total effect in a variety of ways.

The section of the procession in the middle of the image reveals just how deliberately the artist chose to illustrate the progression and radicalization of the Revolution, which had been foreseen in April 1789. Not only has the section with the victims of miscarriages of justice under the *ancien régime* doubled in size,[20] but in the centre of the picture, instead of a royal minister, now there is 'le Président de l'Assemblée Nationale' leading the Virtues; and further to the left there is a dense crowd of mourners made up of nobles, prelates and state officials dressed as female mourners with enormous handkerchiefs. In addition, the list of abuses being carried to the graveside by deputies and female citizens has lengthened considerably, as indicated also by the enlarged mound of insignia on the coffin, which now encompasses the papacy (a tiara with the inscription 'Annates'), the provincial courts (*parlements*), which had meanwhile been abolished ('Procédures horribles de tous les Parlemens du Royaume', as the subtitle of the book placed under the crowns puts it), the royal pensions ('la pature des Fainéans'), detailed in the 'Livre rouge', and the privileges of the Estates, which were abolished by decree on 19 June 1790. A new section made up of ordinary people has been added to the left rear of the procession of mourners, lending a triumphal air – a jubilant crowd of the 'Peuple vainqueur', in other words the *petit-bourgeois* stormers of the Bastille and their wives. The men are streaming out of the gateway of the courtyard of the destroyed state prison[21] and taking possession of the magnificent carriages of the aristocracy, while nearby the women have erected an altar made out of the rubble of the Bastille and are offering their jewellery to the nation. Here the well-informed artist is providing a reminder of the example of his 'colleagues' in the National Assembly on 17 June 1789, which so impressed the public:[22] 'At the front of the group, we see the wives of the Artists, Sculptors,

172 Foreground detail of illus. 171.

Engravers, Goldsmiths, etc., who were the first to carry out the project whose Author is Mme Moitte, wife of the Sculptor to the King; she bears the Casket as depositary.' In the background, crowds of people have settled down along the route to watch the spectacle.

After adding the most important achievements and key events of the first two years of the Revolution, Duplessis enhanced the fore-ground of Sergent-Marceau's picture by bringing the marching protagonists up to date. In the central group (illus. 172), the genies with their pro-reform pamphlets from 1789 have now been trans-formed into pre-revolutionary writers and revolutionary journalists. From left to right are Pierre-Jean Audouin, with his *Journal universel*, Camille Desmoulins with the *Révolutions de France et de Brabant*, Louis-Marie Prudhomme with the *Révolutions de Paris*, as well as the deliberately renamed pamphlet *Crimes des Rois et reines de France*,[23] and further to the right, Marat with the *Ami du Peuple*; between them are the intellectual groundbreakers of the Revolution: Gabriel-Bonnot de Mably with his *Observations sur l'histoire de France* (1765), the Abbé Guillaume-Thomas Raynal with the *Histoire des deux Indes* (1770–80), and Jean-Jacques Rousseau with the *Contrat social* (1762). This entire group of publicists is flanked by opposing pro- and anti-revolutionaries: to the left, by aristocrats who had emigrated, to the right, by members of the Paris Jacobin club, which had become considerably more radical since autumn 1791, and the Revolution Society in London under the leadership of its president, Charles, 3rd Earl Stanhope, who on the first anniversary of the storming of the Bastille had delivered a speech expressing solidarity with the French National Assembly. The two figures at the side serve to accentuate the revolutionary character of the foreground: while the brewer Antoine-Joseph Santerre from Faubourg Saint-Antoine,[24] who is seated on a barrel, is seen laughing at the aristocrats and displaying the plebeian sociability of the *sans-culottes*, Chronos and the deeply notched oak

tree indicate the abolition of feudal rights ('Fin du règne féodal'), which had largely been agreed by August 1789, but which only really came into effect two years later, after the decree of 25 August 1792, which resulted in eliminating the right of the landlords to any compensation.

Not content with extending – both to the front and rear – the line of people accompanying the coffin in the original, Duplessis also made allegorical use of the sky above in order to make the triumphal progression of revolutionary principles absolutely unequivocal. The struggle between the opposing forces on the ground, which are driving the Revolution forward, is reflected symbolically in the heavens; above left, the figure of the king personifies the aristocratic might of the *ancien régime*. In contrast to Sergent-Marceau, who at least displayed some loyalty to the king with the gun cartridge, Duplessis' stance is decidedly anti-royalist.[25] Just as the revolutionaries toppled the Bourbon monuments from their pedestals in August, in this picture the 'Liberté française' is deftly sweeping the infantile-looking monarch from the throne, or to be more precise, from his cosy love nest. His broken sceptre, his crown and the hated 'Lettres de cachet et Ordres du Roi' are tumbling down with him, in fact exactly above the battlements of the Bastille, symbol of the old despotism. A cupid of sorts is carrying a banner commenting on this dual downfall with a repudiation of the absolutist doctrine of the grace of God: 'La Liberté vient de Dieu, l'Autorité des Hommes'. The fallibility of the monarchy is contrasted with a stable bronze column with the names of the revolutionary powers: 'the small number of Patriot Deputies in the Constituent Assembly, whose cherished Memory will be venerated in the centuries to come'. Despite this time limit, the 52 names listed in the legend, to which a genie is still adding, are not only those of revolutionaries of the 'first hour', such as the commander of the National Guard, Gilbert Motier de La Fayette and mayor Bailly, the organizer of the tennis-court oath; not only authors of the Constitution, such as Emmanuel-Joseph Sieyès and Jean-Baptiste Target, but also leading radicals such as – at the top of the list – the Jacobin Pierre-Louis Roederer, who on 10 August 1792 arranged for the royal family to take refuge in the parliament, and Maximilien Robespierre, who was admitted to the National Assembly in October 1791. According to the inscription on its base, the 'Constitution' is written on the commemorative column; this is not, however, the Constitution of September 1791, relating to the constitutional monarchy, but the republican Constitution of 1793, which superseded it.

Unveiled 'Vérité' is hovering between the king and the Constitution, like a protective angel in a votive picture, keeping watch over earthly creatures. In this case she is limiting herself to directing beams of enlightenment onto grievances, the parliamentary president, and also Bailly and the book of law ('la loi'), thereby lending a quasi-religious overtone to the entire scene without altering its course. For this mighty procession, which in the final analysis can be considered as the progression from the *ancien régime* to the Republic, is following the Revolution's own dynamic. Furthermore: it is the actual revolutionary process itself.

A symbolic system for the revolutionary process

The symbolism of the funerary procession, which was also a favourite motif of political satire in certain contexts,[26] had the advantage of portraying the progress of the Revolution by means of a sight familiar to contemporaries. However, it was less suited to portraying the interconnections of revolutionary events, or to looking beyond the funeral – to examining abuses, or the monarchy, for example; hence the pictorial accretion to the print by Duplessis that has just been examined, plus the surfeit of ever more details and textual additions.

A quite different technique was used in the case of a group of large-format etchings published at the turn of 1791–2, which displayed the vicissitudes of the Revolution in the form of a board game. These successful prints took the popular tradition[27] of the didactic 'jeux de l'Oie', skilfully adapting and politicizing it.[28] They all feature a chain of 63 segments (illus. 173),[29] beginning on the outside with the storming of the Bastille, then winding inwards towards the adoption and signing of the first French Constitution in September 1791, the 'goal'. Although there are a number of differences between the versions produced by competing printmakers, some segments were common to all, featuring the same key scenes and symbolism of the Revolution. These events ranged from the unification of the Estates and the patriotic sacrifice on the part of the wives of the artists, to the secularization of the monastic orders, the first Festival of Federation and the failed attempt at escape by Louis XVI. When playing this game from start to finish, players followed the entire revolutionary process, from Bastille to Constitution. If they landed on a 'snake' segment, such as 'Parlemens', they would be thrown back, but they would move forward quickly if they landed on a 'ladder' segment such as 'the procession of the market women to Versailles'. In the process they experienced visual reminders, for the

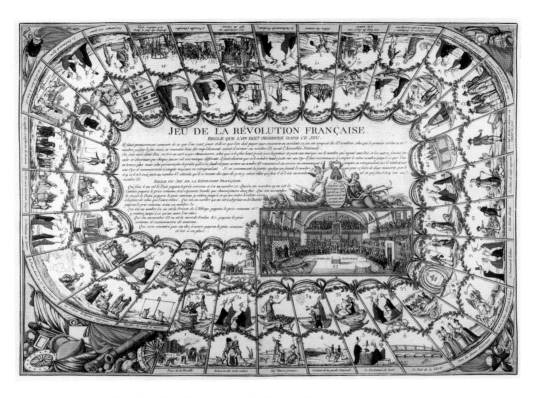

173 *French Revolution Game*, coloured etching, 47 x 64.5 cm, 1791–2.

pictures on the segments of the game are approximately half-size reproductions of revolutionary prints. These games therefore had a dual function: they were miniature galleries of the most popular caricatures, which even the less well off could afford, and they also served as publicity for the originals. Furthermore, they united multifarious individual contemporary prints into one symbolic system of pro- and anti-revolutionary strengths and principles.

One of these prints,[30] which was created and distributed by the by now familiar Paul-André Basset, developed this method of visualizing the Revolution still further (illus. 174). The title and the theatrical framing both served to promote the dual patronage of the still popular 'good king' Henri IV, who had once promised the French people 'la poule au pot' (a chicken in every pot),[31] and Michel Gérard,[32] the sole peasant deputy among those responsible for drafting the Constitution, who also gave his name to the most popular people's almanac produced during the Revolution.[33] Basset gave the individual miniature segments of the board game particularly detailed titles, in some

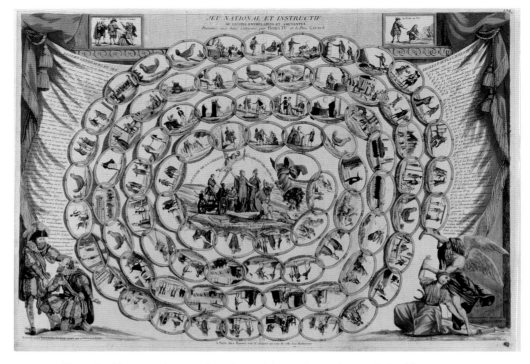

174 *National and Instructive Lesson, or Exemplary and Amusing Lessons Given to the Good Citizens by Henri iv and Father Gerard*, coloured etching, 50.7 × 73.7 cm, Paris: Basset, 1791–2.

cases with contemporary colloquialisms, in others with current events and the names of leading political figures. Furthermore, he arranged the misdeeds of the *ancien regime* against the corresponding achievements of the Revolution in an ingenious system of moves and counter-moves.[34] For example, if a player lands on the 'snake' segment 'Aristocrates' (no. 67), he is sent back to 'Les Droits de l'Homme' (no. 41), whereas he goes forward twenty segments to 'Liberté' (no. 74) if he lands on the 'ladder' of 'Le 14 Juillet 1789' (no. 54). Furthermore, Basset extended the chain of segments of the game to 83 (the number of French *départements* at that time) in order to set the year 1791 in a longer historical time scale: commencing the history of France with its mythical antecedents, and looking forward to the hoped for future outcome of the Revolution and its consequences. The names of the segments of the game, which are coiled round the print in a linear system, reveal the extent to which the Revolution is portrayed as an acceleration and intensification of a lengthy history of progress. The chronological information provides additional clarification (illus. 175).

HISTORICAL EPOCHS		THE GAME'S FIELDS. CONCEPTS
Natural state		*Égalité*
Wars of Religion 1559-1589		*Usurpation · Esclavage · Ignorance · Séduction · Guerres civiles · Anarchie · Cruauté*
1589-1610		*Henri IV · Bonté · Société · Loi · Bien Public*
Absolutism 1610 to 1748	Principles	*Trahison · Despotisme · Esprit de Conquête · Intrigue*
	Guilty Parties	*Clergé · Noblesse · Ministres · Fermiers généraux*
	Means	*Petites Maisons · Impôts · Lettre de cachet · Bastille*
	Results Victims	*Dette Nationale · Misère · Tiers État · Banqueroute*
Enlightenment 1748 - 1789		*Montesquieu · Courage · Voltaire · Philosophie · Tolérance · Rousseau · Droits de l'homme*
Revolution 1789 to 1791	Events Persons	*14 Juillet · Fédération · Acceptation Mirabeau · Louis XVI · Dauphin*
	Principles Virtues	*Révolution · Don patriotique · Religion · France · Gloire · Vigilance*
	Symbolism	*Autel de la patrie · Cocarde nationale · Autel de l'hymen · Citoyennes françaises*
	Institutions	*Assemblée nationale · Pouvoir législatif · Pouvoir judiciaire · Responsabilité · Force armée · Nouvelle Constitution*
	Opposing forces	*Princes · Dissimulation · Varennes · Contre-révolutionnaires · Aristocrates · Moines · Discorde · Inconstance*
Future		*Concorde · Liberté · Couronne civique · Amour du prochain · Prince royal · Régénération · Paradis · Apothéose des grands hommes · Nouvelle éducation*

175 The chrono-thematic schema of Basset's *National and Instructive Game.*

The course of history can be summarized thus: ejected from Paradise by the 'Fall', oppressed by slavery and the superstitions peddled by the clergy, France sank into the mire of religious wars, experienced a brief respite under Henri IV, then suffered for a century and a half under despotic absolutist regimes, until Montesquieu, Voltaire and Rousseau – just these three – disseminated the principles of freedom, until, as a direct consequence, the Revolution took up their ideas, and, against great opposition from the aristocracy, developed the Constitution of 1791 on the basis of them; this was rudimentary at first, as further enlightenment and education of the

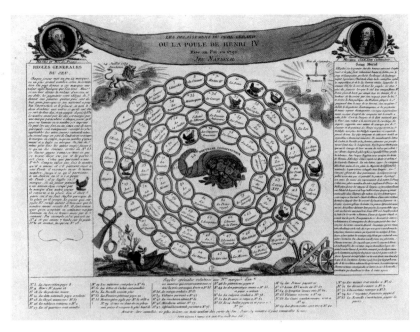

176 Anonymous coloured etching, 43.3 × 5.5 cm, 1792.

citizenry were necessary before the letter of the law could become a political and cultural reality.

Three adaptations of Basset's print,[35] which proved to be especially successful, confirmed this interpretation. In order to reduce costs and keep it within the means of the man in the street,[36] it eliminated the illustrations in the segments of the game, but added on the right side a *Sens moral* text (illus. 176), which developed the chain of segment names into a progressive history of salvation.[37]

The final sections of the game, which appear to be almost in the style of Christian visions of the future, are even more remarkable than either the emphatic condemnation of absolutism, or the close connection between the Enlightenment and the Revolution, which are presented in both the game itself and the accompanying text. Instead of ending with the adoption of the Constitution (segment 65), as in shorter revolutionary games, Basset inserted fifteen further segments before the goal of the Constitution. Relating to the Jacobin republic, they prefigure a future characterized by the development of martial and moral virtues – from the 'love of the nation' to 'new education'. The game also clearly presents the Revolution as the driving force in a progressive history with an open future, as the other two time zones of the game also contribute to this perspective, not

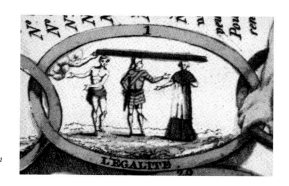

177 *Equality*. Segment no.1,
National and Instructive Lesson
(detail of illus. 172).

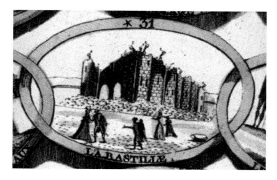

178 *La Bastille*. Segment
no.31, *National and Instructive*
Lesson (detail of illus. 172).

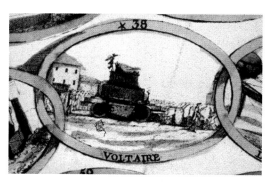

179 *Voltaire*. Segment no.38,
National and Instructive Lesson
(detail of illus. 172).

only those segments relating to the years 1789-91. The mythical
natural state of France (illus. 177), for example, is visualized by means
of a well-known pictorial satire concerning the equalization of the
Estates (see illus. 100). The despotic incarcerations common under the
ancien régime are evoked by the symbol of their abolition, taken from a
contemporary print of the demolition of the Bastille in July 1789
(illus. 178 and 180). The triumphal carriage that conveyed Voltaire to
the Panthéon (see illus. 2) stands for his works on the Enlightenment
(illus. 179). The future is likewise portrayed by means of standard

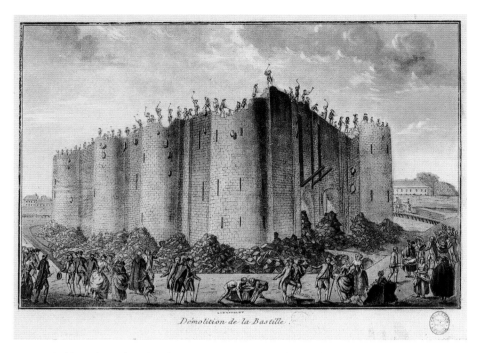

Démolition de la Bastille .

180 Joseph–Alexandre Le Campion after François–Martin Testard, *Demolition of the Bastille*, coloured aquatint, 19.4 x 28.8 cm, 1789.

pictorial representations of the revolutionary present, for example, the aforementioned oft-depicted contribution of the artists' wives in September 1789 serves as the model for a new *mentalité* on the part of the citizens (illus. 181 and 182). The future reward for services to the state is represented by the emblem of the Panthéon. The resurrection of France, represented by Isis (illus. 183), was subsequently erected as a monument in the Fontaine de la Régénération as part of the anniversary celebrations on 10 August 1793 (see illus. 90).

Basset's pictorial history expressed a tripartite vision of the Revolution: as a dialectic process in the present, unfolding in an interconnected chain of key events; as the driving force in a long-term political development from despotism to liberty; and as a symbolic system of values, generating a new perspective on the past and the future.

From revolutions to revolution

Radical pictorial satires were anathema so far as the censors of the Empire and the Restoration were concerned, so did they also try to suppress this new view of the Revolution as freedom-loving and

future-orientated? At first glance it could appear so. However, one anonymous engraver returned to old conceptions of the Revolution, as espoused from the Abbé de Vertot to Chateaubriand, when designing his synoptic schema of 'state revolutions' in 1817 (illus. 184). His conception of the new history was not of a progressive, interconnected series of events designated 'revolution', but as a pendulum, ever alternating between extreme and moderate political regimes. However, he did not represent this idea pictorially. Instead of characterizing the regimes iconographically, as Basset had done with his revolutionary board game, he meticulously described their characteristics beneath the scale,[38] so that the extensive text dominates the drawing. The detailed legend explains the swings of the pendulum, labelled 'the people'. It also contains a reference to the police minister Elie Decazes, who in 1815–16 inveigled Louis XVIII into 'seesaw politics' between the two parties, thereby linking the print to the contemporary circumstances behind it:

Nations tend towards a liberal Government, just as the pendulum tends towards its equipoise, the centre of the arc described by its oscillations. Does a people, through abuses or through a deviation of any kind, lose its state of equilibrium? Is it lured to the point where le bon plaisir holds sway? Then

181 *Oh Bravo Ladies It's Your Turn*, coloured etching, 22.5 x 33.9 cm, 1789.

231

182 *French Women Citizens.*
Segment no. 72, *National and
Instructive Lesson* (detail of
illus. 172).

183 *La Régénération.* Segment
no. 79, *National and Instructive
Lesson* (detail of illus. 172).

with its own weight, just like the pendulum, it throws off the obstruction which held it in that unnatural state. Then, since peoples are no less subject than the pendulum to the laws of gravity, when left to themselves they pass rapidly through that point of rest, the equipoise; they will only settle in that point after a number of oscillations. The see-saw pattern is merely an accident of nature. – Decazes, the favourite, was not aware of that, for he sought to keep that pattern going indefinitely, and did not know enough to stop it where it will sooner or later settle: at the rule of Law. Napoleon seized hold of the pendulum at the moment when its oscillation was coming to an end and it was about to recede downwards; where he failed was in believing the French people could be brought to rest at such a distance from the goal of Civilisation. (The philosopher Statesman who comprehends the harmony of the Universe, and analyses its laws, does not infringe them so as to betray humankind.)

On the tricolor scale, libertarian and moderate regimes are grouped in the centre around the vertical resting axis of the pendulum, to become – in the author's view – correspondingly more authoritarian the more they swing away from it towards either the left or the right. By this he meant in the sense of the new political spec-

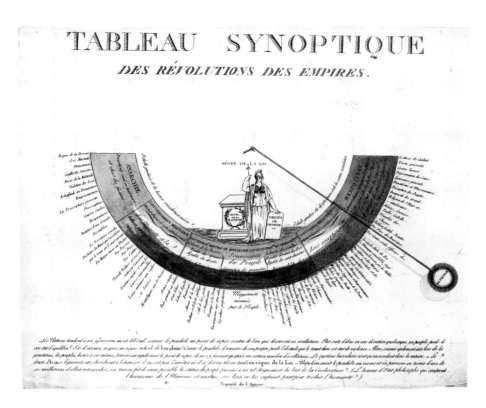

184 *Overview of the Revolutions of Empires*, coloured etching, 34 x 30 cm.

trum that developed along with the Revolution, for on the left side, 'anarchie' and the 'Gouvernement militaire' have joined 'licence révolutionnaire', whereas on the right side, 'Despotisme' and the 'Gouvernement féodal' are both allied with the 'contre-révolution'. The illustration and the legend indicate an initial swing of the pendulum in contemporary France from left to right: from the Revolution, with its 'Règne de la Terreur' and the 'Dictature d'une Grande Assemblée', by way of Napoleon's military dictatorship, to the 'Gouvernement féodal' of the Restoration, which was at that time on the point of degenerating, by way of the 'Lois exceptionnelles' at the end of 1815, to the 'Despotisme' of the 'Lettres de Cachet' and 'Fanatisme'. However, it predicts that the counter-revolutionary swing would not go any further, because the pendulum – according to the rules outlined in this lesson in the law of political-historical gravity – would soon swing back to 'Monarchie constitutionnelle et démocratique', indeed to a 'Gouvernement républicain', which would respect both the principles of the 'Souveraineté du Peuple' and of liberty and

equality. Thus in the centre of the print is an altar to the nation, and Minerva pointing to a tablet inscribed with human rights.

The print expresses an ambivalent relationship to the Revolution in France in particular, and to revolutions, in the new sense, in general. On the one hand, the author drew positive conclusions from the hard-won political experiences post-1789, valorizing the 'people' as the powerful, even if also rather crude, driving force of history, and praising the fundamental revolutionary values of liberty and equality under the law; on the other hand, he detached the values of the Revolution, portraying them as the guiding principles of a future idealized regime, while the French Revolution itself is reduced to the Terror, and thereby downgraded to a 'faux pas'. Being for the most part in tune with the political liberalism of Benjamin Constant,[39] he acknowledged a few of the achievements of the French Revolution; but he no longer considered *révolution(s)* – as Duplessis and Basset did – to be a necessary part of progress, but rather the inevitable chaos accompanying any change of political order.

The July Revolution of 1830, which had been predicted to some extent in the print just discussed, revealed that the change of meaning of the concept 'revolution' was not easily reversed. The 'Trois glorieuses' appeared to people at the time to be a continuation of '89', and reinforced, for the pictorial arts, the historical perspective with regard to the Revolution.[40] The metaphorical description of the Revolution as the modern political equivalent of a force of nature, which was formulated in writings during the 1790s,[41] now began to appear in imagery as well. A tract from 1796 compared the Revolution to a river, bursting through the barriers erected to hold it back, and carrying everything along in the torrent.[42] The journal *Le Charivari* of 1834 published a lithograph illustrating this vision, in fact with reference to the July monarchy (illus. 185). Two leading representatives of the reactionary politics of Louis-Philippe have been dashed against a deadly boulder in the raging torrent: on the left is the public prosecutor Jean-Charles Persil, who is helplessly clutching a coat of arms with the Bourbon lilies, and as he drowns he is lifting his bill of indictment up above the rapids; on the right is the minister for commerce and public works, Antoine-Maurice, Comte d'Argout, with a bag of embezzled state funds. The revolutionary torrent (*le torrent révolutionnaire*) is almost upon the Citizen King in the dark foreground, recognizable by his obligatory umbrella and top hat. He is about to be swept away, along with his plans for fortifying Paris.[43] The legend, apparently adapted from the Bible, reads: 'Ils voulurent

LE TORRENT RÉVOLUTIONNAIRE.

Ils voulurent opposer une digue au torrent, et le torrent les emporta eux et la digue.

(*Ecritures Saintes*)

185 *The Revolutionary Torrent*, lithograph, 23.5 × 30.5 cm, 1834.

opposer une digue au torrent et le torrent les emporta eux et la digue',[44] ascribing a historical mission of salvation to the Revolution. The setting sun in the background signifies a bright realm of liberty, in whose sunny climes all jagged rocks, all reactionary obstacles, will be swept away.

The view that the Revolution would not turn out to be only a short-lived eruption of elemental forces, but would continue to rumble on underground, being continually fed by accumulated political–social explosives, was expressed more pithily and with more general relevance by the metaphor of a volcano.[45] Examples of its use include Georg Forster's majestically flowing 'lava of the Revolution',[46] Gillray's *Eruption of the Mountain*,[47] George Cruikshank's prophetic print of the Battle of Waterloo (illus. 186),[48] and numerous others in the 1830s.[49] None of these representations surpassed the insight and general relevancy of a coloured lithograph published in the weekly newspaper *La Caricature* to coincide with the first anniversary of the failed Paris uprising by the republican left from 5 to 6 June 1832. The publisher Philipon attached such importance to this print produced by his lithographer Auguste Desperret (illus. 187) that, unusually, he provided a detailed commentary upon it:

For a long time now, they have been telling us: WE ARE SITTING ON A VOLCANO [. . .]. But it has already erupted. In the crater of this volcano is a ceaseless fermentation of injustices, acts of violence and oppression, tyrannies of every sort, mingled with the hatreds of the people; on the vast sides of the volcano, the whole of Europe is boiling; this volcano exploded for the first time in '89. That was a huge eruption that shook the world terribly, and you can still see traces of it in these ruins: wrecked towers, châteaux, dovecotes, fortresses, feudal moats; those ruins of divine right, of tithes, rights of primogeniture, *droits du seigneur*, etc., which are lying about in the vicinity of the volcano. Several times, since then, deranged architects have sought in vain to gather up the scattered debris, memorials of a different century; every time, the volcano rumbled, the volcano started the earth shaking, and their formless half-built piles have collapsed. It was 1830 when its second eruption occurred; that time it hailed cobblestones down on the monarchy. And now, when will the third one happen? Where, how, why? Will it be in France yet again? Will it be somewhere else? Will it be in a hundred years? Will it be in two thousand years? Only Mathieu de Laensberg could predict those things for us. But one thing is certain: that third eruption will happen. It cannot be doubted, when on all sides you can feel the ground growing hot and shaking as you walk; when countless small craters are incessantly lighting up; here, there, everywhere, in Belgium, in Poland, Italy, Spain, Portugal, Germany, Piedmont, even in Monaco! – Besides, the third eruption will strike no fear into people's hearts, if we are to believe both our presentiments and the positive assurance given to us by the creator of this beautiful sketch, showing us the new Europe emerging from the very lava of the volcano. Be that as it may, I shall ask Mathieu de Laensberg who those individuals are who are running away at the first tremor, in headlong flight [. . .]. But whoever they may be, *bon voyage*![50]

Auguste Desperret, who was supposed to have developed his pictorial creation in collaboration with Philipon,[51] visualized the revolutionary process as a chain of historical volcanic eruptions, fuelled by a volatile political–social mixture consisting of the ever increasing tension between the oppressors on the one hand and the people on the other: 'injustices, violences, oppressions, tyrannies de toute sorte, mêlées aux haines populaires'. As the main heading of the picture puts it, the 'volcano of 1789' ignited the revolutionary eruptions that followed. It refers to three volcanic eruptions occurring in different areas of the picture and at different times.

The artist intended the high ground in the forefront, which is strewn with debris, to be a reminder of the French Revolution, which he specifically evokes with the date '1789', which is written next to the open entrance in the ruined wall, beneath two crossed swords. This symbolizes the ruins of the *ancien régime*, as indicated by captions on the scattered rubble of the wall ('Droit d'aînesse, Féodalité, Droit

186 George Cruikshank after George Humphrey, *An Eruption of Mount Vesuvius; And the Anticipated Effects of the Waterloo Storm,* coloured etching, London, H. Humphrey, 17 June 1815.

187 Auguste Desperret, *The Third Eruption of the Volcano of 1789,* lithograph, 1833.

Divin, Dîmes'), and confirmed by the elaboration in the commentary. In similar fashion to pictorial satires on the *Convoi des abus,* which had already appeared by 1789, Desperret conflates the Revolution with the destruction of the 'feudal' abuses of the old France, without acknowledging the contemporary constitutional achievements. There is a notable distancing from the Jacobin dictatorship, which can be discerned from Philipon's remark that the first volcanic eruption had been 'terrible'. The effects were felt long afterwards – the supporters of the *ancien régime,* who are identified ironically in the accompanying text in the manner of headings in a popular almanac (including Louis XVIII and Charles X among others), can only turn and flee with all their chattels when their attempts at restoration have been foiled by a number of aftershocks.

Ignited underground by 1789, the volcano of the Revolution is erupting in the centre of the picture for the second time, spewing out a mighty gush of magma with the inscription 'Juillet', meaning the July Revolution of 1830. While the artist leaves the wasteland of the first Revolution in the shade of the past, the environs of the renewed eruption is shown in full light, as if to ascribe the achievements of 1789 to the new 'eruption' in the present. The flames of freedom are blazing forth from the crater, lighting up the European mountain range. The streams of lava pouring down the slopes are threatening only the enemies of liberty, whilst those on the side of liberty find themselves on fertile ground. The states created by the July Revolution have already organized themselves and planted their republican flags in the ground: with France in the lead, then the crater, followed by, among others, Germany, Belgium, Italy, Piedmont, Spain, Portugal and Poland. This was in 1830, and the first genuinely freely produced view of the actual political situation, in the light of the ensuing political reactions, which anticipated with remarkable accuracy the 'European revolution' of 1848–49.[52]

What of the third 'volcanic eruption', which Duplessis purported to portray in detail? This remains out of sight in the future, indicated by the small banner of the 'lava republics', also the revolutionary movements that are flaring up here and there, such as the 1832 uprising of the Paris workers, which is only referred to in Philipon's commentary. However, the significance of the picture goes far further, heralding the final redemptive and most noble of all revolutions; a revolution in which the number of volcanic eruptions would conclude with a triumvirate unity; or, as the subheading expressed it in a visionary, even eschatological way: 'Which must take place before the end of the world, will cause all the thrones to tremble and will overthrow a host of monarchies.'

The new political understanding of the age, which developed after 1789 out of the experience of the progression of the Revolution, the effects of which extended far beyond the boundaries of time and geography, the 'Revolution' of the modern age, can seldom have been portrayed more suggestively or incisively.

Chronology

POLITICS	YEAR / MONTH	CULTURE
	1787	
First Assembly of Notables convenes (22 Feb–25 May)	February / May	Jacques-Louis David, *The Death of Socrates* Hubert Robert, *Le Pont du Gard* – Houdon, *La Frileuse* – Mme Vigée-Lebrun paints *Marie-Antoinette et ses enfants*
Attempt at reform by Provincial Assemblies	June	
Defeat of Dutch 'Patriots' by British and Prussian troops	July / September	
Tolerance edict on behalf of Protestants	November	
	1788	
Edicts against the Parlements stalled	May	Jacques-Louis David, *The Lictors Bring to Brutus the Bodies of His Sons*
	July	De facto abolition of censorship (5 July)
Estates-General of 1789 declared bankrupt (8 Aug) – state bankrupt (16 Aug)	August	
	September	Pamphlet campaign for the rights of the Third Estate (Sept)
Second Assembly of Notables (6 Nov– 13 Dec)	November	
Doubling of the number of mandates of the Third Estate (27 Dec)	December	

	1789	
	January	Emmanuel Sieyès, *Qu'est-ce que le Tiers Etat?*
Elections to the Estates-General (Feb–March)	February	
	March	*Cahiers de doléances* written (March–May)
Workers riot against the Réveillon paper factory (28 April)	April	
Meeting of the Estates-General in Versailles (5 May)	May	
Third Estate declares itself to be *Assemblée nationale* (17 June) – Tennis Court Oath (20 June)	June	
Dismissal of Minister Jacques Necker (11 July) – Paris turnpikes burnt down (12 July) – Creation of a Citizens' Guard (12 July) – Bastille falls (14 July) – Bailly Mayor of Paris, Lafayette Commander of the National Guard (15 July) – Necker reinstated (16 July) – Foulon and Berthier lynched by mob (22 July) – Peasant uprisings and *Grande Peur* in the Provinces (19–30 July)	July	Appearance of Tricolor (15 July) – Destruction of Bastille led by construction entrepreneur Pierre-François Palloy (15 July) – Press revolution, first appearance of weekly newspaper *Révolutions de Paris* (18 July) – First performance of tragedy *Charles ix* by Marie-Joseph Chénier (19 July)
Nominal Abolition of Feudalism (4–5 Aug) – *Déclaration des droits de l'homme et du citoyen* (26 Aug)	August	Art Exhibition in the Salon Carré of the Louvre shows Antoine Vestier's *Portrait de Latude* and Hubert Robert's *Bastille* (25 Aug–6 Oct)
	September	First issue of the newspaper *Ami du Peuple* by Jean-Paul Marat (12 Sept)
The market women go to Versailles and fetch the royal family back to Paris (5–6 Oct) – Founding of the Jacobin Club (19 Oct) – *Loi martiale* against tumults (21 Oct)	October	First issue of *Gazette nationale ou Moniteur universel* (24 Oct)
Nationalization of Church property (*biens nationaux*, 2 Nov)	November	First issue of *Révolutions de France et de Brabant* by Camille Desmoulins (28 Nov) – First Festival of Federation in Dauphiné (Nov)

Introduction of paper currency called *Assignat* (19 Dec)	December	
	1790	
	January	Uprising peasants in Périgord and Quercy start planting liberty trees
	February	Abolition of orders of monks and monastic vows (13 Feb) – Highly profitable nationwide performances of Voltaire's drama of liberty *Brutus* (up to 1794)
Founding of *Cordeliers* Club (27 April)	April	
Law regarding sale of church property (14 May)	May	High point of Festivals of Federation in the provinces
Abolition of aristocratic titles (19 June)	June	
Constitution civile du clergé (12 July)	July	Festival of Federation in Paris (14 July) – Dance festival on the ruins of the Bastille (16–18 July)
Mutiny of the garrison at Nancy put down (31 Aug)	August	
Abolition of Parlements (6 Sept)	September	Founding of *Archives nationales* (7 Sept) – First issue of revolutionary newspaper for rural population: *La Feuille villageoise* (26 Sept)
Removal of domestic tolls (31 Oct)	October	Lily banner replaced by the Tricolor flag (21 Oct)
Oath to constitution by clergy (27 Nov)	November	*Reflections on the Revolution in France* by Edmund Burke (1 Nov) – First issue of radical newspaper *Le Père Duchesne* by Jacques-René Hébert
	1791	
Abolition of Paris Customs barriers (19 Feb) – Swearing in of *Chevaliers du poignard* (28 Feb)	February	Founding of École d'Architecture
Suspension of trade (2 March) – Pope Pius VI condemns the Civil Constitution of the clergy (10 March) – Abolition of 'tax farming' (20 March)	March	Lenoir founds museum Monuments français

	March	
Establishment of *Tribunal révolutionnaire* (10 March) and *Comités de surveillance* (21 March) – Victory of the Vendéans over revolutionary troops at Pont-Charrault (19 March) – General Dumouriez beaten at Neerwinden (18 March)		J.-L. David presents his painting *Michel Le Peletier de Saint-Fargeau sur son lit de mort* to the Convention (29 March) – Legislation regarding establishment of primary schools (30 March)
Appointment of Comité de Salut Public (6 April) – Marat arrested and acquitted on appeal (12–24 April)	April	All French people to wear the revolutionary cockade (3 April)
Maximum tariff for grain fixed (4 May) – Armed *sans-culottes* force purge of Girondin deputies from *Convention*, 29 *Girondins* arrested (31 May–2 June)	May	Founding of the Société des Citoyennes Républicaines Révolutionnaires (10 May)
Manifeste des Enragés conferred on Jacques Roux in Convention (25 June) – Agreement of republican Constitution (24 June)	June	Founding of the Museum d'Histoire Naturelle (10 June)
Charlotte Corday stabs 'people's friend' Marat (13 July) – Constitution accepted by the people (14 July–4 Aug) – Robespierre a member of the Committee of Public Safety (27 July)	July	Law regarding seizure of foreign art treasures (13 July) – Resolution regarding creation of Musée national in the Louvre (27 July) – Jacques Mallet du Pan, *Considérations sur la Révolution de France*
War of attrition against the Vendée concluded (1 Aug) – *Levée en masse* (23 Aug)	August	Introduction of unified metric system (1 Aug) – Abolition of the Academies (8 Aug) – Festival of the Unity and Indivisibility of the Republic, as planned by David (10 Aug) – The Salon exhibits almost 700 works (10 Aug-10 Sept), among them *La Fédération des Français* by Pierre-Antoine Demachy and *La Journée du 10 Août 1792* by Jacques Bertaux
Sans-culottes force radicalization of the Revolution (4–5 Sept) – Legislation regarding *Suspects* (17 Sept) – Beginning of the Terror – *Maximum* fixed for prices and wages (24 Sept)	September	All public signs of royalty and feudalism to be destroyed (14 Sept) – Abolition of the universities (15 Sept)

'Federalist' uprising of Lyon put down (9 Oct) – Legislation regarding *Gouvernement révolutionnaire* (10 Oct) – Republican victory over Vendéans at Cholet (17 Oct) – Guillotining of Marie-Antoinette (19 Oct) and 21 Girondins (31 Oct)	October	Introduction of the republican calendar (5 Oct) – J.-L. David presents his picture *The Death of Marat* to the Convention (14 Oct) – Beginning of 'de-Christianization' (to April 1794) – All citizens to wear the cockade until peace (29 Oct) – Women's clubs prohibited (30 Oct) – Comité de Salut Public proposes universal use of 'tu' form (31 Oct)
	November	Rising tide of revolutionary names (Nov '93–Dec '94) – Start of cult of *Raison* in Notre-Dame (10 Nov) – J.-L. David presents to Convention his plan to erect a colossal statue of the *French People* (7 Nov) – Robespierre's speech against de-Christianization (21 Nov)
The *Représentant en mission* of the Convention, Jean-Baptiste Carrier, permits mass drowning of 'suspects' in the Loire (6–7 Dec) – The 14-year old Tambour Joseph Bara falls in battle against the Vendéans (7 Dec)	December	First issue of newspaper *Le Vieux Cordelier* by Camille Desmoulins (5 Dec) – Compulsory universal school attendance, free education (19 Dec)
	1794	
	January	Competition for provision of elementary text books for primary schools (Jan '94–Nov '95)
Carrier from Nantes recalled (8 Feb) – Suicide of Jacques Roux in prison (10 Feb) – Abolition of slavery (4 Feb)	February	J.-L. David paints *The Death of Joseph Bara*
Condorcet dies in prison (28 March) – Execution of the 'Hébertists' (22 March)	March	
Execution of 'Dantonists' (5 April)	April	Pantheonization of Rousseau decided on (14 April) – Call for bids for several architectural competitions (17 April–17 May)
Execution of 27 former 'tax farmers' (8 May)	May	Robespierre's speech on republican principles (7 May)

Beginning of *Grande Terreur* (10 June) – Defeat of Austria at Fleurus (26 June)	June	École de Mars founded for training of officers (1 June) – Festival of the *tre suprême* (8 June) – David presents to Convention his plan for Pan-theonization of the youthful heroes of liberty Bara and Viala (11 June)
Robespierre overthrown on 9 *Thermidor* (27 July) and guillotined with 105 of his supporters (28 July)	July	
478 political prisoners released (4–5 Aug) – Formation of Thermidor government (24 Aug)	August	First report by Grégoire on revolutionary 'vandalism' (31 Aug)
Separation of Church and state (18 Sept)	September	First use of visual telegraph system developed by Claude Chappe (1 Sept) – Committee of Public Safety finances 18 caricatures against the coalition forces (12 Sept–5 Oct) – Pantheonization of Marat / De-pantheonization of Mirabeau (21 Sept) – Founding of the École Centrale des Travaux Publics (24 Sept)
	October	Founding of the Conservatoire National des Arts et Métiers (10 Oct) – Rousseau's remains conveyed to the Panthéon (11 Oct) – Founding of the École Normale Supérieure (30 Oct)
Closing of Paris Jacobin Clubs (19 Nov) – Trial of Carrier (23 Nov)	November	
Return of 73 surviving Girondins to the Convention (8 Dec) Abolition of Maximums (24 Dec)	December	
	1795	
Founding of Batavian Republic (3 Feb) – Law regarding separa-tion of Church and state and freedom of religion (21 Feb)	February	Children drag busts of Marat in the gutter (2 Feb) – Removal of remains of Marat, Bara and Viala from the Panthéon (8 Feb) – Condorcet, *Esquisse d'un tableau historique des progrès de l'esprit humain* – Founding of Écoles Centrales in the *départements* (25 Feb)

Revolt of *sans-culottes*: 'Du Pain et la Constitution de 93' (1 April)	April	
Fouquier-Tinville executed along with other members of the *Tribunal révolutionnaire* (7 May) – Last stand and arming of *sans-culottes* (20–23 May) – Abolition of *Tribunal révolutionnaire* (31 May)	May	
Counter-revolutionaries' expeditionary corps driven from Quiberon peninsula (21 July)	July	Founding of Collège de France (13 July)
Directoire Constitution (22 Aug)	August	Founding of Conservatoire National de Musique (3 Aug)
Positive Referendum on new Constitution (6 Sept)	September	Founding of École Polytechnique (1 Sept) – *La Liberté ou la Mort* by Jean-Baptiste Regnault
Royalist Vendémiaire uprising defeated by Bonaparte (5 Oct) – Convention dissolved, beginning of government of the Directoire (26 Oct)	October	Repeal of free education (25 Oct) – Place de la Révolution becomes Place de la Concorde (26 Oct) – Grégoire's second and third report on 'vandalism' (29 Oct, 14 Dec)
Babeuf's newspaper *Le Tribun du Peuple* publishes the *Manifeste des plébéiens* (30 Nov)	November	
	December	Founding of Académie des Sciences Morales et Politiques
	1796	
	February	Marat's remains removed from the Panthéon (8 Feb)
Napoleon Bonaparte named Commander in Chief of army of Italy (2 March)	March	
	April	First assembly of the Institut National des Sciences et des Arts (4 April) – Repeal of freedom of the press (16 April)
'Oath of equals' exposed, Gracchus Babeuf and supporters arrested (10 May)	May	
Founding of Cisalpine Republic in Milan (9 July)	July	

Formation of Cispadane Republic (16 Oct)	October	*Portrait de la citoyenne Tallien dans un cachot à la Force* by Jean-Louis Laneuville exhibited in the *Salon* (from 6 Oct) – Establishment of seven national public holidays (24 Oct)
Rehabilitation of priests who refused to swear the oath (4 Dec) – Failure of French attempt to land in Ireland (16–28 Dec)	December	
	1797	
	January	Inauguration of the cult of *Théophilanthropie* (9 Jan) – *Fête de la mort du tyran* (21 Jan)
End of paper currency the *Assignat* (4 Feb)	February	
Conservative election victory (March/April)	March	*Fête de la Souveraineté du Peuple* (20 March)
Babeuf and supporters executed (27 May)	May	
Founding of Ligurian Republic (5 June)	June	*Fête de l'Agriculture* (29 June)
	July	*Fête du 10 Thermidor* (28 July)
	August	*Fête de la Liberté* (10 Aug)
	September	42 newspapers prohibited (8 Sept)
	October	Nationwide mourning for fallen General Louis-Lazare Hoche (1 Oct)
	November	Police control of the press alleged (5 Nov)
Founding of the Roman Republic (28 Dec)	December	
	1798	
Founding of the Helvetic Republic (23 Jan)	January	*Fête de la mort du tyran* (21 Jan)
	February	Abbé Barruel, *Mémoires pour servir à l'histoire du jacobinisme*
	March	*Fête de la Souveraineté du Peuple* (20 March)
Election victory of neo-Jacobin Opposition	April	

Coup d'état by the Directoire: 'cleansing' of Parlement of neo-Jacobin deputies (11 May) – Beginning of Bonaparte's Egyptian Expedition (19 May)	May	
	July	Festival for entry of Italian artworks looted from Italy (27–28 July) – *Fête du 10 Thermidor* (28 July)
Nelson destroys French Fleet in Bay of Aboukir (1 Aug)	August	*Fête de la Liberté* (10 Aug) – *Fête des Vieillards* (27 Aug) – Salon exhibits *Portrait du C. Belley, ex-représentant des Colonies* by Annes-Louis Girodet-Trioson (18 Aug-6 Oct)
Loi Jourdan: Introduction of universal conscription (5 Sept) – Failure of French invasion of Ireland	September	*Fête du 18 Fructidor* (4 Sept) – Legislation regarding *Décadi* and the cycle of republican festivals (5 Sept)
	October	First national industrial exhibition on the Champs de Mars (15 Oct)
Second coalition against France (16 Nov)	November	
	1799	
Proclamation of the Republic of Naples (23 Jan)	January	*Fête de la mort du tyran* (21 Jan)
Election victory of neo-Jacobins – Outbreak of second coalition war	March	*Fête de la Souveraineté du Peuple* (20 March)
	April	*Fête de la Jeunesse* (30 April)
The Council of 500 forces 3 Directors to resign (18 June)	June	J.–L. David completes *The Sabine Women*
French lose Italy in battle of Novi (15 Aug)	August	*Le Retour de Marcus Sextus* by Pierre-Narcisse Guérin exhibited in the Salon (18 Aug–23 Oct)
Bonaparte leaves Egypt (9 Oct)	October	
Bonaparte overthrows Directoire on 18 Brumaire (9 Nov) – 'Cleansed' parliament elects Bonaparte, Sieyès and Lebrun as consuls (10 Nov)	November	
Constitution comes into force (15 Dec): as First Director, Bonaparte becomes de facto supreme ruler	December	

References

Introduction

1 Gerhard Femmel, *Goethes Grafiksammlung, Die Franzosen* (Leipzig, 1980).
2 J. W. Goethe, *Recension einer Anzahl französischer satyrischer Kupferstiche. Text– Bild– Kommentar*, ed. Klaus H. Kiefer (Munich, 1988).
3 Goethe, *Sämtliche Werke* (Artemis edition), ed. Ernst Beutler (Zürich, 1950–59), IX, pp. 403–30, esp. 406.
4 Bernadette Collenberg-Plotnikov, *Klassizismus und Karikatur. Eine Konstellation der Kunst am Beginn der Moderne* (Berlin, 1998), esp. pp. 15–60.
5 Werner Busch, *Das sentimentalische Bild. Die Krise der Kunst im 18. Jahrhundert und die Geburt der Moderne* (Munich, 1993). A few of the basic positions in this book appear in two essays by Werner Busch, 'Copley, West and the Tradition of European High Art', in Thomas W. Gaehtgens and Heinz Ickstadt, eds, *American Icons: Transatlantic Perspectives on Eighteenth- and Nineteenth-century Art* (Santa Monica, 1992), pp. 35–59; idem, 'Hogarth's Marriage A-la-Mode, the Dialectic between Precision and Ambiguity', in David Bindman, Frédéric Ogée and Peter Wagnereds, *Hogarth: Representing Nature's Machines* (Manchester and New York, 2001), pp. 195–218.
6 Busch, *Das sentimentalische Bild*, esp. pp. 9–13, 66, 75, 80–88, 110, 237–39, 474 and 479. We have followed a few of the author's formulations.
7 Michael Diers, *Schlagbilder. Zur politischen Ikonographie der Gegenwart* (Frankfurt, 1997), pp. 17–50.
8 Werner Hofmann, *Das entzweite Jahrhundert. Kunst zwischen 1750 und 1830* (Munich, 1995). Hofmann dedicates several very lucid chapters to works produced during the Revolution (esp. pp. 243–312), but regards them primarily as testimonials of the transition from 'monofocus' to 'polyfocus'.
9 R. Reichardt, 'Expressivität und Wiederholung, Bildsprachliche Erinnerungs-strategien in der Revolutionsgraphik nach 1789', in Astrid Erll and Ansgar Nünning, eds, *Medien des kollektiven Gedächtnisses: Konstruktivität – Historizität – Kulturspezifizität* (Berlin, 2004), pp. 125–57.
10 R. Reichardt, 'Stand und Perspektiven der kulturhistorischen Revolutionsforschung. Ein Überblick', in Katharina and Matthias Middell, eds, *200. Jahrestag der Französischen Revolution. Kritische Bilanz der Forschungen zum Bicentenaire* (Leipzig, 1992), pp. 234–54; idem, 'Histoire de la culture et des opinions', in Martine Lapied and Christine Peyrard', eds, *La Révolution française au carrefour des recherches* (Aix-en-Provence, 2003), pp. 205–47.
11 The bicentennial world congress he organized did not use the word 'picture' in the sense of pictorial art, but as a general metaphor, Michel Vovelle, ed., *L'Image de la Révolution française*, 4 vols (London, 1989–90).
12 Michel Vovelle, *La Révolution française, images et récit*, 5 vols (Paris, 1986).
13 With regard to this widespread tendency, compare R. Reichardt, 'Mehr geschicht-

liches Verstehen durch Bildillustration? Kritische Überlegungen am Beispiel der Französischen Revolution', *Francia. Studien zur westeuropäischen Geschichte*, 13 (1987), pp. 511–23.

14 Annie Jourdan, *Les Monuments de la Révolution, 1770–1804. Une histoire de représentation* (Paris, 1997). The first edition of this work (1993) had no illustrations; later editions contained 18 illustrations, but with no references to them in the text.

15 Prints are for the most part included, but caricatures are completely ignored.

16 Philippe Bordes and Régis Michel, eds, *Aux Armes et aux Arts! Les arts de la Révolution, 1789–1799* (Paris, 1988).

17 David Bindman, ed., *The Shadow of the Guillotine: Britain and the French Revolution* (London, 1989); Werner Hofmann, ed., *Europa 1789. Aufklärung – Verklärung – Verfall* (Cologne, 1989); *La Révolution française et l'Europe*, 3 vols (Paris, 1989).

18 For example, see studies by Thomas E. Crow, *Emulation: Making Artists for Revolutionary France* (New Haven, 1995).

19 Compare the case study by Gisela Gramaccini, *Jean-Guillaume Moitte (1746–1810). Leben und Werk*, 2 vols (Berlin, 1993).

20 Elke Harten and Hans Christian Harten, *Die Versöhnung mit der Natur. Gärten, Freiheitsbäume, republikanische Wälder, heilige Berge und Tugendparks in der Französischen Revolution* (Reinbek, 1989).

21 James A. Leith, *Space and Revolution: Projects for Monuments, Squares and Public Buildings in France, 1789–1799* (Montreal, 1991); see also the excellent exh. cat., *Les Architectes de la liberté, 1789–1799* (Paris, 1989).

22 With regard to this most important rediscovery of the bicentennial, see the following publications in particular, Antoine de Baecque, *La Caricature révolutionnaire* (Paris, 1988); Claude Langlois, *La Caricature contre-révolutionnaire* (Paris, 1988); Klaus Herding and Rolf Reichardt, *Die Bildpublizistik der Französischen Revolution*, (Frankfurt, 1989); see also the exhibition catalogue, *French Caricature and the French Revolution, 1789–1799* (Los Angeles, 1989); and Claudette Hould, ed., *L'Image de la Révolution française* (Montréal, 1989).

23 Jean-Charles Benzaken, *Iconographie des monnaies et médailles des Fêtes de la Fédération, mai 1790–juillet 1791* (Paris, 1992); Rosine Trogan and Philippe Sorel, *Augustin Dupré (1748–1833). Graveur général des Monnaies de France* (Paris, 2000).

24 Nicole Pellegrin, *Les Vêtements de la liberté. Abécédaire des pratiques vestimentaires en France de 1780–1800* (Aix-en-Provence, 1989); Richard Wrigley, *The Politics of Appearances: Representations of Dress in Revolutionary France* (Oxford, 2002).

25 Edith Mannoni, *Les Faïences révolutionnaires* (Paris, 1989); Jacques Garnier, *Faïences révolutionnaires. Collections du Musée de la Céramique de Rouen* (Paris, 1989).

26 Kaus Herding's considerations when planning the book in question.

Chapter 1

1 Harold T. Parker, *The Cult of Antiquity and the French Revolution* (Chicago, 1937); the conference *La Révolution française et l'antiquité* (Tours, Univ. François Rabelais 1991); Jacques Bouineau, 'Le référent antique dans la Révolution française, légitimation d'une société sans église', Michel Ganzin, ed., *L'Influence de l'antiquité sur la pensée politique européenne (xvi–xxème siècles)* (Aix and Marseille, 1996), pp. 317–37; Henri Morel, 'Les poids de l'antiquité sur la Révolution française', ibid., pp. 295–316.

2 For historical connections, compare James A. Leith, 'Les trois apothéoses de Voltaire', *ahrf*, 51 (1979), pp. 161–209.

3 J.-P. Pagès, 'Apothéose de Voltaire, le 12 Juillet 1791', *Collection complète des Tableaux historiques de la Révolution française*, vol. 1 (Paris, 1804), p. 218, 'Those two peoples

[the Greeks and the Romans], in their best choices, had paid homage only to warriors or rulers; it remained for the French nation, regenerated, to confer the supreme honours on the poet *philosophe* who had exercised no other power than that of genius, and whose exploits, borne out by the decline of prejudices, had been a benefaction for the universe.' This text appears in the second edition of the *Tableaux historiques* of 1798. For an interpretation of the image, Philippe de Carbonnières, *Prieur. Les 'Tableaux historiques' de la Révolution. Catalogue raisonné des dessins originaux* (Paris, 2006), pp. 165, 167.

4 *Chronique de Paris*, no. 193 (12 July 1791), p. 781; see also *Gazette nationale ou Le Moniteur universel*, no. 194 (13 July 1791) (*Réimpression de l'ancien Moniteur*, IX, Paris 1847, pp. 107–8).

5 Mona Ozouf, 'Le Panthéon, L'Ecole normale des morts', in Pierre Nora, ed., *Les Lieux de mémoire*. I, *La République* (Paris, 1984), pp. 139–66; Martin Papenheim, *Erinnerung und Unsterblichkeit, Semantische Studien zum Totenkult in Frankreich (1715–1794)* (Stuttgart, 1992); Jean-Claude Bonnet, *Naissance du Panthéon. Essai sur le culte des grands hommes* (Paris, 1998).

6 Karl Möseneder, *Zeremoniell und monumentale Poesie. Die 'Entrée solennelle' Ludwigs xiv. 1660 in Paris* (Berlin, 1983).

7 A number of contemporary commentaries refer to Voltaire's prognosis of a pre-existing 'révolution des esprits'.

8 Regarding the numerous variations, compare BnF, Est., Qb 1 M 100737–740 and M 100753.

9 'Un Roi n'est plus qu'un homme / avec un titre auguste. / Premier sujet des loix./ [il] est forcé d'être juste.' (Now a King is but a man / with an august title. / The first to be subject to the laws. / [He] is forced to be just.)

10 'Ce Monstre votre idole horreur du genre humain / Que votre orgueil trompé veut rétablir en vain. – Tous les vrais Citoyens ont enfin rappellé la liberté publique / Nous ne redoutons plus le pouvoir tirannique.' (This Monster, your idol, the horror of the human race / whom your misguided pride will reinstate in vain. – All the true Citizens have at last called back civil liberty / We no longer fear tyrannical power.)

11 See References 4 and 15.

12 *Pétition à l'Assemblée Nationale* [Paris, June 1791].

13 'He joined battle with atheists and fanatics. He inspired Tolerance. He asserted the rights of liberty against the servitude of feudalism.'

14 For more details see Hans-Jürgen Lüsebrink and Rolf Reichardt, *The Bastille: A History of a Symbol of Despotism and Freedom*, trans. Norbert Schürer (Durham, NC, and London, 1997), pp. 131–47.

15 As in the case of the *Annales politiques et littéraires de la France*, Suppl. zu no. DCL (14 July 1791), p. 1682, for which Jean-Louis Carra was copyeditor at that time. Jacques-Louis Gautier was a royalist agent and publicist; Abbé Thomas-Marie Royou edited the newspaper *Ami du Roi*.

16 Stéphane Roy, 'Paul-André Basset et ses contemporains. L'édition d'imagerie populaire pendant la Révolution, piratage ou entente tacite?', *Nouvelles de l'estampe*, 176 (2001), pp. 5–19.

17 Christoph Danelzik-Brüggemann and Rolf Reichardt, eds, *Das Bildgedächtnis eines welthistorischen Ereignisses: die Tableaux historiques de la Révolution française* (Göttingen, 2001); Alain Chevalier and Claudette Hould, eds, *La Révolution par la gravure. Les Tableaux historiques de la Révolution française, une entreprise éditoriale d'information et sa diffusion en Europe, 1791–1817* (Vizille, 2002).

18 Article I of the Decree reads 'Le nouvel édifice de Sainte–Geneviève sera destiné à recevoir les cendres des grands hommes, à dater de l'époque de la liberté française.' Cf., *Archives parlementaires de 1787 à 1860. Première Série (1787 à 1799)*, vol. 24

(Paris 1886), p. 543; also *Gazette nationale ou Le Moniteur universel*, no. 94, 4 April 1791 (*Réimpression de l'ancien Moniteur*, VIII, Paris, 1847, p. 31).

19 Most relevant, Michael Petzet, *Soufflots Sainte-Geneviève und der französische Kirchenbau des 18. Jahrhunderts* (Berlin, 1961); and for acts of the convention, *Soufflot et l'architecture des Lumières* (Paris, 1982); Daniel Rabreau, 'La Basilique de Sainte-Geneviève de Soufflot', *Le Panthéon, symbole des révolutions* (Paris, 1989), pp. 37–96; see also Armin Krauß, *Tempel und Kirche. Zur Ausbildung von Fassade und 'portail' in der französischen Sakralarchitektur des 17. und 18. Jahrhunderts* (Weimar, 2003), pp. 139–66; also, Dominique Poulot, 'Pantheons in Eighteenth-century France: Temple, Museum, Pyramid', in Richard Wrigley and Matthew Crask, eds, *Pantheons: Transformations of a Monumental Idea* (Burlington, 2004), pp. 123–45.

20 Compare the etching by Laurent Guyot, *Pompe funèbre du convoi de Mirabeau. Aux grands hommes la nation reconnaissante*, Paris 1791 (BnF, Est., DV 1914); also the printed programme of the festival, *Translation de Voltaire à Paris. Ordre de la Marche & du Cortège qui sera exécuté dans cette Cérémonie* (Paris, 1791).

21 Image of a plaster model by Isabelle Leroy-Jay Lemaistre, 'De Sainte-Geneviève au Panthéon, les différents programmes de sculpture, à la lumière des récentes découvertes', *Le Panthéon, symbole des révolutions* (Paris, 1989), pp. 234–47, here 237.

22 Documented by Rabreau, 'La Basilique de Sainte-Geneviève de Soufflot', pp. 86–8.

23 René-Gabriel Schneider, *Quatremère de Quincy et son intervention dans les arts, 1788–1830* (Paris, 1910).

24 Antoine-Chrysostôme Quatremère de Quincy, *Rapport sur l'édifice dite de Sainte-Geneviève fait au Directoire du Département de Paris* (Paris: Imprimerie royale, 1791); *Rapport fait au Directoire du Département de Paris, le 13 novembre 1792* (Paris, 1792).

25 The following observations are based especially on Mark K. Deming, 'Le Panthéon révolutionnaire', in *Le Panthéon, symbole des révolutions*, pp. 97–150.

26 'That surfeit of brightness gave the entire building, moreover, an air of cheerfulness and lightness incompatible with the requirements of a place with a grave religious purpose.' Cf., Quatremère de Quincy, *Rapport fait au Directoire du Département de Paris,... le deuxième jour du second mois de l'an iii* (Paris, 1794), p. 22.

27 Gisela Gramaccini, 'Jean-Guillaume Moitte et la Révolution française', *Revue de l'Art*, 83 (1989), pp. 61–70; idem, 'Quatremère de Quincy, l'architecture et la sculpture historique au Panthéon', *L'Art et les révolutions. xxxviie congrès international d'histoire de l'Art*, Section 1 (Strasbourg, 1992), pp. 157–77; idem, *Jean-Guillaume Moitte (1746–1810). Leben und Werk* (Berlin, 1993), I, pp. 83–99.

28 The form of *Despotisme* resembled that of Dionysus in the Parthenon. See also Gramaccini, *Jean-Guillaume Moitte*, I, p. 90.

29 For relevant witnesses, especially in prints, Lynn Hunt, *Politics, Culture, and Class in the French Revolution* (Berkeley, 1984), pp. 94–116; James A. Leith, 'Die revolutionäre Karriere des Hercules in Frankreich 1789–1799', in *Herakles – Herkules, Metamorphosen des Heros in ihrer medialen Vielfalt*, ed. Ralph Kray and Stephan Oettermann (Stroemfeld, 1994), I, pp. 131–48; Rolf Reichardt, 'Heroic Deeds of the New Hercules: The Politicization of Popular Prints in the French Revolution', in Ian Germani and Robin Swales, eds, *Symbols, Myths and Images of the French Revolution: Essays in Honour of James A. Leith* (Regina, 1998), pp. 17–46.

30 *Archives parlementaires de 1787 à 1860. Première Série (1787 à 1799)*, vol. 79 (Paris, 1911), pp. 371–5.

31 Quatremère, *Rapport* (1791), p. 29.

32 In 1794 P.-A. de Machy produced a watercolour drawing in which this figure rises imposingly over the Panthéon; documented in *Le Panthéon, symbole des révolutions*, colour image p. 17.

33 Paris, Archives Nationales, F¹³ 1165.

34 Quatremère, *Rapport* (1791), p. 29. Further observations in his last *Rapport* of 1793, pp. 28–35.

35 Who was, however, standing. The monumental Zeus, in the Temple of Zeus at Olympia, could have posed for the seated figures; Quatremère prepared an etching of it in 1814, with the title *Le Jupiter Olympien*.

36 Jean-François Varlet, *Le Panthéon français* (Paris, [1795]), p. 3.

37 Several unsuccessful applications for his pantheonization were made in the National Assembly from 1791 to 1792.

38 His accession to the Panthéon on 24 January 1793 was arranged by David.

39 See the plan by J. L. David, which was never put into effect, 'Rapport sur la fête héroïque pour les honneurs au Panthéon à décerner aux jeunes Barra et Viala', *Le Moniteur universel*, XXI, 23 Messidor an II (12 July 1794), pp. 277–80.

40 Alphonse-François Aulard, ed., *La Société des Jacobins* (Paris, 1892), III, p. 263.

41 Quatremère de Quincy, *Considérations sur les arts du dessein en France, suivies d'un plan d'Académie ou d'école publique et d'un système d'encouragements* (Paris, 1791), p. 57.

42 See also Claudette Hould, 'Les Beaux-arts en révolution, au bruit des armes les arts se taisent!', *Études françaises*, 25 (1989), pp. 193–208.

Chapter 2

1 Jacques-Marie Boyer-Brun, *Histoire des caricatures de la révolte des Français* (Paris: Imprimerie du Journal du Peuple, 1792), I, p. 10.

2 Annie Duprat, 'Le Regard d'un royaliste sur la Révolution, Jacques-Marie Boyer de Nimes', *Annales historiques de la Révolution française*, 76 (2004), pp. 21–39.

3 Who, however, took great umbrage at his work. Contrast the anonymous review, 'Sur un Prospectus scandaleux publié par Boyer de Nismes', *Le Courrier de Paris dans les Provinces*, 2nd series, vol. V, no. 20 (20 February 1992), p. 317.

4 With particular reference to painting, see Philippe Bordes, 'Die Darstellung des revolutionären Ereignisses oder Die Herausforderung der Malerei durch die Graphik', in Christoph Danelzik-Brüggemenn and Rolf Reichardt, eds, *Bildgedächtnis eines welthistorischen Ereignisses. Die Tableaux historiques de la Révolution française* (Göttingen, 2001), pp. 17–34.

5 See, among others, the exhibition catalogue edited by Sandra L. Lipshultz, *Regency to Empire: French Printmaking, 1715–1814* (Baltimore, 1985).

6 D. Lambalais-Vuianovith, 'Etude quantitative des thèmes traités dans l'image volante française au XVIIIe siècle', thèse de 3e cycle, Université de Paris IV, 1979. However, this study neglects anonymous prints.

7 Claude Labrosse and Pierre Rétat, *Naissance du journal révolutionnaire, 1789* (Lyon, 1989); Jeremy D. Popkin, *Revolutionary News: The Press in France, 1789–1799* (Durham, 1990).

8 There is no comprehensive examination; compare for now Jack R. Censer, 'The Political Engravings of the *Révolutions de France et de Brabant*, 1789 to 1791', *Eighteenth-Century Life*, 5 (1979), pp. 105–22.

9 In addition the excellent study by Claude Langlois, *La Caricature contre-révolutionnaire* (Paris, 1988).

10 Boyer-Brun, *Histoire des caricatures*, I, p. 10.

11 Also Christine Vogel, *Der Untergang der Gesellschaft Jesu als europäisches Medienereignis (1758–1773). Publizistische Debatten im Spannungsfeld von Aufklärung und Gegenaufklärung* (Mainz, 2006).

12 Boyer-Brun, *Histoire des caricatures*, I, p. 9.

13 François Bonneville, *Portraits des personnages célèbres de la Révolution* (Paris: Bonneville, 1796), 2 vols.

14 'It is […] astounding that the municipality of Paris, which gets mud and waste removed, does not order the burning of the disgusting caricatures strewn all over the riverbanks.' Cf. *Petit Dictionnaire des grands hommes et des grandes choses qui ont rapport à la Révolution, composé par une société d'aristocrates* (Paris, 1790), p. 68.

15 'The caricatures seem intended to replace them, and to form an addition to the limitless freedom of the press.' Louis-Sébastien Mercier, *Nouveau Tableau de Paris* (Paris: Pougens and Cramer, 1798), III, chap. XCIV, p. 164.

16 Joachim Heinrich Campe, *Briefe aus Paris zur Zeit der Revolution geschrieben*, second letter of 9 August 1789, first published in *Braunschweigisches Journal* (1790), quoted from Horst Günther, ed., *Die Französische Revolution. Berichte und Deutungen deutscher Schriftsteller und Historiker* (Frankfurt, 1985), p. 26.

17 Friedrich Johann Lorenz Meyer, *Fragmente aus Paris im ivten Jahr der französischen Republik* (Hamburg, 1797), pp. 20–21.

18 Carla Hesse, *Publishing and Cultural Politics in Revolutionary Paris, 1789–1810* (Berkeley, 1991).

19 Pierre Casselle, 'Pierre-François Basan, marchand d'estampes à Paris (1723–1797)', *Paris et Ile-de-France*, 33 (1982), pp. 99–185.

20 Joëlle Raineau, 'La Gravure, techniques et économies. Les discours sur la décadence de la gravure de l'ancien régime à la Révolution', in Philippe Kaenel and Rolf Reichardt, eds, *European Print and Cultural Transfer in the 18th and 19th Centuries* (Hildesheim, 2007).

21 See Stéphane Roy, 'Paul-André Basset et ses contemporains. L'édition d'imagerie populaire pendant la Révolution, piratage ou entente tacite?', *Nouvelles de l'estampe*, no. 176 (2001), pp. 5–19.

22 *Le Moine qui se fait séculariser*, coloured etching, 1790–91 (BnF, Est., Coll. De Vinck, no. 3363).

23 François-Alphonse Aulard, ed., *Recueil des Actes du Comité de Salut Public* (Paris, 1889–1933), VI, p. 443.

24 As well as David, there was the copper engraver Pierre Audouin, the sculptor Antoine-Denis Chaudet, the engraver Dominique Vivant Denon, François(?) Godefroy and Jean Massard; the painter Frédéric(?) Dubois, Pépin(?) Dupuis and Jean-Claude Naigeon, the etcher Jean-Joseph-François Tassaert as well as the otherwise unknown artists Bouarme, Courcelle, Mailly and Roo. For the entire process, see Claudette Hould, 'La Propagande de l'Etat par l'estampe durant la Terreur', in Michel Vovelle, ed., *Les Images de la Révolution française* (Paris, 1988), pp. 29–37.

25 *L'Armée des Cruches* and *Le gouvernement anglais*, both coloured etchings from May 1794. Also James Cuno, 'Obscene Humor in French Revolutionary Caricature: Jacques-Louis David's The Army of Jugs and The English Government', in James A. W. Heffernan, ed., *Representing the French Revolution: Literature, Historiography and Art* (Hanover, NH, 1992), pp. 193–210; also idem, 'En temps de guerre: Jacques-Louis David et la caricature officielle', in Régis Michel, ed., *David contre David. Actes du colloque organisé au musée du Louvre* (Paris, 1993), I, pp. 519–42 and 548–52.

26 That is of course also the case with both prints that David himself subsidized. See also Philippe Bordes, 'Jacques-Louis David et l'estampe', in François Fossier, ed., *Delineavit et sculpsit. Dix-neuf contributions sur les rapports dessin-gravure du xvie au xxe siècle* (Lyon, 2003), pp. 171–9.

27 Aulard, ed., *Recueil des Actes du Comité de Salut Public*, XVI, p. 800.

28 *Anthologie patriotique, ou Choix d'Hymnes, Chansons, Romances, Vaudevilles & Rondes civiques, extrait des Recueils & Journaux qui ont paru depuis la Révolution* (Paris: Pougin, 1794), p. 19.

29 'Liberté Egalité Fraternité / Unité Indivisibilité de la République'.

30 Annie Duprat, 'Autour de Villeneuve: le mystérieux auteur de la gravure *La Contre-*

Révolution', *Annales historiques de la Révolution française*, 69 (1997), pp. 423–39.

31 Thanks to Stéphane Roy for helpful information.

32 In the catalogue of the Collection de Vinck in the Bibliothèque Nationale de France alone, the relevant prints run from no. 1322 to no. 7428.

33 *Journal des Révolutions de l'Europe en 1789 et 1790* (Neuwied/Strasbourg: Société Typographique, 1790), IV, pp. 76–7. Italics in the original.

34 Bernd Vogelsang, 'Ami, le temps n'est plus. Johann Anton de Peters als anti-revolutionärer Karikaturist?', *Wallraf-Richartz-Jahrbuch*, 43 (1982), pp. 195–206.

35 As proved by an anonymous coloured etching from 1789, of which there are several versions, *Allegory dedicated to the Third Estate. Engraved from the painting kept in one of the rooms of the town hall of Aix-en-Provence, representing the composition of the Estates, which shows, by the clothing worn by the figures, that it was executed in the 16th Century* (BnF, Est., DV 2041). Also, especially, Régis Bertrand, 'L'allégorie des trois ordres d'Aix-en-Provence ou la relecture révolutionnaire d'une image du temps de la Ligue', in Alain Croix, André Lespagnol and Georges Provost, eds, *Église, Éducation, lumières..., Histoires culturelles de la France, 1500–1830* (Rennes, 1999), pp. 437–42. For the European background, see Lutz Röhrich, 'Homo Homini Daemon. Tragen und Ertragen. Zwischen Sage und Bildlore', in Carola Lipp, ed., *Medien populärer Kultur: Erzählung, Bild und Objekt in der volkskundlichen Forschung* (Frankfurt, 1995), pp. 346–61.

36 The anonymous pair of pictures, *A faut esperer qu'eu jeu finira bentot / J'savois ben Qu'jaurions not tour*, is documented in the Frankfurt catalogue by Viktoria Schmidt-Linsenhoff, ed., *Sklavin oder Bürgerin? Französische Revolution und neue Weiblichkeit 1760–1830* (Marburg, 1989), pp. 474–8.

37 As in the double caricature *L'Œuf à la coque*, consisting of two aquatint prints with the same title (BnF, Est., DV 2779–80) and in another one concerning oppressive taxation.

38 *Le François d'autre-fois, Le François d'aujourd'hui* (BnF, Est., DV 2801 and 2804).

39 'D. du 23 Fevrier', 'Pacte féderatif 14 Juillet 1790', 'Décret du 4 Aoust', 'decret du 2 novem.'

40 *Le Francois d'autrefois. / Le Francois d'aujourd'hui*, anonymous coloured etchings from 1789–90 (BnF, Est., Qb1 M 99093).

41 *L'Abbé d'Autre-fois. / l'Abbé d'Aujourd'hui*, anonymous coloured etchings, 1789–90 (BnF, Est., DV 3057). See also the anonymous and untitled etching from 1790–91 with the legend 'Jadis je fut un bon gros Moine/ Plein d'alimens jusques au Cou/ Comme le Porc de St. Antoine/ Mais je suis aujourd'hui maigre comme un Coucou' (Once I was a nice fat Monk / full to the Neck with food / like St Anthony's pig / But today I'm as thin as a Cuckoo) (BnF, Est., DV 3060).

42 The catalogue of the collection De Vinck lists two variations, nos. 3054 and 3056; see also BnF, Est., Coll. Hennin, vol. CXXI, p. 27.

43 Rolf Reichardt, 'Heroic Deeds of the New Hercules: The Politicization of Popular Prints in the French Revolution', in Ian Germani and Robin Swales, eds, *Symbols, Myths and Images of the French Revolution: Essays in Honour of James A. Leith* (Regina, 1998), pp. 22–5.

44 Christian Henke, *Coblentz. Symbol für die Gegenrevolution* (Stuttgart, 2000).

45 The latter are climbing a snake named 'Artois' in the background.

46 See Diego Venturino, 'La Naissance de l'Ancien Régime', in Colin Lucas, ed., *The French Revolution and the Creation of Modern Political Culture*, vol. II: *The Political Culture of the French Revolution* (Oxford, 1988), pp. 1–40; see also François Furet, 'Ancien Régime', idem and Mona Ozouf, eds, *A Critical Dictionary of the French Revolution*, trans. Arthur Goldhammer (Cambridge, MA, 1989).

47 Patrice Higonnet, '*Aristocrate, Aristocratie*, Language and Politics in the French

Revolution', in Sandy Petrey, ed., *The French Revolution, 1789–1989: Two Hundred Years of Rethinking* (Lubbock, TX, 1989), pp. 47–66.

48 See Régis Michel, 'De la chimère au fantasme', in the Louvre exh. cat., *La Chimère de Monsieur Desprez* (Paris, 1994), pp. 7–14.

49 'This Horrific beast, born in the burning Sands of Africa, had made a lair for itself in the ruins of the Palace of Minissa; it ever only emerged from there to devour animals and Travellers. It was found to have an enormous pouch under its belly in which it held Men as prisoners to eat off them. In turn, one after another, the three heads ate the limbs of the wretches it had come upon on the roads [. . .].'

50 *Harpie, monstre amphibie . . .* , etching by Bouteloup, Paris 1784 (BnF, Est., DV 1150). Ibid., no. 1148 to no. 1157 revolutionary realizations of pictorial motifs. Also Annie Duprat, *Les Rois de papier. La caricature de Henri iii à Louis xvi* (Paris, 2002); for the background, Chantal Thomas, *The Wicked Queen: The Origins of the Myth of Marie-Antoinette* (New York, 1999); also Lynn Hunt, 'The Many Bodies of Marie-Antoinette: Political Pornography and the Problem of the Feminine in the French Revolution', in Dena Goodman, ed., *Marie Antoinette: Writings on the Body of a Queen* (New York and London, 2003), pp. 117–55.

51 *Discours à la lanterne aux Parisiens. En France, l'an premier de la liberté* [Paris, 1789].

52 See the anonymous leaflet *Découverte de la conjuration* [Paris, 1789]. See also Pierre Caron, 'La Tentative de contre-révolution de juin–juillet 1789', *Revue d'histoire moderne et contemporaine*, 1st series, vol. 8 (1906–07), pp. 649–78; also Hans-Jürgen Lüsebrink and Rolf Reichardt, *The Bastille: A History of a Symbol of Despotism and Freedom,* trans. Norbert Schürer (Durham, NC, and London, 1997), pp. 54–5.

53 *Le Despotisme terrassé*, anonymous aquatint, Paris 1789 (BnF, Est., H 10382); Roze Le Noir, *Chasse patriotique de la Grosse Bête*, etching, Paris 1789 (BnF, Est., DV 1698). There were two other versions of this last print (ibid., nos. 1699 and 1700).

54 See also two other anonymous etchings from 1789, *La France soutenue par Mrs. Bailly et De la Fayette sort glorieuse du Tombeau creusé par le Despotisme Ministeriel* (BnF, Est., H 10554); *La Nation Française assistée de Mr. De la Fayette terrasse le Despotisme et les Abus du Règne Féodal qui terrassaient le Peuple* (BnF, Est., DV 1791).

55 Documented by Rolf Reichardt, 'Die Bildpublizistik der Bastille 1715 bis 1880', in Berthold Roland and Andreas Anderhub, eds, *Die Bastille, Symbolik und Mythos in der Revolutionsgraphik* (Mainz, 1989), pp. 23–70, here 35–6.

56 *A bas les impiots*, anonymous coloured etching from 1789–90 (BnF, Est., DV 2839).

57 *Séance du 19 juin 1790*, Paris 1790, with updated heading and legend (BnF, Est., DV 3614).

58 It is no coincidence that the collectors of the Coll. Histoire de France in the Paris Bibliothèque de France library have assigned the reproduced emblems from Rollen-hagen to the Iconography of the Revolution (Qb1 1794, janvier–juin).

59 See the emblem *Dominat omnia Virtus* in Jean-Jacques Boissard, *Emblematum liber* (Frankfurt, 1593; new edn Hildesheim, 1977), p. 13.

60 J.-P. Pagès, 'Commémoration de la Prise de la Bastille le 14 Juillet 1792', *Collection complète des Tableaux historiques de la Révolution française* (Paris, 1804), I, p. 251. The text of this 'Discourse' was first published in the edition of 1798. The historical accuracy of the depiction is confirmed by the festival programme *L'Ordre et la marche du cortège de la Fédération, du 14 juillet 1792, l'an quatrième de la Liberté. Cérémonies qui seront observées* (Paris: Tremblay, 1792).

61 Michael Meinzer, *Der französische Revolutionskalender (1792–1805): Planung, Durchführung und Scheitern einer politischen Zeitrechnung* (Munich, 1992).

62 Rolf Reichardt, 'Zeit-Revolution und Revolutionserinnerung in Frankreich 1789–1805', in Hans-Joachim Bieber, Hans Ottomeyer and Georg Christoph Tholen, eds, *Zeit im Wandel der Zeiten* (Kassel, 2002), pp. 149–90.

63 Pierre Rétat, 'Représentations du temps révolutionnaire d'après les journaux de 1789', in Philippe Joutard, ed., *L'espace et le temps reconstruits. La Révolution française, une révolution des mentalités et des cultures?* (Aix-en-Provence, 1990), pp. 120–29.

64 Two authoritative monographs by Annie Duprat, *Le roi décapité. Essai sur les imaginaires politiques* (Paris, 1992); idem, *Les Rois de papier. La caricature de Henri iii à Louis xvi* (Paris, 2002). See also Klaus Herding and Rolf Reichardt, *Die Bildpublizistik der Französischen Revolution* (Frankfurt, 1989), pp. 112–31. For a very stimulating, albeit specialist, assessment of a few puzzling etchings, see Claude Langlois, *Les Sept Morts du roi* (Paris, 1993).

65 Duprat, *Le Roi décapité*, pp. 172–4.

66 Reported in the *Gazette de France* on 20 June 1789.

67 Cf. also, Clelia Alberici, 'Vincenzo Vangelisti, primo professore della scuola d'incisione dell'Accademia Brera', *Rassegna di studi e di notizie*, XIX–XXII (1995), pp. 11–38, esp. 34–7. Our thanks for this reference to Alberto Milano.

68 She was using the name of her first husband, the printmaker Pierre-Claude de Lagardette.

69 Wortman and Mutlow from Spilbury, *Soyez libres, vivez*, frontispiece to Simon-Nicolas-Henri Linguet, *Mémoires sur la Bastille* (London, 1783).

70 Cf. the anonymous etching *Le jeune Patriote* (BnF, Est., DV 3011). Further examples in Duprat, *Les Rois de papier*, pp. 180–84.

71 The print was conveyed to Louis on 30 March 1790.

72 *Archives parlementaires de 1787 à 1860. Première Série (1787 à 1799)*, vol. XI (Paris 1880), p. 430.

73 *Louis XIV à Saint-Cloud au chevet de Louis xvi* [Paris, 1790]. Also, Annie Duprat, 'Louis XVI origenan par ses ancêtres en 1790: Les Entretiens des Bourbons', *Dixhuitième Siècle*, 26 (1994), pp. 317–32.

74 Annie Duprat, 'Le commerce de la librairie Wébert à Paris sous la Révolution', *Dixhuitième Siècle*, 33 (2001), pp. 357–66.

75 Ibid., p. 360.

76 Cf. two coloured etchings, both published anonymously, *Le Gargantua du siècle ou l'Oracle de la dive bouteille* (BnF, Est., Coll. De Vinck, no. 3398); *Le Ci-devant Grand Couvert du Gargantua moderne en Famille* (BnF, Est., Qb1, M 100480). Comments in Duprat, *Le Roi décapité*, pp. 134–89.

77 Also, among others, the text and picture reportage in *Révolutions de Paris*, no. 93 (16–23 April 1791), to p. 67.

78 For the historical context, Timothy Tackett, *When the King Took Flight* (Cambridge, MA, 2003).

79 *L'Aveugle mal conduit* (BnF, Est., DV 3935).

80 *Je fais mon tour de france* (BnF, Est., no. 3928).

81 As in the etching that appeared in the press on 26 June, *Enjambée de la Sainte famille des Thuilleries à Montmidy* (BnF, Est., no. 3929).

82 *Hé Hu! Da da!* (BnF, Est.,no. 3930).

83 Duprat, *Le Roi décapité*, pp. 77–88 and 170–87.

84 See also variations to this print with the title *L'Entrée – franche* (Paris, Musée Carnavalet, Estampes, Ha 016 C 024). A whole herd of 'kingly' swine appears in the print *Il étaient une fille* (BnF, Est., DV 3985).

85 *Ventre Saint Gris ou est mon fils? Quoi! C'est un cochon?* (BnF, Est., Qb1 M 100744). Compare J.-M. Boyer-Brun, *Histoire des caricatures*, II, pp. 5–32.

86 *Cette Leçon vaut bien un fromage* (BnF, Est., DV 3991); *Vous m'avez connu trop tard* (ibid., no. 3992).

87 Boyer-Brun, *Histoire des caricatures*, I, pp. 315–28, here p. 317; also ibid., pp. 203–4.

259

88 One anonymous etching from this time depicts him sitting in a bird-cage decorated with lilies: *Que faites vous là? Je suis en Pénitence* (BnF, Est., DV 3995).

89 Quotation from Duprat, *Le Roi décapité*, p. 92. Ibid., pp. 88–104 for further witnesses of this 'affair'.

90 *L'Ami du Roi* of 3 July 1791, quotation from Duprat, *Le Roi décapité*, pp. 99–100.

91 This view was put forward in the anonymous print *Le Masque levé* (BnF, Est., DV 3999).

92 The masquerade was depicted in the coloured etching *Le Convoi de la royauté*, documented in Herding and Reichardt, *Die Bildpublizistik*, pp. 100–101.

93 *Louis le faux*, anonymous etching from 1791 (Paris, Musée Carnavalet, Estampes, Ha 016 C 004). See also the anonymous coloured etching *Ci gît Louis Le faux Capet Lainé*, probably Paris 1791 (BnF, Est., H 11.192).

94 See the discussion regarding the meaning and date of the print in Duprat, *Le Roi décapité*, pp. 201–4.

95 Boyer-Brun, *Histoire des caricatures*, I, p. 196 (italics in the original).

96 See, among others, two etchings by Jacques-François Chereau, *Louis xvi accepte la Constitution le xiv 7bre mdcclxxxxi*; *Louis xvi signe la Constitution que la France assise sur les Droits de l'Homme présente* (BnF, Est., DV 4268 and 4269); also two etchings by a certain Dorgez, *Louis xvi couronné par la Nation*; *Promulgation de la Constitution françoise* (BnF, Est., nos. 4273 and 4274); also the etching in pointillist style by Pierre-Thomas Leclerc, *Le Pacte National présenté à l'Assemblée Nationale le lundi vingt six septembre 1791* (BnF, Est., no. 4261).

97 Such as the anonymous etching *Que fais tu la Beau fraire? . . . Je sanctionne* (BnF, Est., DV 4275).

98 Boyer-Brun, *Histoire des caricatures*, II, pp. 6–7.

99 Such as the anonymous etching *Journée des sans culottes* in the newspaper *Révolutions de Paris* no. 154 (June 1792).

100 See the anonymous coloured engraving *Louis Seize Roi des Français* (BnF, Est., DV 397), together with its forerunner, documented in the exhibition catalogue *French Caricature and the French Revolution, 1789–1799* (Los Angeles, 1988), nos. 64 and 65, p. 179.

101 For example the etching, probably by Villeneuve, *Étrenne aux fidelles 1792* (BnF, Est., DV 2864).

102 See the anonymous graphic satire *Louis le dernier et sa famille conduits au Temple le 13 Aoust 1792* (BnF, Est., H 11.181).

103 Villeneuve could have been alluding to incriminating material which was actually discovered in a secret cupboard (*armoire de fer*) in the Temple.

104 Cf. an anonymous etching that was mentioned as early as 20 August, *Les Animaux rares. Ou la translation de la Ménagerie Royale au Temple, le 20 Août* (BnF, Est., DV 4930).

105 M de Lescure, ed., *Correspondance secrète inédite sur Louis xvi, Marie-Antoinette, la Cour et la Ville, de 1777 à 1792* (Paris, 1866), II, p. 620. Louis appears as a crowned pig in the prints cited in reference no. 84; he appears as a fugitive crawling through the excrement under the latrines in the anonymous etching *L'égout royal* (BnF, Est., Qb1 M 100656).

106 Villeneuve was duplicating this comparison, probably from a drawing by J.-L. David, in his oval aquatint *Ecce Veto. Louis Capet, le Charles ix du 18e siècle* (BnF, Est., DV 5208).

107 This formula had already appeared by July 1789, as the fear of a *complot de l'aristo-cratie* was taking hold.

108 Cf. L. Durocher, *Réponse d'un Sans-culotte aux Réflexions de Necker sur le procès de Louis Capet* (s.l., 1792), p. 13.

109 Klaus Herding in Herding and Reichardt, *Bildpublizistik*, p. 130; cf. also Karl Heintz Bohrer, *Plötzlichkeit. Zum Augenblick des ästhetischen Scheins* (Frankfurt, 1981).

110 The theatricality of this gesture is discussed by Daniel Arasse, *La Guillotine et l'imaginaire de la terreur* (Paris, 1987), pp. 141–8.

111 Many spectators dipped their handkerchiefs or other objects in the blood of the decapitated king; cf. Arasse, *La Guillotine*, pp. 80–85.

112 Maximilien Robespierre, *Lettre à ses commettans*, 2nd series, no. 3 (25 January 1793), critically edited in *Œuvres de Maximilien Robespierre*, V (Paris, 1961), pp. 226–7.

113 For example, two pointillist engravings by a certain Colin, *Louis seize lisant son testament à Mr de Lamoignon de Malesherbes son défenseur* (BnF, Est., DV 5083); *Louis seize s'occupant de l'éducation de son fils dans la tour du Temple* (BnF, Est., Ad 20). In addition Evelyne Lever, 'Le Testament de Louis XVI et la propagande royaliste par l'image pendant la Révolution et l'Empire', *Gazette des Beaux-Arts*, 94 (1979), pp. 159–73.

114 Such as the anonymous etching *Catastrophe de Louis xvi* (BnF, Est., DV 5165); see also the anonymous pointillist engraving by Carlo Silanio, taken from Charles Benazech, *Le Dernier Moment de la Vie du Roy Louis xvi . . .* (BnF, Est., no. 5147); also the anonymous etching *J'ai toujours aimé mon peuple . . . je meurs innocent* (BnF, Est., no. 5163).

115 Copies were in circulation immediately, but it was only printed abroad, some time afterwards, in the diary of Jean-Baptiste Cléry.

116 *Dernière entrevue de Louis xvi avec sa famille*, oil on canvas, 42 x 56 cm (Versailles, Musée du Château, inv. no. RF 2297 – MV 5831).

117 Cf. the entries in the catalogue by Laure Beaumont-Maillet and Odile Faliu, eds, *Images de la Révolution française. Catalogue du vidéodisque produit à l'occasion du Bicentenaire de la Révolution française* (Paris and London, 1990), nos. 5836–5986.

118 For the significance of this work, which also appeared in France, see the seminal work by Werner Busch, *Das sentimentalische Bild. Die Krise der Kunst im 18. Jahrhundert und die Geburt der Moderne* (Munich, 1993), pp. 39–58.

119 Under a variety of titles, these widely circulated prints portrayed thematically the events of 20 June to 21 January 1793 (BnF, Est., DV 4861, 4865, 5063, 5145 and 5439).

120 The anonymous pointillist engraving was dedicated on the date of Louis' death, 21 January 1795 (Musée Carnavalet, Paris, Est., Hist. PC 21D), documented in the exhibition catalogue *La Guillotine dans la Révolution* (Vizille: Musée de la Révolution française, 1987), p. 74.

121 David Bindman, *The Shadow of the Guillotine: Britain and the French Revolution* (London, 1989), p. 132.

122 Gillray's etching was parodying several French prints at the same time according to Caroline Buchartowski, *Nachahmung und individuelle Ausdrucksform. Eine Untersuchung zu den Motiventlehnungen in der politischen Karikatur James Gillrays im Zeitraum 1789 bis 1806* (Frankfurt and Berlin, 1994), pp. 85–97.

123 See also the insightful interpretation by Klaus Herding, *Im Zeichen der Aufklärung. Studien zur Moderne* (Frankfurt, 1989), pp. 95–104.

Chapter 3

1 David's letter to the National Assembly of 5 February 1792; see Philippe Bordes, *Le Serment du Jeu de Paume de Jacques Louis David* (Paris, 1984), Document 15.

2 *Archives parlementaires*, 1ère série, vol. VIII (Paris, 1876), p. 127. For the background, see Eberhard Schmitt, *Repräsentation und Revolution. Eine Untersuchung zur Genesis der kontinentalen Theorie und Praxis parlamentarischer Repräsentation aus der*

Herrschaftspraxis des Ancien régime in Frankreich (1760–1789) (Munich, 1969).

3 See Régis Michel, 'L'Art des Salons', in Philippe Bordes and Régis Michel, eds, *Aux armes et aux arts! Les arts de la Révolution, 1789–1799* (Paris, 1988), p. 28.

4 Bordes, *Serment*, p. 23. Thomas Crow, 'The *Oath of the Horatii* in 1785: Painting and Prerevolutionary Radicalism in France', *Art History*, 1 (1978), pp. 424–71.

5 Bordes, *Serment*, p. 60.

6 William Olander, *Pour transmettre à la postérité: French Painting and Revolution 1774–1795* (Ann Arbor, MI, 1996) p. 183. See also Robert Chagny, 'La symbolique des trois ordres', and Marie V. Poinsot, 'La Comédie des trois ordres', both in Michel Vovelle, ed., *Les Images de la Révolution française* (Paris, 1988), pp. 267–82 and 283–90.

7 The portrayal is alluding to 13 June 1789, when three deputies from the clergy led the way as deputies from the upper Estates went over to the *tiers état*.

8 Bordes, *Serment*, p. 58 (from a letter by Chénier, published in the *Supplément* of the *Journal de Paris* on 24 March 1792).

9 Warren Roberts, *Jacques Louis David and Jean Louis Prieur: Revolutionary Artists. The Public, the Populace and Images of the French Revolution* (New York, 2000). In addition C. Danelzik-Brüggemann and R. Reichardt, eds., *Das internationale Bildgedächtnis eines welthistorischen Ereignisses. Die 'Tableaux historiques de la Révolution française' in Frankreich, den Niederlanden und Deutschland (1791–1819)* (Göttingen, 2000).

10 Edouard Pommier, 'Winckelmann et la vision de l'Antiquité classique dans la France des Lumières et de la Revolution', *Revue de l'art*, 83 (1989), pp. 9–20.

11 Olander, *Pour transmettre à la postérité*, p. 192.

12 The painter and architect from Montpellier, Jérôme–René Demoulin, quoted in Dominique Laredo, 'Deux exemples de monuments révolutionnaires en Province, une Colonne de la Liberté (1791) et un temple de la Raison (1793) à Montpellier', in Vovelle, *Les Images de la Revolution française*, p. 151.

13 Olander, *Pour transmettre à la postérité*, p. 205f.

14 Wolfgang Kemp, 'Das Revolutionstheater des Jacques Louis David. Eine neue Interpretation des Schwurs im Ballhaus', *Marburger Jahrbuch für Kunstwissenschaft*, 21 (1986), pp. 165–84.

15 Cf. Bordes, *Serment*, p. 71. In other sketches this is usually not the case, cf. an engraving by Masquelier from Flouest (BnF, Est., DV 1458).

16 This should not be taken literally as, in spite of its great width, the picture would have fallen some way short of covering the actual breadth of the Parliamentary chamber.

17 Michel Foucault, *Überwachen und Strafen. Die Geburt des Gefängnisses* (Frankfurt, 1981), p. 256ff.

18 Roger Barny, *Rousseau dans la Révolution: le personnage de Jean-Jacques et les débuts du culte révolutionnaire, 1787–1791* (Oxford, 1986); idem, *L'Eclatement révolutionnaire du rousseauisme (*Paris, 1988); Carol Blum, *Rousseau and the Republic of Virtue: The Language of Politics in the French Revolution* (Ithaca, NY, 1986).

19 Hans-Ulrich Gumbrecht, *Funktionen parlamentarischer Rhetorik in der Französischen Revolution* (Munich, 1978); Peter Krause-Tastet, *Analyse der Stilentwicklung in politischen Diskursen während der Französischen Revolution (1789–1794)* (Frankfurt, 1999); Eric Négrel and Jean-Paul Sermain, eds., *Une expérience rhétorique, L'éloquence de la Révolution* (Oxford, 2002). No wonder many commentators on David's *Tennis Court Oath* had the impression of being confronted by a theatrical scene. Regarding theatricality in general, see Paul Friedland, *Political Actors: Representative Bodies and Theatricality in the Age of the French Revolution* (Ithaca, NY, 2003).

20 Bailey Stone, *The French Parlements and the Crisis of the Old Regime* (Chapel Hill, NC,

1986); Michael Wagner, 'Parlements', in R. Reichardt and Eberhard Schmitt, eds, *Handbuch politisch-sozialer Grundbegriffe in Frankreich 1680–1820* (Munich, 1988), X, pp. 55–106.

21 Cf. for example Emmanuel Du Rusquec, *Le Parlement de Bretagne 1554–1994* (Rennes, 1994), p. 177.

22 For the historical–political background, Philip Manow, 'Der demokratische Leviathan – eine kurze Geschichte parlamentarischer Sitzanordnungen seit der französischen Revolution', *Leviathan*, 32 (2004), pp. 319–47.

23 Rudolf von Albertini, 'Parteiorganisation und Parteibegriff in Frankreich, 1789–1940', *Historische Zeitschrift*, 193 (1963), pp. 529–600.

24 James A. Leith, *Space and Revolution: Projects for Monuments, Squares, and Public Buildings in France, 1789–1799* (Montreal, 1991), p. 79f.

25 Remarkably, the plan was extended by a thoroughly futuristic amphitheatre-like layout, which was so incompatible with the whole that it can almost be assumed it was a later extension.

26 Pierre Pinon, 'L'Architecte Pâris et les premières salles d'assemblée: des Menus-Plaisirs au Manège', *Les Architectes de la liberté, 1789–1799*, exh. cat. (Paris: ENSBA, 1989–90), p. 77ff.

27 Leith, *Space and Revolution* , p. 81f.

28 Etienne-Louis Boullée, *Architektur. Abhandlung über die Kunst* (Zürich, 1987), p. 56.

29 Claudine de Vaulchier, 'La Recherche d'un palais pour l'Assemblée nationale', *Les Architectes de la liberté, 1789–1799*, p. 146.

30 Leith, *Space and Revolution* , p. 107.

31 From the 'Second mémoire. Projet et description du palais national' of the designing architect; cf. Vaulchier, 'La Recherche d'un palais pour l'Assemblée nationale', p. 153.

32 *La Bouche de Fer*, no. 44 (18 April 1791), pp. 172–3.

33 Cf. Lynn Hunt, 'Hercules and the Radical Image in the French Revolution', *Representations*, 2 (1983), pp. 95–117.

34 Richard L. Cleary, *The Place Royale and Urban Design in the Ancien Régime* (Cambridge, 1999); Andreas Köstler, *Place Royale: Metamorphosen einer kritischen Form des Absolutismus* (Munich, 2003).

35 See Régis Spiegel, 'Une métaphore du vide. Des destructions révolutionnaires aux projets du Premier Empire', in Isabelle Dubois, A. Gady and F. Ziegler, eds, *La Place des Victoires: histoire, architecture, société* (Paris, 2004), p. 109f.

36 *La Place des Victoires et ses abords*, p. 28.

37 Most portrayals of the event focused on the enormous number of participants, cf. the picture by Thévenin of 1792, see *Aux Armes et aux arts*, p. 110.

38 This explains the paradoxical fact that with the advent of the revolutionary period, an enormous amount of 'despotic' art was destroyed, while at the same time the first museum committees were formed. Cf. Edouard Pommier, *L'Art de la Liberté: doctrines et débats de la Révolution française* (Paris, 1991), p. 48. Furthermore, it is remarkable that, at least in the case of official records, acts of destruction of politically undesirable monuments were inventoried very correctly.

39 *Archives parlementaires*, vol. 16, p. 375. Quoted in Pommier, *L'Art de la Liberté*, p. 32.

40 *Lettre de M. Caffieri, sculpteur du Roi et professeur en son académie royale de peinture et de sculpture à M. Bailly, maire de la ville de Paris*, Paris, 27 June 1790, quoted from ibid., p. 34.

41 *Archives parlementaires. Première Série*, vol. 48 (Paris, 1897), p. 115.

42 Dubois, Gady and Ziegler, *La Place des Victoires*, p. 40.

43 Cf. Jean-Louis Harouel, *L'embellissement des villes. L'urbanisme français au xviiie siècle* (Paris, 1993), p. 148ff.

44 See also the exhibition catalogue, *Die Bastille – Symbolik und Mythos in der Revolu-*

tionsgraphik (Mainz, 1989).

45 *Explication du projet de Louis Combes*, Archives Nationales N. IV Seine 87, quoted from Vaulchier, 'La Recherche d'un palais pour l'Assemblée nationale', p. 141.

46 Leith, *Space and Revolution*, p. 68f.; *Sous les pavés de la Bastille. Archéologie d'un mythe révolutionnaire*, exh. cat. (Paris: Hôtel de Sully, 1989–90), p. 140f.

47 Leith, *Space and Revolution*, p. 68f.

48 Cf. Bordes, *Le Serment du Jeu de Paume de Jacques Louis David*, p. 60. 'Metaphors of Regeneration and their Politicization Before and During the the Revolution'; cf. Antoine de Baecque, 'La Révolution accueille la Régénération. Naissance, éducation et prétention du nouvel homme', in C. Mazauric, ed., *La Révolution française et le processus de socialisation de l'homme moderne* (Paris, 1989), pp. 661–8.

49 *Sous les pavés de la Bastille*, p. 154f.

50 *De la place Louis xv à la place de la Concorde*, exh. cat. (Paris: Musée Carnavalet, 1982), p. 91ff.

51 Hunt, 'Hercules and the Radical Image in the French Revolution', p. 113. There is a misleading assertion that Napoleon would ultimately have had the *Arc de Triomphe* constructed in the Place de la Concorde.

52 In this connection see Gilbert Gardes, 'La Décoration de la Place Royale de Louis le Grand (Place Bellecour) à Lyon, 1686–1793', *Bulletin des musées et monuments lyonnais*, 5 (1974), p. 185.

53 Ibid., p. 207.

54 Leith, *Space and Revolution*, p. 60.

55 Christian Taillard, 'De l'Ancien Régime à la Révolution: l'histoire exemplaire des projets d'aménagement du Château Trompette à Bordeaux', *Revue de l'Art*, 83 (1989), pp. 77–85, here p. 84f.

56 This happened during the turn of the years 1789–90 in the course of the peasants' revolt in the south-west. Cf. in addition Mona Ozouf, 'Du mai de la liberté à l'arbre de la liberté: symbolisme révolutionnaire et tradition paysanne', *Ethnologie française*, n.s., 5 (1975), pp. 9–32; further examples in Jean Boutier, *Campagnes en émoi, révoltes et Révolution en Bas-Limousin, 1789–1800* (Treignac, 1987).

57 Jules Michelet, *Histoire de la Révolution française* (Paris, 1847–53), book 3, chap.XI; printed in the Edition du Bicentenaire (Paris: J. de Bonnot, 1988), II, pp. 175–89.

58 Cf. Antoine de Baecque, 'The Allegorical Image of France, 1750–1800: A Political Crisis of Representation', *Representations*, 47 (1994), pp. 111–43.

59 See Gerd van den Heuvel, *Der Freiheitsbegriff der Französischen Revolution. Studien zur Revolutionsideologie* (Göttingen, 1988).

60 Further details in Richard Wrigley, *The Politics of Appearances: Representations of Dress in Revolutionary France* (Oxford, 2002), p. 135ff.

61 Cf. in this connection and the following, Andreas Stolzenburg, 'Freiheit oder Tod – ein missverstandenes Werk Jean Baptiste Regnaults?', *Wallraf-Richartz Jahrbuch*, 48/49 (1987–8), pp. 463–72, esp. p. 469. The meaning of the motto was also in current usage during the American Civil War.

62 Hunt, 'Hercules and the Radical Image in the French Revolution', esp. p. 99ff.

63 See the exh. cat. *La Révolution française et l'Europe* (Paris: Conseil de l'Europe 1989), II, p. 538.

64 Ibid., III, p. 661, no. 868.

65 Numerous variations of prints with the title *Trois têtes sous le même bonnet* were in circulation, BnF, Est., Coll. De Vinck, DV 2030–2031; BnF, Est., Qb 1, M 99905–99914.

66 A peasant is swearing an oath to this unity with the inscription on a memorial stone, 'Moi de tous les états l'père nourricier j'di qu'il faudroit que tout fut ainsi pour que tous Sarangi Pour not bon Roi et ma patrie' (I, nurturing father of all the Estates, I

say that all things should be thus, that all should agree, for our good King and for my country).

67 Allusions to this can be seen on the ground, the horns of plenty and sheets of paper with the verbatim Declaration of 5 August 1789, 'Dîme Supprimée, Abandon du Casuel, Abandon des droits Seigneuriaux, Chasse permise, Main Morte Supprimée'.

68 Cf. Michel Vovelle, *Die Französische Revolution, soziale Bewegung und Umbruch der Mentalitäten* (Munich, 1982), p. 87.

69 In this connection and following, Werner Szambien, *Les projets de l'an ii. Concours d'architecture de la période révolutionnaire* (Paris, 1986), p. 83ff.

70 New strophe of the song that appeared in 1792, quoted in Vovelle, *Die Französische Revolution*, p. 107.

71 See for the background Marcel David, *Fraternité et Révolution française* (Paris, 1987).

Chapter 4

1 See in this connection and following, Elke Harten, *Museen und Museumsprojekte der Französischen Revolution. Ein Beitrag zur Entstehungsgeschichte einer Institution* (Munster, 1989).

2 Ibid., p. 38.

3 Yveline Cantarel-Besson, *La Naissance du musée du Louvre, La politique muséologique sous la Révolution d'après les archives des musées nationaux* (Paris, 1981); Andrew McClellan, *Inventing the Louvre: Art, Politics, and the Origins of the Modern Museum in Eighteenth-century Paris* (Cambridge, 1994), esp. p. 91ff.

4 The Minister of the Interior in a letter to David. Cf. *Le Moniteur*, vol. 14, p. 263, quoted from McClellan, *Inventing the Louvre*, p. 91f.

5 Cf. Bénédicte Savoy, *Patrimoine annexé: les biens culturels saisis par la France en Allemagne autour de 1800*, 2 vols. (Paris, 2003).

6 In this regard and following, Udolpho van de Sandt, 'Institutions et Concours', in Philippe Bordes and Régis Michel, eds, *Aux armes et aux arts! Les arts de la Révolution, 1789–1799* (Paris, 1988), p. 138ff.

7 Henry Lapauze, ed., *Procès-Verbaux de la Commune Générale des Arts de peinture, sculpture, architecture et gravure (18 juillet 1793 – tridi de la 1ère décade di 2e mois de l'an ii) et de la société populaire et républicaine des arts (3 nivose an ii – 28 floréal an iii)* (Paris, 1903), p. xx.

8 Ibid., p. 13.

9 Cf. ibid., p. 89.

10 Albert Boime, 'The Teaching Reforms of 1863 and the Origins of Modernism in France', *Art Quarterly* (Autumn 1977), pp. 1–39.

11 See the books by Patricia Mainardi, especially, *The End of the Salon: Art and the State in the Early Third Republic* (Cambridge, 1993).

12 For the social–historical context of eighteenth-century French painting, see especially Thomas Crow, *The Painter and Public Life in Eighteenth Century Paris* (New Haven, 1986); for the many developments under the late *ancien régime* that prefigured revolutionary achievements, see a still important work, Jean Locquin, *La Peinture d'histoire en France de 1747 à 1785, etude sur l'évolution des idées artistiques dans la seconde moitié du xviiie siècle*, Paris, 1912; repr. 1978).

13 Cf. van de Sandt, 'Institutions et Concours', p. 141.

14 Ibid.

15 *Description des ouvrages de peinture, sculpture, architecture et gravures exposés au Louvre, Salon de 1793*, p. 46, no. 481.

16 See Lapauze, ed., *Procès-Verbaux de la Commune Générale*, p. lix.

17 *Explication des peintures, sculptures et gravures de Messieurs de l'Académie Royale, Salon*

de 1789, p. 27, no. 111.

18 In this, he was aided by the memoirs compiled by the lawyer Thiery (*Le Despotisme dévoilé*, 1790), the frontispiece of which was a reproduction engraving by Canu of Vestier's painting.

19 *Explication des peintures . . . Salon de 1789*, p. 11, no. 6 and p. 55, no. 324ff.

20 See Régis Michel, 'L'Art des Salons', in *Aux armes et aux arts!*, p. 26.

21 *Ouvrages de peinture, sculpture et architecture, gravures, dessins, modèles etc. exposé au Louvre par ordre de l'Assemblée nationale au mois de septembre 1791, l'an iii de la liberté, Salon de 1791*, p. 18, no. 134 and p. 25, no. 274.

22 *Ouvrages de peinture . . . Salon de 1791*, p. 14, no. 67, p. 19, no. 161, p. 22, no. 215, p. 23, no. 239, p. 27, no. 317, p. 28, no. 337, p. 33, no. 429, p. 41, no. 557 and 562, p. 43, no. 587, p. 44, no. 611.

23 See Carl Aldenhoven, *Katalog der Herzoglichen Gemäldegalerie (Herzogliches Museum zu Gotha)* (Gotha, 1890), p. 109.

24 See van de Sandt, 'Institutions et Concours', p. 40.

25 *Salon de 1793*, p. 11, no. 35.

26 Ibid., p. 105, no. 736.

27 Ibid., p. 54, no. 599.

28 See Roger Caratini, *Dictionnaire des personnages de la Révolution* (Paris, 1988), p. 78.

29 *Salon de 1793*, p. 97, no. 631.

30 Ibid., p. 51, no. 541.

31 Ibid., p.18, no. 125. See also van de Sandt, 'Institutions et Concours', p. 41f.

32 *Salon de 1793*, p. 45, no. 469.

33 Ibid., p. 54, no. 595.

34 *Salon de 1795*, p. 13, no. 2, p. 31, no. 210, p. 44, nos. 345 and 347, p. 55, no. 460,

35 Ibid., p. 63, no. 1002ff.

36 Ibid., p. 25, no. 152.

37 *Explication des ouvrages de peinture, sculpture, architecture, gravures, dessins, modèles etc. exposé dans le grand Salon du Musée central des arts, Salon de 1796*, p. 32, no. 164.

38 Ibid., p. 30, no. 140.

39 Ibid., p. 45, no. 267, p. 64, no. 438.

40 See van de Sandt, 'Institutions et Concours', p. 141.

41 *Salon de 1796*, p. 13.

42 P. Chaussard, 'Exposition des ouvrages dans les salles du Museum', *La Décade philosophique*, an VI (1797–8), no. 34, p. 418, quoted from van de Sandt, 'Institutions et Concours', p. 144.

43 *Salon de 1793*, p. 8.

44 See Brigitte Gallini, 'Concours et prix d'encouragement', in *La Révolution française et l'Europe*, III, 3, pp. 830–51. See also van de Sandt, 'Institutions et Concours', pp. 137–65, here p. 144ff.

45 *La Révolution française et l'Europe*, III, p. 862, no. 1084.

46 See Lapauze, ed., *Procès-Verbaux de la Commune Générale*, p. liv.

47 With regard to this picture, see David Wisner, 'Deux images de la République, le Serment du Jeu de Paume de David et l'Insurrection du 10 Août de Gérard', in Roger Bourderon, ed., *Saint-Denis, ou le jugement dernier des rois* (Saint-Denis, 1993), pp. 397–405.

48 *La Révolution française et l'Europe*, III, p. 858, no. 1080.

Chapter 5

1 Nicolas Ruault, *Gazette d'un Parisien sous la Révolution. Lettres à son frère, 1783–1796* (Paris, 1975); quotation from William Olander, *Pour transmettre à la postérité: French*

Painting and Revolution, 1774–1795 (Ann Arbor, MI, 1996), p. 100.

2 Susan Siegfried, *The Art of Louis-Léopold Boilly: Modern Life in Napoleonic France* (New Haven and London, 1995), p. 42. It is impossible to be absolutely certain as to whether there is a persiflage in the picture.

3 Herbert Schneider, 'Der Formen- und Funktionswandel in den Chansons und Hymnen der Französischen Revolution', in Reinhart Koselleck and Rolf Reichardt, eds., *Die Französische Revolution als Bruch des gesellschaftlichen Bewußtseins* (Munich, 1988), pp. 421–78.

4 Jean Jacques Rousseau, *Emile, ou de l'éducation* (Paris, 1966), p. 298.

5 For the political position of women during the time of the Revolution, see among others Dominique Godineau, *Citoyennes tricoteuses, Les femmes du peuple à Paris pendant la Révolution française* (Aix-en-Provence, 1988); Viktoria Schmidt-Linsen-hoff, ed., *Sklavin oder Bürgerin? Französische Revolution und neue Weiblichkeit, 1760–1830*, exh. cat. Historisches Museum (Frankfurt/Marburg, 1989).

6 See the following chapter.

7 The text beneath the drawing quotes from a *Prière des Amazones à Bellone*, 'And we too can fight and conquer. We can handle other weapons than the needle and the spindle. Oh, Bellona, Companion to Mars! Should not all women follow your example and march alongside the men, in Stepp with them? Goddess of strength and courage! At least FRENCHWOMEN will give you no cause to blush.'

8 The artists who were members of the *Société populaire et républicaine des arts* did not on the whole tend to view women as equals. See Henry Lapauze, ed., *Procès-Verbaux de la Commune Générale des Arts de peinture, sculpture, architecture et gravure (18 juillet 1793 – tridi de la 1ère décade di 2e mois de l'an ii) et de la société populaire et républicaine des arts (3 nivose an ii – 28 floréal an iii)*, Paris1903, pp. xx and l.

9 Documented by Nicole Pellegrin, 'Les Femmes et le don patriotique. Les offrandes d'artistes de Septembre 1789', in Marie-France Brive, ed., *Les femmes et la Révolution française*, 3 vols (Toulouse, 1989–91), II [1990], pp. 361–80.

10 Cf. Stefan Germer and Hubertus Kohle, 'From the Theatrical to the Aesthetic Hero: On the Privatization of the Concept of Virtue in David's Brutus and Sabines', *Art History*, 9/2 (1986), pp. 168–84.

11 Quoted from Michel Vovelle, 'Héroïsation et Révolution: la fabrication des héros sous la Révolution française', *Le Mythe du héros. Actes du colloque interdisciplinaire du centre aixois de recherches anglaises* (Aix-en-Provence and Marseille, 1982), p. 226.

12 Quoted from Michel Ganzin, 'Le Héros révolutionnaire, 1789–1794', *Revue historique de droit français et étranger*, 61 (1983), pp. 371–92, here p. 386.

13 With regard to this posthumous theatrical success in all France, from 1790 to 1794, see Hans-Jürgen Lüsebrink, 'Brutus, idole patriotique. Dimensions symboliques et mises en scène théâtrales', in Franco Piva, ed., *Bruto il maggiore nella letteratura francese e dintorni* (Brindisi, 2002), pp. 285–305.

14 Philippe Bordes, *La Mort de Brutus de Pierre-Narcisse Guérin*, exh. cat., Vizille, Musée de la Révolution française (1996).

15 *La Révolution française et l'Europe*, exh. cat. Paris, Grand Palais (1989), II, p. 429, no. 557.

16 See Germer and Kohle, 'From the Theatrical to the Aesthetic Hero'. With regard to the controversial new history of the meaning of the work, see the comprehensive critical work by D. Carrier, 'The Political Art of Jacques Louis David and his Modern-Day American Successors', *Art History* 26/5 (2003), pp. 730–51.

17 See Ganzin, 'Le Héros révolutionnaire'.

18 Quoted from David L. Dowd, *Pageant-Master of the Republic: Jacques Louis David and the French Revolution* (Lincoln, NE, 1988), p. 79, note 6 (there also is the source for the French original).

19 Andrew McClellan, 'D'Angiviller's "Great Men" of France and the Politics of the Parlements', *Art History* 13/2 (1990), pp. 175–92.

20 *La Mort de Bara. De l'événement au mythe. Autour du tableau de Jacques Louis David*, exh. cat., Avignon, Musée Calvet (1989); see also Jean-Philippe Chimot, 'Entre l'exécution de Louis XVI et celle de Robespierre, faire évanouir les Martyrs', *Revue des Sciences humaines*, no. 275 (2004), pp. 103–9.

21 Robespierre on 28 December 1793, quoted from Ganzin, 'Le héros révolutionnaire', p. 380.

22 See Olander, *Pour transmettre à la postérité*, pp. 301–2.

23 Hans-Christian Harten, *Utopie und Pädagogik in Frankreich. 1789–1860. Ein Beitrag zur Vorgeschichte der Reformpädagogik* (Bad Heilbrunn, 1996), pp. 11–67.

24 Robert Simon, 'Portrait de martyr, Le Peletier', in Régis Michel, ed., *David contre David* (Paris, 1993), vol. I, p. 351ff.

25 Louis-Sébastien Mercier, *Le Nouveau Paris* (Paris, 1798), V, p. 103; see also Antoine de Baecque, 'Le corps meurtri de la Révolution. Le discours politique et les blessures des martyrs (1792–1794)', *Annales historiques de la Révolution française*, 59 (1987), pp. 17–41.

26 See Dowd, *Pageant-Master of the Republic*, p. 98ff.

27 See Antoine Schnapper, *David und seine Zeit* (Fribourg and Würzburg, 1981), p. 151.

28 David's explanation on the occasion of the reception of his painting in the Convention on 29 March 1793, quoted from Daniel and Guy Wildenstein, *Documents complémentaires au catalogue de l'Œuvre de J.-L. David* (Paris, 1973), p. 50, no. 427.

29 Jean-Claude Bonnet, ed., *La Mort de Marat* (Paris, 1986).

30 Klaus Herding, 'Diogenes als Bürgerheld', in Herding, *Im Zeichen der Aufklärung. Studien zur Moderne* (Frankfurt, 1989), pp.163–82.

31 A well-known picture by Boilly from 1794 is dedicated to the acquittal in this trial. He painted it at just the time when he himself was coming under suspicion for his lack of commitment to the Revolution.

32 Charles Baudelaire, *Le Musée classique du Bazar Bonne-Nouvelle, Œuvres complètes de Charles Baudelaire, ii, Curiosités esthétiques* (Paris, 1989), p. 199ff.

33 Quoted from Ganzin, 'Le Héros révolutionnaire', p. 378.

34 Klaus Herding, 'Davids *Marat* als dernier appel à l'unité révolutionnaire', *Idea. Jahrbuch der Hamburger Kunsthalle*, 2 (1983), pp. 89–112; William Vaughan and Helen Weston, *Jacques-Louis David's Marat* (Cambridge, 2000). A penetrating analysis also in James Rubin, 'Disorder/Order, Revolutionary Art as Performative Representation', in Sandy Petrey, ed., *The French Revolution 1789–1989: Two Hundred Years of Rethinking* (Lubock, 1989), esp. p. 90ff.

35 De Baecque, 'Le Corps meurtri de la Révolution', here p. 24.

36 Baudelaire, *Le Musée classique du Bazar Bonne-Nouvelle*, p. 202.

37 Herding, 'Davids *Marat* . . .'. In contrast, see especially Jörg Träger, *Der Tod des Marat. Revolution des Menschenbildes* (Munich, 1986), p. 76. Träger, on the other hand, who refutes Herding's ambivalence thesis with the assertion that the National Assembly was not for the people, but for the educated elite, can be countered with the observation that the parliamentary sessions were clearly quite open, and that they found great resonance with the public in the gallery.

38 Lise Andries, 'Les Estampes de Marat sous la Révolution, une emblématique', in Bonnet, ed., *La Mort de Marat*, p. 190.

39 Schnapper, *David und seine Zeit*, p. 156.

40 *La Révolution française et l'Europe*, II, p. 455, no. 599.

41 See Gérard Hubert and Guy Ledoux-Lebard, *Napoleon. Portraits contemporains, bustes et statues* (Paris, 1999), p. 133f.

42 For the relevant museum projects, see Elke Harten, *Museen und Museumsprojekte der*

Französischen Revolution. Ein Beitrag zur Entstehungsgeschichte einer Institution (Munster, 1989), esp p. 26ff.

43 Bernardin de Saint-Pierre, *Harmonies de la Nature* (*Œuvres*, XIII, 136; XIV, 197), quoted from Werner Hofmann, *Das irdische Paradies. Motive und Ideen des 19. Jahrhunderts* (Munich, 1974), p. 96.

44 Vovelle, 'Héroïsation et Révolution'.

45 Hans-Jürgen Lüsebrink and Rolf Reichardt, *The Bastille: A History of a Symbol of Despotism and Freedom* (Durham, NC, and London, 1997), pp. 86–106.

46 They all received an iron medallion from Palloy, which depicted an emancipated slave with a Phrygian cap, with the inscription 'La liberté a rompu mes fers, l'égalité m'a élevé'; documented by Michel Hennin, *Histoire numismatique de la Révolution française* (Paris, 1826), nos. 351–2 and plate 33. See also the anonymous etching *Première fête de la Liberté à l'occasion des quarante Soldats de Château-Vieux, arrachés des galères de Brest*, *Révolutions de Paris*, no. 145 (14–21 April 1792), p. 98.

47 *Recueil des actions héroïques et civiques des Républicains français*, 5 vols (Paris, an II [1793–4]).

48 Schnapper, *David und seine Zeit*, p. 143.

49 Gisela Gramaccini, *Jean-Guillaume Moitte (1746–1810). Leben und Werk* (Berlin, 1995), vol. I, p. 107ff.

50 David's speech to the Convention is in *Archives parlementaires*, vol. 78 (Paris, 1911), p. 560, 'I propose to place this monument, composed of the heaped debris of those [demolished royal] statues, on the Place du Pont Neuf, and to set *on top of it the image* of the giant people, *the French people*. Let that image, imposing by its quality of strength and simplicity, carry these words written in large letters, on its forehead, *light*; on its breast, *nature*, *truth*; on its arms, *strength*; on its hands, *work*. On one of its hands, let the figures of liberty and equality, tightly clasped to each other and ready to travel the world, show all men that they rely solely on the genius and the virtue of the people. Let this image of the people *standing* hold in its other hand the terrifying club which is the real thing of which the mythic Hercules' club was merely the symbol. [...]' (emphasis in original).

51 Gramaccini, *Jean-Guillaume Moitte*, pp. 284–92.

52 See, among others, the anonymous etching *Au Peuple français* of 1793 (BnF, Est., Coll. De Vinck, no. 6321) and *Le Patriote Hercule terrassant l'Hydre*, frontispiece to *Almanach républicain chantant, pour l'an 2e de la République française* (Paris: Lalle-mand, 1793).

53 Bronislaw Baczko, *Ending the Terror: The French Revolution after Robespierre* (New York, 1994). Also, from the perspective of art history, the case study by Stefan Germer, 'Comment sortir de la Révolution? Symbolische Verarbeitungsformen einer geschichtlichen Umbruchsituation im nachthermidorianischen Frankreich', in Andreas Beyer et al., eds, *Hülle und Fülle. Festschrift für Tilmann Buddensieg* (Alfter, 1993), pp. 241–50.

54 P. F. Page, *Essai sur les causes et les effets de la Révolution* (Paris, 1795), p. 2.

55 Kathrin Simons, 'Der *Triumph der Zivilisation* von Jacques Réattu', *Idea. Jahrbuch der Hamburger Kunsthalle*, 2 (1983), pp. 113–28. See also the catalogue *Jacques Réattu sous le signe de la Révolution*, Vizille, Musée de la Révolution française (2000).

56 For a similar development on the part of David after the Revolution, see Germer and Kohle, 'From the Theatrical to the Aesthetic Hero'.

57 Etching from the *Révolutions de Paris* of autumn 1793; see illus. 17.

58 See Gudrun Gersmann and Hubertus Kohle, 'Auf dem Weg ins juste milieu, 1794–1799', idem, eds, *Frankreich 1800. Gesellschaft, Kultur, Mentalitäten* (Stuttgart, 1990), p. 16.

Chapter 6

1 For a 'psychological history' of the guillotine, see Daniel Arasse, *La Guillotine et l'imaginaire de la Terreur* (Paris, 1987).

2 For the verbal aspect of the concept, Gerd van den Heuvel, 'Terreur, Terroriste, Terrorisme', in Rolf Reichardt and Eberhard Schmitt, eds, *Handbuch politisch-sozialer Grundbegriffe in Frankreich 1680–1820* (Munich, 1985), III, pp. 89–132.

3 Keith Michael Baker, ed., *The French Revolution and the Creation of Modern Political Culture*, vol. IV: *The Terror* (New York and London, 1994); Bronislaw Baczko, *Ending the Terror: The French Revolution after Robespierre* (New York, 1994); Patrice Guenif-fey, *La Politique de la Terreur. Essai sur la violence révolutionnaire, 1789–1794* (Paris, 2000). See also Arno Mayer, *The Furies, Violence and Terror in the French and Russian Revolutions* (Princeton, NJ, 2000), and the concommitant debate in *French Historical Studies* 24/4 (Autumn 2001), pp. 549–600.

4 For the important role of prints in this sphere see also the archival references in Patrick Laharpie, 'Les Burins de la Terreur', *Histoire et Archives*, 6 (1999), pp. 77–136 and 151–72.

5 Pierre Rétat, ed., *L'Attentat de Damiens: discours sur l'événement au XVIIIe siècle* (Paris, 1979); Dale K. Van Kley, *The Damiens Affair and the Unraveling of the Ancien Régime, 1750–1770* (Princeton, NJ, 1979).

6 Pierre-Jean-Georges Cabanis, *Note sur le supplice de la Guillotine*, with a study recently edited by Yannick Beaubatie (Périgueux, 2002).

7 See Jürgen Martschukat, 'Ein schneller Schnitt, ein sanfter Tod? Die Guillotine als Symbol der Aufklärung', in Anne Conrad et al., eds, *Das Volk im Visier der Aufklärung. Studien zur Popularisierung der Aufklärung im späten 18. Jahrhundert* (Hamburg, 1998), p. 129.

8 Frédéric Braesch, *Le Père Duchesne d'Hébert* (Paris, 1938).

9 Arasse, *La Guillotine et l'imaginaire de la Terreur*, p. 41.

10 'For as long as the sun has been in the firmament, with the planets orbiting around it, the like has not been seen, that people stand on their heads, that is to say on their thoughts, and build reality upon them. [...] Consequently it was a magnificent sunset.' G.F.W. Hegel, *Vorlesungen über die Philosophie der Geschichte, Sämtliche Werke*, ed. H. Glockner (Stuttgart, 1961), XI, p. 557.

11 *La Guillotine dans la Révolution*, exh. cat., Vizille, Musée de la Révolution française (1987), no. 44.

12 Ibid., no. 45.

13 Ibid., no. 57.

14 Henry William Bunbury's coloured etching *A Barber's Shop* (1785) was adapted and politicized in the anonymous French etching *Le Perruquier patriote* (1789), from an unsigned English etching. *Le Gourmand* (1791), a reversed French copy was also produced; while the print *The Contrast* (1792) by Thomas Rowlandson from George Murray's was translated from French into English from an anonymous etching, *Le Contraste* (1793). Furthermore, English caricatures could be purchased in Paris print shops, e.g., the periodical *London und Paris* (vol. II, Weimar ,1798, pp. 387–89). There are also a few similar references in David Bindman, *The Shadow of the Guillotine: Britain and the French Revolution* (London, 1989), p. 34f. Furthermore, most recently, the exh. cat. of Wolfgang Cillessen, Rolf Reichardt and Christian Deuling, eds., *Napoleons neue Kleider. Paris und Londoner Karikaturen im klassischen Weimar* (Berlin, 2006).

15 See our chapter Two, also the Paris exh. cat., *La Révolution française et l'Europe*, II, pp. 594–600.

16 *La Guillotine dans la Révolution* , no. 58.

17 *James Gillray: The Art of Caricature*, exh. cat., Tate Britain, London (2001), p. 18.

18 Ibid., no. 60.

19 Ibid., no. 56.

20 Ibid., p. 17. Also Michel Jouve, 'L'image de la Révolution dans la caricature anglaise (stéréotypes et archétypes)', in Michel Vovelle, ed., *Les Images de la Révolution francaise* (Paris, 1988), pp. 185–92.

21 In connection with similarities in the art of Gillray and Cruikshank during the time of the Revolution, see K. Renger, 'Karneval und Fasten. Bilder vom Fressen und Hungern', *Weltkunst*, 58 (1988), pp. 184–9.

22 *James Gillray*, p. 19.

23 Günther Lottes, *Politische Aufklärung und plebejisches Publikum. Zur Theorie und Praxis des englischen Radikalismus im späten 18. Jahrhundert* (Munich, 1979); Harry Thomas Dickinson, 'Counter-revolution in Britain in the 1790s', *Tijdschrift voor Geschiedenis*, 102 (1989), pp. 354–67.

24 Edmund Burke, *Reflections on the Revolution in France* (Oxford, 1993), p. 10.

25 Ibid., p. 146ff.

26 Cf. Albert Boime, 'Jacques-Louis David: Scatological Discourse in the French Revolution, and the Art of Caricature', *Arts Magazine* (February 1988), pp. 72–81.

27 Ibid., p. 76.

28 Ibid., p. 78.

29 'Some slightly acerbic forms were treated as accusations, but those forms destroyed the snares of the aristocracy, the representative [Le Bon] was reproached for excessive severity, but he only unmasked false patriots, and not one patriot was attacked. [. . .] One must speak of the revolution only with respect, and of the revolutionary measures only with consideration.' *Archives parlementaires*, series I, vol. 93 (1982), pp. 27–8.

30 In this connection, and the pictorial settling of accounts with the Jacobins during Year II, see Ian Germani, 'Les Bêtes féroces: Thermidorian Images of Jacobinism', *Proceedings of the Annual Meeting of the Western Society for French History*, 17 (1990), pp. 205–19.

31 She is alluding to pamphlets that Poirier published after his release from prison, *Les Angoisses de la Mort, ou Idées des horreurs des Prisons d'Arras* (Paris, an III); *Atrocités commises envers les citoyennes cidevant détenues dans la maison d'arrêt dite de la Providence, à Arras* (Paris, an III).

32 Also Joseph Zizek, '"Plume de fer". Louis-Marie Prudhomme writes the French Revolution', *French Historical Studies*, 26 (Autumn 2003), pp. 619–60.

33 Louis-Marie Prudhomme, *Histoire générale et impartiale des erreurs, des fautes et des crimes commis pendant la Révolution francaise* (Paris, 1797), I, p. viii, 'Expl. des gravures'.

34 A. Aulard, ed., *Paris pendant la réaction thermidorienne et sous le Directoire* (Paris, 1899), II, p. 28.

35 François Gendron, *La Jeunesse dorée. Episodes de la Révolution française* (Sillery, 1979).

36 See Hans-Ulrich Thamer, 'Revolution, Krieg, Terreur. Zur politischen Kultur und Ikonographie der Französischen Revolution', H. Keller and N. Staubach, eds, *Iconologia sacra. Mythos, Bildkunst und Dichtung in der Religions- und Sozialgeschichte Alteuropas* (Berlin and New York, 1994), p. 649.

37 Riho Hayakawa, 'L'Assassinat du boulanger Denis François le 21 octobre 1789', *Annales historiques de la Révolution française*, 75 (2003), pp. 1–19.

38 In this connection see Odile Faliu, '*Le Calculateur patriote*. Fortune d'une estampe révolutionnaire', *Nouvelles de l'estampe*, no. 111 (July 1990), pp. 11–21; and Claudette Hould, ed., *L'image de la Révolution français*, exh. cat. (Québec, 1989), p. 286.

1 François René de Chateaubriand, *Essai historique, politique et moral sur les révolutions anciennes et modernes, considérées dans leurs rapports avec la Révolution française* (1797), ed. Maurice Regnard (Paris, 1978), p. 15, 'Avertissement' for the new edition of 1826.

2 Reinhart Koselleck, 'Revolution, Rebellion, Aufruhr, Bürgerkrieg', in Otto Brunner, Werner Conze and R. Koselleck, eds, *Geschichtliche Grundbegriffe*, vol. 5 (Stuttgart, 1984), pp. 653–788; Hans-Jürgen Lüsebrink and Rolf Reichardt, '*Révolution* à la fin du 18e siècle. Pour une relecture d'un concept-clé du siècle des Lumières', *Mots*, no. 16 (1988), pp. 35–67.

3 'Réflexions sur la révolution, & sur les causes qui l'ont maintenue', *Journal de la République Française*, no. 108 (27 January 1793), pp. 3–8, quotation on p. 6.

4 *Alphabet des sans-culottes* (Paris, 1793–4), p. 9.

5 Léonard Snetlage, *Nouveau Dictionnaire français contenant les expressions de nouvelle création du peuple français* (Göttingen, 1795), pp. 196–8. After François-Xavier Pagès (*Histoire secrète de la Révolution française*, 1797), the French Revolution was made up of eleven 'révolutions'; cf. Rolf Reichardt, 'Die Revolution – ein magischer Spiegel. Historisch-politische Begriffsbildung in französisch-deutschen Übersetzungen', in Hans-Jürgen Lüsebrink and R. Reichardt, eds, *Kulturtransfer im Epochenumbruch, Frankreich – Deutschland 1770 bis 1815* (Leipzig, 1997), pp. 883–999, here 943–4.

6 Paris, Archives Nationales, V²551; quoted from François-Louis Bruel, *Une siècle d'histoire de France par l'estampe, 1770–1871, Collection de Vinck. Inventaire analytique* (Paris, 1914), II, pp. 375–6.

7 BnF, Est. DV 2763–2767, also QB1, M 98319–98326.

8 In the absence of more definite proof, imagined by Antoine de Baecque, *La caricature révolutionnaire* (Paris, 1988), p. 69.

9 'That caricature, one of the first to appear for the cause of the French revolution, was carefully prohibited from the moment it was put on sale.' Jacques-Marie Boyer-Brun, *Histoire des caricatures de la révolte des Français* (Paris: Imprimerie du Journal du Peuple, 1792), I, p. 57; see also ibid., pp. 35–56.

10 Explanation in the legend: 'Deep Mourning of all those apt to lament the loss of the abuses'. An anonymous detailed copy adds the following commentary on the ruins: 'Downfall of the Ancien Régime and Feudalism', and also adds 'It is written in the Gospels that one must burn the useless vine'; *Convoi de Haut et Puissant Seigneur des Abus* (Vizille, Musée de la Révolution française, inv. 86–122).

11 Their backs bear the names 'Grandier – J.J.Rousseau – Latude – Sirven – Jᶜ D'Arc – Calas – Salmon – Monbailly'. For the background to this scandalous miscarriage of justice and its victim, see Sarah Maza, *Private Lives and Public Affairs: The causes célèbres of Prerevolutionary France* (Berkeley, 1993).

12 Legend, 'Mᵣ Necker, who, having investigated the abuses thoroughly, takes them to the tomb'.

13 Legend, 'Genies singing from the most highly esteemed Treatises on the Estates General'.

14 BnF, Est., DV 1765; image in de Baecque, *La Caricature révolutionnaire*, pp. 66–7.

15 This corresponded to the prevailing situation with regard to construction, adhered to in Jean-Baptiste Martin's painting *Vue du château de Versailles* of 1722, images in Claire Constans and Jean Mounicq, *Versailles* (Paris, 1998), p. 69. The railings and figures were all destroyed during the course of the Revolution.

16 *Ami du Peuple*, no. 443 (29 April 1791), pp. 1–2; emphases in original.

17 Duplessis improved the effectiveness of the picture by a series of alterations to the drawing. In the sky he erased the piece of paper next to the commemorative column, and also a figure that was unveiling Vérité; in the architectonic background he added

a livelier silhouette and more depth of field.

18 *La Révolution française arrivée sous le Règne de Louis xvi le 14 Juillet 1789*, 'inventé, dessiné et gravé par A. Duplessis. Se vend à Paris chez l'Auteur Rue de la Calandre Quartier du Palais, la Porte cochere en face de la Rue St Eloy n° 14'. Aquatint, 38.8 x 59.6 cm (Paris BnF, Estampes, Coll. De Vinck, no. 1701).

19 The legend in full reads: 'High in the Sky, we see August Truth resplendent, coming to give light to the Universe, the Nation and the National Assembly. The French Liberty, in the form of a winged woman about to come down to Earth, has in a single motion dislodged the Crown and broken the iron Sceptre of ghastly Despotism who has settled into the Bastille; alongside is an Eagle crowned with the Imperial Crown, the symbol of the unjust war being waged against France. Behind that group, we see diverse Monsters in the shape of Harpies, representing the defaulting Priests breathing the poison of Fanaticism, the Courtiers exhaling their pestiferous breath, the vicious Ministers, etc. On the other side [of Liberty and Truth] is a beneficent Genie who is engraving on a bronze Column the names of the small number of Patriot Deputies of the Constituent Assembly, whose cherished Memory will be an object of veneration in the centuries to come. The Rainbow announces universal Peace in all the Nations of the Earth after such an astonishing revolution; this is the Prologue of the Events that took place in France.

The Ceremony begins with the principal victims who were stabbed with the Dagger of Despotism and assassinated with the Sword of Justice. They are followed by the Council and, in its midst, the immense Body of the Abuses, on which we can note the Tiara, the Purple, the Censer designating the abuses of the Clergy. The Sword tied to a Purse and a broken Club on the torn Coats of Arms, those of the former Nobility, a Mortar, a square bonnet, and the dreaded Procedures of all the High Courts of the Kingdom, which are the Procedures of Chicanery. The Sceptre and iron Crown beside the Flail, and the Red Book, Tyrannical Empire of abuses. The four corners of the Pall are held by Envy, Avarice, Pride and Folly; all of this borne by the different classes of the erstwhile Third Estate. There follows behind it the President of the National Assembly who, having investigated the Abuses thoroughly, now takes them to the Tomb. Thereafter comes Justice accompanied by France and Equality. Monsieur Bailly, Grand Master of Ceremonies, precedes the Book of the Law borne in Veneration by honourable Members. Behind them is Chicanery, a gag over its mouth, accompanied by Prosecutors in the form of female mourners, wearing long mourning cloaks. Great Despair of Princes, Dukes and Peers, and of all those apt to lament the loss of the Abuses and the burial of the Red Book, the food supply of the idle. The Clergy, the *Présidents à mortier* [Judges], the five fat Tax Farmers General holding one another up and giving mutual consolation, are followed by a throng of Priestesses of Venus in great desolation. The march is closed by the Beadle of the Aristocrats. In the right-hand corner of the Picture, we see Time, ashamed at having so long spared the dregs of the feudal system, now destroying its edifice, the Coats of Arms and all the puerile Distinctions so sought after by Fools and Intriguers. Beside this pile is an Oak Tree with an enormous gash in its trunk announcing its imminent and much desired demolition.

In the front, a crowd of Aristocratic conspirators who, unable to cause any more damage, are obliged to become expatriates and to consume their rage and their money in foreign lands; we will miss them all the less for the fact that they can never die in their beds in France. Beside them are the various Writers of the Revolutions who educated the People about their rights and who avenged the Revolution of the attacks on it by sacrilegious Judges, whose fearsome, iniquitous Procedures led so justly to their own annihilation; these Writers shackled them to the Press to debase them and defame them forever, unto our most distant Posterity. After the Writers

comes the Society of the Friends of the Constitution, from France and also from other lands, who have formed a universal federation and sent their Deputies, at whose head we see Lord Stanhope, President of the English Society of Friends, with the President of the Parisian Jacobins Club.

In the background is the Bastille, from which we see the conquering People emerging; the Procession has passed in front of the Bastille, with a throng of people and of Carriages coming after it. Alongside is the debris left after its demolition, where an Altar to Liberty has been raised, and to this Altar the most zealous Patriots bring their Patriotic Offerings and Gifts. At the head of this group come the wives of Artists, Painters, Sculptors, Engravers, Goldsmiths etc. who were the first to carry out the project created by Madame Moitte, the wife of the Sculptor to the King; she carries the Casket as its depositary. At the back stands the brave and intrepid National Guard, bearing arms commanded by Monsieur de La Fayette, in front of a superb Colonnade in the form of an Ionic Amphitheatre, in which the People stand for a comfortable view of the Procession as it passes by. In the recess an immense throng of various tax-collectors along with other Finance-sucking Vampires, who are being sent off to the moors of Bordeaux and Brittany where hands are needed too cultivate the Land. It was time to sweep away all that Fiscal and Aristocratic rubbish.

By their free Patriot servant Duplessis.

Courage, Honourable Deputies, and you, brave Parisians, here is your Work. Enjoy the Glory of such a beautiful Revolution.'

20 It encompassed now also the Chevalier de La Barre, then Baron Friedrich von der Trenck, Thomas Arthur Lally and – in a cosmopolitan development – even Thomas Morus. Behind them, the National Guard can be seen herding the crowd of court scribes and tax collectors together.

21 Duplessis later adapted the ruins in the original to signify the Bastille.

22 As proved by a dozen prints; cf. Paris BnF, Est., DV 2846–2858.

23 The correct title is *Les crimes des reines de France* (Paris: Bureau des Révolutions de Paris, 1791); a new, enlarged edition appeared in 1792.

24 Raymonde Monnier, *Un bourgeois sans-culotte, Le général Santerre* (Paris, 1989).

25 He replaced the globe decorated with fleurs de lis with the emblem of the destroyed Bastille, Louis XVI's book of fame with the 'Fastes des Français l'An Ier de la Liberté 1789' and added as well the tablet of the 'Droits de l'Homme et du Citoyen'. Further, he has fanatical little devils fluttering about the King, which were not in the first version of the print.

26 Herding and Reichardt, *Bildpublizistik*, pp. 89–103; Wolfgang Cilleßen and R. Reichardt, 'Satirische Begräbnis-Rituale in der revolutionären Bildpublizistik 1786–1848', in Rolf Reichardt, Rüdiger Schmidt and Hans-Ulrich Thamer, eds, *Symbolische Politik und politische Zeichensysteme im Zeitalter der französischen Revolutionen, 1789–1848* (Munster, 2005), pp. 17–81.

27 Henri-René d'Allemagne, *Le Noble Jeu de l'Oie en France de 1640 à 1950* (Paris, 1950); Alain R. Gérard and Claude Quétel, *Histoire de France racontée par le jeu de l'Oie* (Paris, 1982).

28 James A. Leith, 'Clio and the Goose: The Jeu de l'Oie as Historical Evidence', in Carolyn W. Whitte, ed., *Essays in European History, Selected from the Annual Meeting of the Southern Historical Association* (Lanham, NY, and London, 1996), III, pp. 225–61; idem, 'La Pédagogie à travers les jeux, le jeu de l'oie pendant la Révolution et l'Empire', in Josiane Boulad-Ayoub, ed., *Former un Nouveau Peuple? Pouvoir – Education – Révolution* (Paris, 1996), pp. 159–86.

29 There is also the similarly built-up, anonymous coloured etching *Jeu de la Revolution française, tracé sur le plan du jeu d'oye renouvelé des Grecs* (Paris BnF, Est., H 11.050).

30 The following is also attested in some instances by Rolf Reichardt, *Das Revolutions-spiel von 1791. Ein Beispiel für Medienpolitik und Selbstdarstellung der Französischen Revolution* (Frankfurt, 1989); idem, 'Historical Semantics and Political Iconography: The Case of the Game on the French Revolution (1791–2)', in Iain Hampsher-Monk, Karin Tilmans and Frank van Vree, eds, *History of Concepts: A Comparative Approach* (Amsterdam, 1998), pp. 191–226.

31 Consequently in a row of segments, the usual geese have been replaced by hens. Anyone landing on a hen would double the number just thrown and would receive symbolically what had once been promised by Henri IV.

32 Charles Tillon, *Le Laboureur et la République. Michel Gérard, deputé paysan sous la Révolution française* (Paris, 1983).

33 Jean-Marie Collot d'Herbois, *Almanach du Père Gérard pour l'année 1792* (Paris: Société des amis de la Constitution, autumn 1791); seven French versions, by four publishers, were in circulation about 1792.

34 General rules of the game are on the left side, while special rules for individual segments are on the right side of the print.

35 Aside from these, the closest reproduced print is a lightly coloured etching, *Les Délassemens du Père Gérard ou la Poule de Henri iv mise au pot en 1792. Jeu national*, 1792 (Paris, BnF, Est., DV 4292); and *Nationalspiel oder das Huhn Heinrich des Vierten in den Topf gethan im Jahr 1792*, Strasbourg, Treuttel 1792 (Strasbourg, Musée municipal, prints collection, without inv. no.).

36 Adverts for this print for the 'pulp trade' were published by the Strasbourg publisher Treuttel in the 1792 Revolutionary almanac by Rabaut Saint-Etienne.

37 'The first state in which men lived with one another was that of Equality. The most cunning and the most strong soon brought the weak down under their yoke and usurpation produced slavery. From slavery was born ignorance; the habit of cowardly submission gave birth to superstition and thence to civil wars, anarchy, cruelty. Such was the lot of all peoples; such was the fate of the French, when heaven sent them Henri IV, a ruler full of goodness who loved all men, created happiness in society through his respect for the law, and desired the public good [!]. Treachery plunged its dagger into the heart of that good king. His successor established despotic rule. Extravagance and excess of every kind characterized his reign and particularly his court. The spirit of conquest brought that folly to its paroxysm. That is the origin of the national debt, which the Third Estate bore with as much fortitude as gentleness and patience, although reduced to destitution by their excessive burden of taxes. The Clergy paid nothing; neither did the Nobility. Noble families with quarterings believed themselves exempt from everything. The most conniving schemers within that proud and useless caste became ministers. They invented the *lettres de cachet* [orders sent to individuals under the king's private seal], the Bastille, and the farmers general who precipitated the State into bankruptcy. Finally there appeared Montesquieu, who had the courage to raise one corner of the curtain concealing our rights. The spirit of philosophy spread. Voltaire preached toleration, Jean-Jacques Rousseau taught us human rights. The Slave, enlightened, took back his rights and wore the National Cockade with a flourish. The revolution takes place. Mirabeau, with his courage and his genius, brings the Majority of the National Assembly to life. The warmth of patriotic feeling fires the whole Empire. The citizens present patriotic gifts; religion is recalled to its primal, pure state; legislative power is in the hands of the representatives of the nation. France stands up in glory in the midst of the other powers of Europe. The Federation of all the citizens of the empire is solemnly sworn on the Altar of the *patrie*, and the 14 July marks an epoch forever memorable in the history of nations. Chains of every kind are broken. Innocent victims, condemned to languish in the prisons of fanaticism

[young girls confined in convents] are brought to the altar of wedlock. Judicial power, properly organised, frightens traitors. Princes dissimulate or threaten; vigilance thwarts their projects. Responsibility sets up a barrier in opposition to ministers. Louis XVI and the Dauphin take flight. They are arrested at Varennes. The warmth of love of country unites all parties. The extravagance of the Aristocrats appears in its truest light; the monks sow discord. The only thing we have to fear, the failure of constancy, would take us back into slavery, but the French *citoyennes*, motivated by their patriotic feelings, inculcate the advantages of the Constitution in their children at an early age. A new education forms a generation of new men. Concord reigns among the citizens, liberty is unshakeable. Great virtues will be rewarded with civic crowns. Love of one's neighbour, commanded by religion as by the Constitution, makes of our regenerated Frenchmen nothing more or less than brothers. Executive power, enlightened about the true duties, will advance in the direction marked out by the Constitution; the royal ruler, educated by the great examples of the revolution, will complete the regeneration; society, composed of virtuous men, will be a paradise on earth, and it will be from the new Constitution that all kinds of wealth will pour forth.'

38 These are sometimes the same expressions as on the segments of the revolutionary board games.

39 B. Constant likewise condemned the excesses of the Revolution (*Des effets de la Terreur*, 1997), also the politics of conquest of Napoleon (*De l'esprit de conquête et de l'Usurpation*, 1814) and developed his liberal credo and his print together, *Principes de politique applicables à tous les gouvernements* (1815).

40 Klaus Deinet, *Die mimetische Revolution oder die französische Linke und die Re-Inszenierung der Französischen Revolution im neunzehnten Jahrhundert, 1830–1871* (Stuttgart, 2001); for political symbolism, see Raimund Rütten, ed., *Die Karikatur zwischen Republik und Zensur. Bildsatire in Frankreich 1830 bis 1880 – eine Sprache des Widerstands?* (Marburg, 1991).

41 As attested in Reichardt, 'Die Revolution – ein magischer Spiegel' , pp. 938–42.

42 According to the former liberal representative of the nobility in the first National Assembly, François-Emmanuel Toulongeon, *Manuel révolutionnaire, ou pensées morales sur l'état politique des peuples en Révolution* (Paris, Dupont 1796).

43 As evidenced by the piece of paper inscribed 'Ordonnances état de siège'. By this was meant the construction, which had just commenced, of a ring of fortifications around the capital; the opposition saw this as a precautionary measure against new workers' uprisings.

44 This saying is modelled on the prophetic books of the Old Testament, but the exact wording cannot be proved by reference to the Bible.

45 Joachim von der Thüsen, 'Die Lava der Revolution fließt majestätisch. Vulkanische Metaphorik zur Zeit der Französischen Revolution', *Francia. Forschungen zur westeuropäischen Geschichte*, 23/2 (1996), pp. 113–42.

46 In identification with the radical Jacobins, on 24 October 1794 he wrote from Paris to his wife Therese, 'Just as we have eliminated the Vendée, so we will eliminate everything which stands in our way. [. . .] The lava of the Revolution flows majestically and unstoppably.' Georg Forster, *Werke. Sämtliche Schriften, Tagebücher, Briefe*, published by the Deutschen Akademie der Wissenschaften in Berlin, vol. XVII, ed. Klaus-Georg Popp (Berlin, 1979), p. 469.

47 James Gillray, *The Eruption of the Mountain, or the horrors of the 'Bocca del Inferno', with the head of the Protector Saint Januarius carried in procession by the Cardinal Archvêque of the Lazaroni*, coloured etching, London, H. Humphrey, 25 July 1794 (BM 8479).

48 The image here shows the second version of the print, a day before the battle. The

earlier first version had no mention in the caption of the 'Waterloo Storm', but of the 'approaching Storm'. Cf. Hans Peter Mathis, ed., *Napoleon 1. im Spiegel der Karikatur / Napoleon 1 in the Mirror of Caricature* (Zürich, 1998), p. 282.

49 Examples in Susanne Bosch-Abele, *La Caricature (1830–1835). Katalog und Kommentar*, I (Weimar, 1997), p. 397.

50 *La Caricature (Journal)*, no. 135 (6 June 1833), col. 1075.

51 Philipon exerted a great influence on the artists he employed, with regard to both theme and content, as attested by David S. Kerr, *Caricature and French Political Culture, 1830–1848: Charles Philipon and the Illustrated Press* (London, 2000), pp. 65–71 and 99–103.

52 This was also the case with pictorial publicity; see in this connection the exh. cat. *Les révolutions de 1848: l'Europe des images*, 2 vols (Paris: Assemblée Nationale 1998).

Bibliography

Alberici, Clelia, 'Vincenzo Vangelisti, primo professore della scuola d'incisione dell'Accademia Brera', *Rassegna di studi e di notizie*, XIX–XXII (1995), pp. 11–38

Albertini, Rudolf von, 'Parteiorganisation und Parteibegriff in Frankreich, 1789–1940', *Historische Zeitschrift*, 193 (1963), pp. 529–600

Aldenhoven, Carl, *Katalog der Herzoglichen Gemäldegalerie (Herzogliches Museum zu Gotha)* (Gotha, 1890)

d'Allemagne, Henri-René, *Le Noble Jeu de l'Oie en France de 1640 à 1950* (Paris, 1950)

Andries, Lise 'Les Estampes de Marat sous la Révolution, une emblématique', in *La Mort de Marat*, ed. Jean-Claude Bonnet (Paris, 1986), pp. 187–201

Anthologie patriotique, ou Choix d'Hymnes, Chansons, Romances, Vaudevilles & Rondes civiques, extrait des Recueils & Journaux qui ont paru depuis la Révolution (Paris: Pougin, 1794)

Arasse, Daniel, *La Guillotine et l'imaginaire de la Terreur* (Paris, 1987)

Archives parlementaires de 1787 à 1860. Première Série (1787 à 1799), vol. 1– (Paris, 1867–)

Aulard, François-Alphonse, ed., *Paris pendant la Réaction thermidorienne et sous le Directoire. Recueil de documents pour l'histoire de l'esprit public à Paris*, vols I–V (Paris, 1898–1902)

—, ed., *Recueil des Actes du Comité de Salut Public*, vols I–XXX and Suppl. I–IV (Paris, 1889–1933 / 1964–71)

—, ed., *La Société des Jacobins. Recueil de documents pour l'histoire du Club des Jacobins de Paris*, vols I–VI (Paris, 1899–97)

Baczko, Bronislaw, *Ending the Terror: The French Revolution after Robespierre* (New York, 1994)

Baecque, Antoine de, 'The Allegorical Image of France, 1750–1800: A Political Crisis of Representation', *Representations*, 47 (1994), pp. 111–43

—, *La Caricature révolutionnaire* (Paris, 1988)

—, 'Le corps meurtri de la Révolution. Le discours politique et les blessures des martyrs (1792–1794)', *Annales historiques de la Révolution française*, 59 (1987), pp. 17–41

—, 'La Révolution accueille la Régénération. Naissance, éducation et prétention du nouvel homme', in *La Révolution française et le processus de socialisation de l'homme moderne*, ed. Claude Mazauric (Paris, 1989), pp. 661–8

Baker, Keith Michael, ed., *The French Revolution and the Creation of Modern Political Culture*, vol. IV: *The Terror* (New York and London, 1994)

Barny, Roger, *L'Eclatement révolutionnaire du rousseauisme* (Paris, 1988)

—, *Rousseau dans la Révolution: le personnage de Jean-Jacques et les débuts du culte révolutionnaire, 1787–1791* (Oxford, 1986)

Beaumont-Maillet, Laure and Odile Faliu, eds, *Images de la Révolution française. Catalogue du vidéodisque produit à l'occasion du Bicentenaire de la Révolution française*, 3 vols (Paris and London, 1990)

Benzaken, Jean-Charles, *Iconographie des monnaies et médailles des Fêtes de la Fédération, mai 1790–juillet 1791* (Paris, 1992)

Bertrand, Régis, 'L'allégorie des trois ordres d'Aix-en-Provence ou la relecture révolutionnaire d'une image du temps de la Ligue', in *Église, Éducation, Lumières . . . , Histoires culturelles de la France, 1500–1830*, ed. Alain Croix, André Lespagnol and Georges Provost (Rennes, 1999), pp. 437–42

Bindman, David, *The Shadow of the Guillotine: Britain and the French Revolution* (London, 1989)

Blum, Carol, *Rousseau and the Republic of Virtue: The Language of Politics in the French Revolution* (Ithaca, NY, 1986)

Bohrer, Karl Heintz, *Plötzlichkeit. Zum Augenblick des ästhetischen Scheins* (Frankfurt, 1981)

Boime, Albert, 'Jacques-Louis David: Scatological Discourse in the French Revolution, and the Art of Caricature', *Arts Magazine* (February 1988), pp. 72–81

Boime, Albert, 'The Teaching Reforms of 1863 and the Origins of Modernism in France', *Art Quarterly* (Autumn 1977), pp. 1–39

Boissard, Jean-Jacques, *Emblematum liber* (Frankfurt, 1593; new edn Hildesheim, 1977)

Bonnet, Jean-Claude, ed., *La Mort de Marat* (Paris, 1986)

—, *Naissance du Panthéon. Essai sur le culte des grands hommes* (Paris, 1998)

Bonneville, François, *Portraits des personnages célèbres de la Révolution* (Paris: Bonneville, 1796)

Bordes, Philippe and Régis Michel, eds, *Aux Armes et aux Arts! Les arts de la Révolution, 1789–1799* (Paris, 1988)

Bordes, Philippe, 'Die Darstellung des revolutionären Ereignisses oder Die Herausforderung der Malerei durch die Graphik', in *Bildgedächtnis eines welthistorischen Ereignisses. Die Tableaux historiques de la Révolution française*, ed. Christoph Danelzik-Brüggemann and Rolf Reichardt (Göttingen, 2001), pp. 17–34

—, 'Jacques-Louis David et l'estampe', in *Delineavit et sculpsit. Dix-neuf contributions sur les rapports dessin-gravure du XVIe au XXe siècle*, ed. François Fossier (Lyon, 2003), pp. 171–9

—, *La Mort de Brutus de Pierre-Narcisse Guérin*, exh. cat., Musée de la Révolution française (Vizille, 1996)

—, *Le Serment du Jeu de Paume de Jacques Louis David* (Paris, 1984)

Bosch-Abele, Susanne, *La Caricature (1830–1835). Katalog und Kommentar*, 2 vols (Weimar, 1997)

Bouineau, Jacques, 'Le référent antique dans la Révolution française, légitimation d'une société sans église', in *L'Influence de l'antiquité sur la pensée politique européenne (XVI–XXème siècles)*, ed. Michel Ganzin (Aix and Marseille, 1996), pp. 317–37

Boullée, Etienne-Louis, *Architektur. Abhandlung über die Kunst* (Zürich, 1987)

Boutier, Jean, *Campagnes en émoi. Révoltes et Révolution en Bas-Limousin, 1789–1800* (Treignac, 1987)

Boyer-Brun, Jacques-Marie, *Histoire des caricatures de la révolte des Français*, 2 vols (Paris: Imprimerie du Journal du Peuple, 1792)

Braesch, Frédéric, *Le Père Duchesne d'Hébert* (Paris, 1938)

Bruel, François-Louis et al., *Une siècle d'histoire de France par l'estampe, 1770–1871, Collection de Vinck. Inventaire analytique*, 9 vols (Paris, 1909–68)

Buchartowski, Caroline, *Nachahmung und individuelle Ausdrucksform. Eine Untersuchung zu den Motiventlehnungen in der politischen Karikatur James Gillrays im Zeitraum 1789 bis 1806* (Frankfurt and Berlin, 1994)

Burke, Edmund, *Reflections on the Revolution in France* (Oxford, 1993)

Busch, Werner, 'Copley, West and the Tradition of European High Art', in *American Icons: Transatlantic Perspectives on Eighteenth- and Nineteenth-century Art*, ed.

Thomas W. Gaehtgens and Heinz Ickstadt (Santa Monica, CA, 1992), pp. 35–59

—, *Das sentimentalische Bild. Die Krise der Kunst im 18. Jahrhundert und die Geburt der Moderne* (Munich, 1993)

—, 'Hogarth's *Marriage A-la-Mode*: The Dialectic between Precision and Ambiguity', in *Hogarth: Representing Nature's Machines*, ed. David Bindman, Frédéric Ogée and Peter Wagner (Manchester and New York, 2001), pp. 195–218

Cabanis, Pierre-Jean-Georges, *Note sur le supplice de la Guillotine*. With a study by Yannick Beaubatie (Périgueux, 2002)

Campe, Johann Heinrich, *Briefe aus Paris zur Zeit der Revolution geschrieben*, second letter of 9 August 1789, in *Die Französische Revolution. Berichte und Deutungen deutscher Schriftsteller und Historiker*, ed. Horst Günther (Frankfurt, 1985), pp. 9–102

Cantarel-Besson, Yveline, *La Naissance du musée du Louvre. La politique muséologique sous la Révolution d'après les archives des musées nationaux* (Paris, 1981)

Caratini, Roger, *Dictionnaire des personnages de la Révolution* (Paris, 1988)

Carbonnières, Philippe de, *Prieur. Les 'Tableaux historiques' de la Révolution. Catalogue raisonné des dessins originaux* (Paris, 2006)

Caron, Pierre, 'La Tentative de contre-révolution de juin–juillet 1789', *Revue d'histoire moderne et contemporaine*, 1st series, vol. VIII (1906–07), pp. 5–31 and 649–78

Carrier, D., 'The Political Art of Jacques Louis David and his Modern-Day American Successors', *Art History* 26/5 (2003), pp. 730–51

Casselle, Pierre, 'Pierre-François Basan, marchand d'estampes à Paris (1723–1797)', *Paris et Ile-de-France*, 33 (1982), pp. 99–185

Censer, Jack R., 'The Political Engravings of the *Révolutions de France et de Brabant*, 1789 to 1791', *Eighteenth-Century Life*, 5 (1979), pp. 105–22

Chagny, Robert, 'La symbolique des trois ordres', in *Les Images de la Révolution française*, ed. Michel Vovelle (Paris, 1988), pp. 267–82

Chateaubriand, François René de, *Essai historique, politique et moral sur les révolutions anciennes et modernes, considérées dans leurs rapports avec la Révolution française* (1797), ed. Maurice Regnard (Paris, 1978)

Chevalier, Alain and Claudette Hould, eds., *La Révolution par la gravure. 'Les Tableaux historiques de la Révolution française': une entreprise éditoriale d'information et sa diffusion en Europe, 1791–1817* (Vizille, 2002)

Chimot, Jean-Philippe, 'Entre l'exécution de Louis XVI et celle de Robespierre: faire évanouir les martyrs', *Revue des Sciences humaines*, no. 275 (2004), pp. 103–9

Cilleßen, Wolfgang and Rolf Reichardt, 'Satirische Begräbnis-Rituale in der revolutionären Bildpublizistik 1786–1848', in *Symbolische Politik und politische Zeichensysteme im Zeitalter der französischen Revolutionen 1789–1848*, ed. Rolf Reichardt, Rüdiger Schmidt and Hans-Ulrich Thamer (Munster, 2005), pp. 17–81

—, Rolf Reichardt and Christian Deuling, eds, *Napoleons neue Kleider. Paris und Londoner Karikaturen im klassischen Weimar*, exh. cat., Staatliche Museen zu Berlin (2006)

Cleary, Richard L., *The Place Royale and Urban Design in the Ancien Régime* (Cambridge, 1999)

Collenberg-Plotnikov, Bernadette, *Klassizismus und Karikatur. Eine Konstellation der Kunst am Beginn der Moderne* (Berlin, 1998)

Collot d'Herbois, Jean-Marie, *Almanach du Père Gérard pour l'année 1792* (Paris: Société des amis de la Constitution, autumn 1791)

Constans, Claire and Jean Mounicq, *Versailles* (Paris, 1998)

Crow, Thomas E., *Emulation: Making Artists for Revolutionary France* (New Haven, CT, 1995)

—, 'The *Oath of the Horatii* in 1785: Painting and Prerevolutionary Radicalism in France', *Art History*, 1 (1978), pp. 424–71

—, *The Painter and Public Life in Eighteenth Century Paris* (New Haven, CT, 1986)

Cuno, James, 'En temps de guerre: Jacques-Louis David et la caricature officielle', in *David contre David. Actes du colloque organisé au musée du Louvre*, ed. Régis Michel (Paris, 1993), vol. I, pp. 519–42 and 548–52

Cuno, James, 'Obscene Humor in French Revolutionary Caricature: Jacques-Louis David's *The Army of Jugs* and *The English Government*', in *Representing the French Revolution: Literature, Historiography and Art*, ed. James A. W. Heffernan (Hanover, NH, 1992), pp. 193–210

Danelzik-Brüggemann, Christoph and Rolf Reichardt, eds., *Das internationale Bildgedächtnis eines welthistorischen Ereignisses. Die* Tableaux historiques de la Révolution française *in Frankreich, den Niederlanden und Deutschland (1791–1819)* (Göttingen, 2000)

David, Marcel, *Fraternité et Révolution française* (Paris, 1987)

De la place Louis XV à la place de la Concorde, exh. cat. (Paris: Musée Carnavalet, 1982).

Deinet, Klaus, *Die mimetische Revolution oder die französische Linke und die Re-Inszenierung der Französischen Revolution im neunzehnten Jahrhundert, 1830–1871* (Stuttgart, 2001)

Deming, Mark K., 'Le Panthéon révolutionnaire', in *Le Panthéon, symbole des révolutions*, exh. cat. (Paris, 1989), pp. 97–150

Dickinson, Harry Thomas, 'Counter-revolution in Britain in the 1790s', in *Tijdschrift voor Geschiedenis*, 102 (1989), pp. 354–67

Diers, Michael, *Schlagbilder. Zur politischen Ikonographie der Gegenwart* (Frankfurt, 1997)

Dowd, David L., *Pageant-Master of the Republic: Jacques Louis David and the French Revolution* (Lincoln, NE, 1988)

Du Rusquec, Emmanuel, *Le Parlement de Bretagne 1554–1994* (Rennes, 1994)

Dubois, Isabelle, A. Gady and F. Ziegler, eds, *La Place des Victoires: histoire, architecture, société*, exh. cat. (Paris, 2004)

Duprat, Annie, 'Autour de Villeneuve: le mystérieux auteur de la gravure *La Contre-Révolution*', *Annales historiques de la Révolution française*, 69 (1997), pp. 423–39

—'Le commerce de la librairie Wébert à Paris sous la Révolution', *Dixhuitième Siècle*, 33 (2001), pp. 357–66

—, 'Louis XVI morigéné par ses ancêtres en 1790: *Les Entretiens des Bourbons*', *Dixhuitième Siècle*, 26 (1994), pp. 317–32

—, 'Le Regard d'un royaliste sur la Révolution: Jacques-Marie Boyer de Nîmes', *Annales historiques de la Révolution française*, 76 (2004), pp. 21–39

—, *Le roi décapité. Essai sur les imaginaires politiques* (Paris, 1992)

—, *Les Rois de papier. La caricature de Henri III à Louis XVI* (Paris, 2002)

Faliu, Odile, '*Le Calculateur patriote*. Fortune d'une estampe révolutionnaire', *Nouvelles de l'estampe*, no. 111 (July 1990), pp. 11–21

Femmel, Gerhard, *Goethes Grafiksammlung, Die Franzosen* (Leipzig, 1980)

Forster, Georg, *Werke. Sämtliche Schriften, Tagebücher, Briefe*, published by the Deutschen Akademie der Wissenschaften in Berlin, vol. XVII, ed. Klaus-Georg Popp (Berlin, 1979)

Foucault, Michel, *Überwachen und Strafen. Die Geburt des Gefängnisses* (Frankfurt, 1981)

French Caricature and the French Revolution, 1789–1799, exh. cat. (Los Angeles, 1988)

Friedland, Paul, *Political Actors, Representative Bodies and Theatricality in the Age of the French Revolution* (Ithaca, NY, 2003).

Furet, François and Mona Ozouf, eds, *A Critical Dictionary of the French Revolution*, trans. by Arthur Goldhammer (Cambridge, MA, 1989)

Gallini, Brigitte, 'Concours et prix d'encouragement', in *La Révolution française et l'Europe, 1789–1799*, exh. cat., vol. III (Paris, 1989), pp. 830–51

Ganzin, Michel, 'Le Héros révolutionnaire, 1789–1794', *Revue historique de droit français*

et étranger, 61 (1983), pp. 371–92

Gardes, Gilbert, 'La Décoration de la Place Royale de Louis le Grand (Place Bellecour) à Lyon, 1686–1793', *Bulletin des musées et monuments lyonnais*, 5 (1974), p. 185

Garnier, Jacques, *Faïences révolutionnaires. Collections du Musée de la Céramique de Rouen* (Paris, 1989)

Gazette nationale ou Le Moniteur universel, no. 194, 13 July 1791 (*Réimpression de l'ancien Moniteur*, IX, Paris 1847)

Gazette nationale ou Le Moniteur universel (*Réimpression de l'ancien Moniteur*), 31 vols (Paris, 1847)

Gendron, François, *La Jeunesse dorée. Episodes de la Révolution française* (Sillery, 1979)

Gérard, Alain R. and Claude Quétel, *Histoire de France racontée par le jeu de l'Oie* (Paris, 1982)

Germani, Ian, 'Les Bêtes féroces: Thermidorian Images of Jacobinism', *Proceedings of the Annual Meeting of the Western Society for French History*, 17 (1990), pp. 205–19

Germer, Stefan, 'Comment sortir de la Révolution? Symbolische Verarbeitungsformen einer geschichtlichen Umbruchsituation im nachthermidorianischen Frankreich', in *Hülle und Fülle. Festschrift für Tilmann Buddensieg*, ed. Andreas Beyer et al. (Alfter, 1993), pp. 241–50

—, and Hubertus Kohle, 'From the Theatrical to the Aesthetic Hero: On the Privatization of the Concept of Virtue in David's *Brutus* and *Sabines*', *Art History*, 9/2 (1986), pp. 168–84

Gersmann, Gudrun and Hubertus Kohle, eds., *Frankreich 1800. Gesellschaft, Kultur, Mentalitäten* (Stuttgart, 1990)

Godineau, Dominique, *Citoyennes tricoteuses. Les femmes du peuple à Paris pendant la Révolution française* (Aix-en-Provence, 1988)

Goethe, J. W., *Recension einer Anzahl französischer satyrischer Kupferstiche. Text– Bild– Kommentar*, ed. Klaus H. Kiefer (Munich, 1988)

Gramaccini, Gisela, 'Jean-Guillaume Moitte et la Révolution française', *Revue de l'Art*, 83 (1989), pp. 61–70

—, *Jean-Guillaume Moitte (1746–1810). Leben und Werk*, 2 vols (Berlin, 1993)

—, 'Quatremère de Quincy, l'architecture et la sculpture historique au Panthéon', in *L'Art et les révolutions. XXXVIIe congrès international d'histoire de l'Art*, Section 1 (Strasbourg, 1992), pp. 157–77

Gueniffey, Patrice, *La Politique de la Terreur. Essai sur la violence révolutionnaire, 1789–1794* (Paris, 2000)

Gumbrecht, Hans-Ulrich, *Funktionen parlamentarischer Rhetorik in der Französischen Revolution* (Munich, 1978)

Harouel, Jean-Louis, *L'embellissement des villes. L'urbanisme français au XVIIIe siècle* (Paris, 1993)

Harten, Elke, *Museen und Museumsprojekte der Französischen Revolution. Ein Beitrag zur Entstehungsgeschichte einer Institution* (Munster, 1989)

—, and Hans Christian Harten, *Die Versöhnung mit der Natur. Gärten, Freiheitsbäume, republikanische Wälder, heilige Berge und Tugendparks in der Französischen Revolution* (Reinbek, 1989)

Harten, Hans-Christian, *Utopie und Pädagogik in Frankreich. 1789–1860. Ein Beitrag zur Vorgeschichte der Reformpädagogik* (Bad Heilbrunn, 1996)

Hayakawa, Riho, 'L'Assassinat du boulanger Denis François le 21 octobre 1789', *Annales historiques de la Révolution française*, 75 (2003), pp. 1–19

Hegel, G.F.W., *Vorlesungen über die Philosophie der Geschichte, Sämtliche Werke*, ed. H. Glockner (Stuttgart, 1961)

Henke, Christian, *Coblentz. Symbol für die Gegenrevolution* (Stuttgart, 2000)

Hennin, Michel, *Histoire numismatique de la Révolution française* (Paris, 1826)

Herding, Klaus, 'Davids *Marat* als dernier appel à l'unité révolutionnaire', *Idea. Jahrbuch der Hamburger Kunsthalle*, 2 (1983), pp. 89–112

—, *Im Zeichen der Aufklärung. Studien zur Moderne* (Frankfurt, 1989)

—, and Rolf Reichardt, *Die Bildpublizistik der Französischen Revolution* (Frankfurt, 1989)

Hesse, Carla, *Publishing and Cultural Politics in Revolutionary Paris, 1789–1810* (Berkeley, CA, 1991)

Heuvel, Gerd van den, *Der Freiheitsbegriff der Französischen Revolution. Studien zur Revolutionsideologie* (Göttingen, 1988)

—, 'Terreur, Terroriste, Terrorisme', in *Handbuch politischsozialer Grundbegriffe in Frankreich 1680–1820*, ed. Rolf Reichardt and Eberhard Schmitt, vol. 3 (Munich, 1985), pp. 89–132

Higonnet, Patrice, '*Aristocrate, Aristocratie*: Language and Politics in the French Revolution', in *The French Revolution, 1789–1989: Two Hundred Years of Rethinking*, ed. Sandy Petrey (Lubbock, TX, 1989), pp. 47–66

Hofmann, Werner, *Das entzweite Jahrhundert. Kunst zwischen 1750 und 1830* (Munich, 1995)

—, ed., *Europa 1789. Aufklärung – Verklärung – Verfall*, exh. cat. (Cologne, 1989)

—, *Das irdische Paradies. Motive und Ideen des 19. Jahrhunderts* (Munich, 1974)

Hould, Claudette, 'Les Beaux-arts en révolution, au bruit des armes les arts se taisent!', *Études françaises*, 25 (1989).

—, ed., *L'image de la Révolution française*, exh. cat. (Québec and Montréal, 1989)

—'La Propagande de l'Etat par l'estampe durant la Terreur', in *Les Images de la Révolution française*, ed. Michel Vovelle (Paris, 1988), pp. 29–37

Hubert, Gérard and Guy Ledoux-Lebard, *Napoléon. Portraits contemporains, bustes et statues* (Paris, 1999)

Hunt, Lynn, 'Hercules and the Radical Image in the French Revolution', *Representations*, 2 (1983), pp. 95–117.

—, 'The Many Bodies of Marie-Antoinette: Political Pornography and the Problem of the Feminine in the French Revolution', in *Marie Antoinette: Writings on the Body of a Queen*, ed. Dena Goodman (New York and London, 2003), pp. 117–55

—, *Politics, Culture, and Class in the French Revolution* (Berkeley, CA, 1984)

Jacques Réattu sous le signe de la Révolution, exh. cat., Vizille, Musée de la Révolution française , (Vizille, 2000)

James Gillray: The Art of Caricature, ed. Richard T. Godfrey and Mark Hallett, exh. cat., Tate Britain (London, 2001).

Jourdan, Annie, *Les Monuments de la Révolution, 1770–1804. Une histoire de représentation* (Paris, 1997)

Jouve, Michel, 'L'image de la Révolution dans la caricature anglaise: stéréotypes et archétypes', in *Les Images de la Révolution française*, ed. Michel Vovelle (Paris, 1988), pp. 185–92

Kemp, Wolfgang, 'Das Revolutionstheater des Jacques Louis David. Eine neue Interpretation des Schwurs im Ballhaus', in *Marburger Jahrbuch für Kunstwissenschaft'*, 21 (1986), pp. 165–84

Kerr, David S., *Caricature and French Political Culture, 1830–1848: Charles Philipon and the Illustrated Press* (London, 2000)

van Kley, Dale K., *The Damiens Affair and the Unraveling of the Ancien Régime, 1750–1770* (Princeton, NJ, 1979)

Koselleck, Reinhart, 'Revolution, Rebellion, Aufruhr, Bürgerkrieg', in *Geschichtliche Grundbegriffe*, ed. Otto Brunner, Werner Conze and R. Koselleck, vol. V (Stuttgart, 1984), pp. 653–788

Köstler, Andreas, *Place Royale: Metamorphosen einer kritischen Form des Absolutismus* (Munich, 2003)

283

Krause-Tastet, Peter, *Analyse der Stilentwicklung in politischen Diskursen während der Französischen Revolution (1789–1794)* (Frankfurt, 1999)

Krauß, Armin, *Tempel und Kirche. Zur Ausbildung von Fassade und 'portail' in der französischen Sakralarchitektur des 17. und 18. Jahrhunderts* (Weimar, 2003)

La Guillotine dans la Révolution, ed. Valérie Rousseau-Lagarde and Daniel Arasse, exh. cat., Vizille, Musée de la Révolution française (Vizille, 1987)

La Mort de Bara. De l'événement au mythe. Autour du tableau de Jacques Louis David, exh. cat., Musée Calvet (Avignon, 1989)

La Révolution française et l'Europe, exh. cat., vol. I–III (Paris, Grand Palais: Conseil de l'Europe 1989).

Labrosse, Claude and Pierre Rétat, *Naissance du journal révolutionnaire, 1789* (Lyon, 1989)

Laharpie, Patrick, 'Les Burins de la Terreur', in *Histoire et Archives*, 6 (1999), pp. 77–136 and 151–72

Lambalais-Vuianovith, D., 'Etude quantitative des thèmes traités dans l'image volante française au XVIIIe siècle', thèse de 3e cycle, Université de Paris IV, 1979

Langlois, Claude, *La Caricature contre-révolutionnaire* (Paris, 1988)

—, *Les Sept Morts du roi* (Paris, 1993)

Lapauze, Henry, ed., *Procès-Verbaux de la Commune Générale des Arts de peinture, sculpture, architecture et gravure (18 juillet 1793 – tridi de la 1ère décade du 2e mois de l'an II) et de la Société populaire et républicaine des arts (3 nivose an II – 28 floréal an III)* (Paris 1903)

Laredo, Dominique, 'Deux exemples de monuments révolutionnaires en Province: une Colonne de la Liberté (1791) et un Temple de la Raison (1793) à Montpellier', in *Les Images de la Revolution française*, ed. Michel Vovelle, p. 151

Leith, James A., 'Clio and the Goose: The Jeu de l'Oie as historical evidence', in *Essays in European History, Selected from the Annual Meeting of the Southern Historical Association*, ed. Caroyn W. Whitte (Lanham, NY and London, 1996), pp. 225–61

—, 'La Pédagogie à travers les jeux, le jeu de l'oie pendant la Révolution et l'Empire', in *Former un Nouveau Peuple? Pouvoir – Education – Révolution*, ed. Josiane Boulad-Ayoub (Paris, 1996), pp. 159–86

—, 'Die revolutionäre Karriere des Hercules in Frankreich 1789–1799', in *Herakles – Herkules, Metamorphosen des Heros in ihrer medialen Vielfalt*, ed. Ralph Kray and Stephan Oettermann (Stroemfeld, 1994), vol. I, pp. 131–48

—, *Space and Revolution: Projects for Monuments, Squares and Public Buildings in France, 1789–1799* (Montreal, 1991)

—, 'Les trois apothéoses de Voltaire', *Annales historique de la Révolution française*, 51 (1979), pp. 161–209

Leroy-Jay Lemaistre, Isabelle, 'De Sainte-Geneviève au Panthéon, les différents programmes de sculpture, à la lumière des récentes découvertes', in *Le Panthéon, symbole des révolutions* (Paris, 1989), pp. 234–47

Lescure, Adaolphe-Mathurin de, ed., *Correspondance secrète inédite sur Louis XVI, Marie-Antoinette, la Cour et la Ville, de 1777 à 1792* (Paris, 1866)

Lever, Evelyne, 'Le Testament de Louis XVI et la propagande royaliste par l'image pendant la Révolution et l'Empire', *Gazette des Beaux-Arts* 94 (1979), pp. 159–73

Linguet, Simon-Nicolas-Henri, *Mémoires sur la Bastille* (London, 1783)

Lipshultz, Sandra, L., *Regency to Empire: French Printmaking, 1715–1814* (Baltimore, 1985)

Locquin, Jean, *La peinture d'histoire en France de 1747 à 1785: Étude sur l'évolution des idées artistiques dans la seconde moitié du XVIIIe siècle* (Paris, 1912)

Lottes, Günther, *Politische Aufklärung und plebejisches Publikum. Zur Theorie und Praxis des englischen Radikalismus im späten 18. Jahrhundert* (Munich, 1979)

Lüsebrink, Hans-Jürgen, 'Brutus, idole patriotique. Dimensions symboliques et mises en scène théâtrales', in *Bruto il maggiore nella letteratura francese e dintorni*, ed. Franco Piva (Brindisi, 2002), pp. 285–305

—, and Rolf Reichardt, '*Révolution* à la fin du 18e siècle. Pour une relecture d'un concept-clé du siècle des Lumières', *Mots*, 16 (1988), pp. 35–67

—, and Rolf Reichardt, *The Bastille: A History of a Symbol of Despotism and Freedom*, trans. Norbert Schürer (Durham, NC, and London, 1997)

Mainardi, Patricia, *The End of the Salon: Art and the State in the Early Third Republic* (Cambridge, 1993)

Mannoni, Edith, *Les Faïences révolutionnaires* (Paris, 1989)

Manow, Philip, 'Der demokratische Leviathan – eine kurze Geschichte parlamentarischer Sitzanordnungen seit der Französischen Revolution', *Leviathan*, 32 (2004), pp. 319–47

Martuschkat, Jürgen, 'Ein schneller Schnitt, ein sanfter Tod? Die Guillotine als Symbol der Aufklärung', in *Das Volk im Visier der Aufklärung. Studien zur Popularisierung der Aufklärung im späten 18. Jahrhundert*, ed. Anne Conrad et al. (Hamburg, 1998), pp. 121–42

Mathis, Hans Peter, ed., *Napoleon I. im Spiegel der Karikatur / Napoleon I in the Mirror of Caricature* (Zürich, 1998)

Mayer, Arno, *The Furies: Violence and Terror in the French and Russian Revolutions* (Princeton, NJ, 2000)

Maza, Sarah, *Private Lives and Public Affairs: The causes célèbres of Prerevolutionary France* (Berkeley, 1993)

McClellan, Andrew, 'D'Angiviller's "Great Men" of France and the Politics of the Parlements', *Art History* 13/2 (1990), pp. 175–92

—, *Inventing the Louvre: Art, Politics, and the Origins of the Modern Museum in Eighteenth-century Paris* (Cambridge, 1994)

Meinzer, Michael, *Der französische Revolutionskalender (1792–1805): Planung, Durchführung und Scheitern einer politischen Zeitrechnung* (Munich, 1992)

Mercier, Louis-Sébastien, *Le Nouveau Paris*, vols I–II (Paris: Pougens and Cramer, 1798)

Meyer, Friedrich Johann Lorenz, *Fragmente aus Paris im IVten Jahr der französischen Republik* (Hamburg, 1797), pp. 20–21

Michel, Régis, 'L'Art des Salons', in *Aux armes et aux arts!*, ed. Philippe Bordes and Régis Michel (Paris, 1988), pp. 103–35

—, 'De la chimère au fantasme', in *La Chimère de Monsieur Desprez*, exh. cat. (Paris, 1994), pp. 7–14

Monnier, Raymonde, *Un bourgeois sans-culotte: Le général Santerre* (Paris, 1989)

Morel, Henri, 'Les poids de l'antiquité sur la Révolution française', in *L'Influence de l'antiquité sur la pensée politique européenne (XVI–XXème siècles)*, ed. Michel Ganzin (Aix and Marseille, 1996), pp. 295–316

Möseneder, Karl, *Zeremoniell und monumentale Poesie. Die 'Entrée solennelle' Ludwigs XIV. 1660 in Paris* (Berlin, 1983)

Négrel, Eric and Jean-Paul Sermain, eds, *Une expérience rhétorique: L'éloquence de la Révolution* (Oxford, 2002)

Olander, William, *Pour transmettre à la postérité: French Painting and Revolution, 1774–1795* (Ann Arbor, MI, 1996)

Ozouf, Mona, 'Du mai de la liberté à l'arbre de la liberté: symbolisme révolutionnaire et tradition paysanne', *Ethnologie française*, n.s., 5 (1975), pp. 9–32

—, 'Le Panthéon: l'Ecole normale des morts', in *Les Lieux de mémoire*, part I: *La République*, ed. Pierre Nora (Paris, 1984), pp. 139–66

Page, P. F., *Essai sur les causes et les effets de la Révolution* (Paris, 1795)

Papenheim, Martin, *Erinnerung und Unsterblichkeit, Semantische Studien zum Totenkult in*

Frankreich (1715–1794) (Stuttgart, 1992)

Parker, Harold T., *The Cult of Antiquity and the French Revolution* (Chicago, IL., 1937)

Pellegrin, Nicole 'Les Femmes et le don patriotique. Les offrandes d'artistes de Septembre 1789', in *Les femmes et la Révolution française*, ed. Marie-France Brive, vol. II (Toulouse, 1990), pp. 361–80

Pellegrin, Nicole, *Les Vêtements de la liberté. Abécédaire des pratiques vestimentaires en France de 1780–1800* (Aix-en-Provence, 1989)

Petit Dictionnaire des grands hommes et des grandes choses qui ont rapport à la Révolution, composé par une société d'aristocrates (Paris, 1790)

Petzet, Michael, *Soufflots Sainte-Geneviève und der französische Kirchenbau des 18. Jahrhunderts* (Berlin, 1961)

Pinon, Pierre, 'L'Architecte Pâris et les premières salles d'assemblée, des Menus-Plaisirs au Manège', *Les Architectes de la liberté, 1789–1799*, exh. cat. (Paris: ENSBA, 1989–90), pp. 77–84

Poinsot, Marie V., 'La Comédie des trois ordres', in *Les Images de la Révolution française*, ed. Michel Vovelle (Paris, 1988), pp. 283–90

Pommier, Edouard, *L'Art de la Liberté: doctrines et débats de la Révolution française* (Paris, 1991)

—, 'Winckelmann et la vision de l'Antiquité classique dans la France des Lumières et de la Revolution', *Revue de l'art*, 83 (1989), pp. 9–20

Popkin, Jeremy D., *Revolutionary News: The Press in France, 1789–1799* (Durham, 1990)

Poulot, Dominique, 'Pantheons in Eighteenth-century France. Temple, Museum, Pyramid', in *Pantheons: Transformations of a Monumental Idea*, ed. Richard Wrigley and Matthew Crask (Burlington, VT, 2004), pp. 123–45

Prudhomme, Louis-Marie, *Histoire générale et impartiale des erreurs, des fautes et des crimes commis pendant la Révolution française* (Paris, 1797)

Quatremère de Quincy, Antoine-Chrysostôme, *Considérations sur les arts du dessein en France, suivies d'un plan d'Académie ou d'école publique et d'un système d'encouragements* (Paris, 1791)

Quatremère de Quincy, Antoine-Chrysostôme, *Rapport fait au Directoire du Département de Paris,. . . le deuxième jour du second mois de l'an III* (Paris, 1794)

—, *Rapport sur l'édifice dite de Sainte-Geneviève fait au Directoire du Département de Paris* (Paris: Imprimerie royale, 1791)

Rabreau, Daniel, 'La Basilique de Sainte-Geneviève de Soufflot', *Le Panthéon, symbole des révolutions* (Paris, 1989), p. 37–96

Raineau, Joëlle, 'La Gravure, techniques et économies. Les discours sur la décadence de la gravure de l'ancien régime à la Révolution', in *The European Print and Cultural Transfer in the 18th and 19th Centuries*, ed. Philippe Kaenel and Rolf Reichardt (Hildesheim, 2007), pp. 655–68

Reichardt, Rolf, 'Die Bildpublizistik der Bastille 1715 bis 1880', in *Die Bastille – Symbolik und Mythos in der Revolutionsgraphik*, ed. Berthold Roland and Andreas Anderhub, exh. cat. (Mainz, 1989), pp. 23–70

—, 'Expressivität und Wiederholung. Bildsprachliche Erinnerungsstrategien in der Revolutionsgraphik nach 1789', in *Medien des kollektiven Gedächtnisses: Konstruktivität – Historizität – Kulturspezifizität*, ed. Astrid Erll and Ansgar Nünning (Berlin, 2004), pp. 125–57

—, 'Heroic Deeds of the New Hercules: The Politicization of Popular Prints in the French Revolution', in *Symbols, Myths and Images of the French Revolution: Essays in Honour of James A. Leith*, ed. Ian Germani and Robin Swales (Regina, 1998), pp. 17–46

—, 'Histoire de la culture et des opinions', in *La Révolution française au carrefour des recherches*, ed. Martine Lapied and Christine Peyrard (Aix-en-Provence, 2003), pp.

205–47

—, 'Historical Semantics and Political Iconography: The Case of the Game on the French Revolution (1791–2)', in *History of Concepts: A Comparative Approach*, ed. Ian Hampsher-Monk, Karin Tilmans and Frank van Vree (Amsterdam, 1998), pp. 191–226

—, 'Mehr geschichtliches Verstehen durch Bildillustration? Kritische Überlegungen am Beispiel der Französischen Revolution', *Francia. Studien zur westeuropäischen Geschichte*, 13 (1987), pp. 511–23

—, 'Die Revolution – ein magischer Spiegel. Historisch-politische Begriffsbildung in französisch-deutschen Übersetzungen', in *Kulturtransfer im Epochenumbruch, Frankreich – Deutschland 1770 bis 1815*, ed. Hans-Jürgen Lüsebrink and R. Reichardt (Leipzig, 1997), pp. 883–999

—, *Das Revolutionsspiel von 1791. Ein Beispiel für Medienpolitik und Selbstdarstellung der Französischen Revolution* (Frankfurt, 1989)

—, 'Stand und Perspektiven der kulturhistorischen Revolutionsforschung. Ein Überblick', in *200. Jahrestag der Französischen Revolution. Kritische Bilanz der Forschungen zum Bicentenaire*, ed. Katharina and Matthias Middell (Leipzig, 1992), pp. 234–54

—, 'Zeit-Revolution und Revolutionserinnerung in Frankreich 1789–1805', in *Zeit im Wandel der Zeiten*, ed. Hans-Joachim Bieber, Hans Ottomeyer and Georg Christoph Tholen (Kassel, 2002), pp. 149–90

Renger, K., 'Karneval und Fasten. Bilder vom Fressen und, Hungern', *Weltkunst*, 58 (1988), pp. 184–9

Rétat, Pierre, ed., *L'Attentat de Damiens: discours sur l'événement au XVIIIe siècle* (Paris, 1979)

—, 'Représentations du temps révolutionnaire d'après les journaux de 1789', in *L'espace et le temps reconstruits. La Révolution française, une révolution des mentalités et des cultures?*, ed. Philippe Joutard (Aix-en-Provence, 1990), pp. 120–29

Roberts, Warren, *Jacques Louis David and Jean Louis Prieur: Revolutionary Artists. The Public, the Populace and Images of the French Revolution* (New York, 2000)

Röhrich, Lutz, 'Homo Homini Daemon. Tragen und Ertragen. Zwischen Sage und Bildlore', in *Medien populärer Kultur: Erzählung, Bild und Objekt in der volkskundlichen Forschung*, ed. Carola Lipp (Frankfurt, 1995), pp. 346–61

Roy, Stéphane, 'Paul-André Basset et ses contemporains. L'édition d'imagerie populaire pendant la Révolution, piratage ou entente tacite?', *Nouvelles de l'estampe*, no. 176 (2001), pp. 5–19

Ruault, Nicolas *Gazette d'un Parisien sous la Révolution. Lettres à son frère, 1783–1796* (Paris, 1975)

Rubin, James, 'Disorder/Order, Revolutionary Art as Performative Representation', in *The French Revolution 1789–1989: Two Hundred Years of Rethinking*, ed. Sandy Petrey (Lubock, 1989), p. 90ff.

Rütten, Raimund, ed., *Die Karikatur zwischen Republik und Zensur. Bildsatire in Frankreich 1830 bis 1880 – eine Sprache des Widerstands?* (Marburg, 1991)

Sandt, Udolpho van de, 'Institutions et Concours', in *Aux armes et aux arts! Les arts de la Révolution, 1789–1799*, ed. Philippe Bordes and Régis Michel (Paris, 1988), pp. 137–65

Savoy, Bénédicte, *Patrimoine annexé: les biens culturels saisis par la France en Allemagne autour de 1800*, 2 vols. (Paris, 2003)

Schmidt-Linsenhoff, Viktoria, ed., *Sklavin oder Bürgerin? Französische Revolution und neue Weiblichkeit, 1760–1830*, exh. cat., Historisches Museum (Frankfurt/Marburg, 1989)

Schmitt, Eberhard, *Repräsentation und Revolution. Eine Untersuchung zur Genesis der*

kontinentalen Theorie und Praxis parlamentarischer Repräsentation aus der Herr-
schaftspraxis des Ancien régime in Frankreich (1760–1789) (Munich, 1969)

Schnapper, Antoine, David und seine Zeit (Fribourg and Würzburg, 1981)

Schneider, Herbert, 'Der Formen- und Funktionswandel in den Chansons und Hymnen
der Französischen Revolution', in Die Französische Revolution als Bruch des gesell-
schaftlichen Bewußtseins, ed. Reinhart Koselleck and Rolf Reichardt (Munich, 1988),
pp. 421–78

Schneider, René-Gabriel, Quatremère de Quincy et son intervention dans les arts,
1788–1830 (Paris, 1910)

Siegfried, Susan, The Art of Louis-Léopold Boilly: Modern Life in Napoleonic France
(New Haven and London, 1995)

Simon, Robert, 'Portrait de martyr, Le Peletier', in David contre David, ed. Régis Michel
(Paris, 1993), vol. I, pp. 349–77

Simons, Kathrin, 'Der Triumph der Zivilisation von Jacques Réattu', Idea. Jahrbuch der
Hamburger Kunsthalle, 2 (1983), pp. 113–28

Snetlage, Léonard, Nouveau Dictionnaire français contenant les expressions de nouvelle
création du peuple français (Göttingen, 1795)

Soufflot et l'architecture des Lumières, ed. Michel Petzet (Paris, 1980)

Sous les pavés de la Bastille. Archéologie d'un mythe révolutionnaire, ed. Claude Malécot,
exh. cat. (Paris: Hôtel de Sully, 1989–90)

Spiegel, Régis, 'Une métaphore du vide. Des destructions révolutionnaires aux projets
du Premier Empire', in La Place des Victoires: histoire, architecture, société, ed. Isabelle
Dubois, A. Gady and F. Ziegler (Paris, 2004), pp. 109–23

Stolzenburg, Andreas, 'Freiheit oder Tod – ein missverstandenes Werk Jean Baptiste
Regnaults?', Wallraf-Richartz Jahrbuch, 48/49 (1987–8), pp. 463–72

Stone, Bailey, The French Parlements and the Crisis of the Old Regime (Chapel Hill, NC,
1986)

Szambien, Werner, Les projets de l'an II. Concours d'architecture de la période révolution-
naire (Paris, 1986)

Tackett, Timothy, When the King Took Flight (Cambridge, MA, 2003)

Taillard, Christian, 'De l'Ancien Régime à la Révolution: l'histoire exemplaire des
projets d'aménagement du Château Trompette à Bordeaux', Revue de l'Art, 83
(1989), pp. 77–85

Thamer, Hans-Ulrich, 'Revolution, Krieg, Terreur. Zur politischen Kultur und Ikono-
graphie der Französischen Revolution', in Iconologia sacra. Mythos, Bildkunst und
Dichtung in der Religions- und Sozialgeschichte Alteuropas, ed. H. Keller and
N. Staubach (Berlin and New York, 1994).

Thomas, Chantal, The Wicked Queen: The Origins of the Myth of Marie-Antoinette (New
York, 1999)

Thüsen, Joachim von der, 'Die Lava der Revolution fließt majestätisch. Vulkanische
Metaphorik zur Zeit der Französischen Revolution', Francia. Forschungen zur westeu-
ropäischen Geschichte, 23/2 (1996), pp. 113–42

Tillon, Charles, Le Laboureur et la République. Michel Gérard, depute paysan sous la Révo-
lution française (Paris, 1983)

Toulongeon, François-Emmanuel, Manuel révolutionnaire, ou pensées morales sur l'état
politique des peuples en Révolution (Paris: Dupont, 1796)

Träger, Jörg, Der Tod des Marat. Revolution des Menschenbildes (Munich, 1986)

Trogan, Rosine and Philippe Sorel, Augustin Dupré (1748–1833). Graveur général des
Monnaies de France, exh. cat. (Paris, 2000)

Varlet, Jean-François, Le Panthéon français (Paris, 1795)

Vaughan, William and Helen Weston, Jacques-Louis David's 'Marat' (Cambridge, 2000)

Venturino, Diego, 'La Naissance de l'Ancien Régime', in The French Revolution and the

Creation of Modern Political Culture, vol. II: *The Political Culture of the French Revolution,* ed. Colin Lucas (Oxford, 1988), pp. 1–40

Vogel, Christine, *Der Untergang der Gesellschaft Jesu als europäisches Medienereignis (1758–1773). Publizistische Debatten im Spannungsfeld von Aufklärung und Gegenaufklärung* (Mainz, 2006)

Vogelsang, Bernd, 'Ami, le temps n'est plus. Johann Anton de Peters als anti-revolutionärer Karikaturist?', *Wallraf-Richartz-Jahrbuch*, 43 (1982), pp. 195–206

Vovelle, Michel, *Die Französische Revolution. Soziale Bewegung und Umbruch der Mentalitäten* (Munich, 1982)

—, 'Héroïsation et Révolution: la fabrication des héros sous la Révolution française', *Le Mythe du héros. Actes du colloque interdisciplinaire du centre aixois de recherches anglaises* (Aix-en-Provence and Marseille, 1982), p. 215–34

—, ed., *L'Image de la Révolution française*, 4 vols (London, 1989–90)

—, *La Révolution française: images et récit*, 5 vols (Paris, 1986)

Wagner, Michael, 'Parlements', in *Handbuch politisch-sozialer Grundbegriffe in Frankreich 1680–1820*, vol. 10, ed. Rolf Reichardt and Eberhard Schmitt (Munich, 1988), pp. 55–106

Wildenstein, Daniel and Guy, *Documents complémentaires au catalogue de l'Œuvre de J.-L. David* (Paris, 1973)

Wisner, David, 'Deux images de la République, le *Serment du Jeu de Paume* de David et *l'Insurrection du 10 Août* de Gérard', in *Saint-Denis, ou le jugement dernier des rois*, ed. Roger Bourderon (Saint-Denis, 1993), pp. 397–405.

Wrigley, Richard, *The Politics of Appearances: Representations of Dress in Revolutionary France* (Oxford, 2002)

Zizek, Joseph, 'Plume de fer: Louis-Marie Prudhomme writes the French Revolution', *French Historical Studies*, 26 (Autumn 2003), pp. 619–60

Index

Figures in *italics* indicate illustration numbers.